Muybridge's

COMPLETE HUMAN AND ANIMAL LOCOMOTION

All 781 Plates from the 1887
Animal Locomotion

BY
EADWEARD MUYBRIDGE

VOLUME III
containing original volumes

9: HORSES
10: DOMESTIC ANIMALS
11: WILD ANIMALS & BIRDS
ORIGINAL PROSPECTUS
& CATALOGUE OF PLATES

DOVER PUBLICATIONS, INC.
New York

⌖ *IMPORTANT NOTE* ⌖

The present republication of this landmark work in the history of photography would not have been possible without the substantial cooperation of Mr. Harry Lunn of Lunn Gallery / Graphics International, Washington, D.C., who made the original portfolios I through VIII, X and XI available for reproduction; and particularly of the Gilman Paper Company, New York City, who loaned the original portfolio IX, thereby making publication possible.

The publisher is grateful to these persons and organizations for the public spirit they have displayed in sharing their rare possessions with a wider audience.

Published in Canada by General Publishing Company, Ltd., 30 Lesmill Road, Don Mills, Toronto, Ontario.
Published in the United Kingdom by Constable and Company, Ltd., 3 The Lanchesters, 162–164 Fulham Palace Road, London W6 9ER.

This Dover edition, first published in 1979, is an unabridged republication of the eleven-volume work *Animal Locomotion; an electro-photographic investigation of consecutive phases of animal movements,* originally published under the auspices of the University of Pennsylvania, Philadelphia, in 1887; together with the *Prospectus and Catalogue of Plates,* published separately by the University earlier in the same year. A new Introduction has been written specially for the present edition by Anita Ventura Mozley.

DOVER *Pictorial Archive* SERIES

This book belongs to the Dover Pictorial Archive Series. You may use the designs and illustrations for graphics and crafts applications, free and without special permission, provided that you include no more than ten in the same publication or project. (For permission for additional use, please write to Dover Publications, Inc., 31 East 2nd Street, Mineola, N.Y. 11501.)
However, republication or reproduction of any illustration by any other graphic service, whether it be in a book or in any other design resource, is strictly prohibited.

Book design by Carol Belanger Grafton

International Standard Book Number: 0-486-23794-X
Library of Congress Catalog Card Number: 79-51299

Manufactured in the United States of America
Dover Publications, Inc.
31 East 2nd Street
Mineola. N.Y. 11501

CONTENTS

LOCATION OF PLATES IN THE PRESENT DOVER VOLUME

As in the original edition of *Animal Locomotion,* the numbering of the 781 plates corresponds to that of the *Prospectus and Catalogue of Plates* (reprinted at the end of this volume). However, the plates do not occur in a continuous numerical order within the eleven original volumes (the sequence of which is followed here), so that the following breakdown will be helpful.

VOLUME 9, *Horses,* contains Plates 563–657.

VOLUME 10, *Domestic Animals,* contains Plates 658–679, 703–720.

VOLUME 11, *Wild Animals* & *Birds,* contains Plates 680–702, 721–781.

A full concordance of plate numbers with their page numbers in the Dover edition will be found in the first 'Dover volume.

Volume 9

HORSES

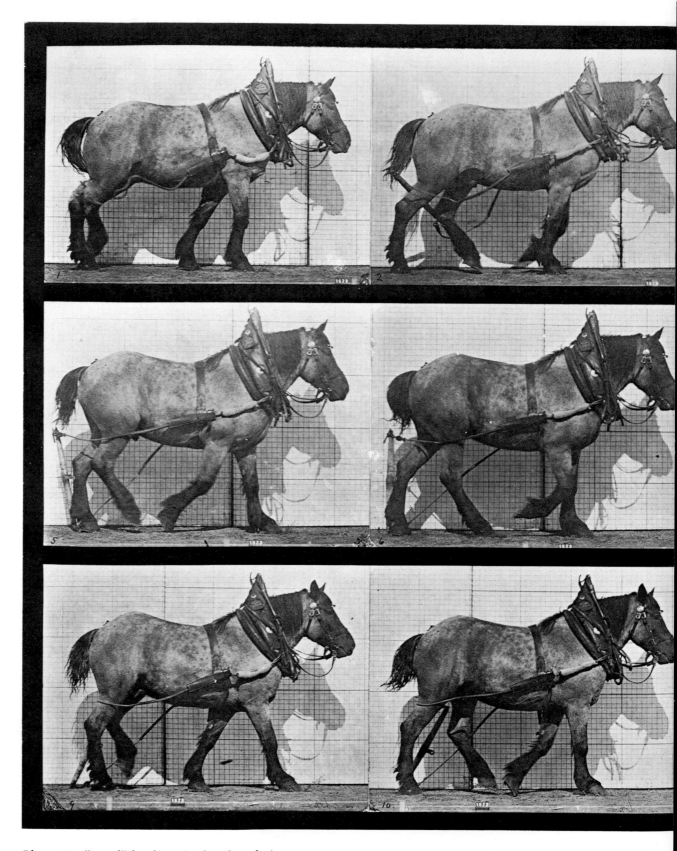

Plate 563. "Dusel" hauling, broken log chain.

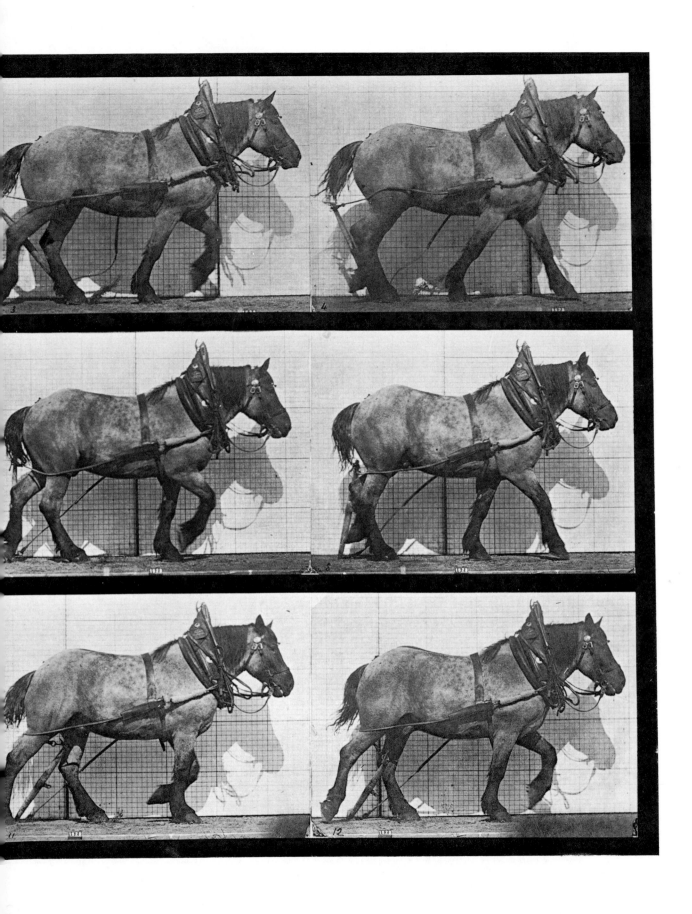

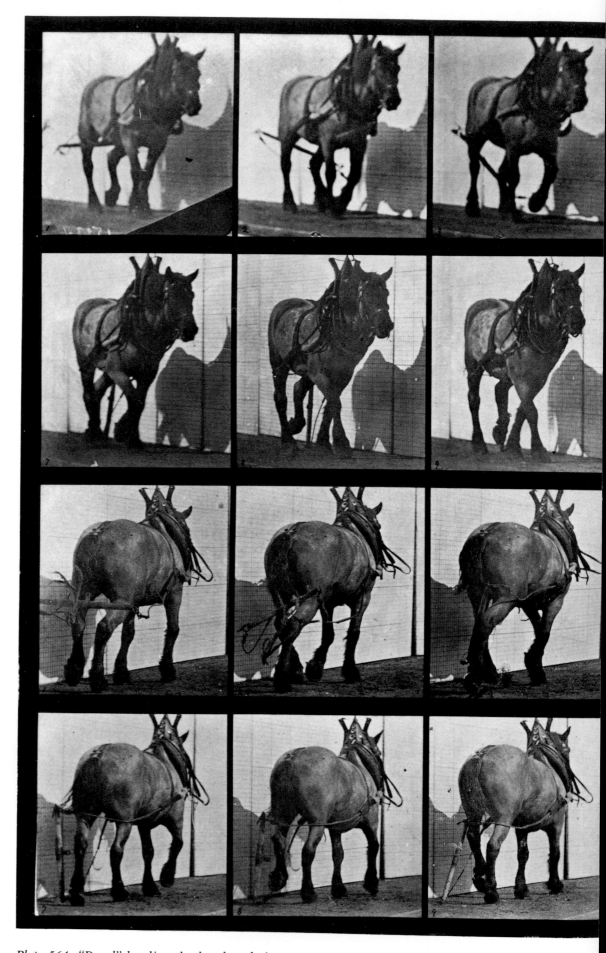

Plate 564. "Dusel" hauling, broken log chain.

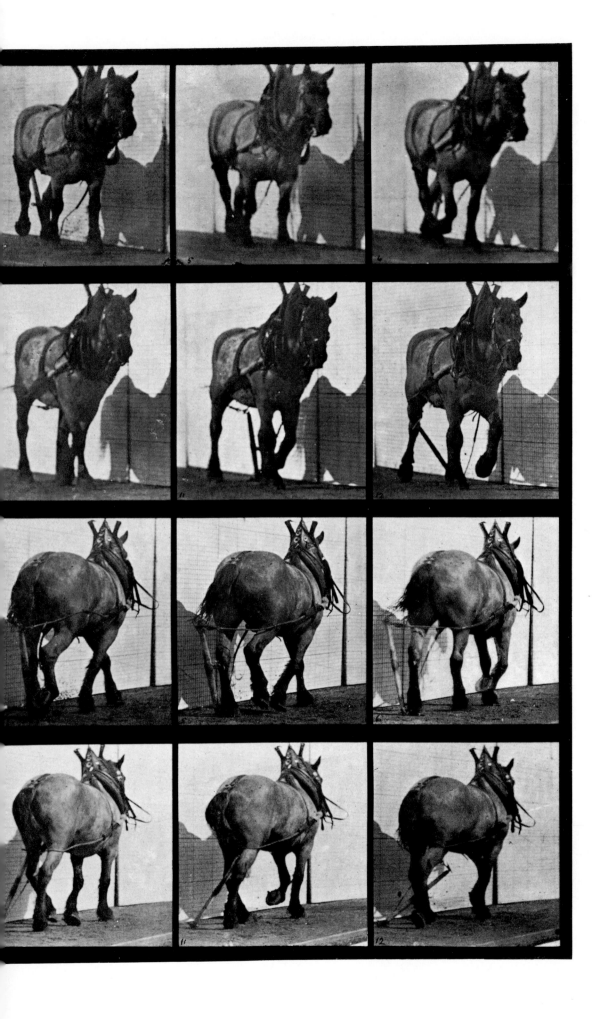

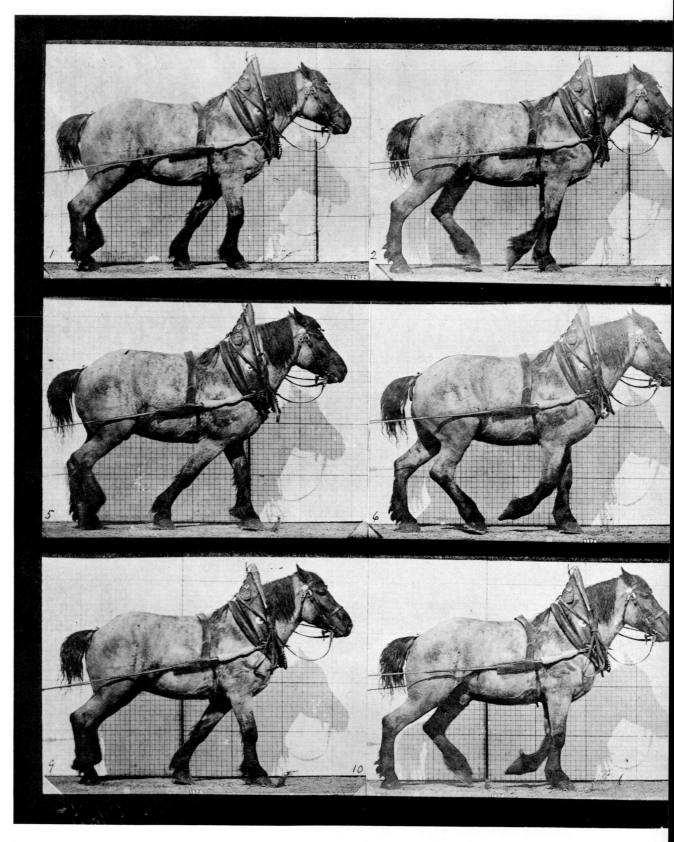

Plate 565. "Dusel" hauling.

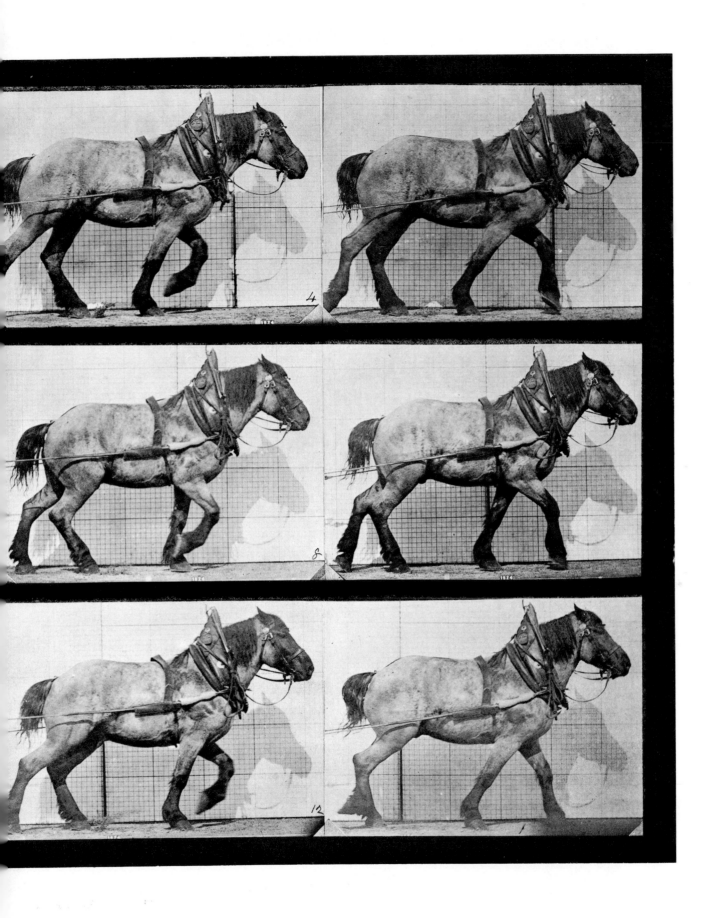

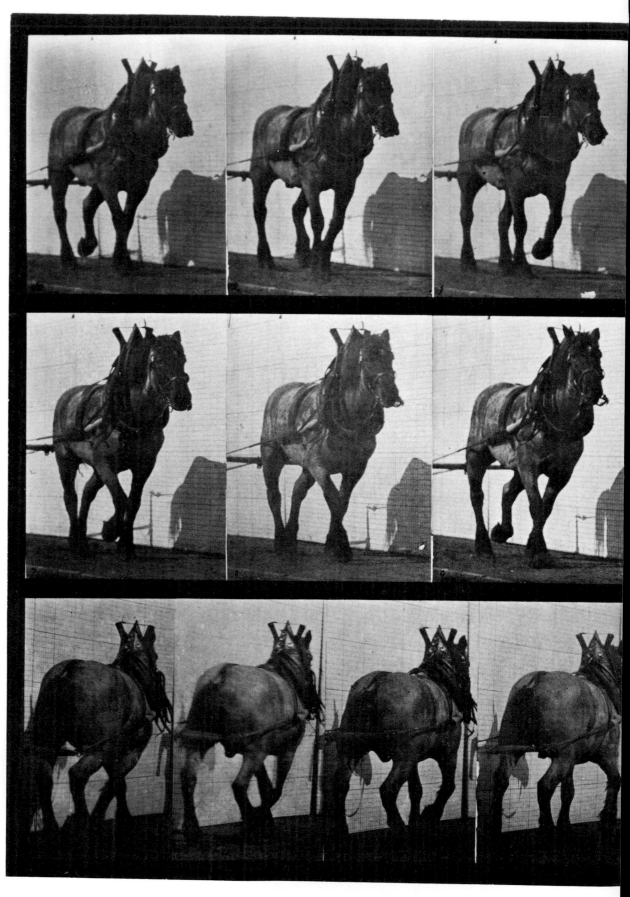

Plate 566. "Dusel" hauling.

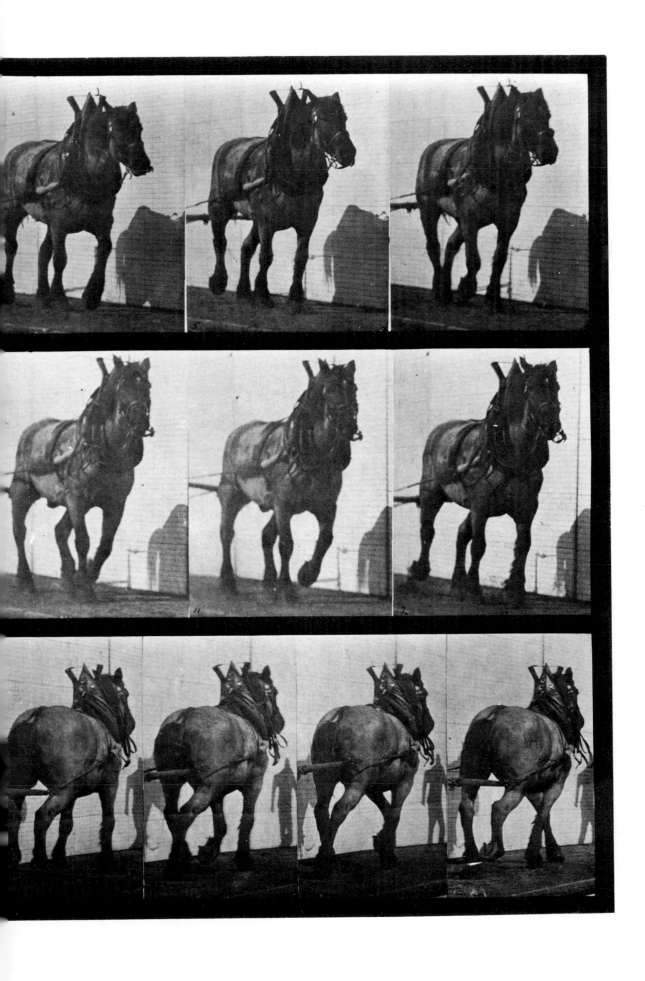

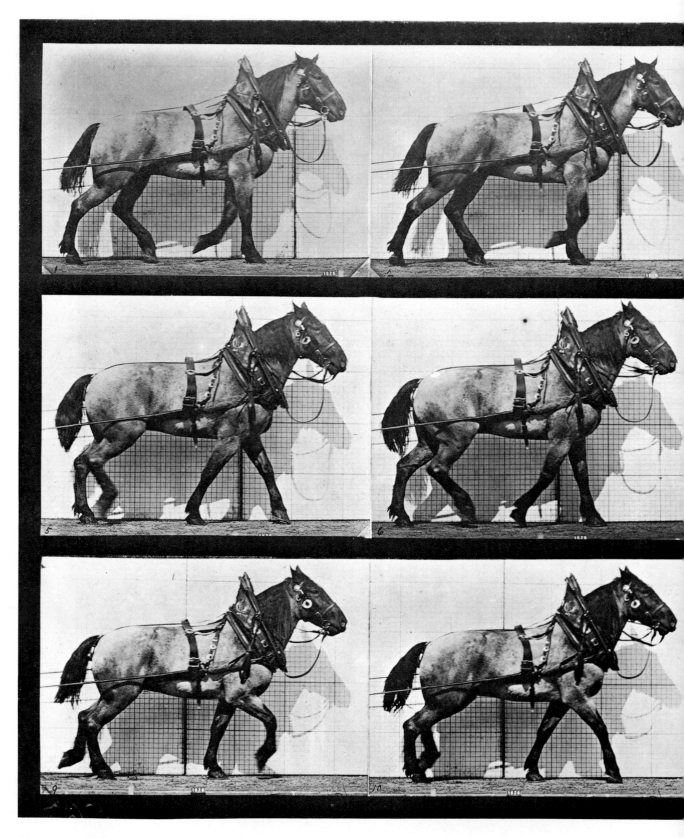

Plate 567. "Billy" hauling.

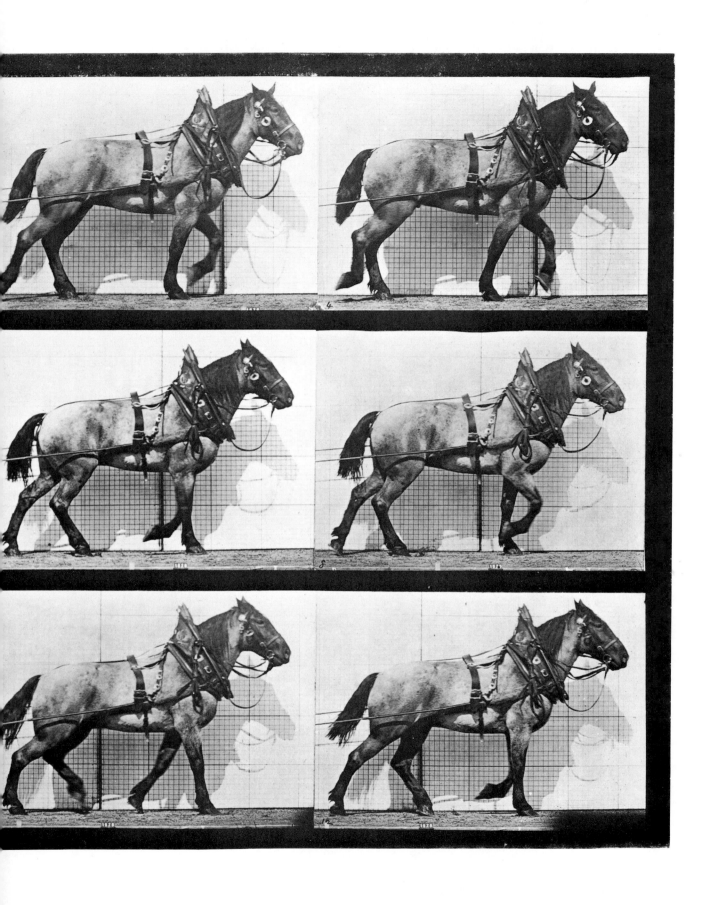

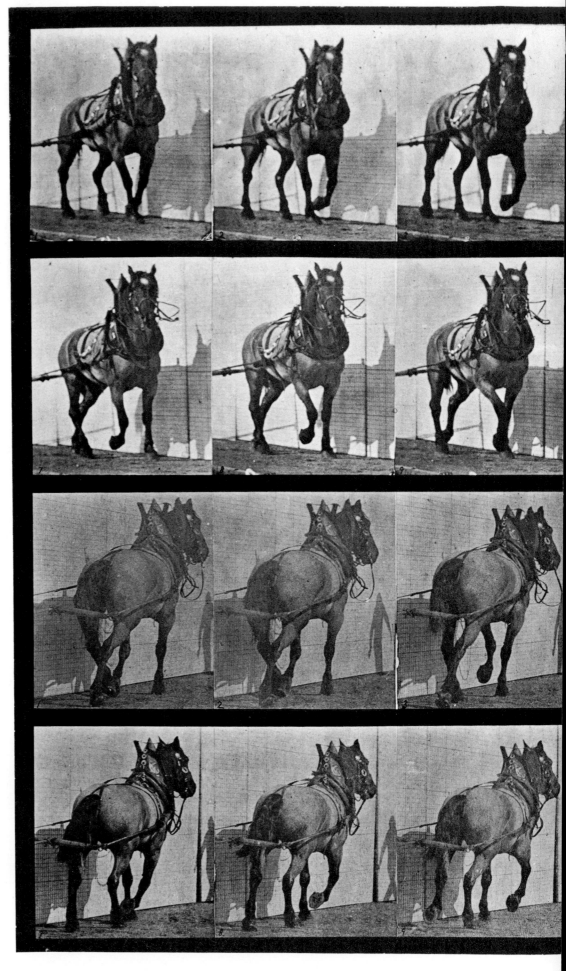

Plate 568. "Billy" hauling.

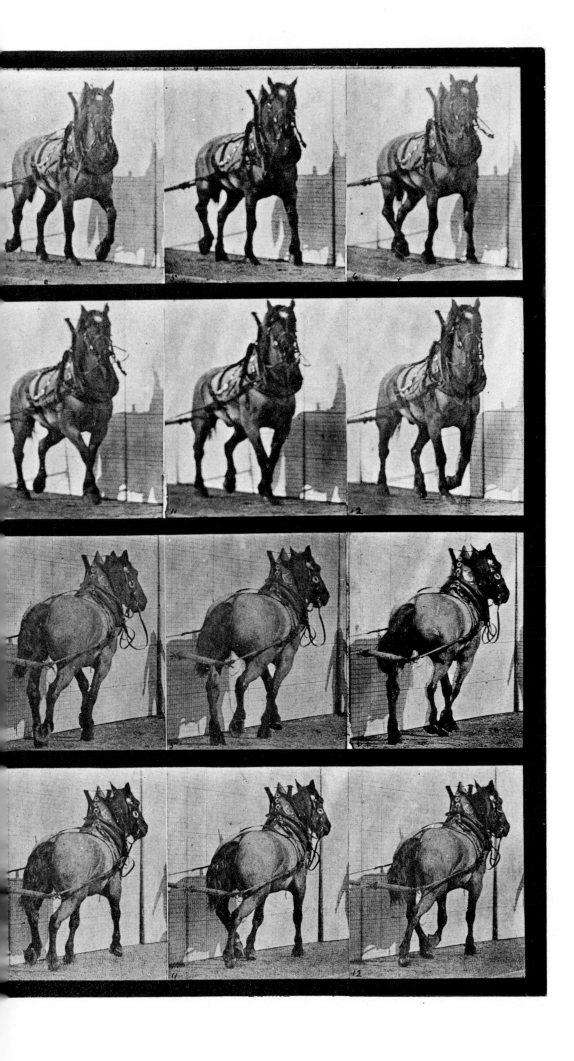

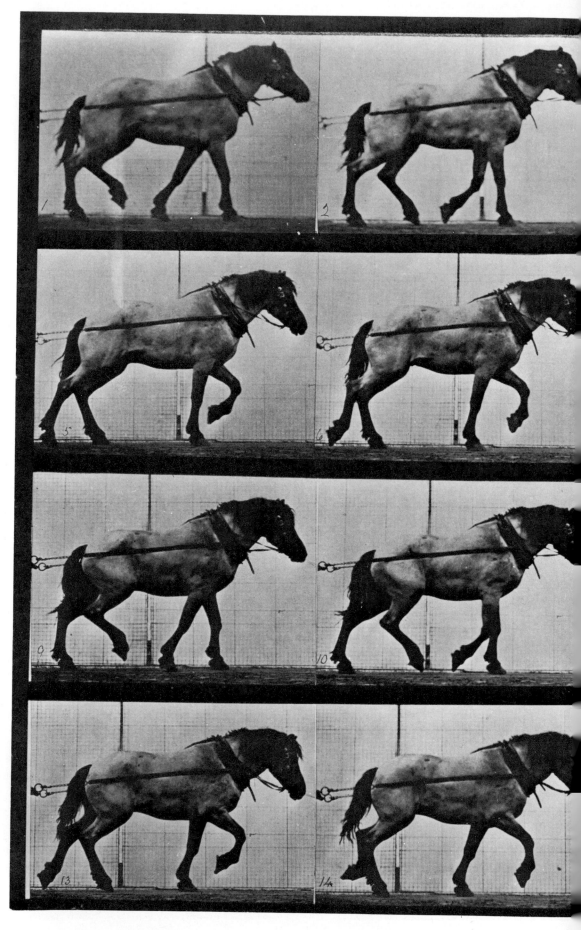

Plate 569. "Hansel" hauling.

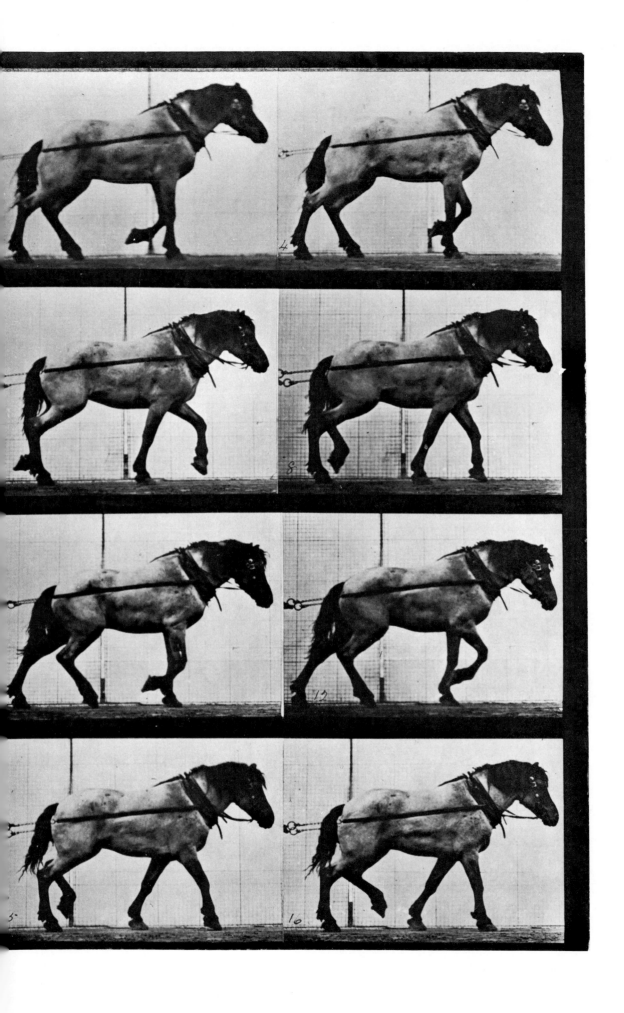

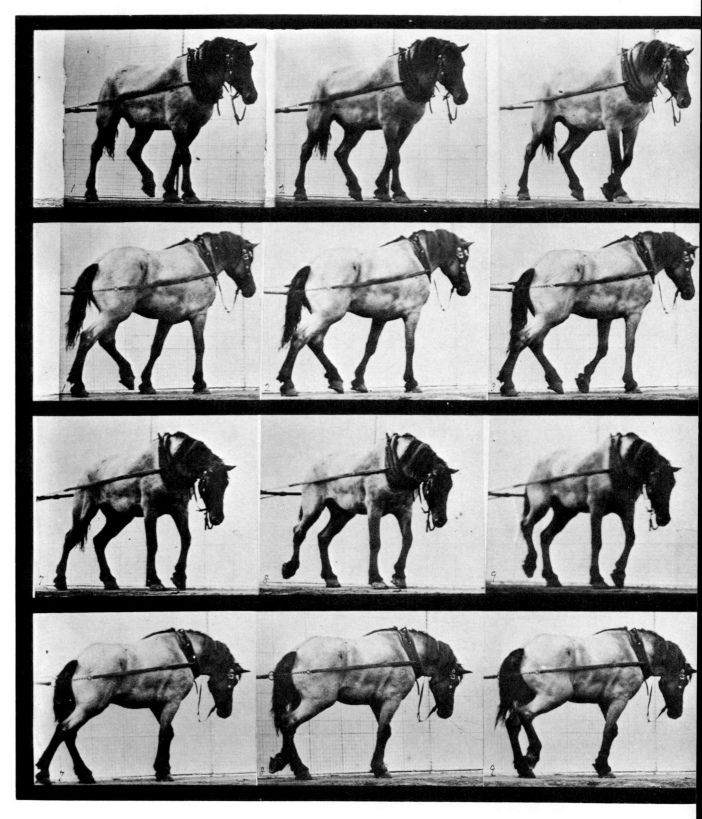

Plate 570. "Hansel" hauling.

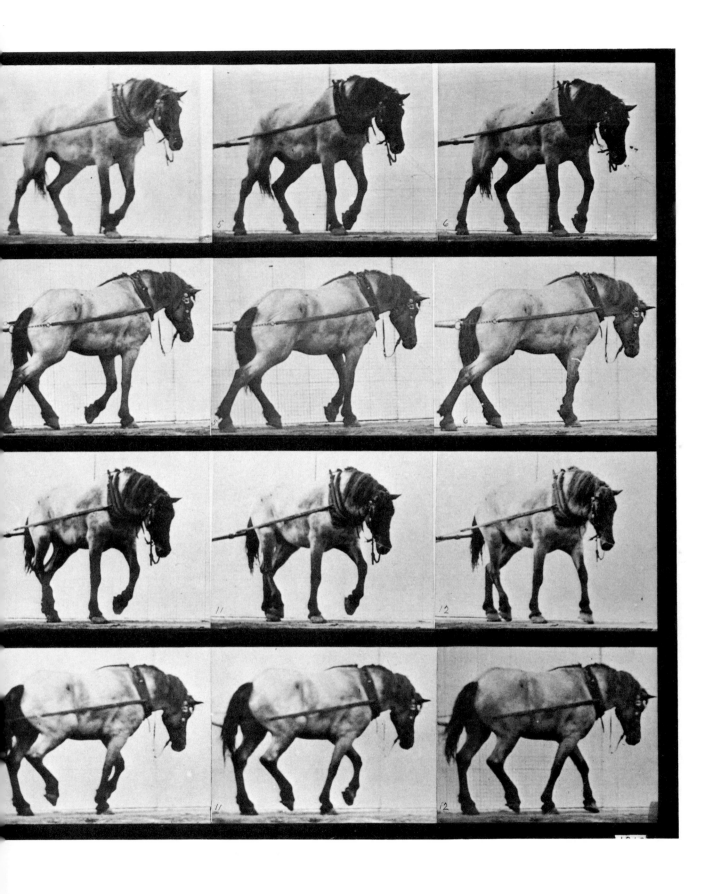

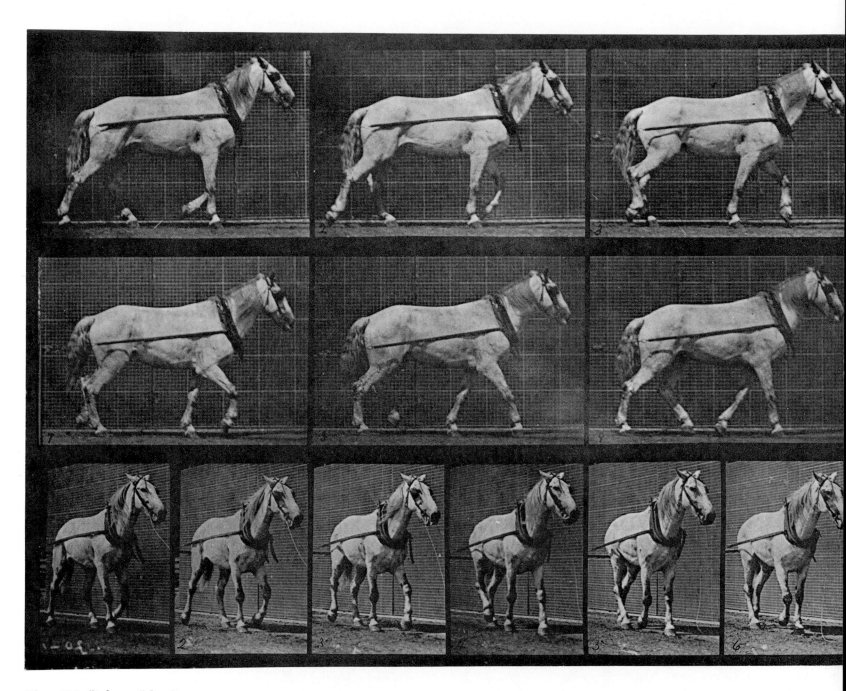

Plate 571. "Johnson" hauling.

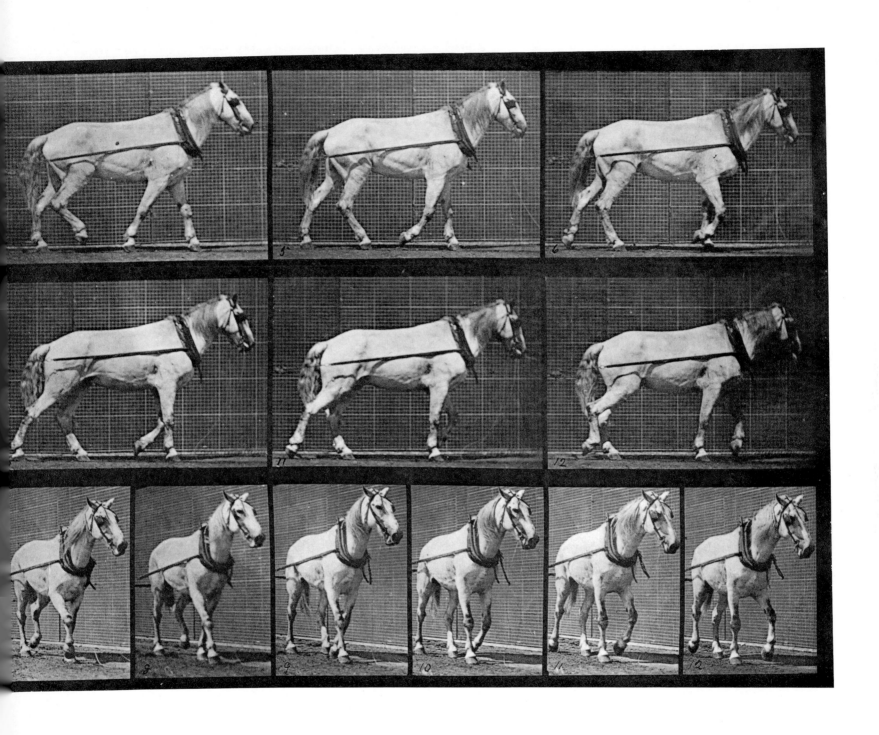

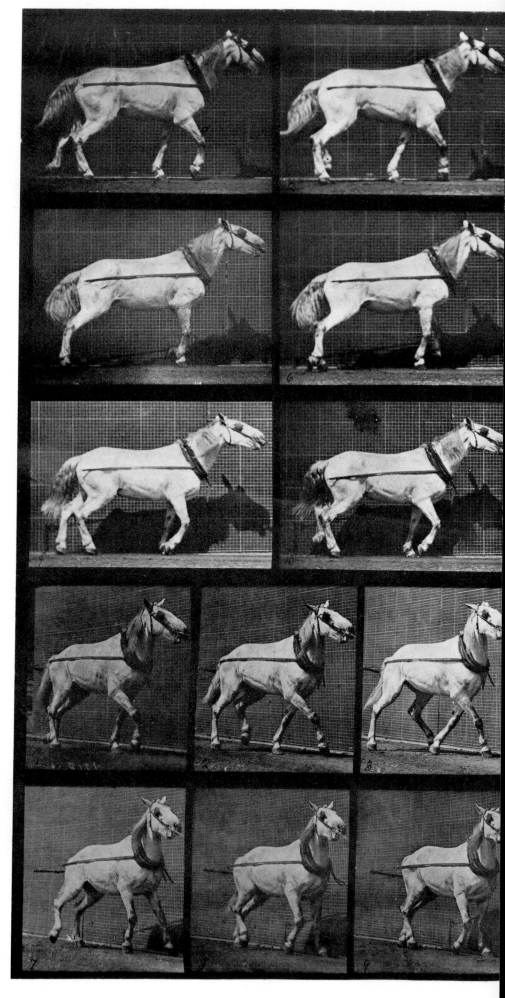

Plate 572. "Johnson" hauling, head being pulled.

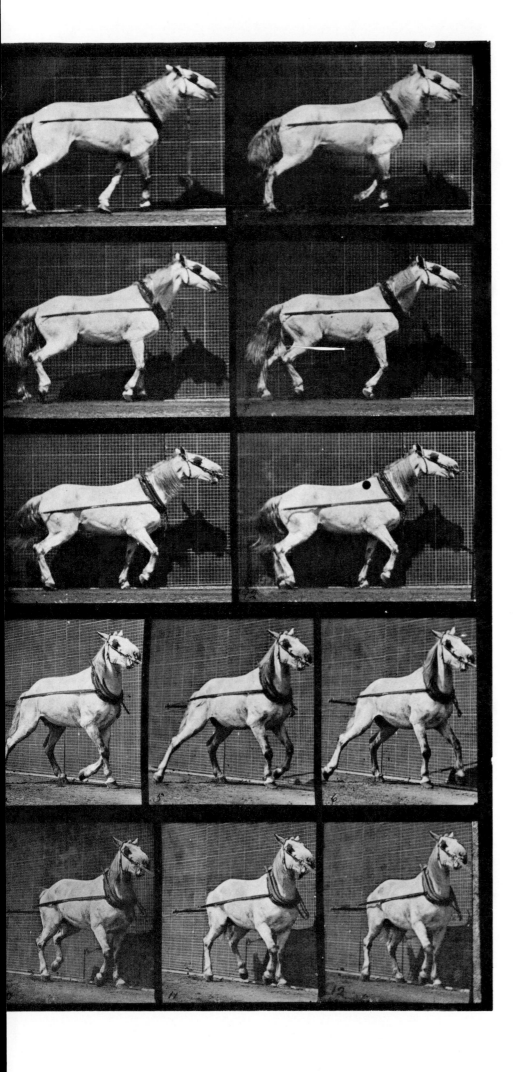

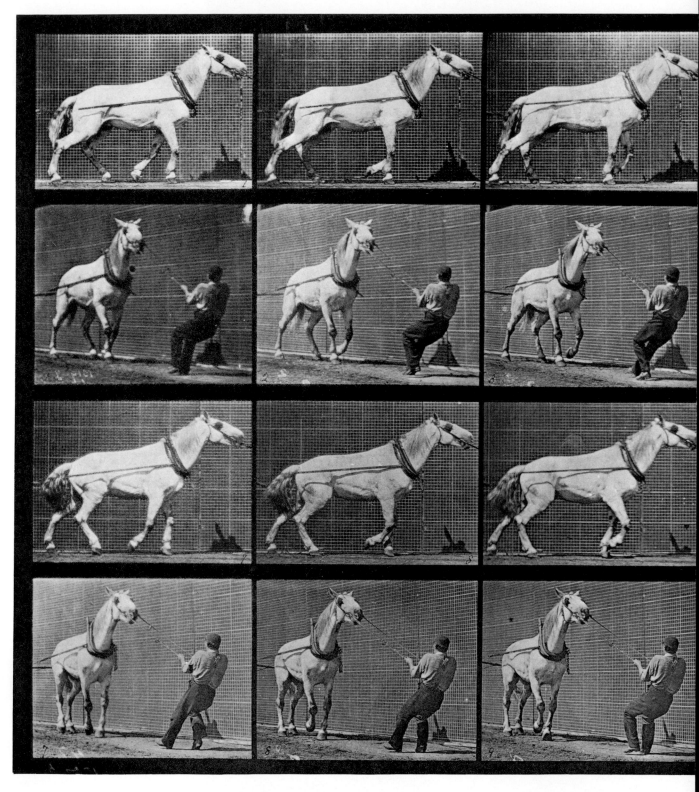

Plate 573. "Johnson" hauling, man pulling at head.

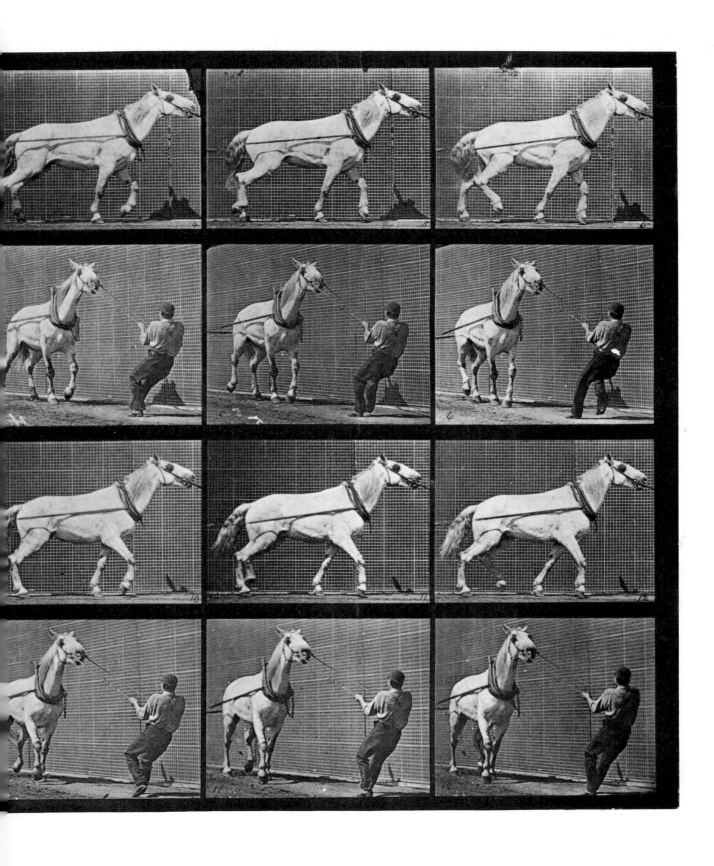

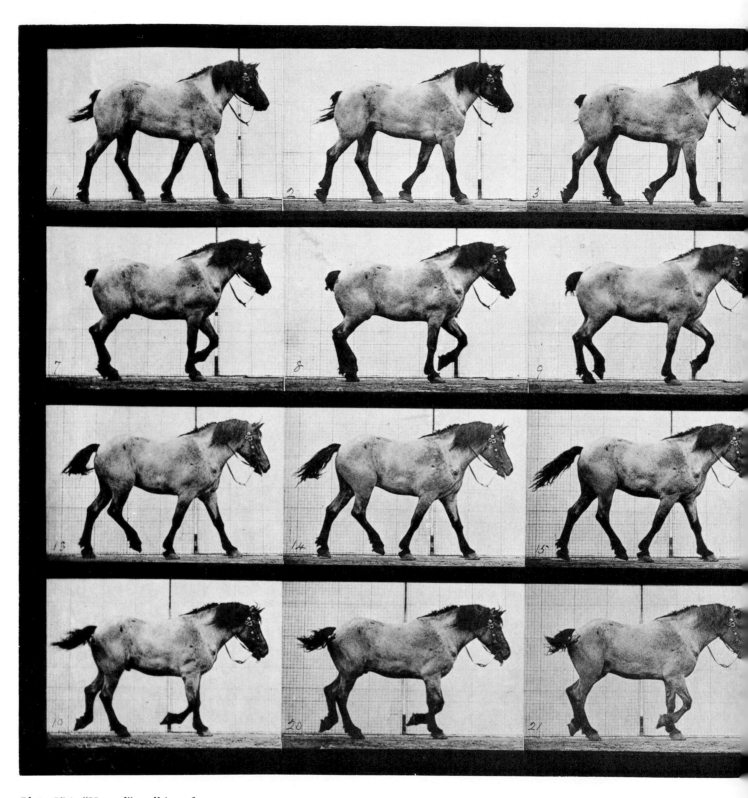

Plate 574. *"Hansel" walking, free.*

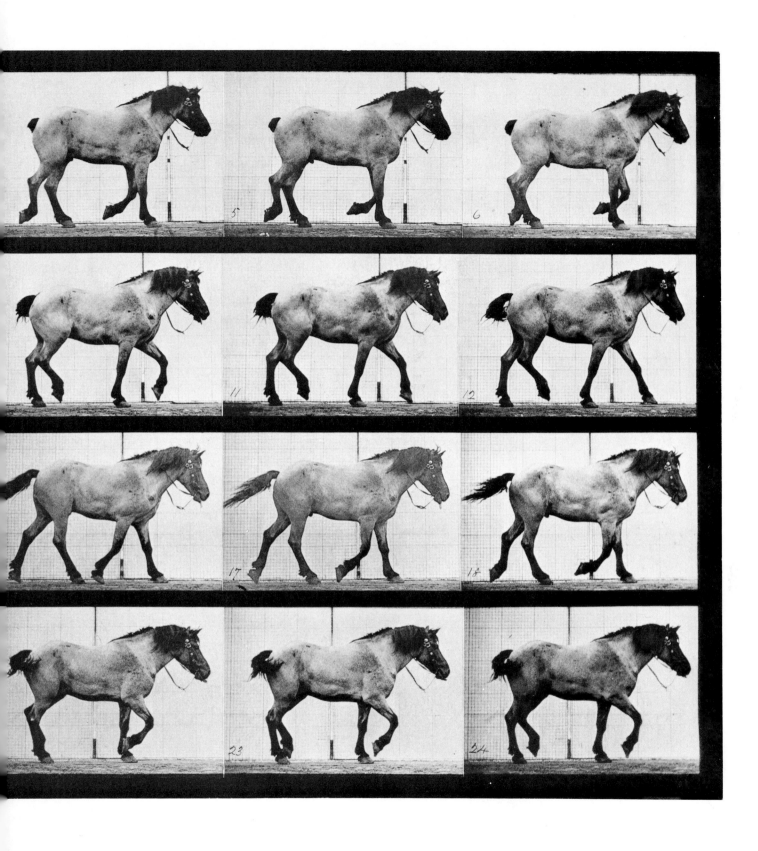

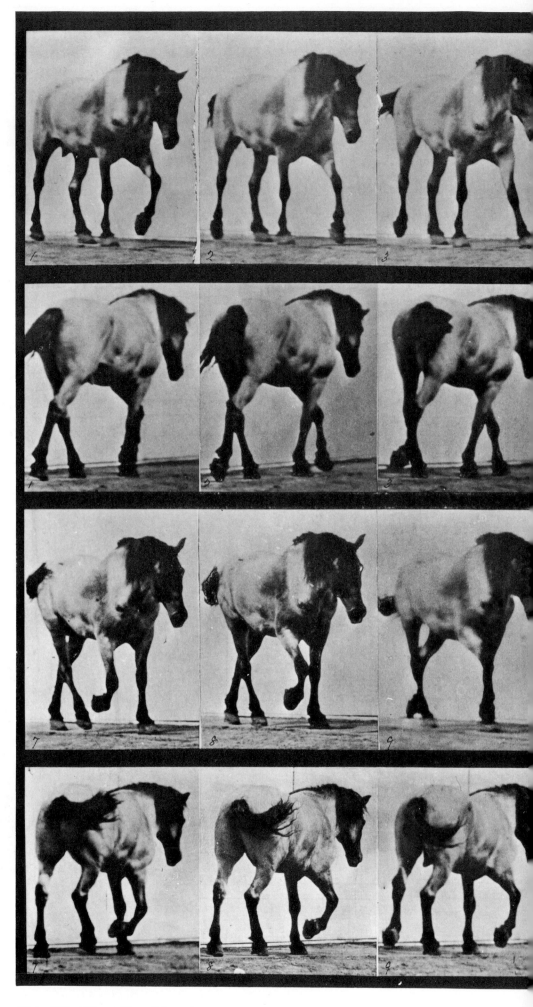

Plate 575. "Hansel" walking, free.

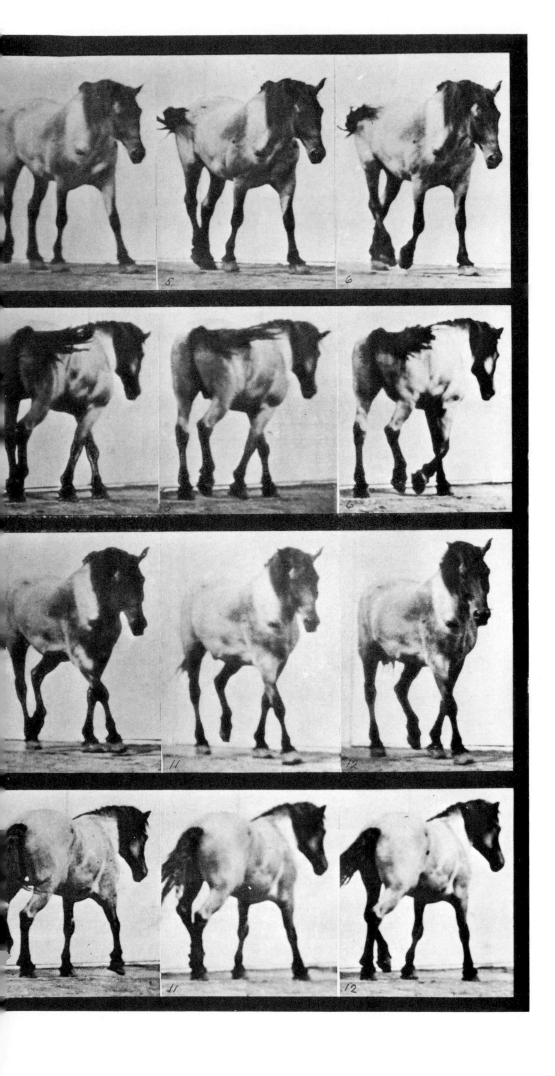

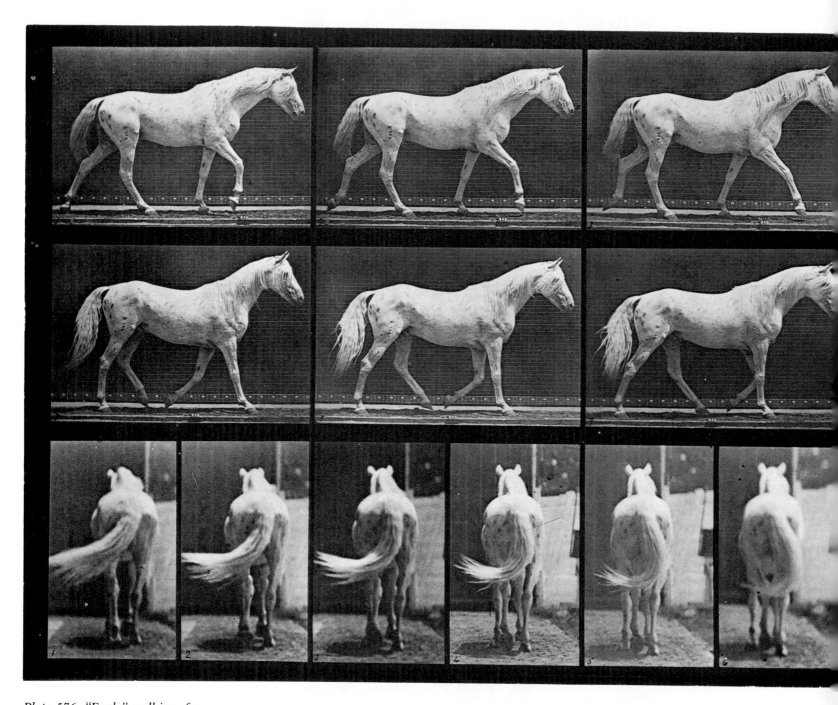

Plate 576. "Eagle" walking, free.

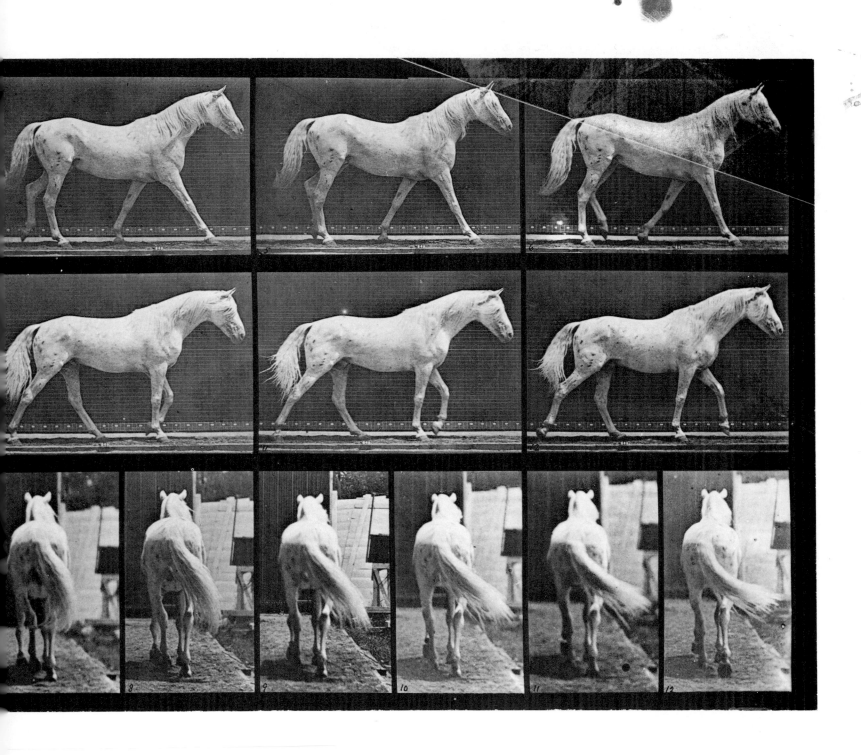

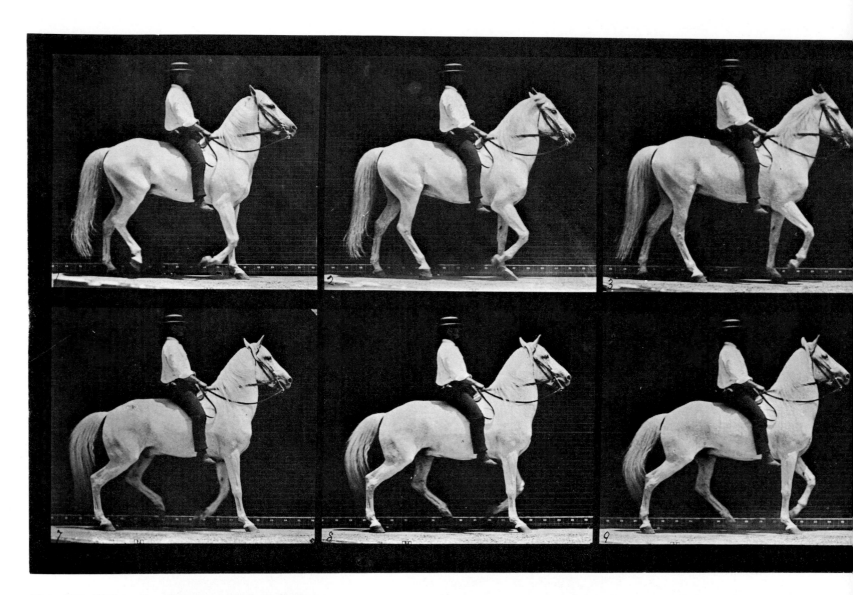

Plate 577. "Clinton" walking, mounted, irregular.

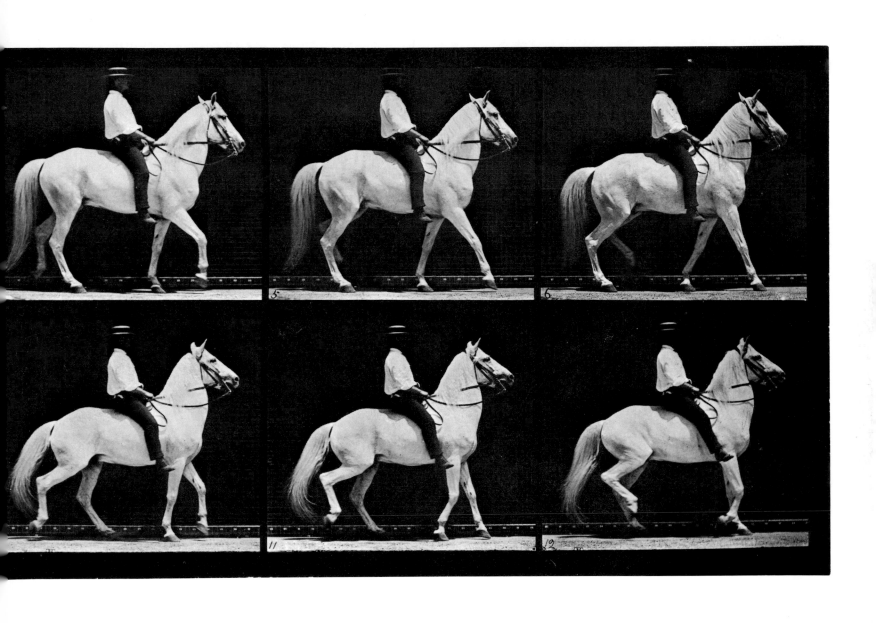

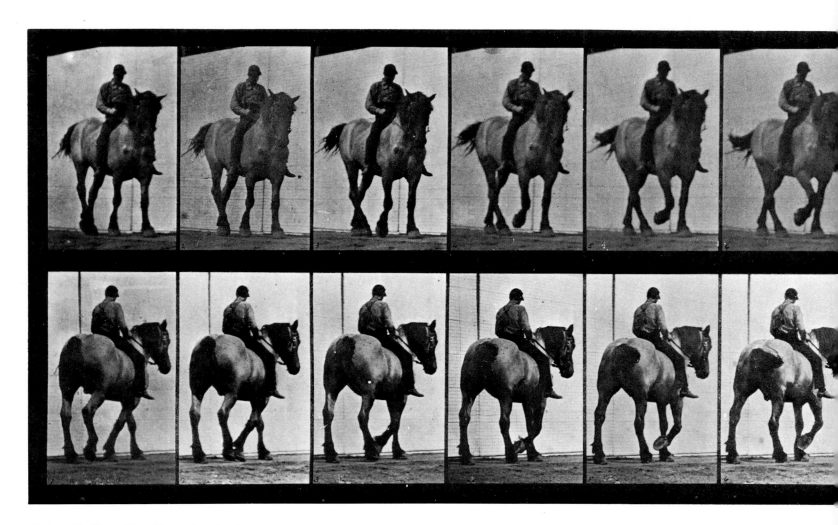

Plate 578. "Dusel" walking, bareback.

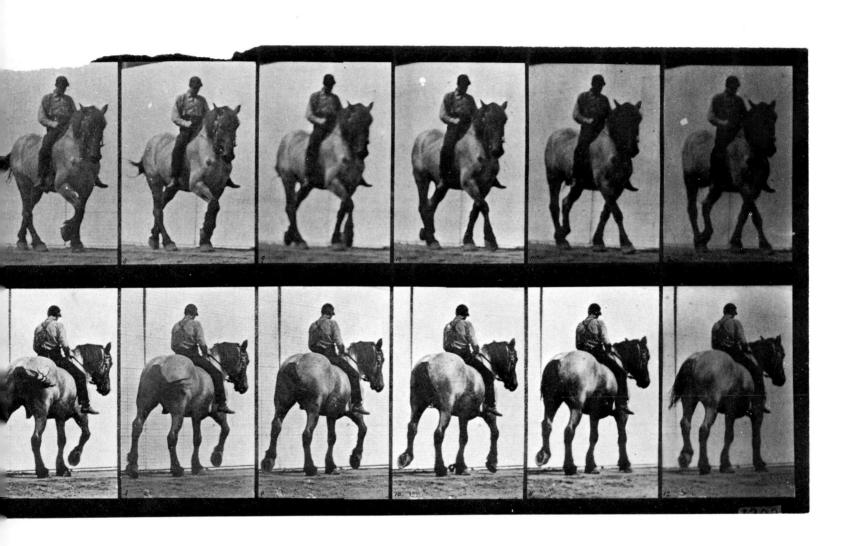

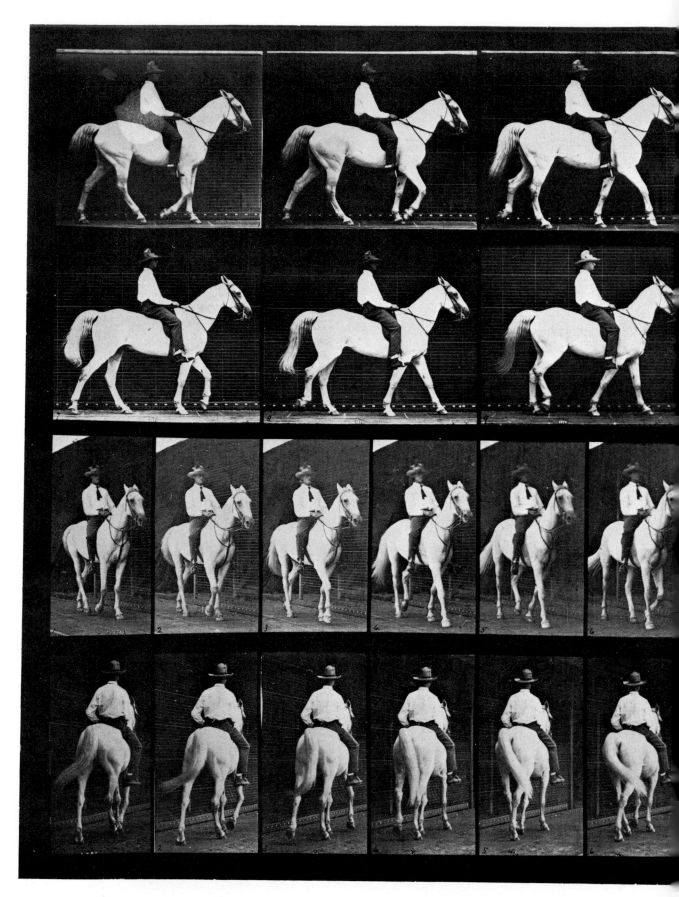

Plate 579. "Elberon" walking, saddled.

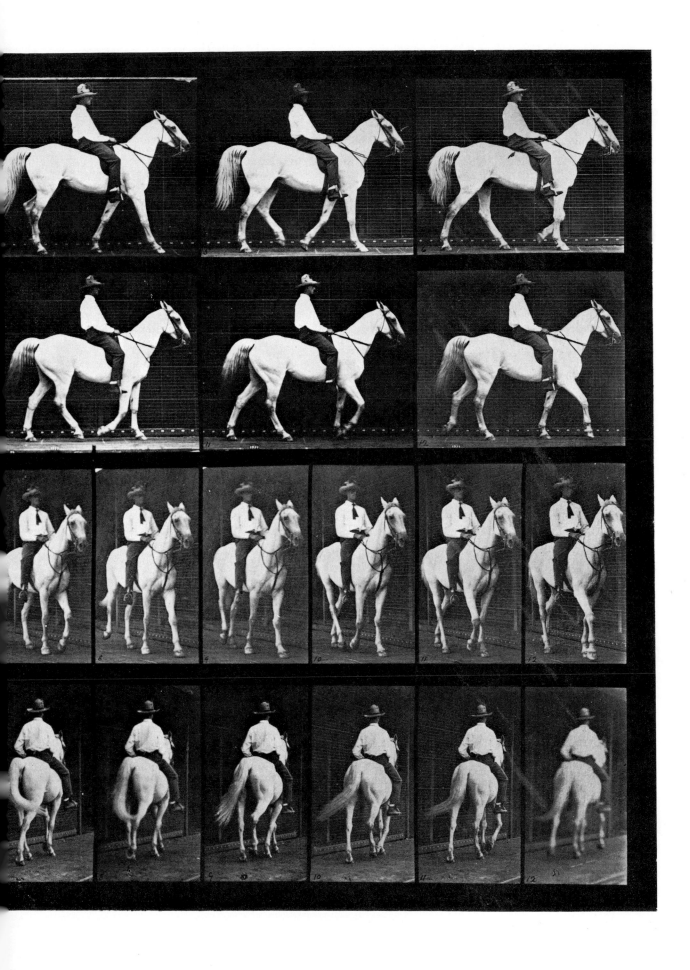

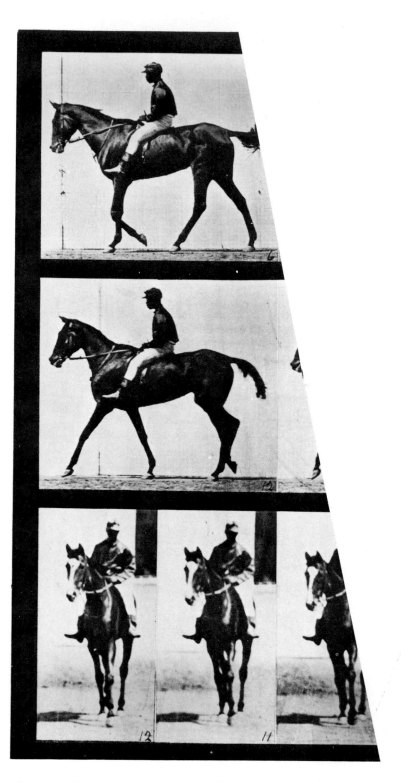

Plate 580. "Annie G." walking, saddled.

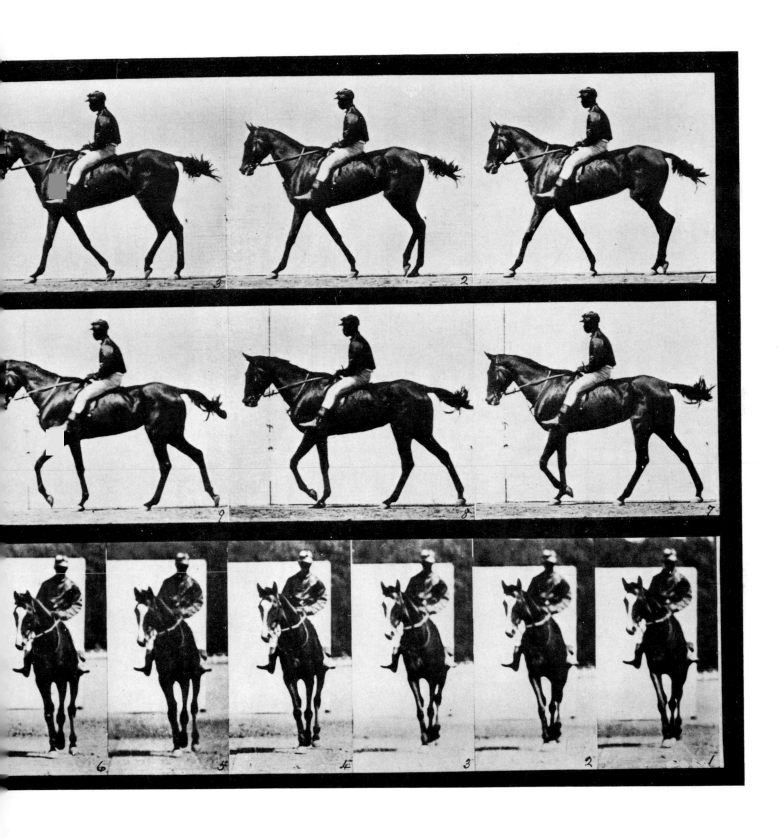

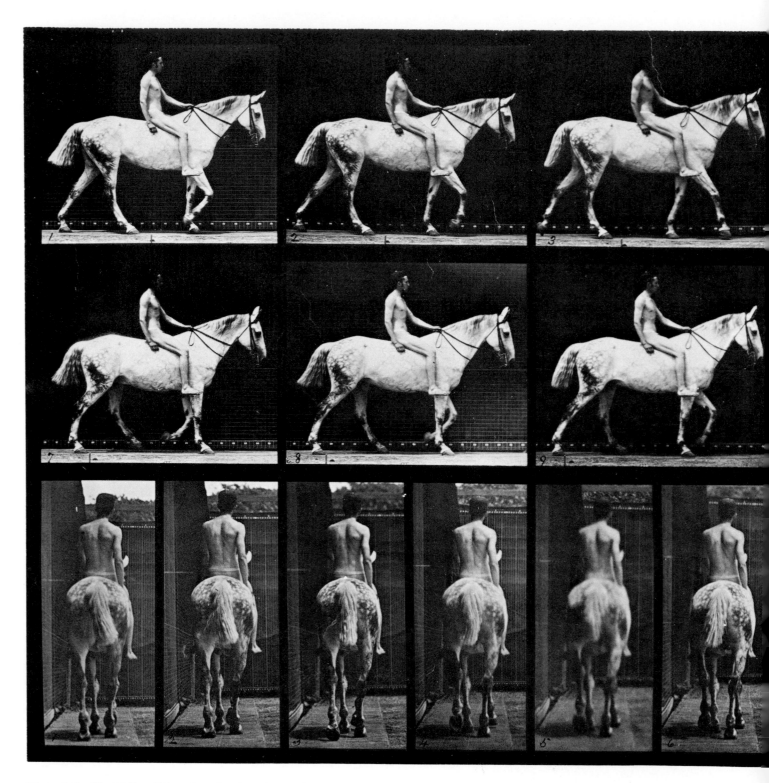

Plate 581. "Smith" walking, bareback; rider nude.

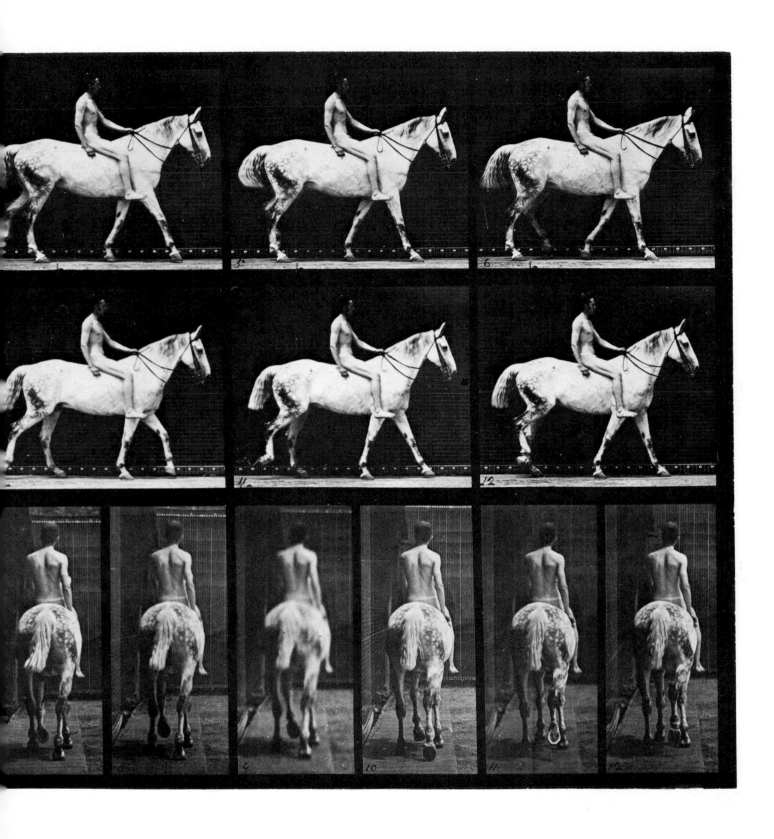

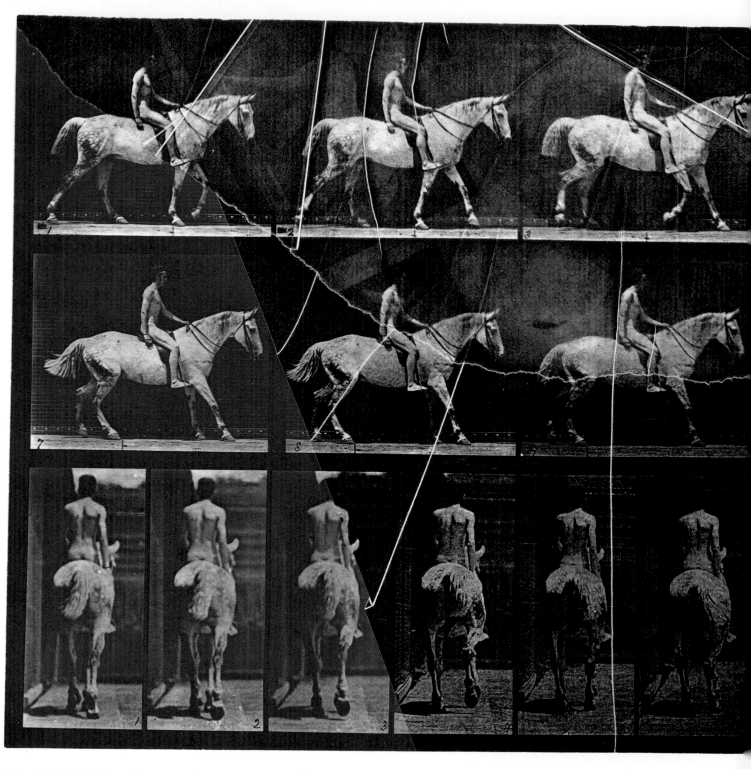

Plate 582. "Smith" walking, saddled; rider nude.

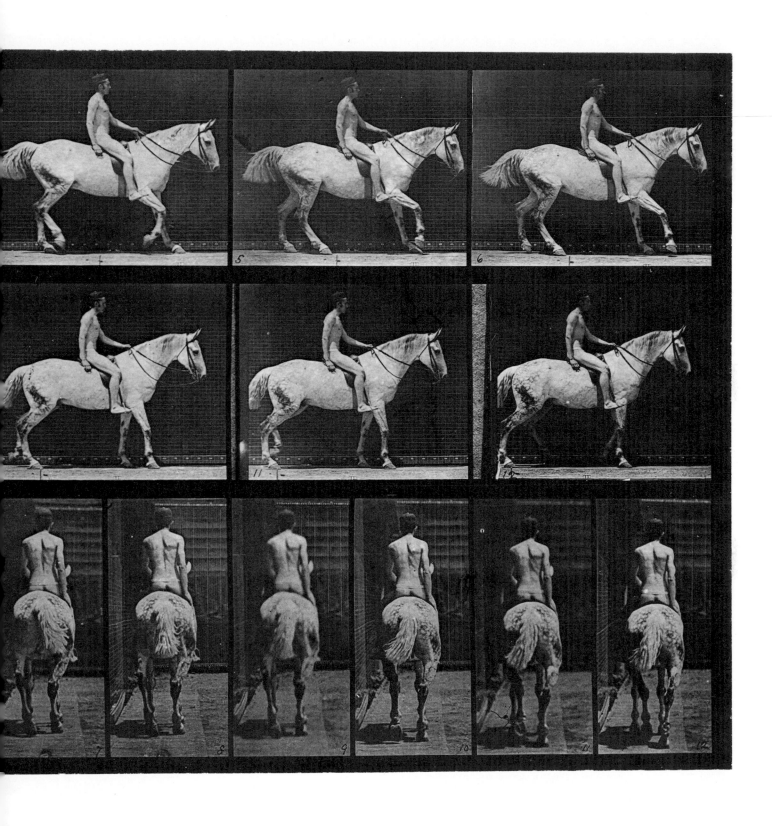

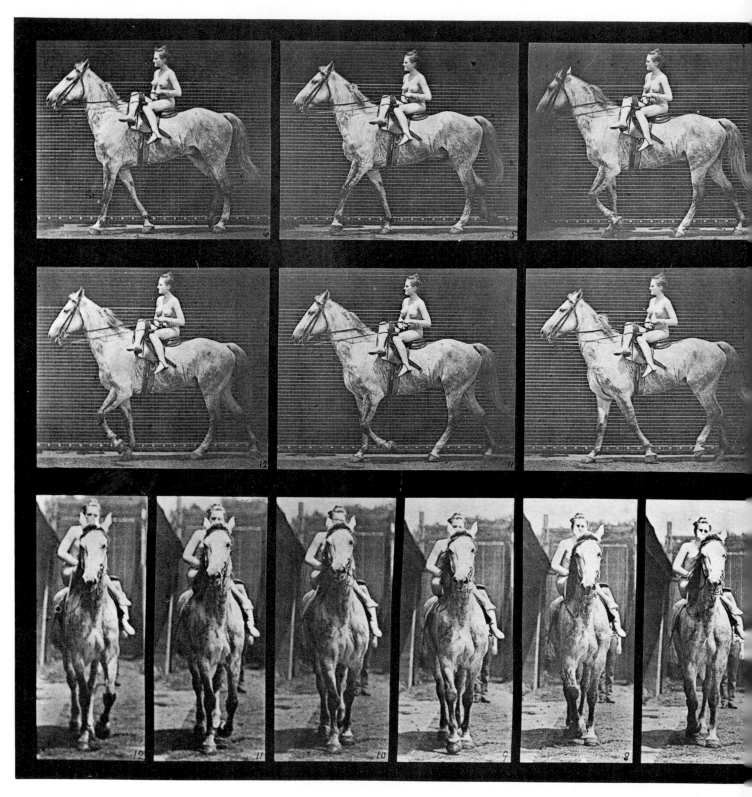

Plate 583. "Tom" walking, saddled; female rider nude.

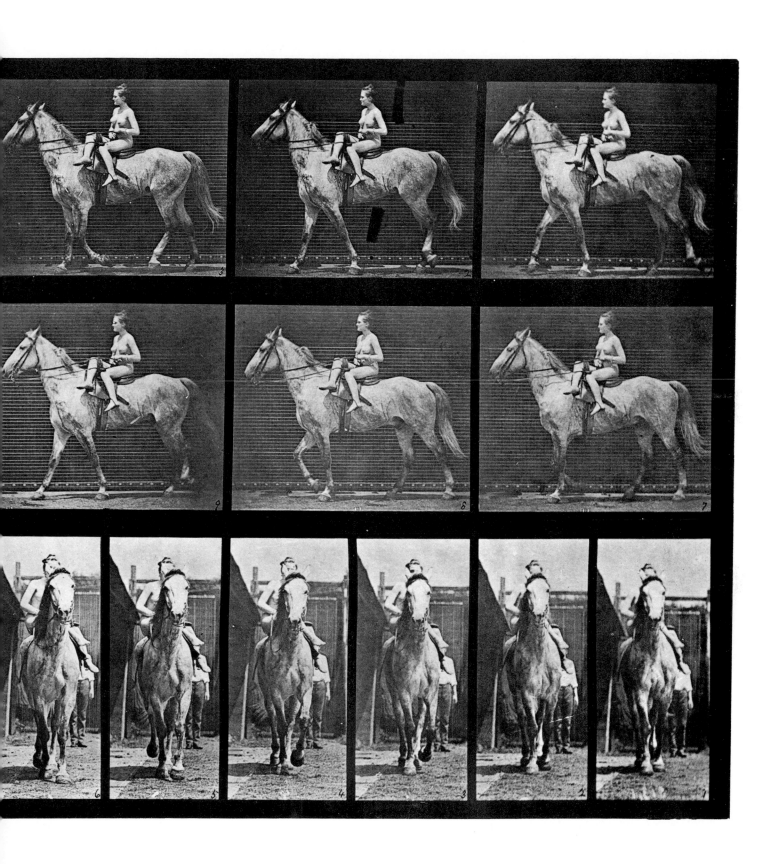

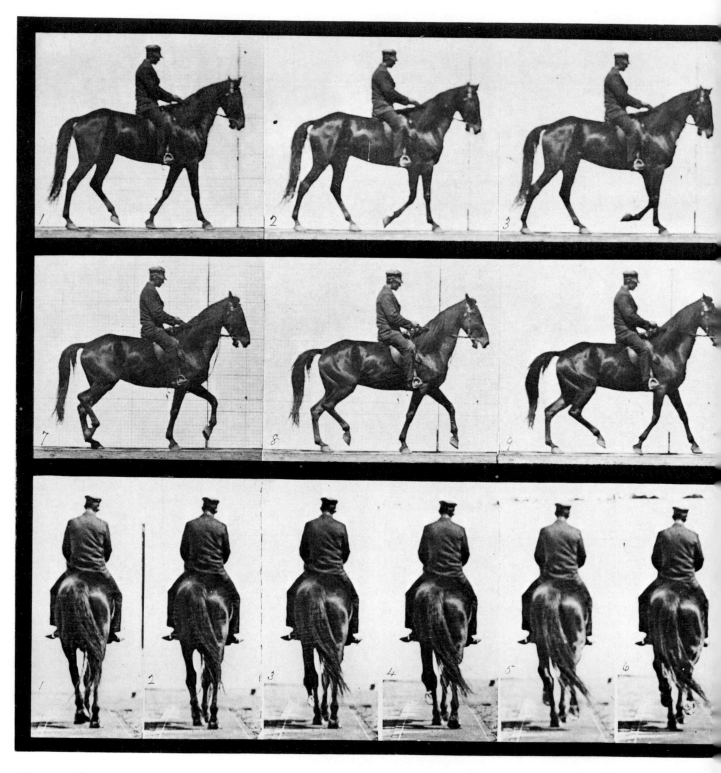

Plate 584. "Beauty" walking, saddled, irregular.

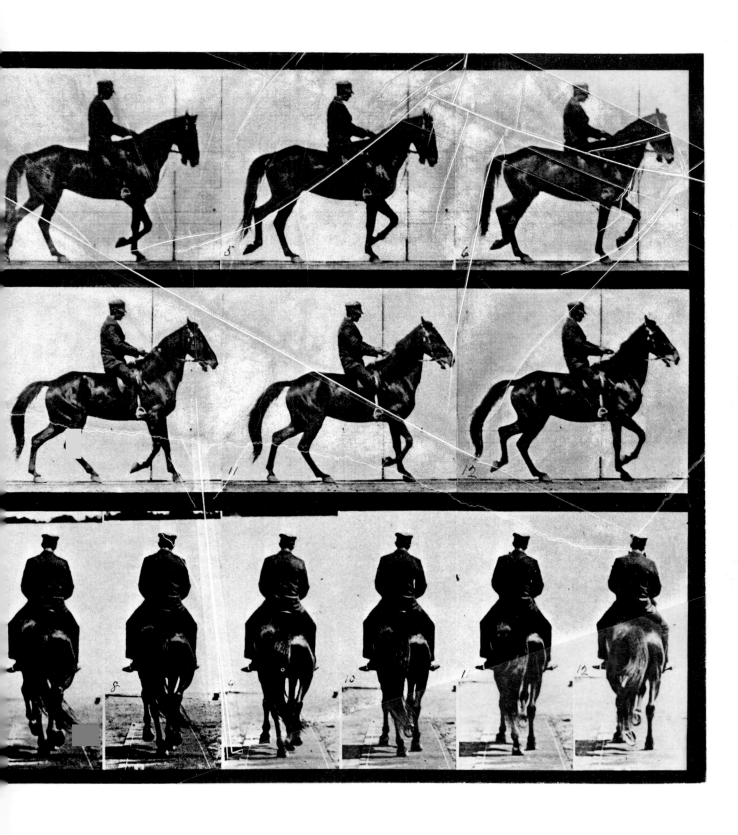

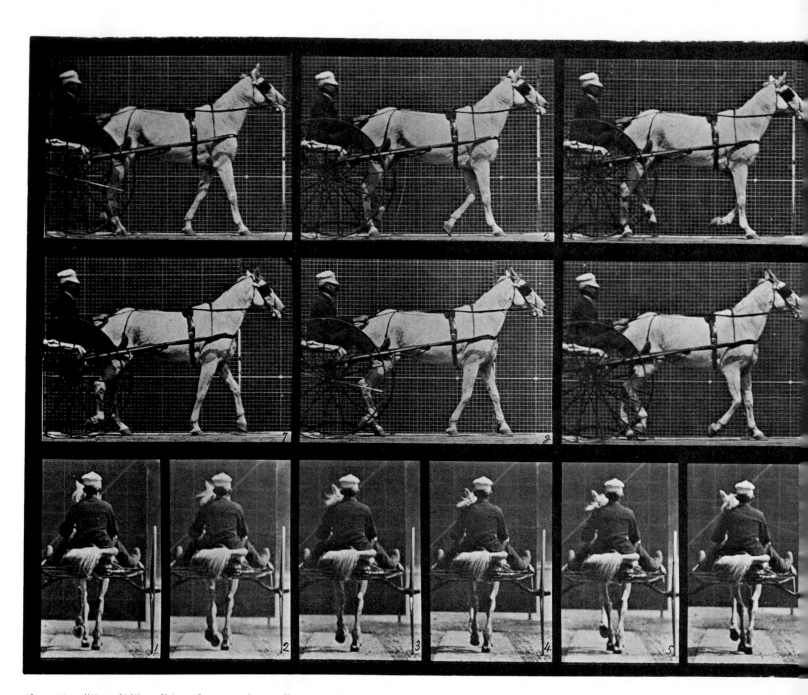

Plate 585. "Katydid" walking, harnessed to sulky.

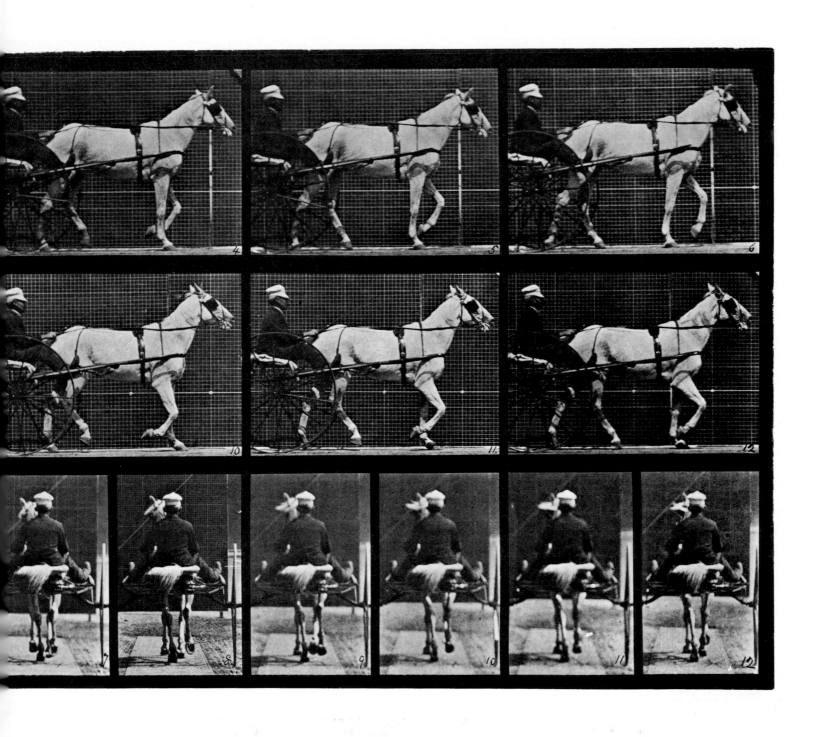

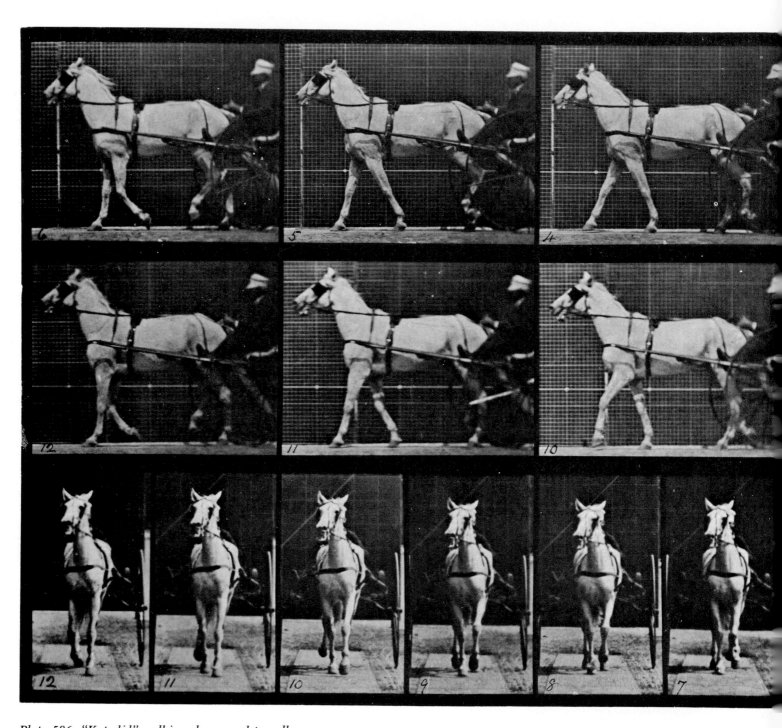

Plate 586. "Katydid" walking, harnessed to sulky.

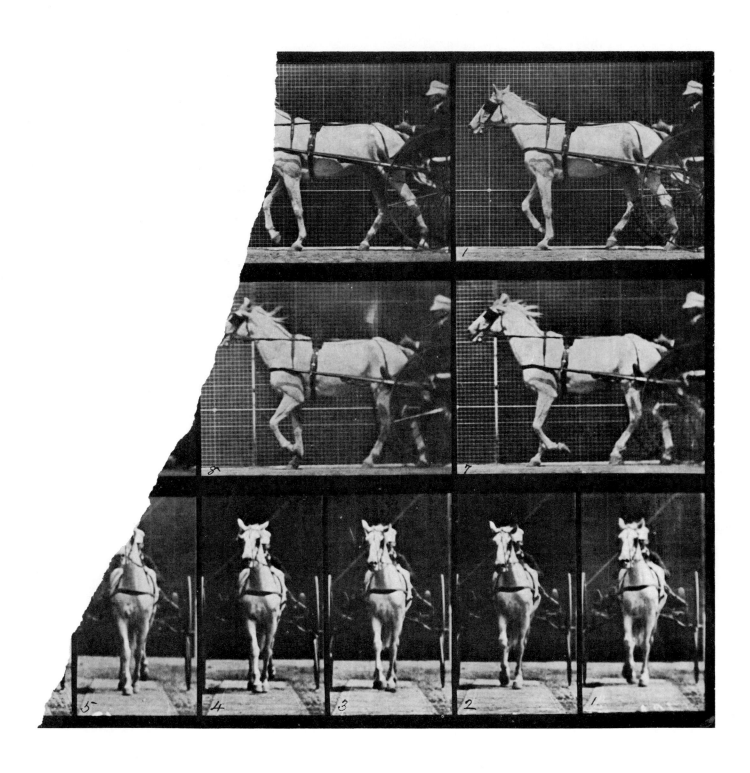

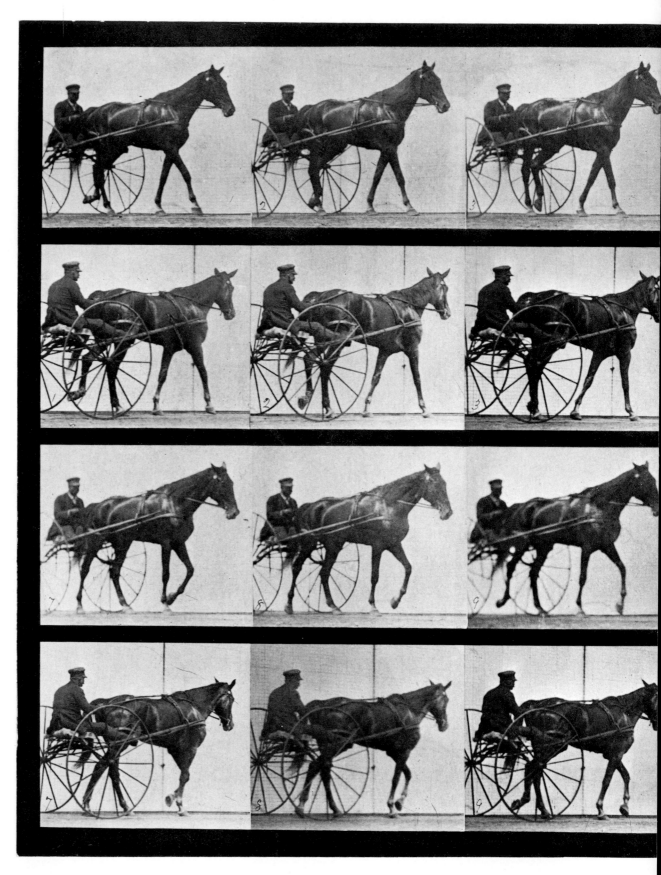

Plate 587. "Nellie Rose" walking, harnessed to sulky.

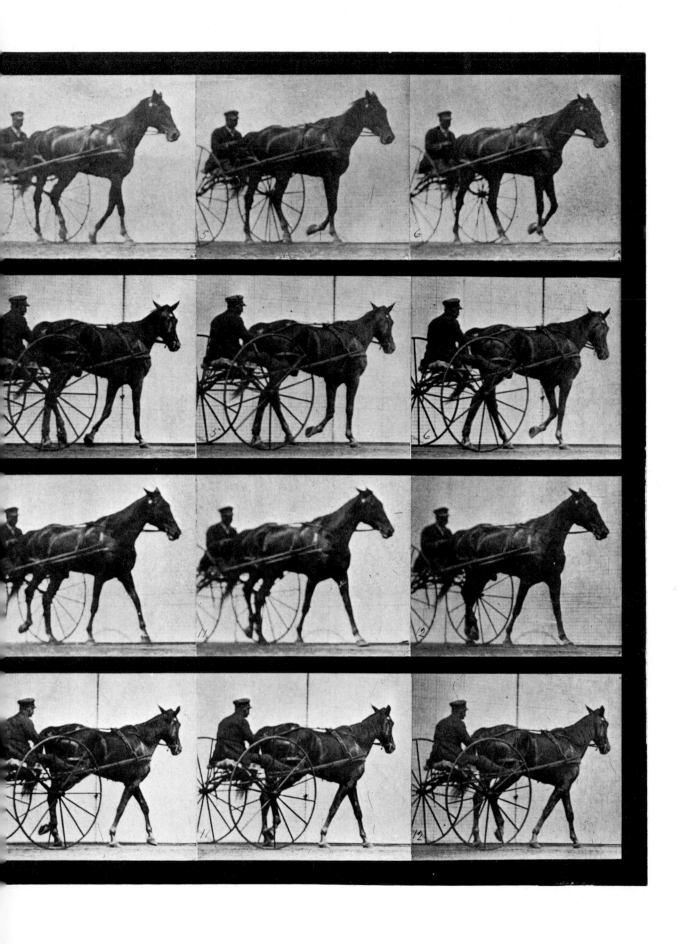

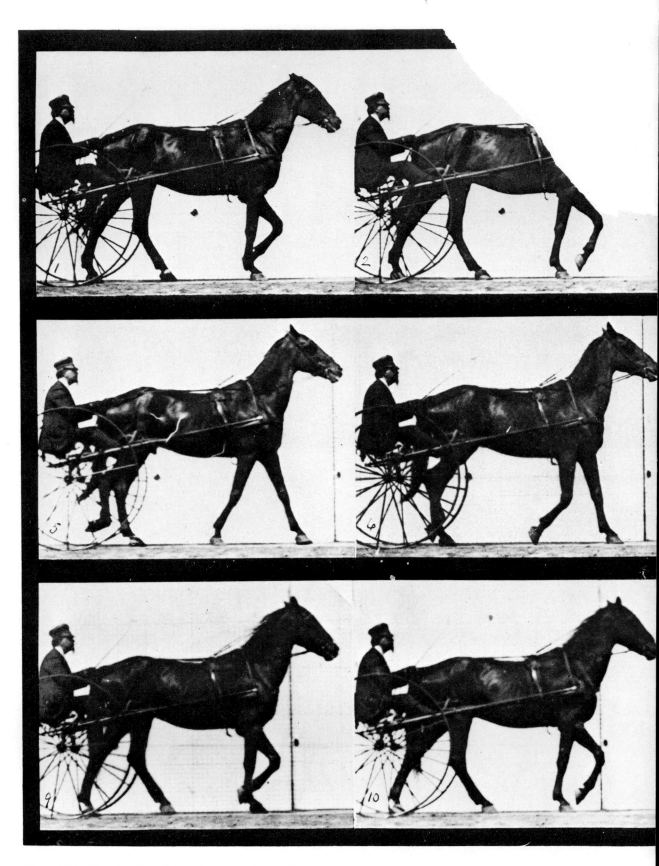

Plate 588. "Reuben" walking, harnessed to sulky.

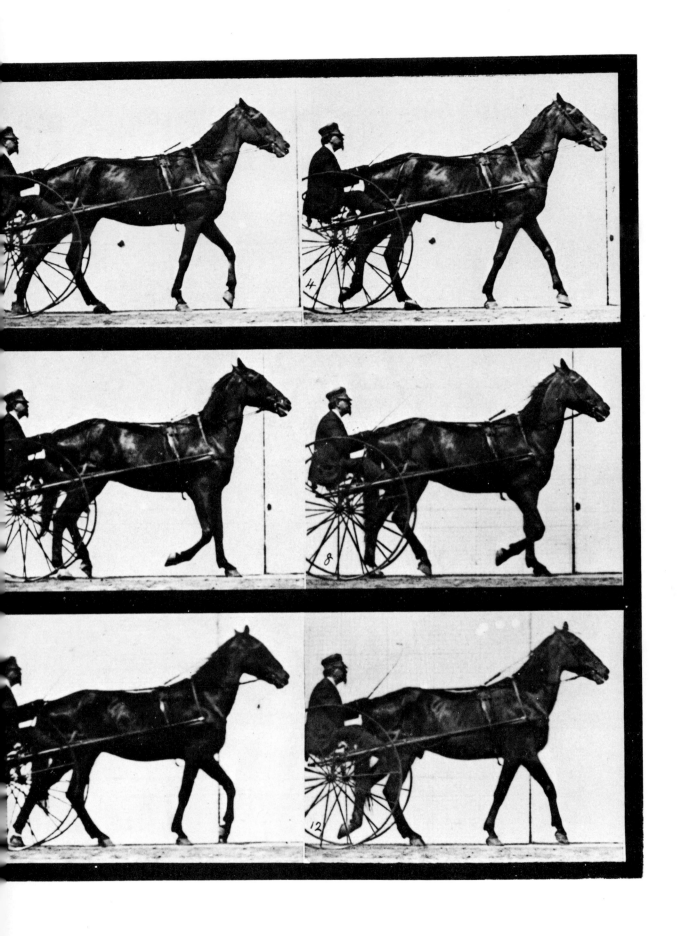

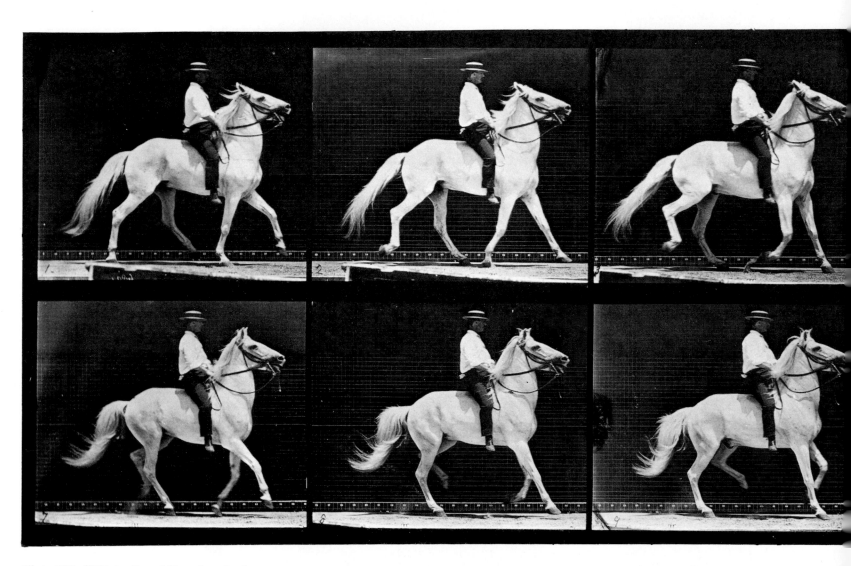

Plate 589. "Clinton" ambling, bareback.

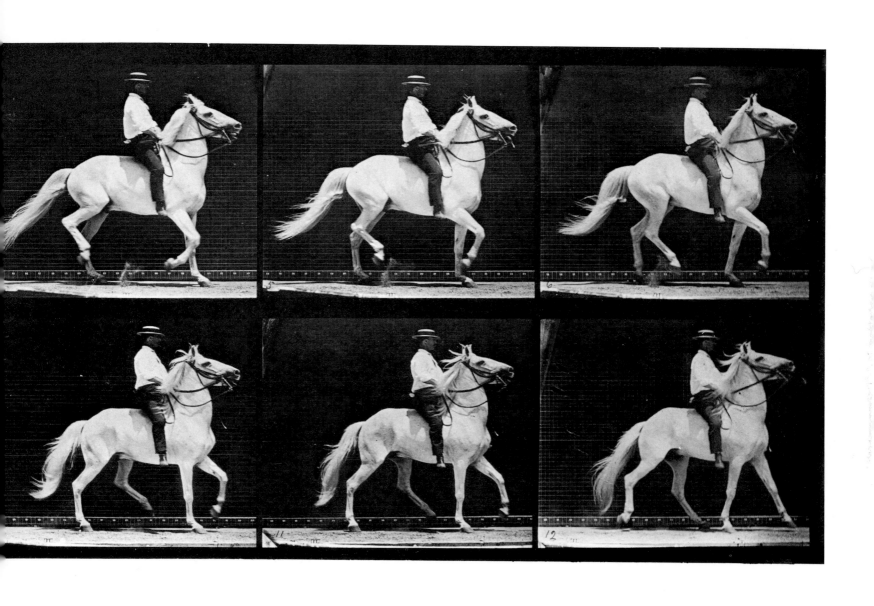

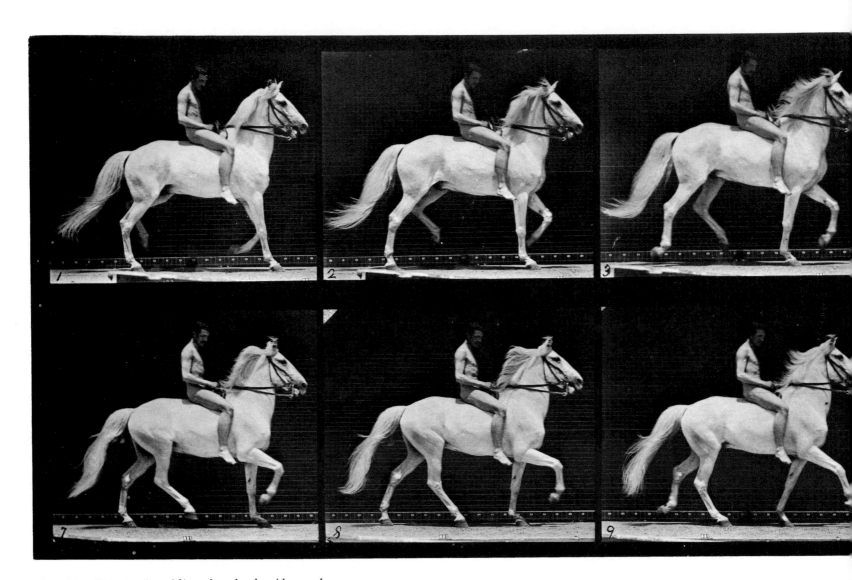

Plate 590. "Clinton" ambling, bareback; rider nude.

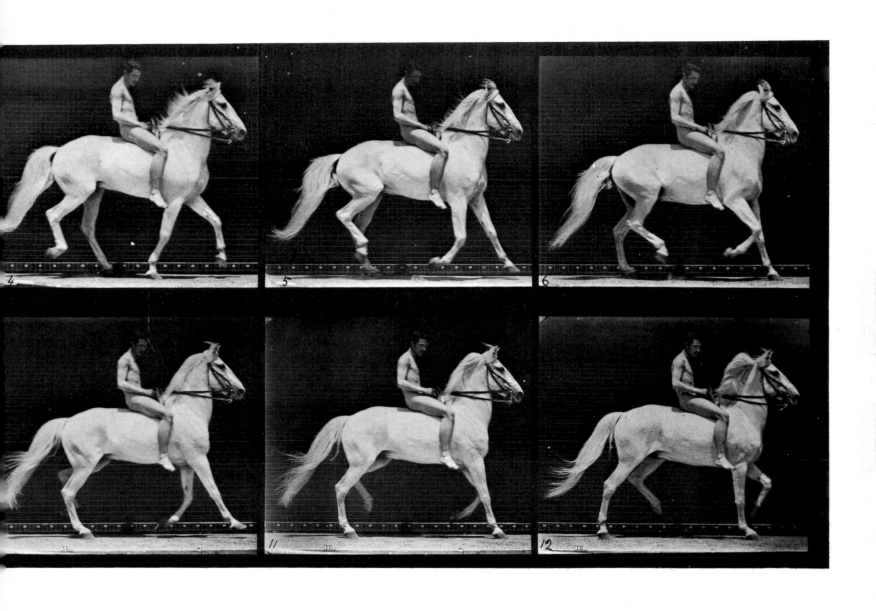

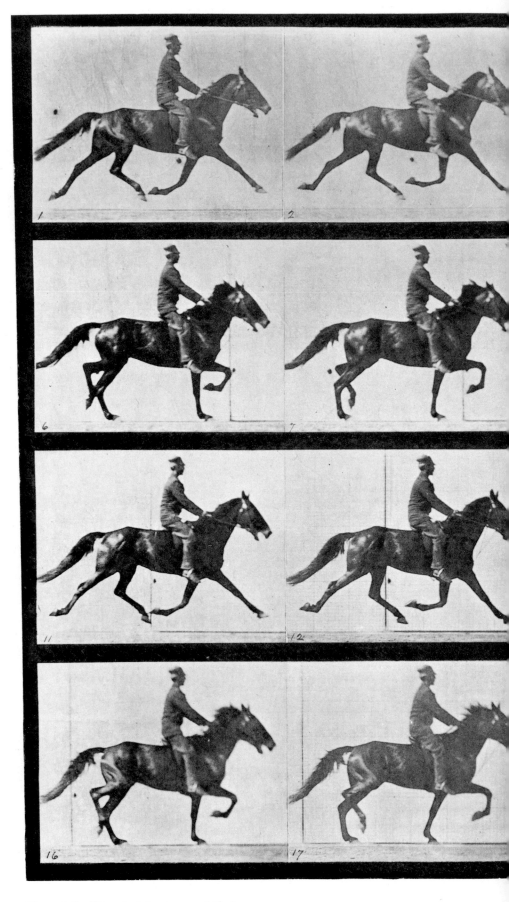

Plate 591. "Pronto" pacing, saddled.

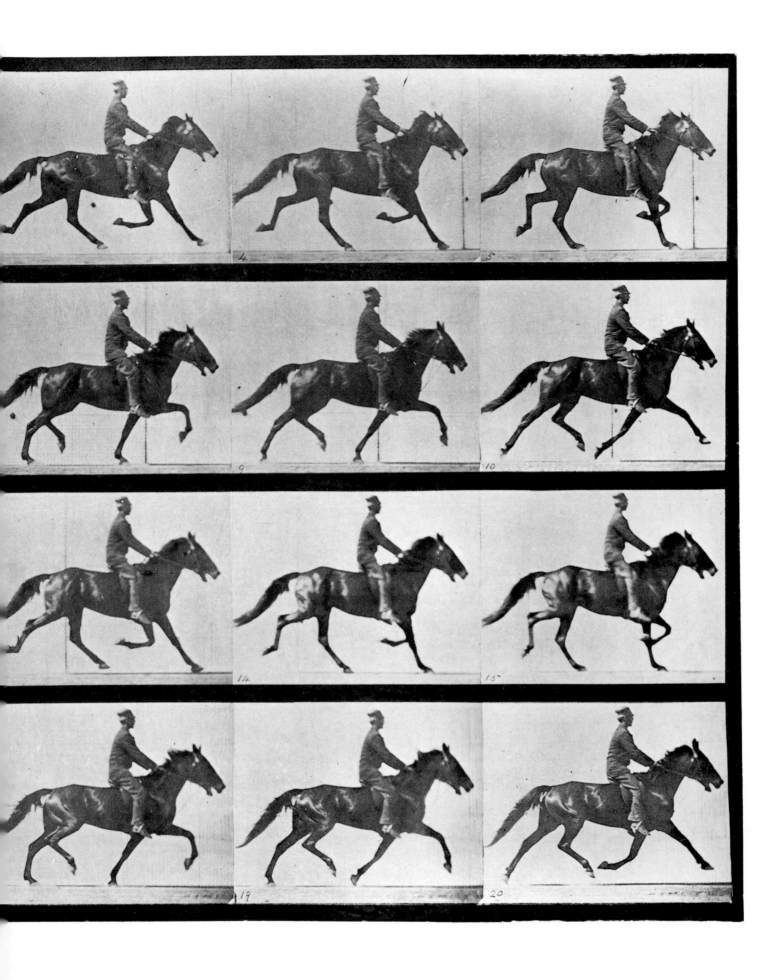

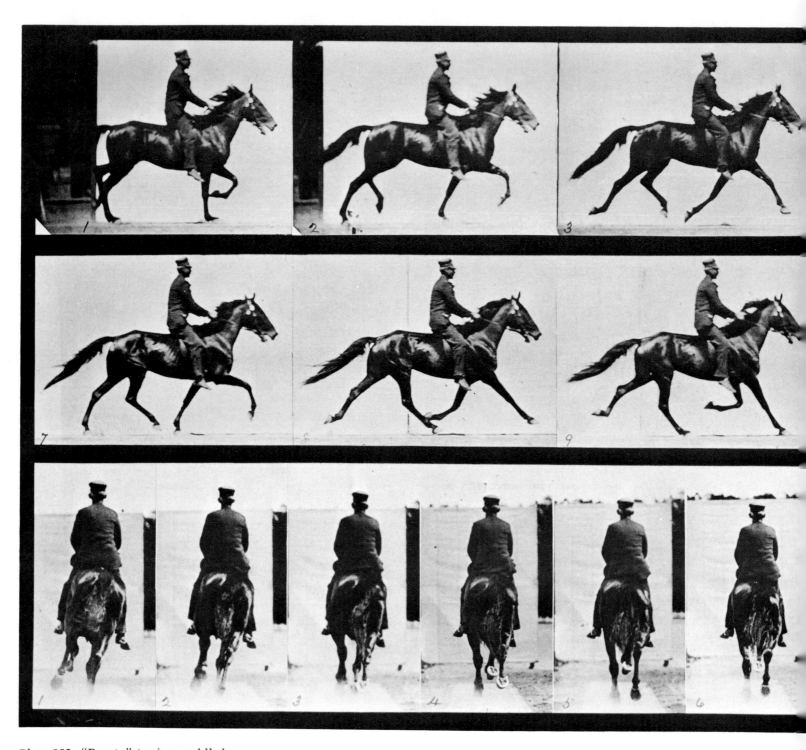

Plate 592. "Pronto" pacing, saddled.

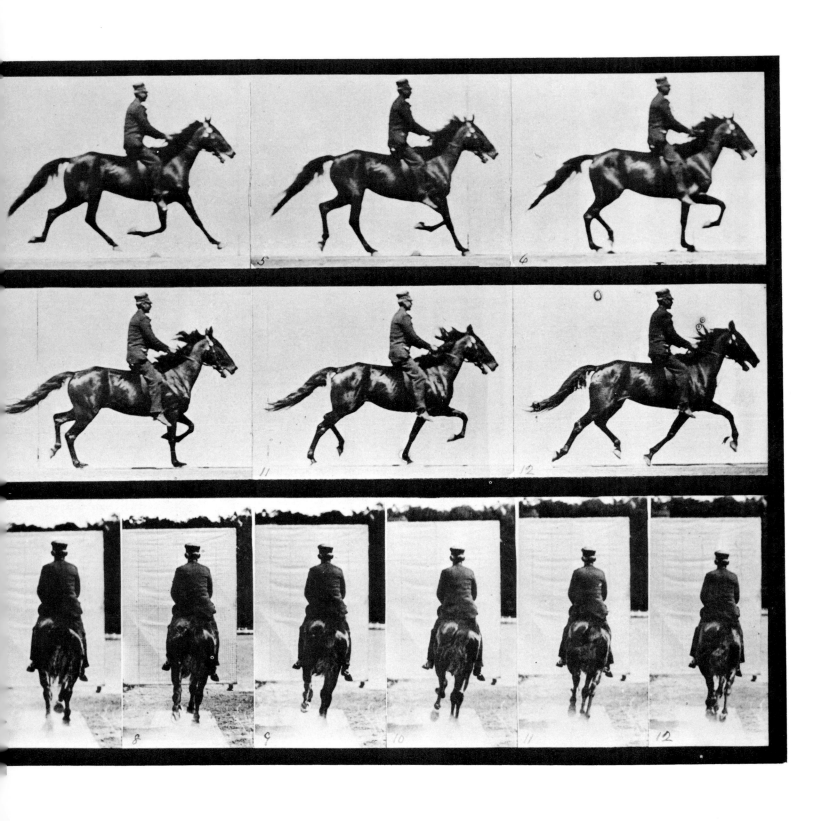

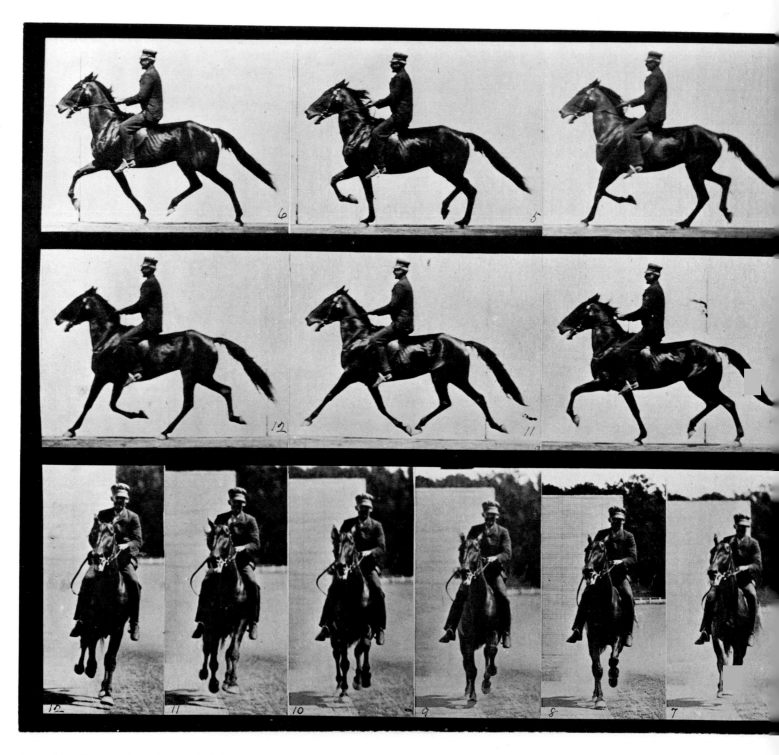

Plate 593. "Pronto" pacing, saddled.

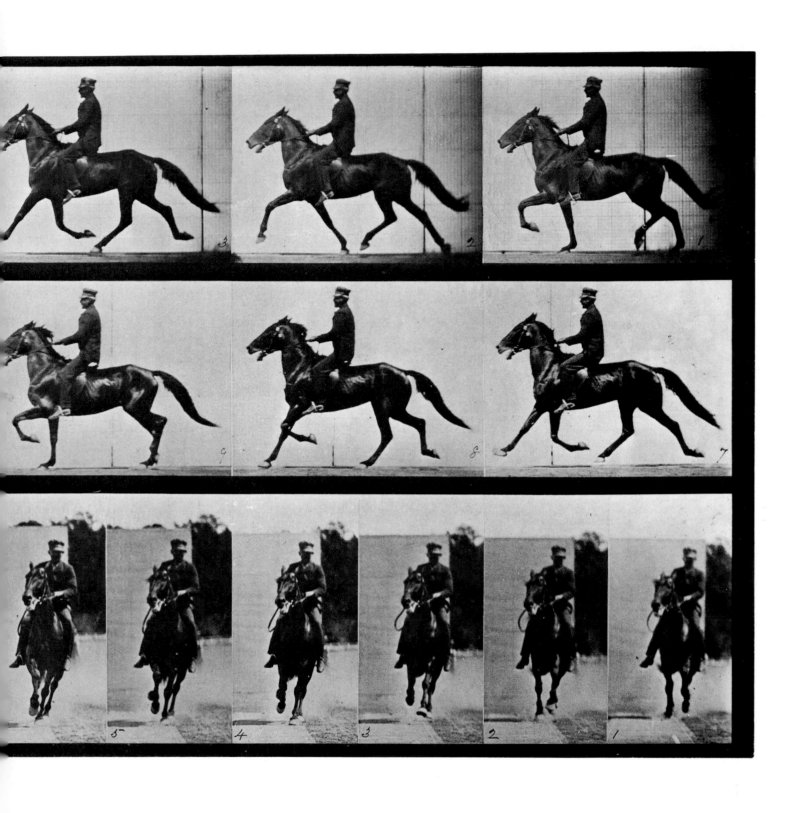

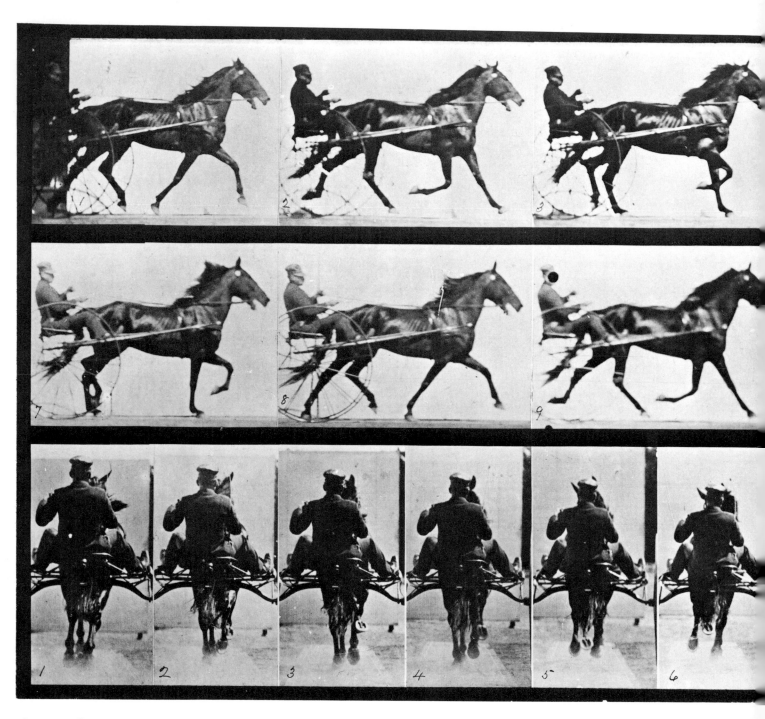

Plate 594. "Pronto" pacing, harnessed to sulky.

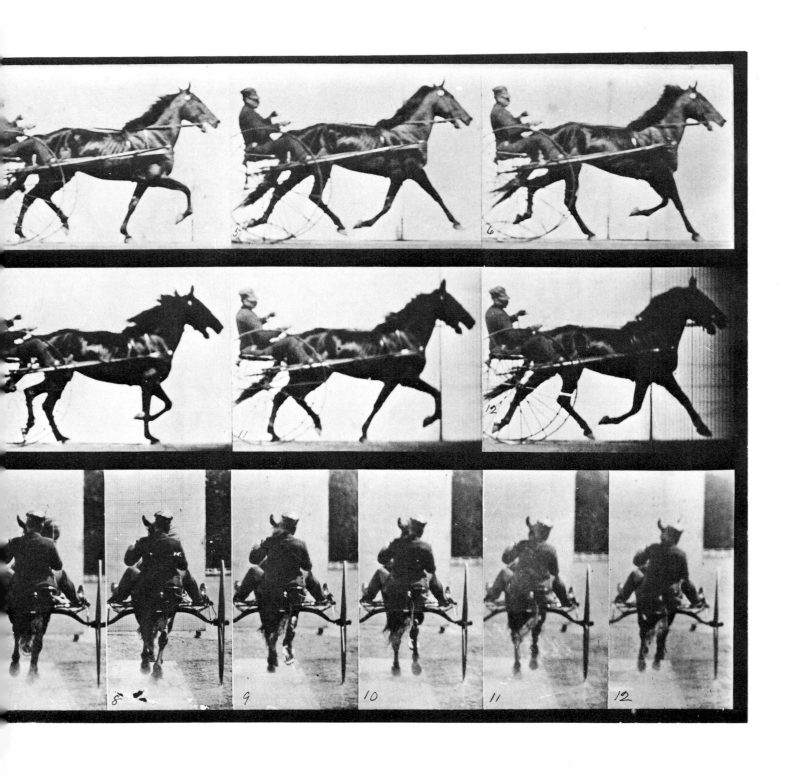

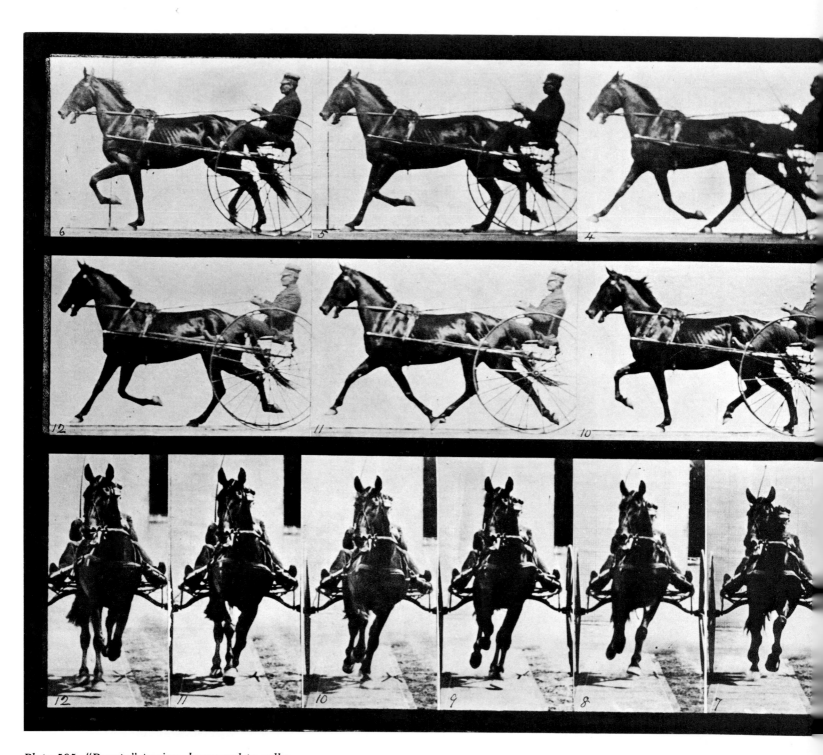

Plate 595. "Pronto" pacing, harnessed to sulky.

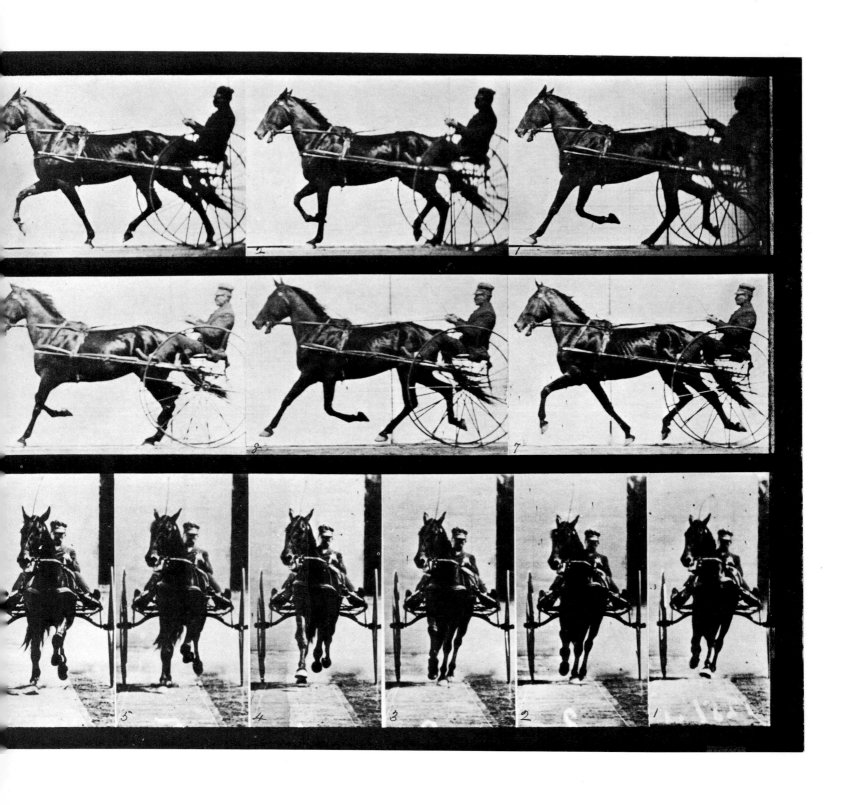

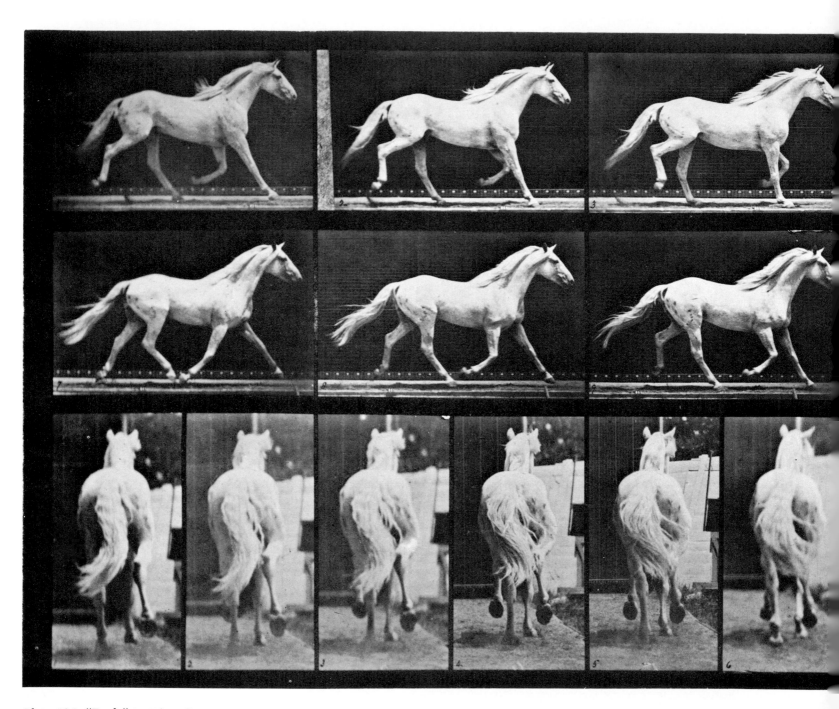

Plate 596. "Eagle" trotting, free.

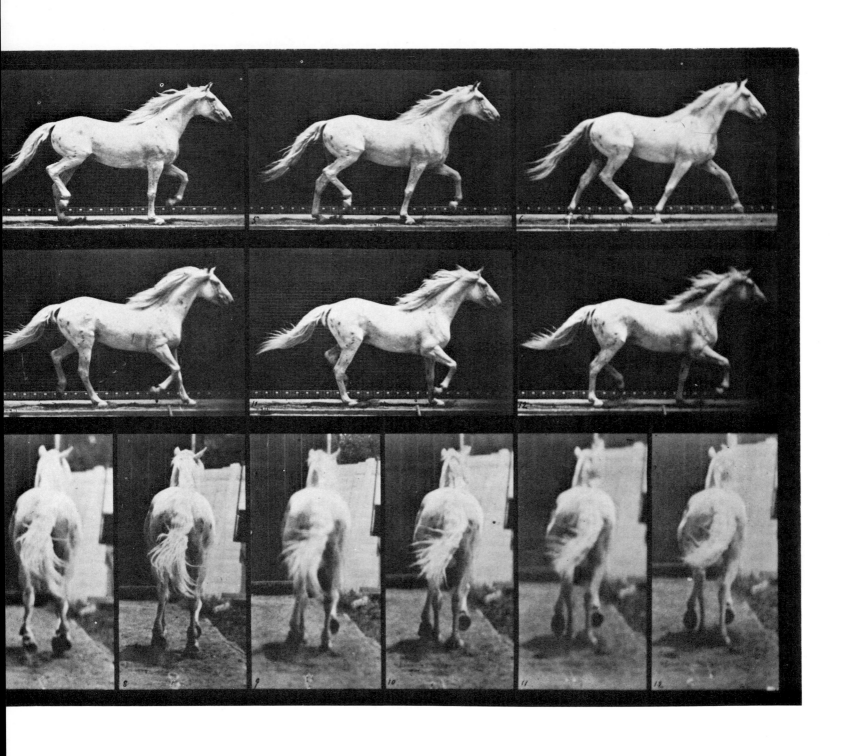

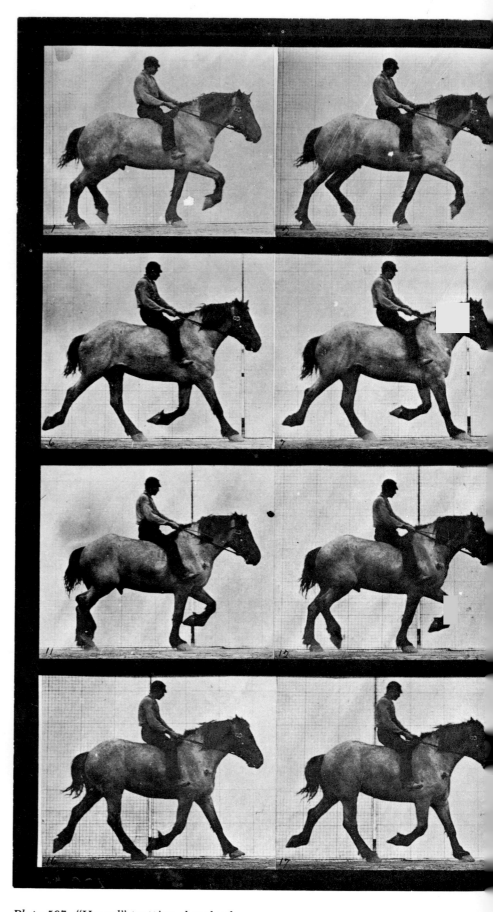

Plate 597. "Hansel" trotting, bareback.

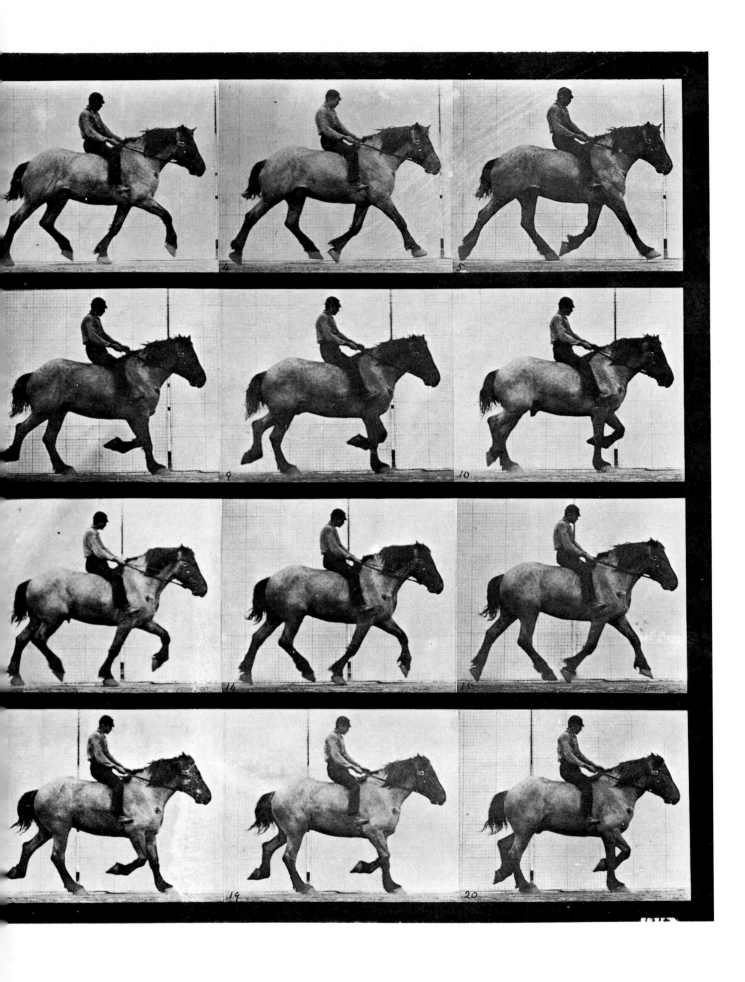

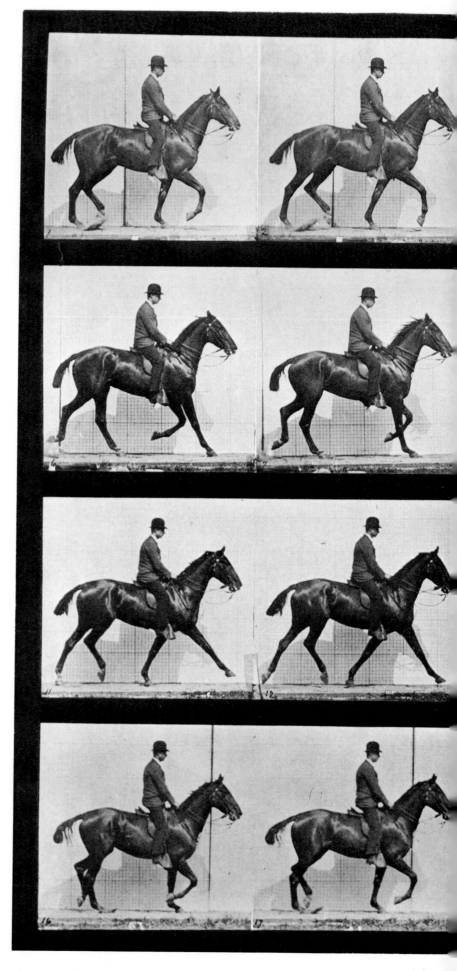

Plate 598. "Daisy" trotting, saddled.

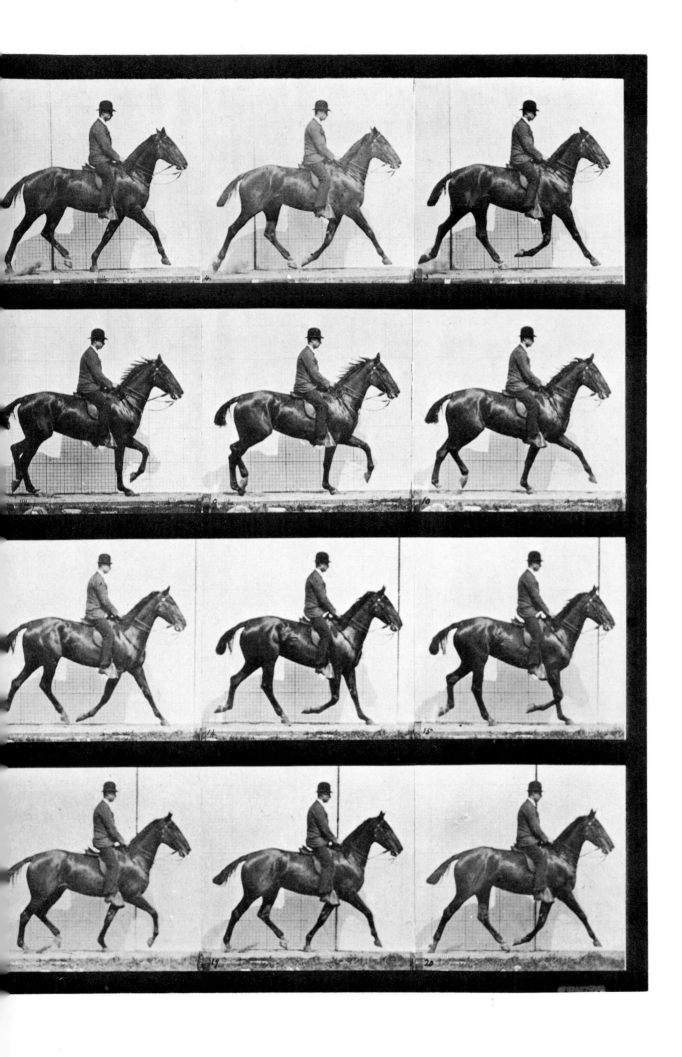

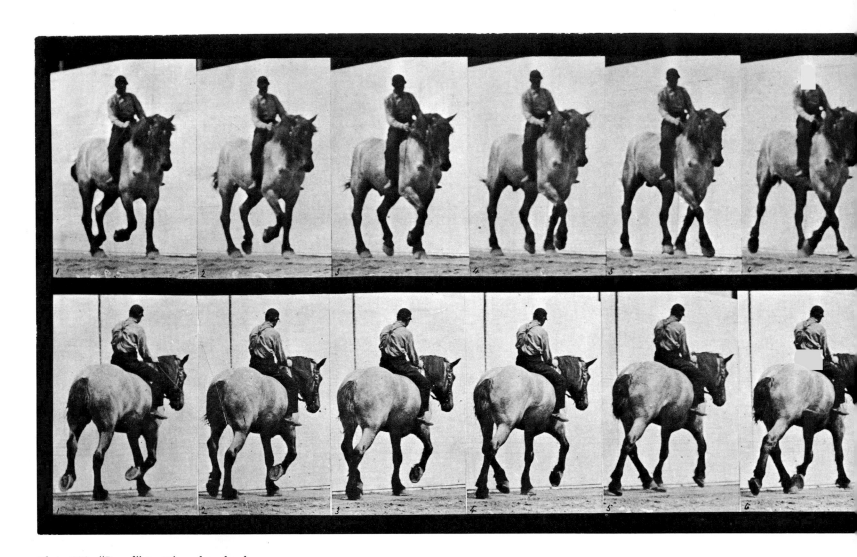

Plate 599. "Dusel" trotting, bareback.

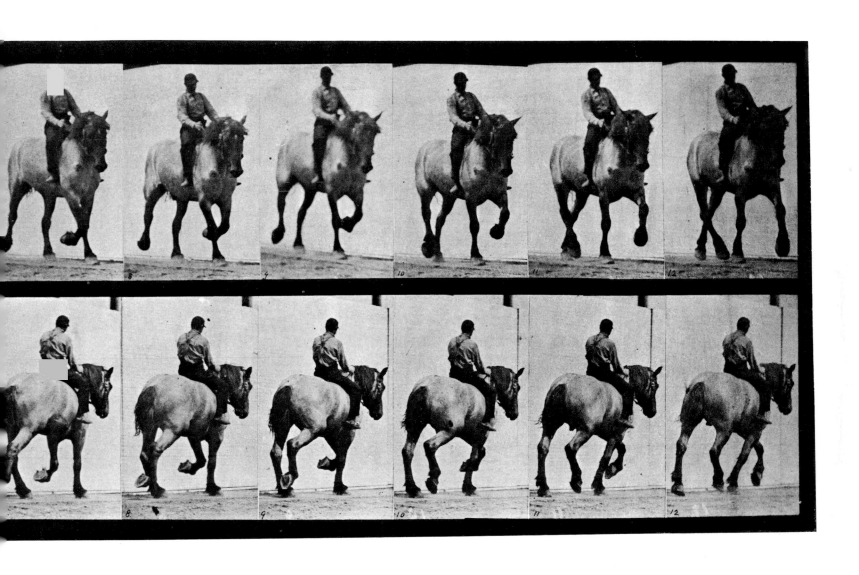

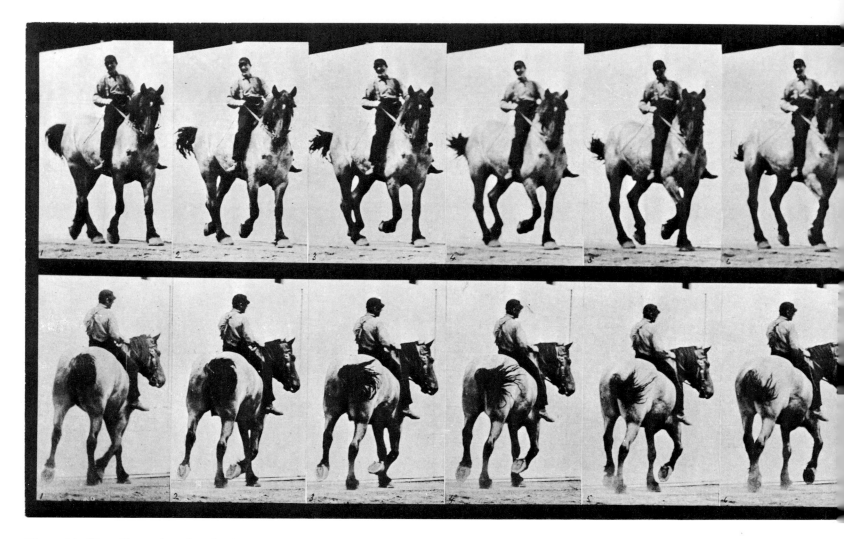

Plate 600. *"Dusel" trotting, bareback.*

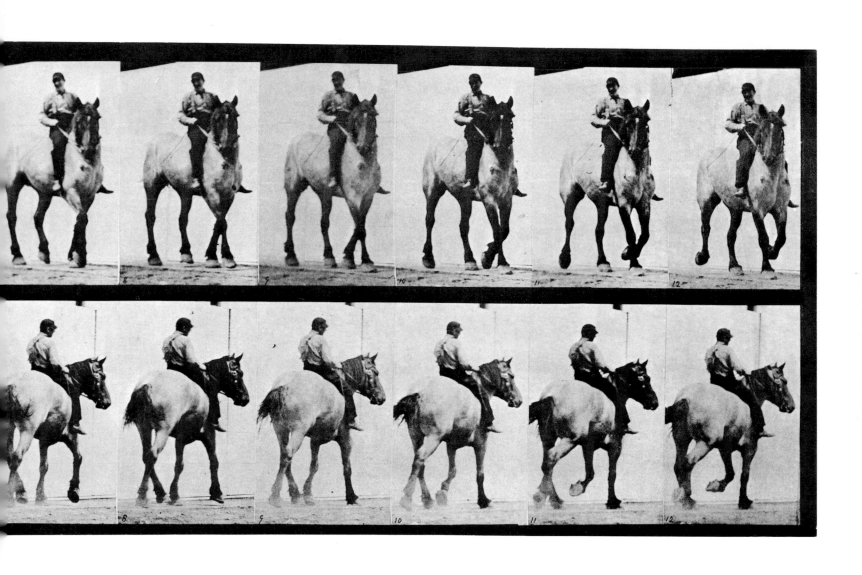

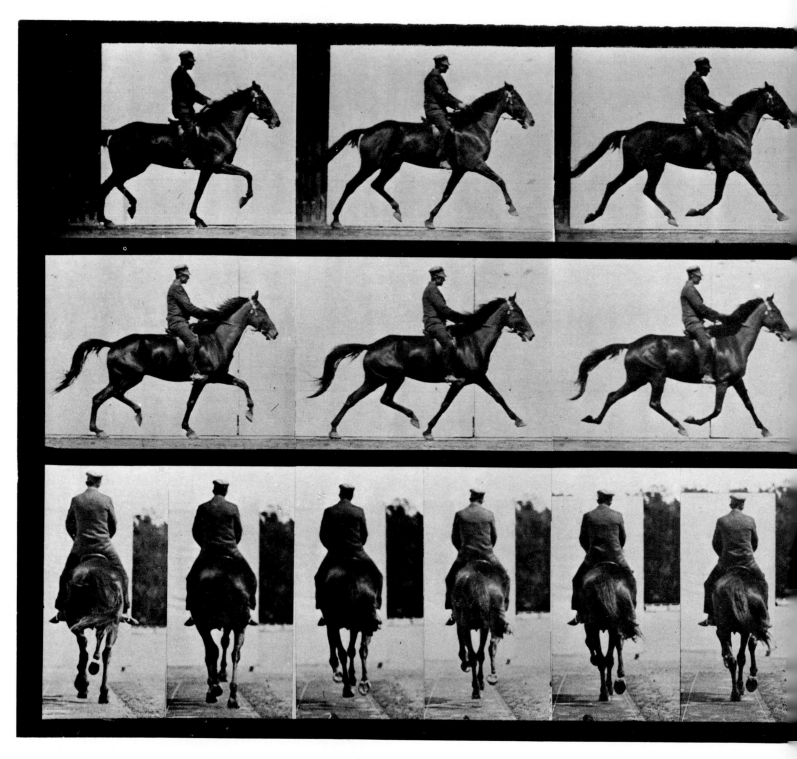

Plate 601. "Beauty" trotting, saddled.

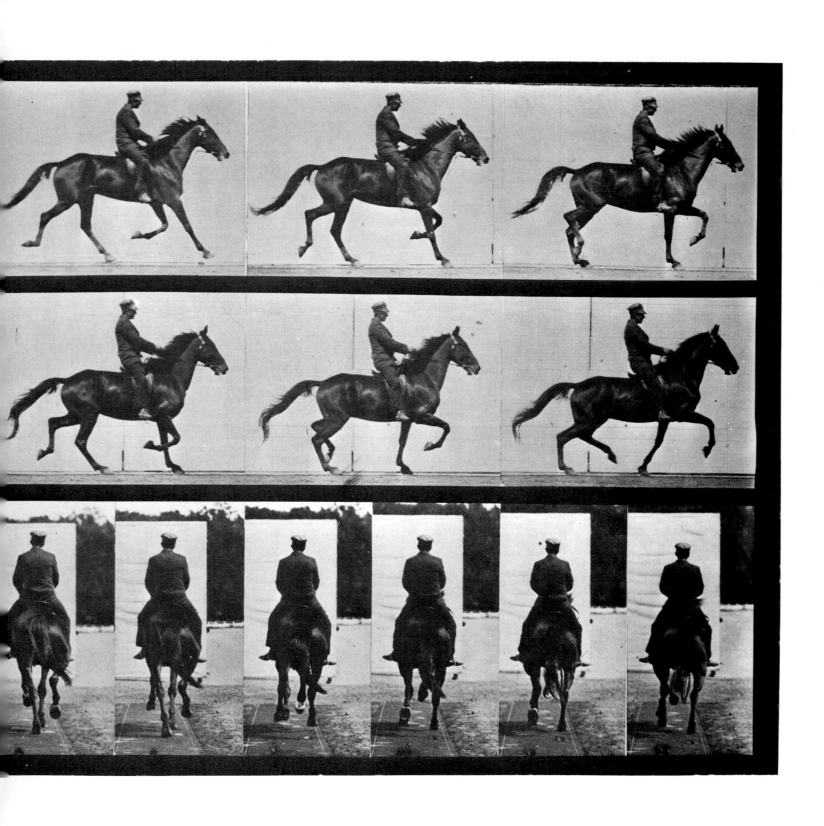

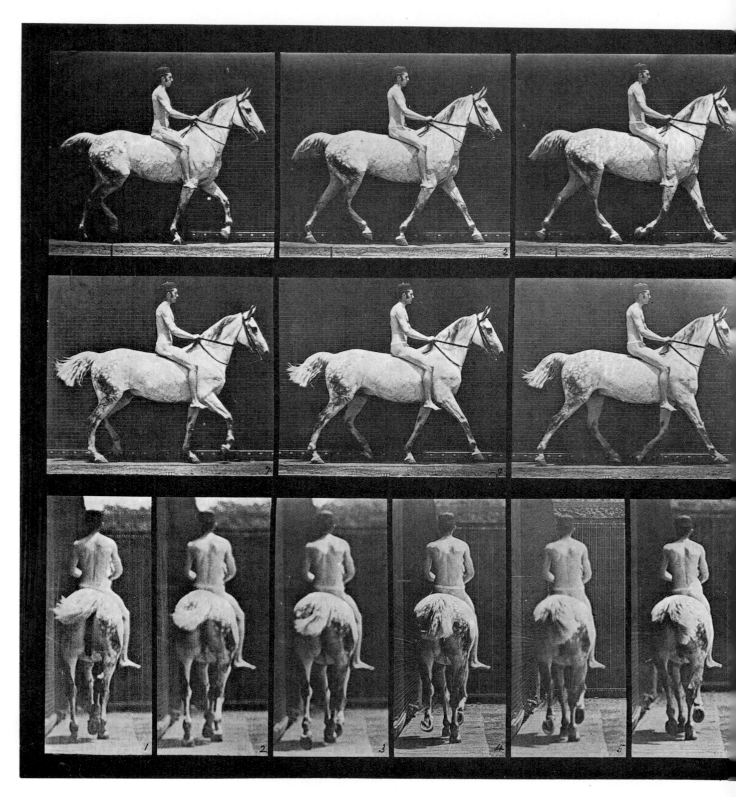

Plate 602. "Smith" trotting, bareback; rider nude.

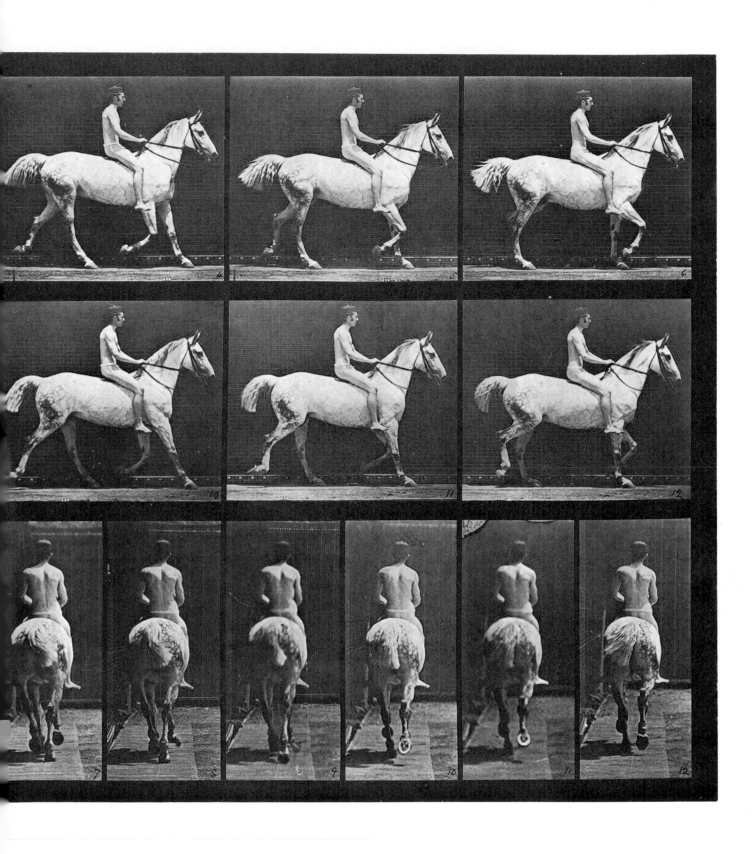

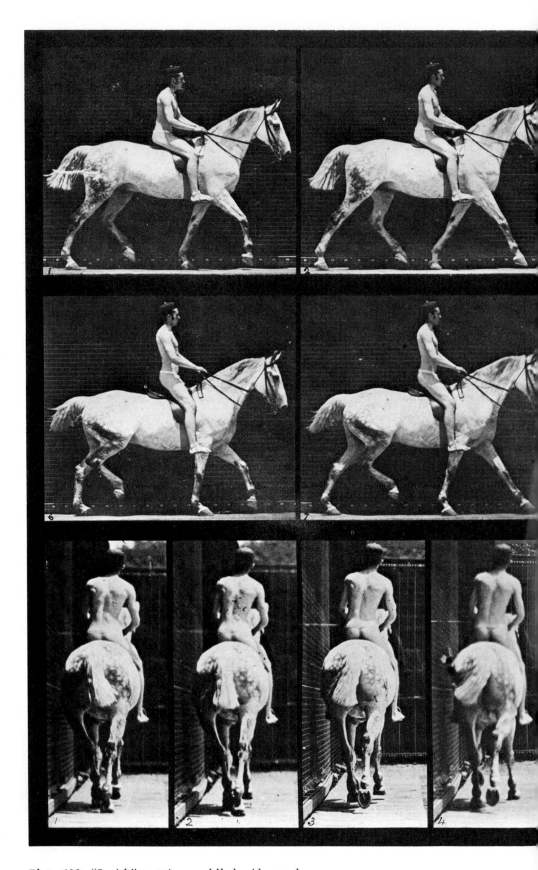

Plate 603. "Smith" trotting, saddled; rider nude.

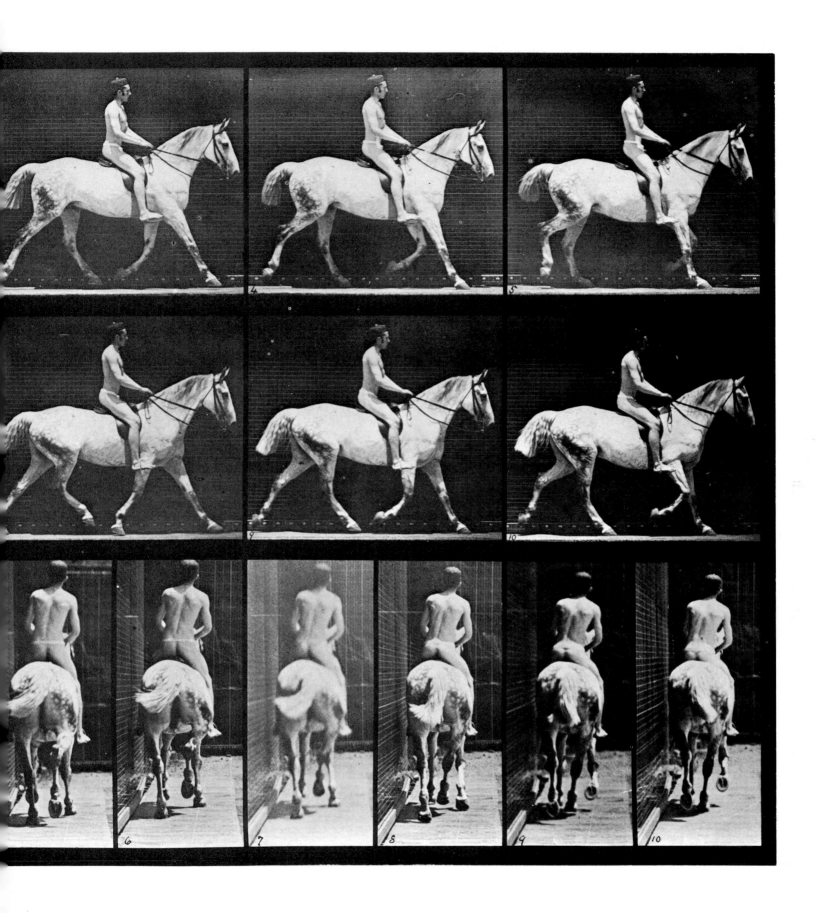

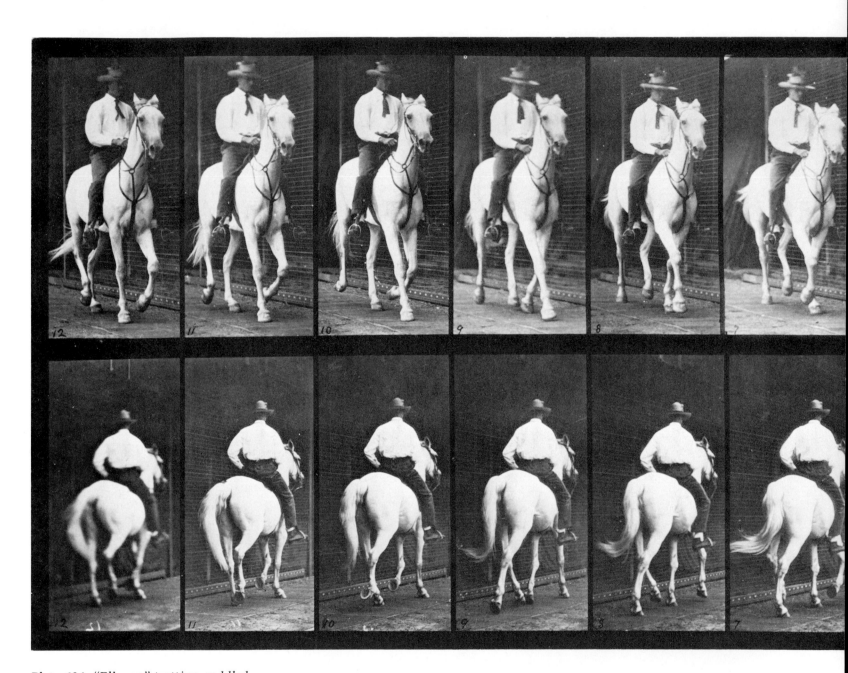

Plate 604. "Elberon" trotting, saddled.

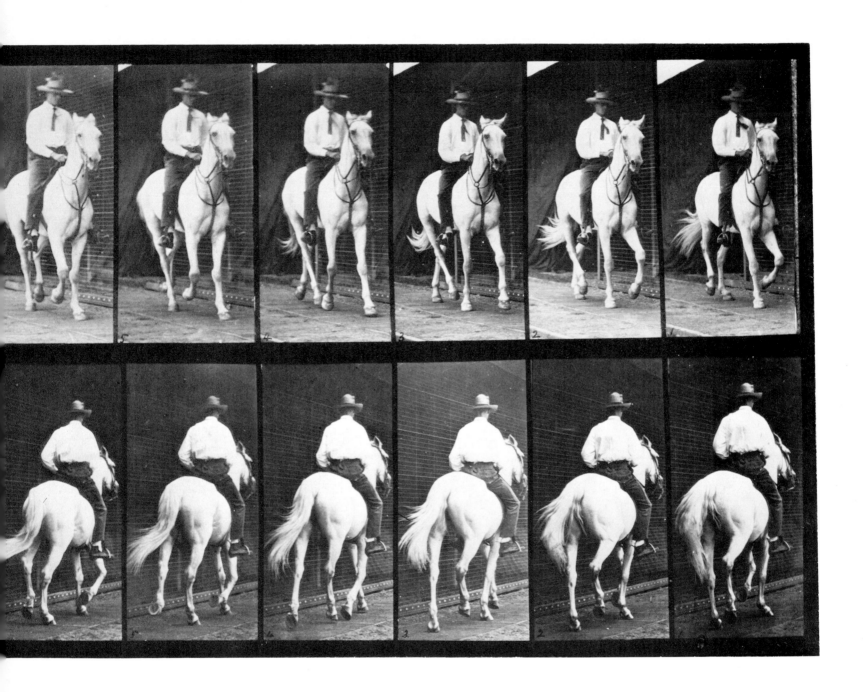

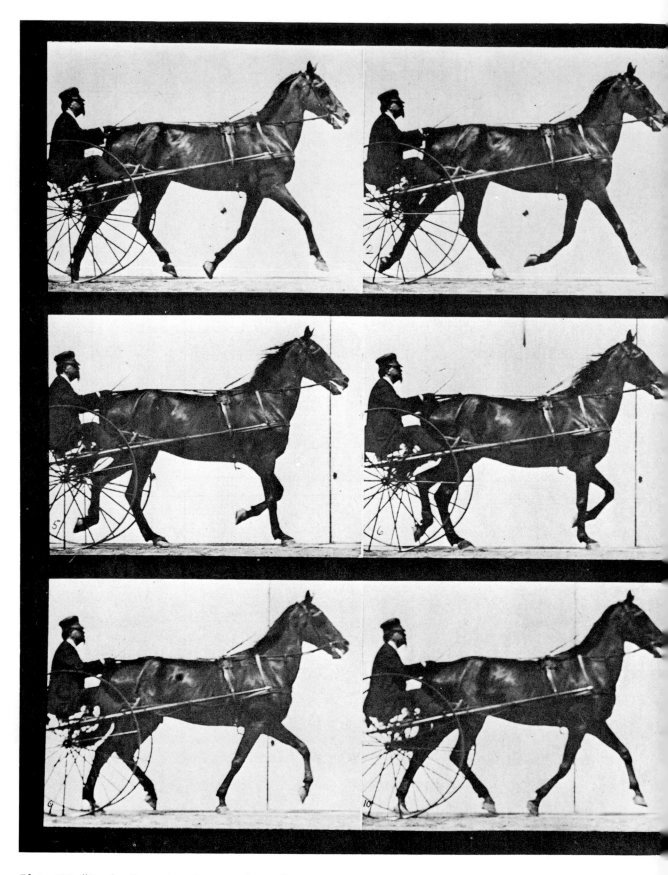

Plate 605. "Reuben" trotting, harnessed to sulky.

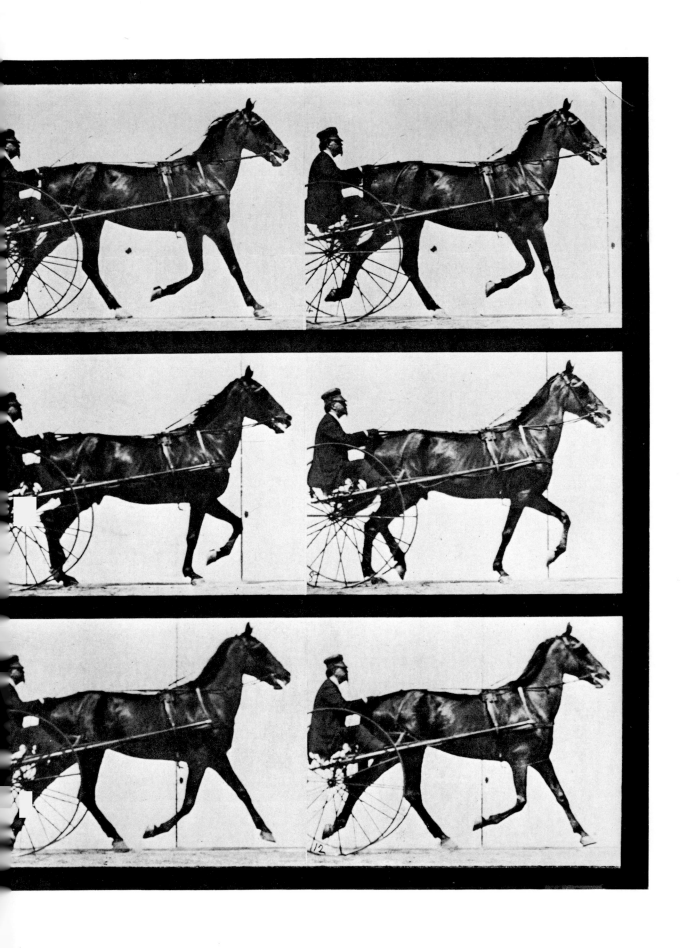

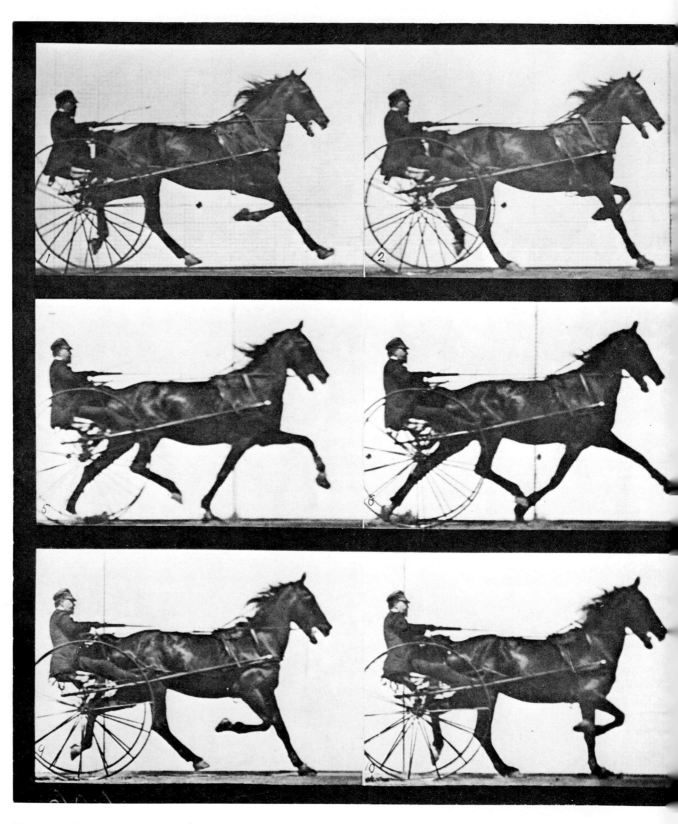

Plate 606. "Reuben" trotting, harnessed to sulky.

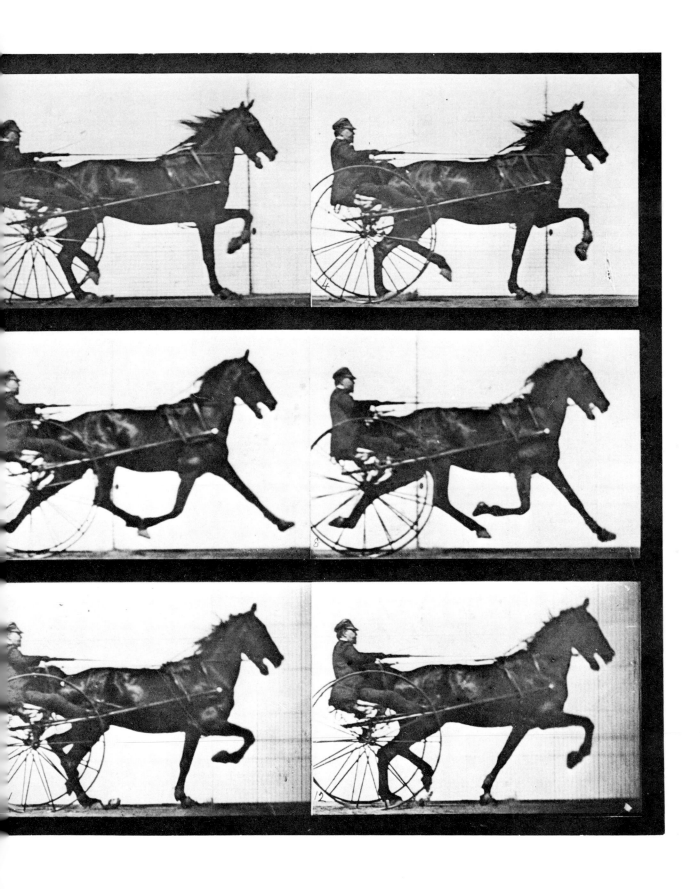

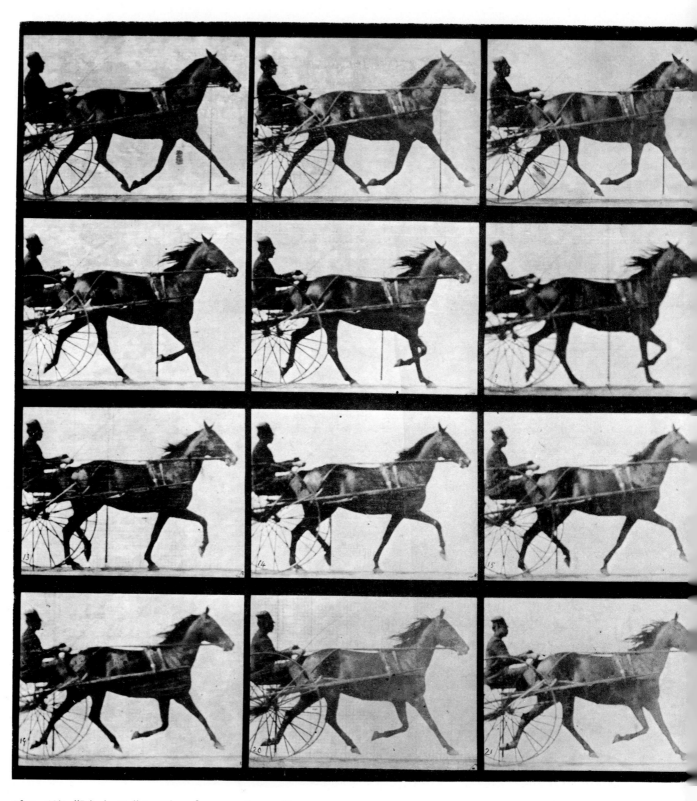

Plate 607. "Lizzie M." trotting, harnessed to sulky.

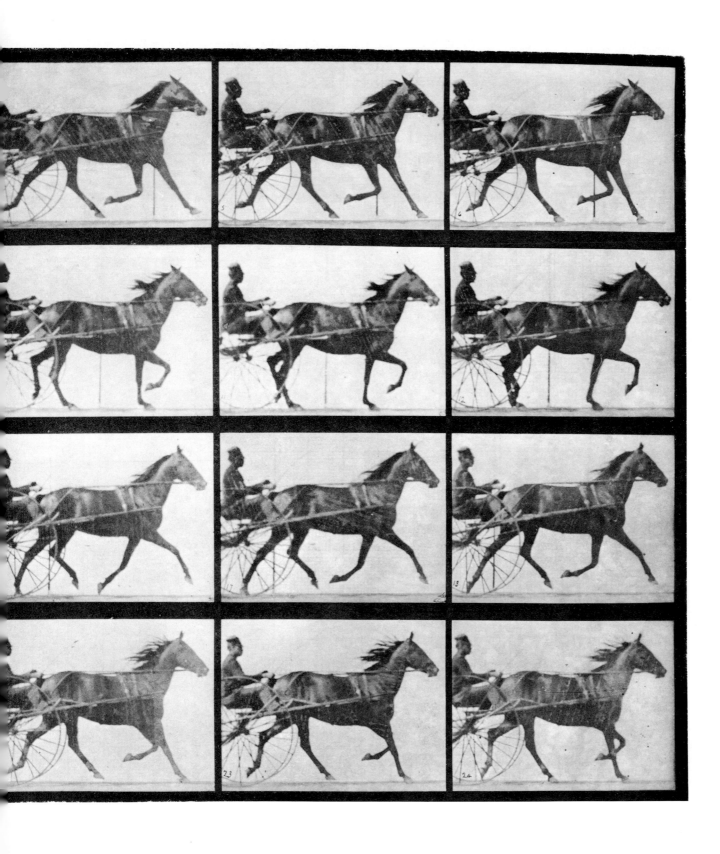

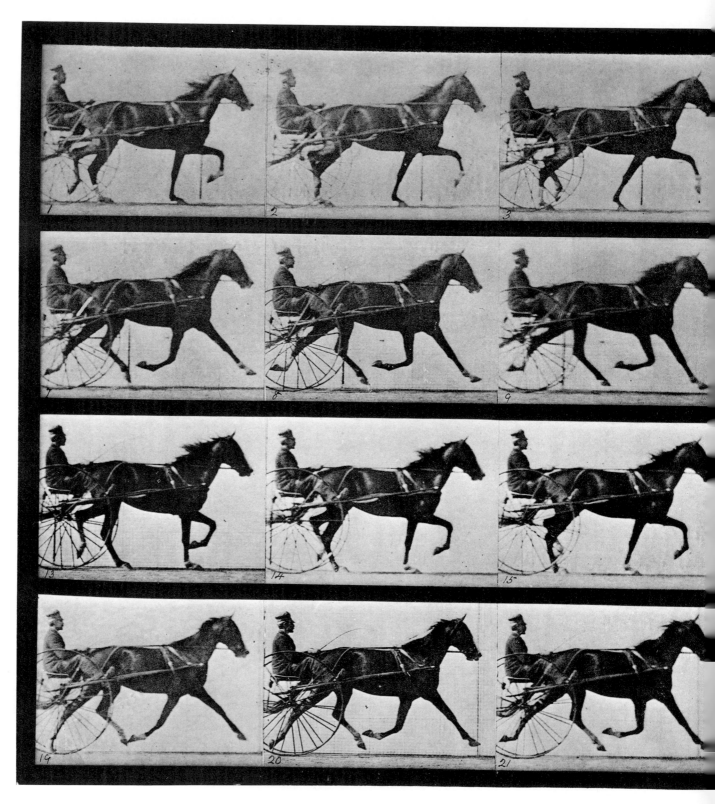

Plate 608. "Flode Holden" trotting, harnessed to sulky.

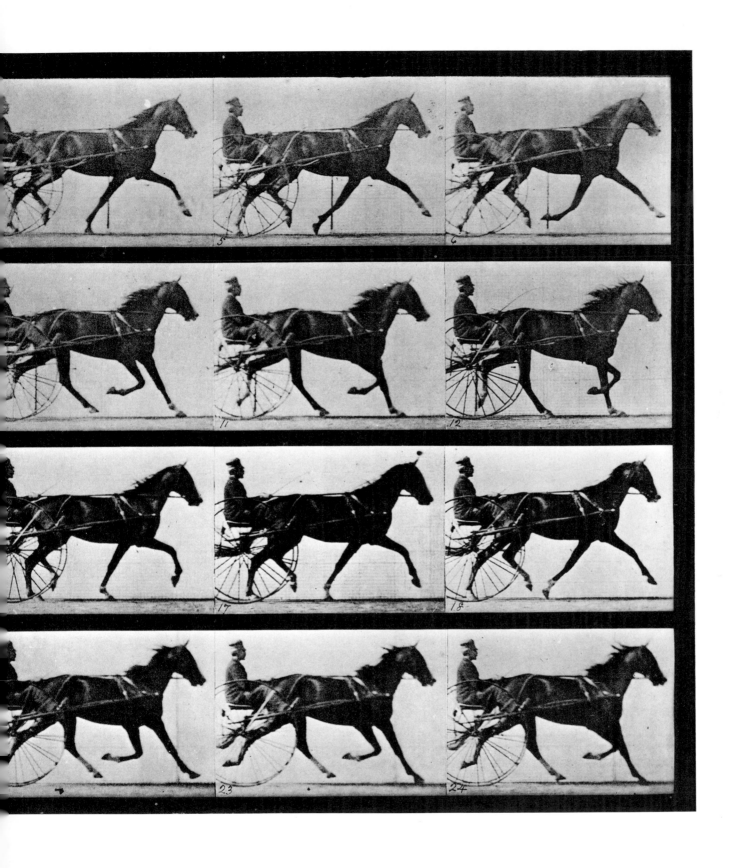

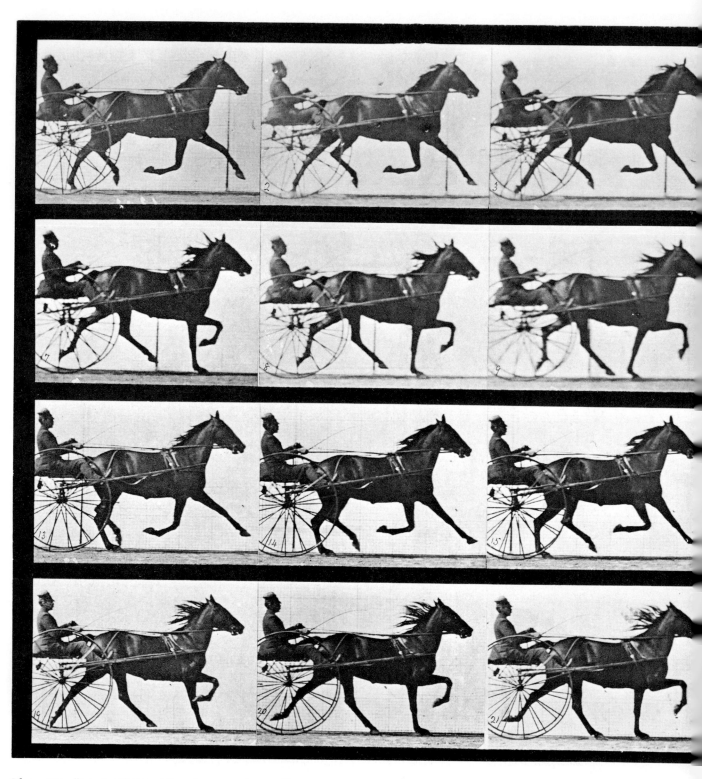

Plate 609. "Lizzie M." trotting, harnessed to sulky.

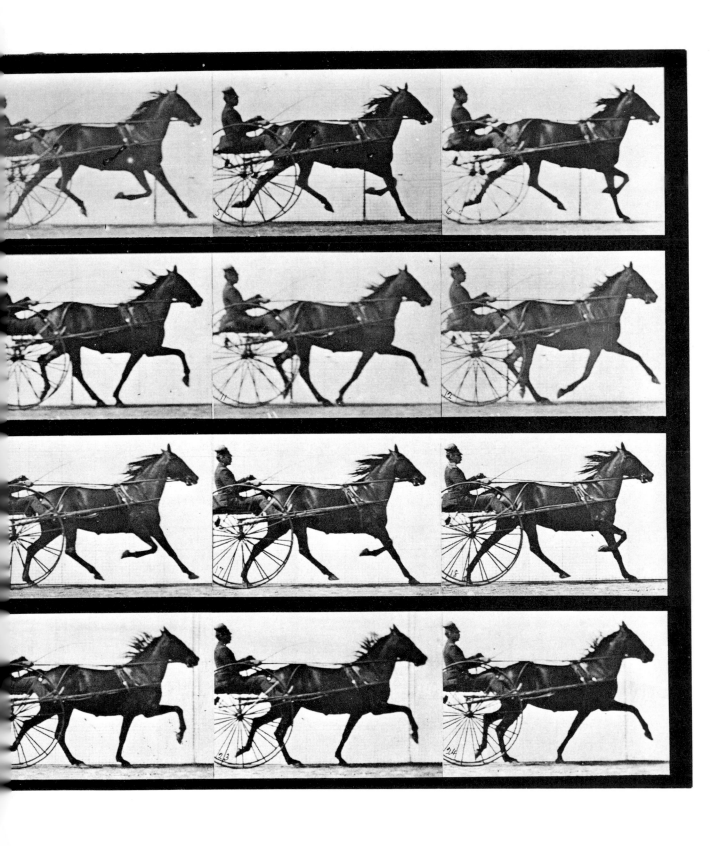

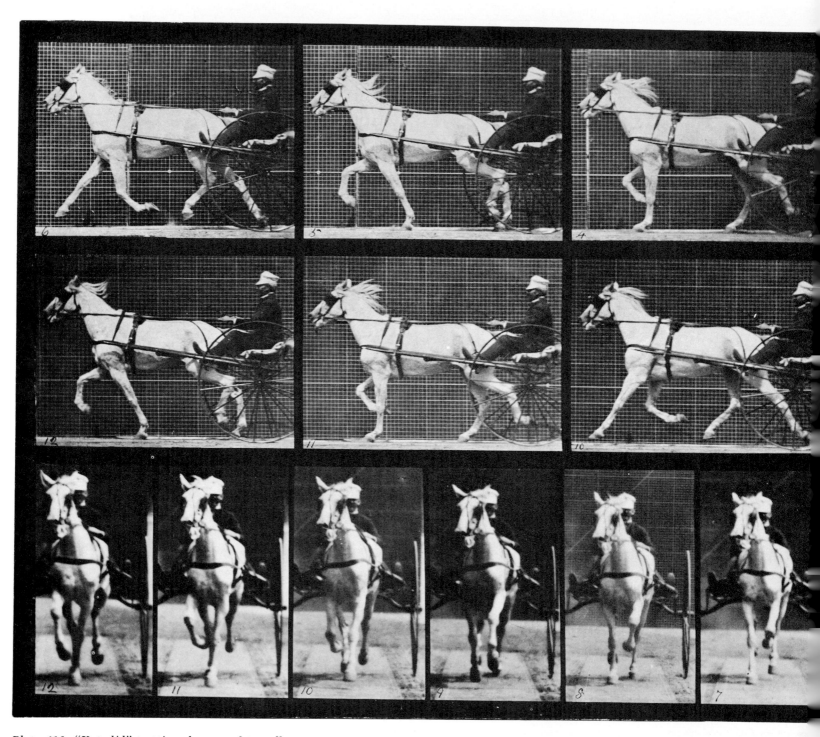

Plate 610. "Katydid" trotting, harnessed to sulky.

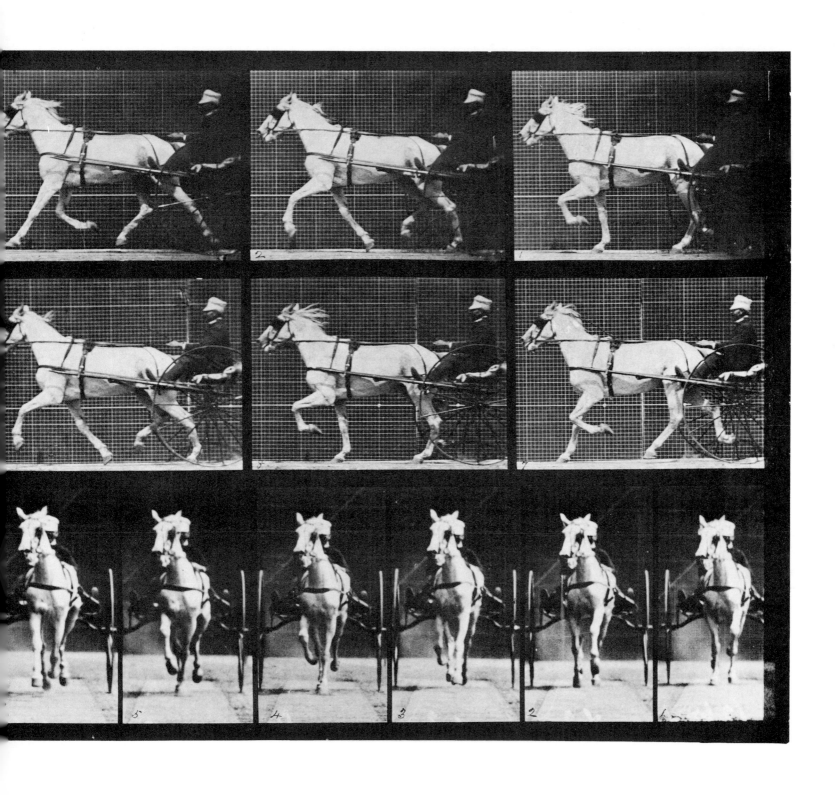

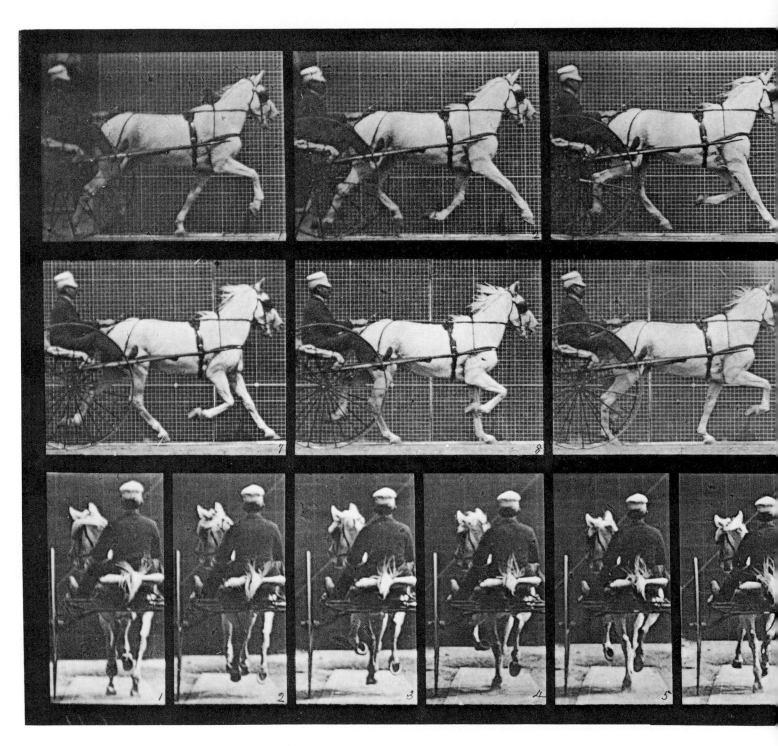

Plate 611. "Katydid" trotting, harnessed to sulky.

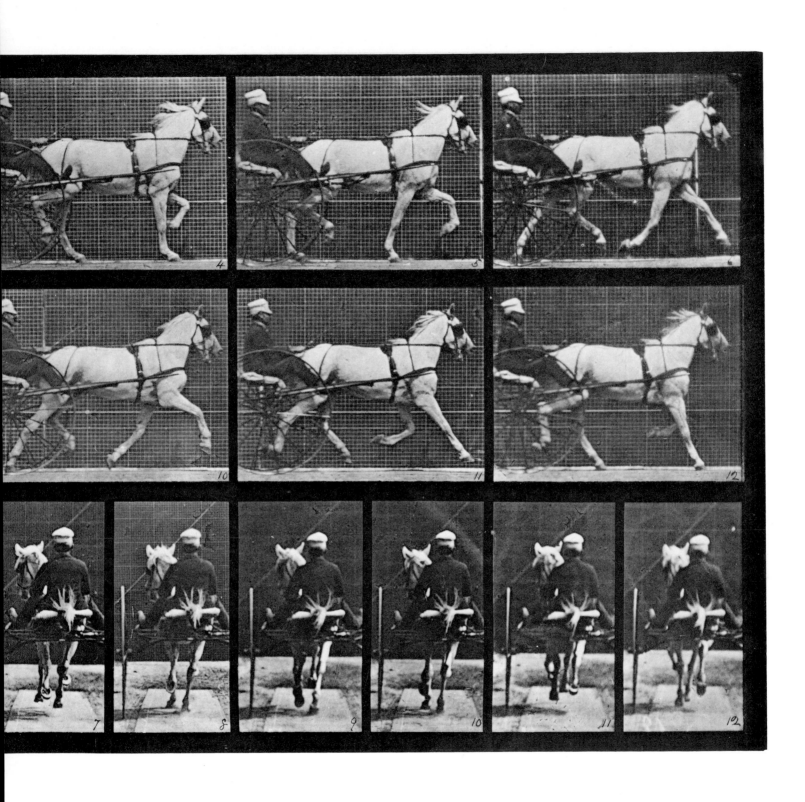

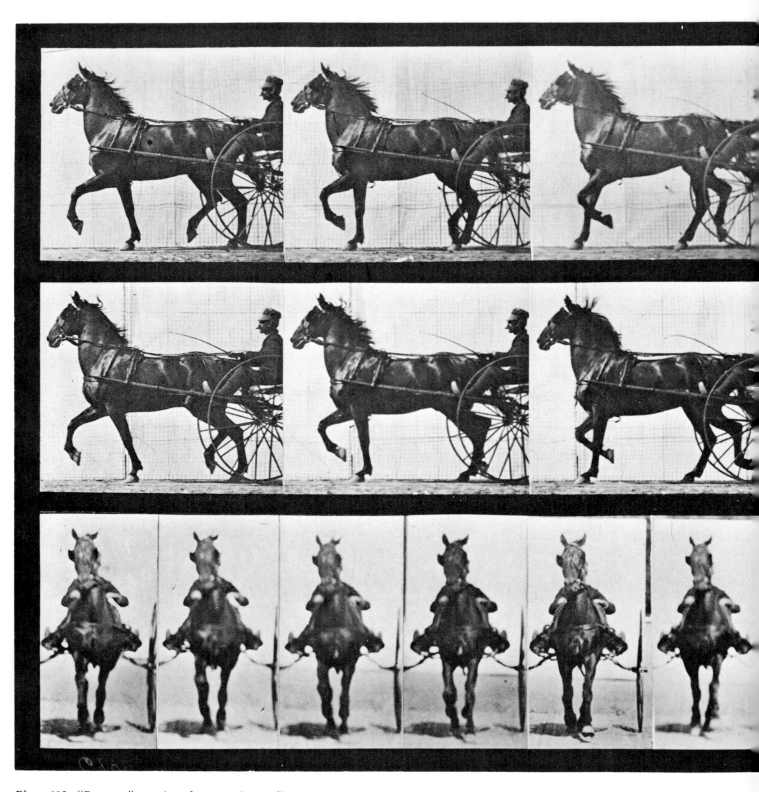

Plate 612. "Dercum" trotting, harnessed to sulky.

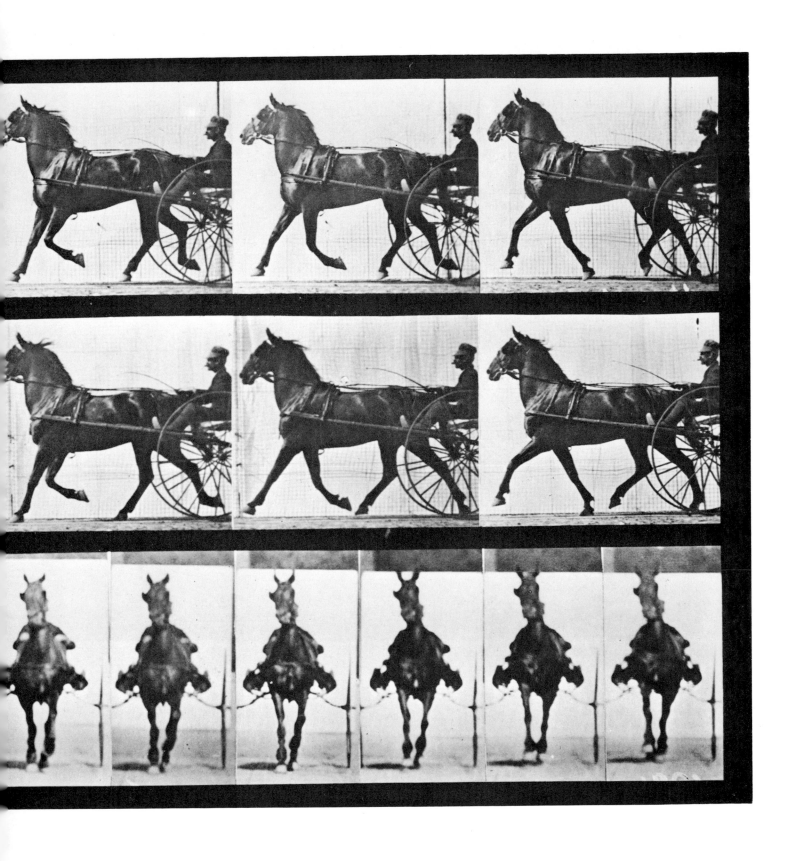

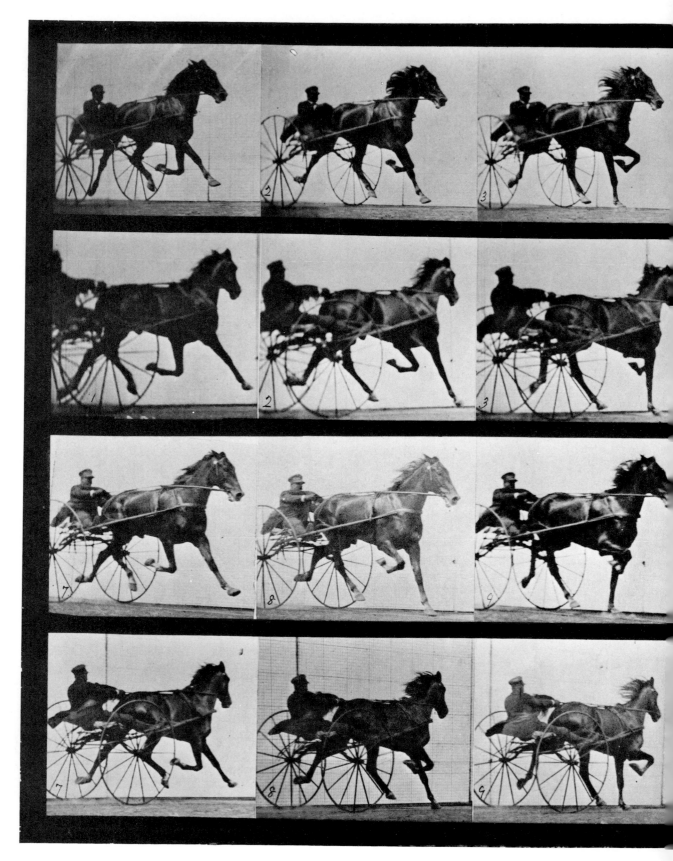

Plate 613. "Nellie Rose" trotting, harnessed to sulky.

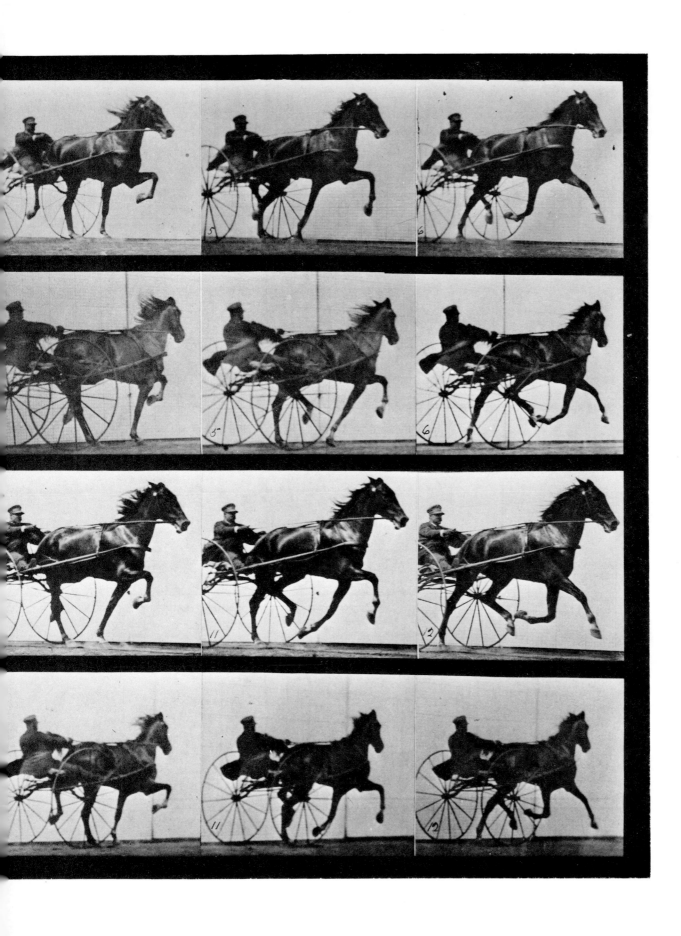

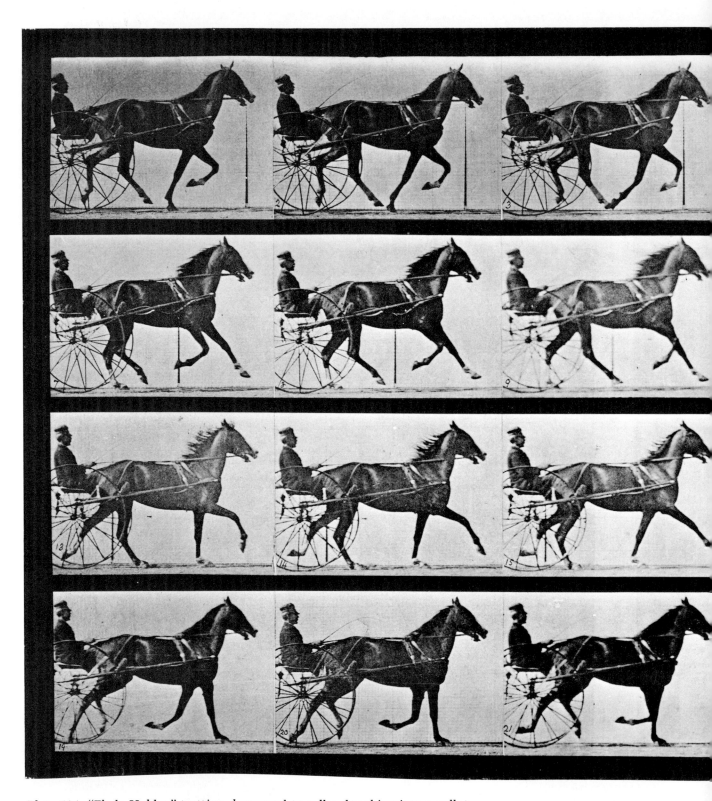

Plate 614. "Flode Holden" trotting, harnessed to sulky, breaking into a gallop.

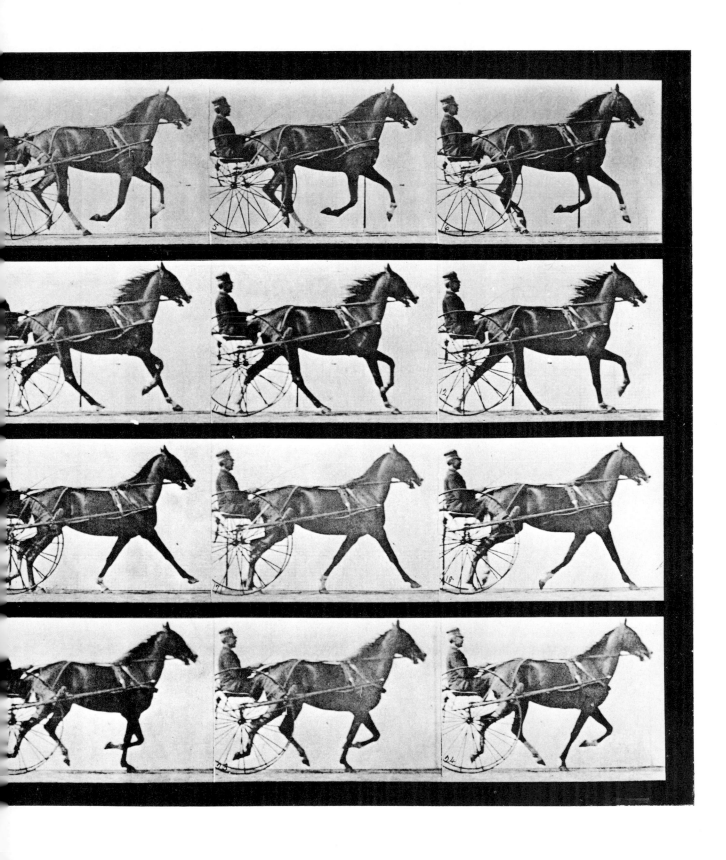

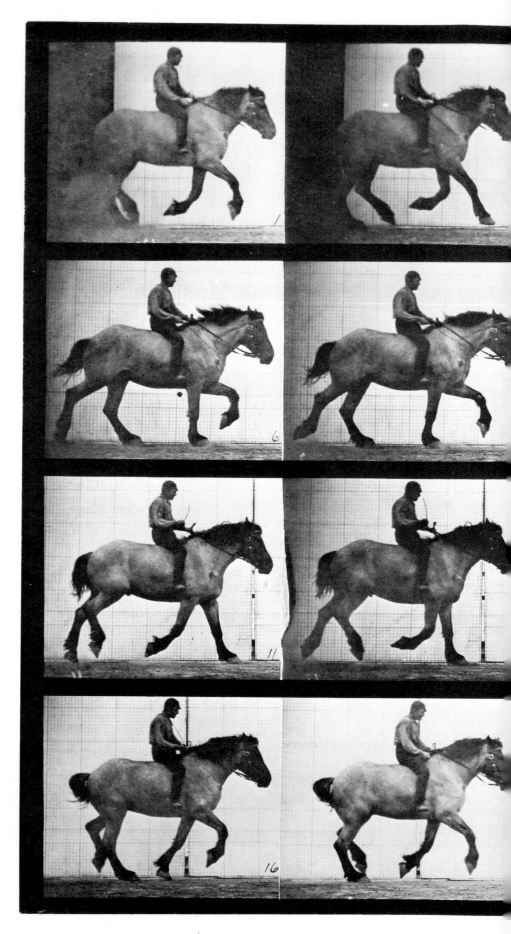

Plate 615. "Hansel" cantering, bareback.

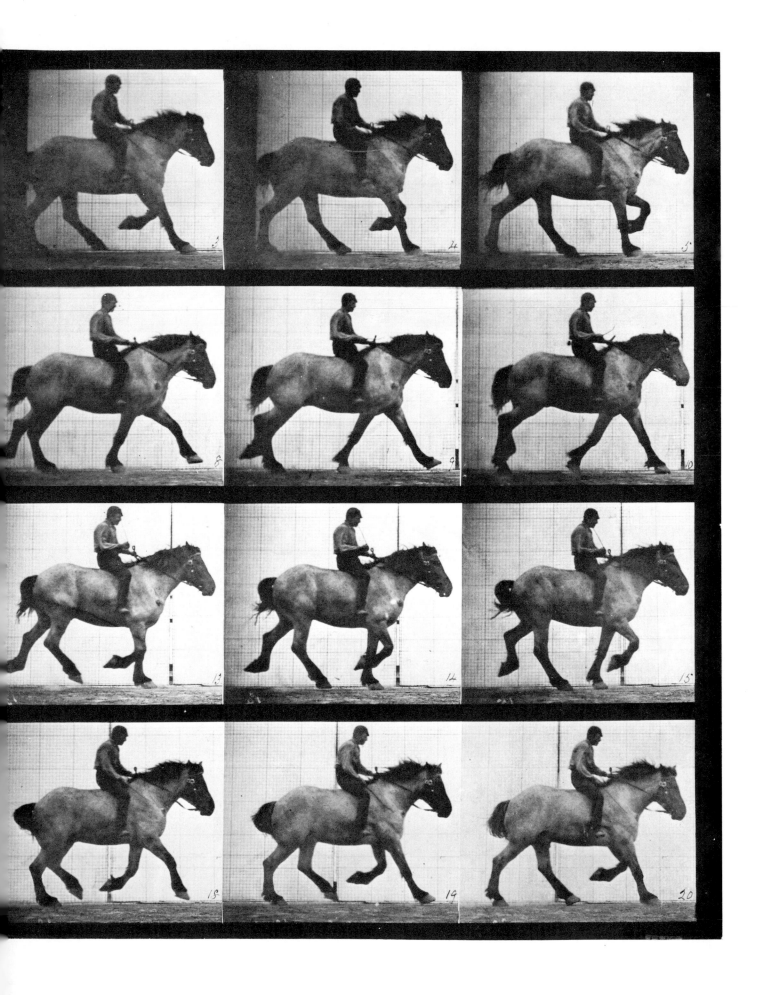

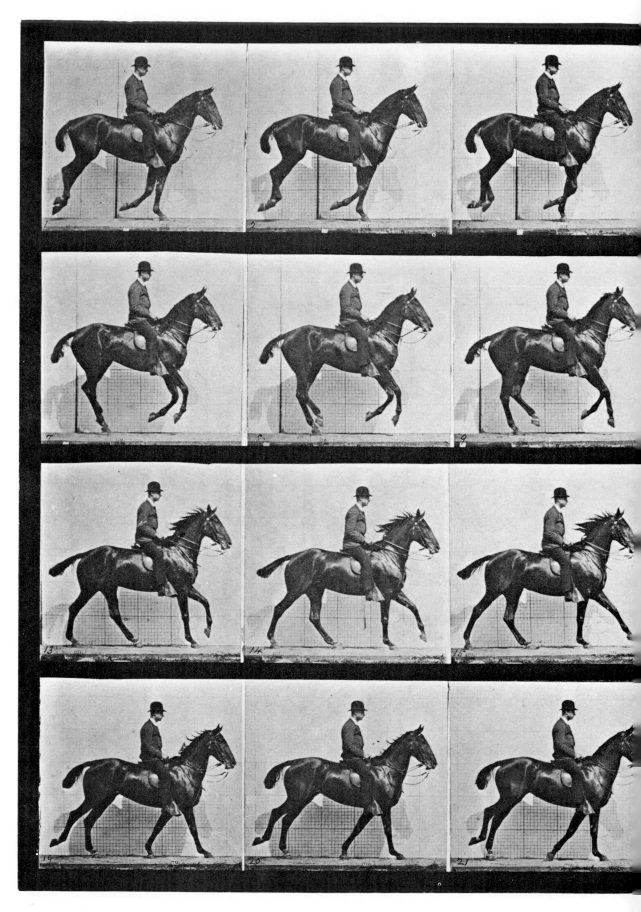

Plate 616. "Daisy" cantering, saddled.

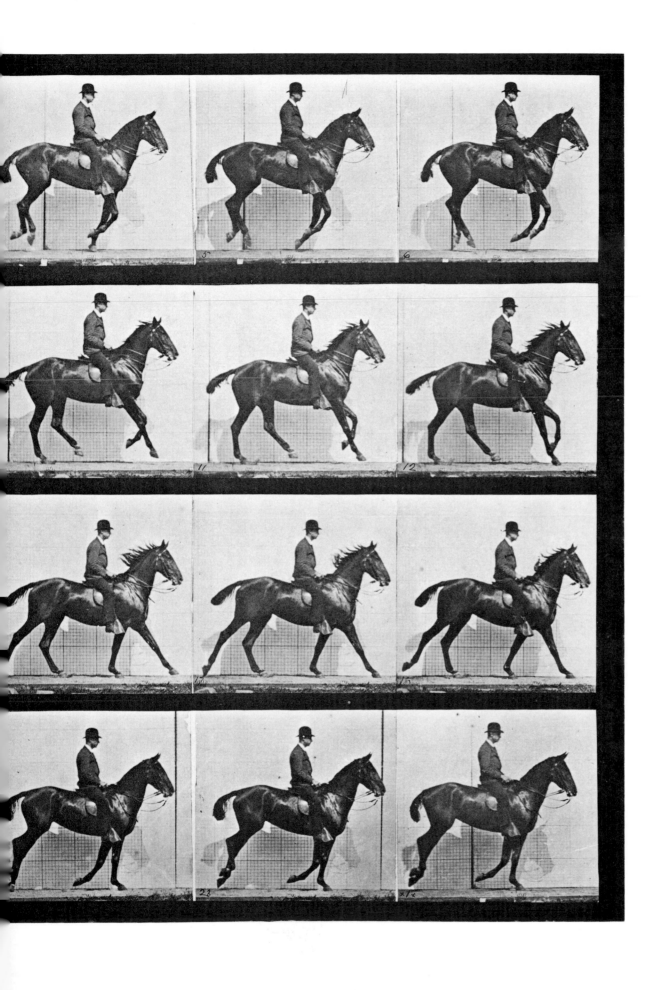

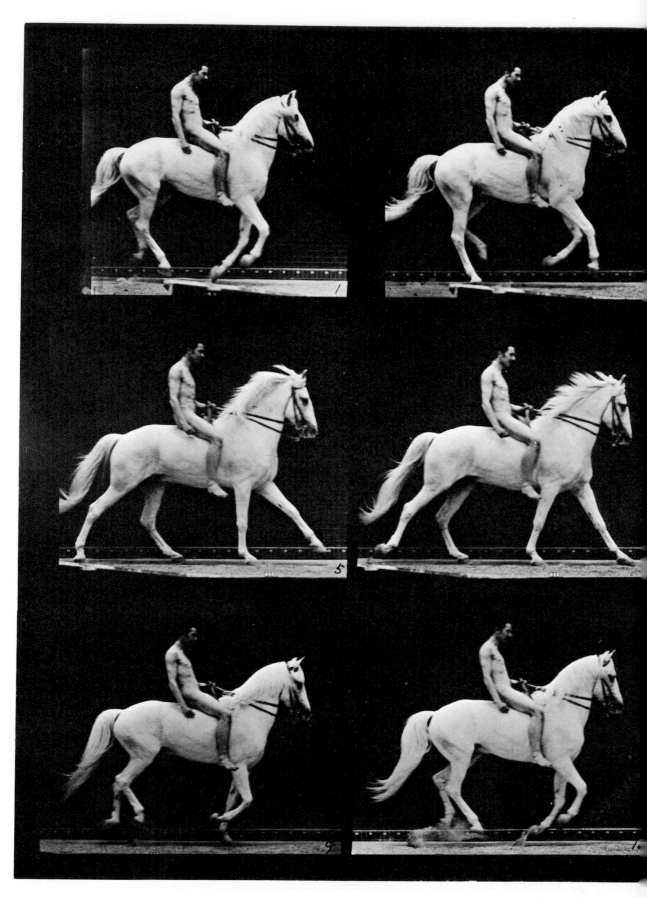

Plate 617. "Clinton" cantering, bareback; rider nude.

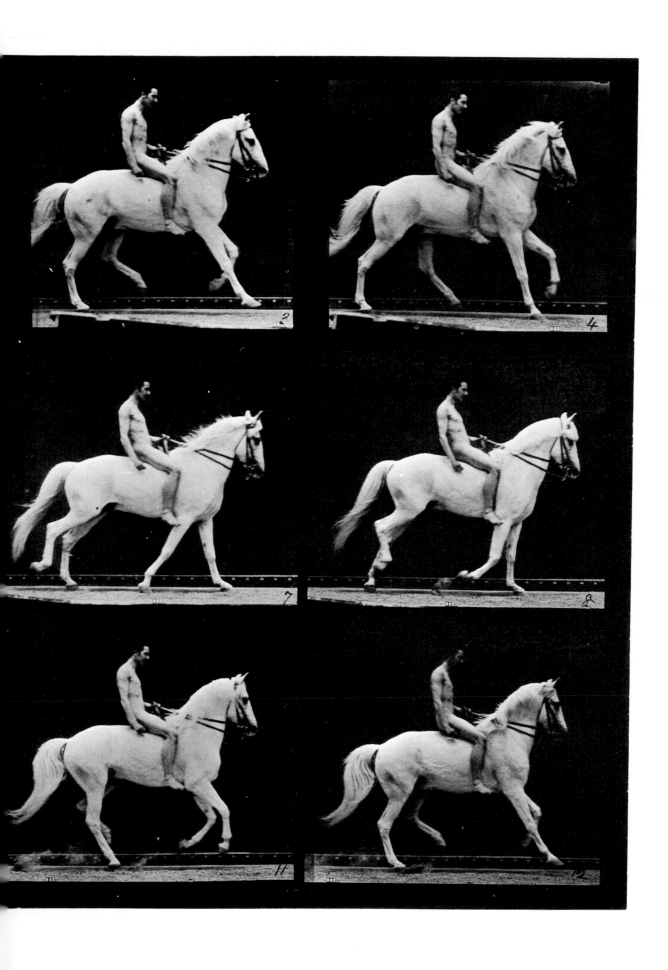

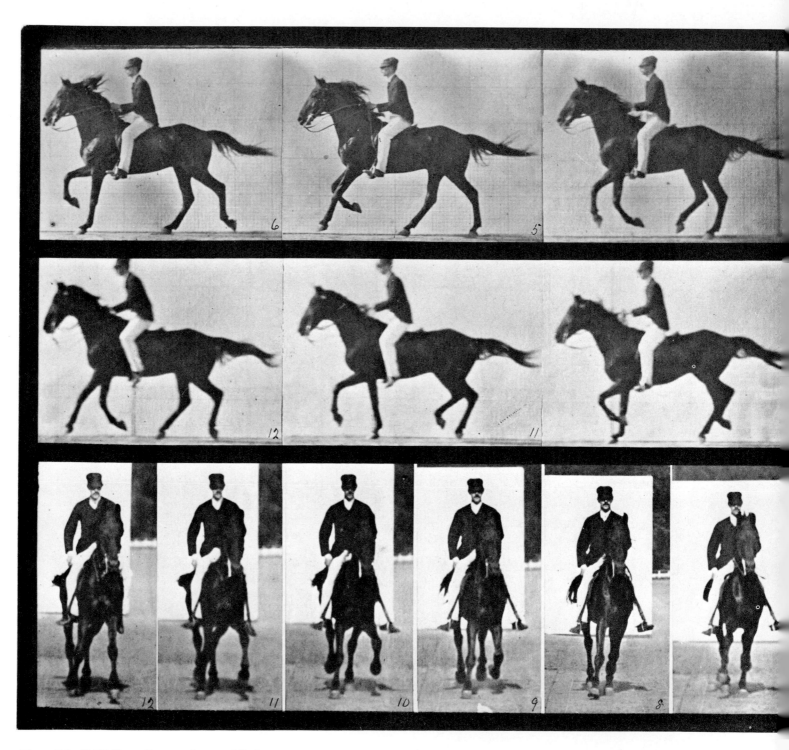

Plate 618. "Middleton" cantering, saddled.

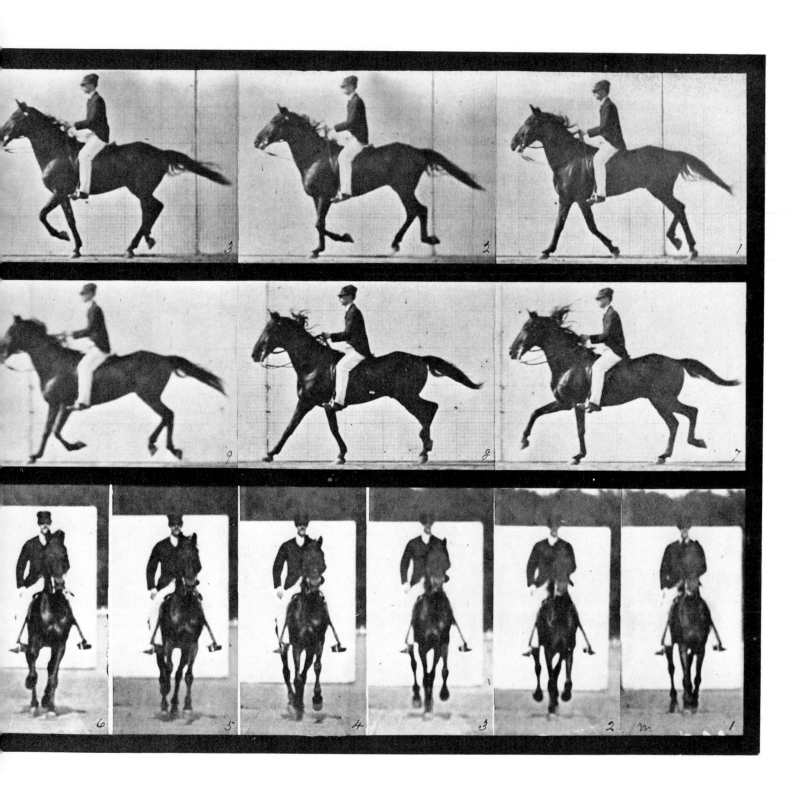

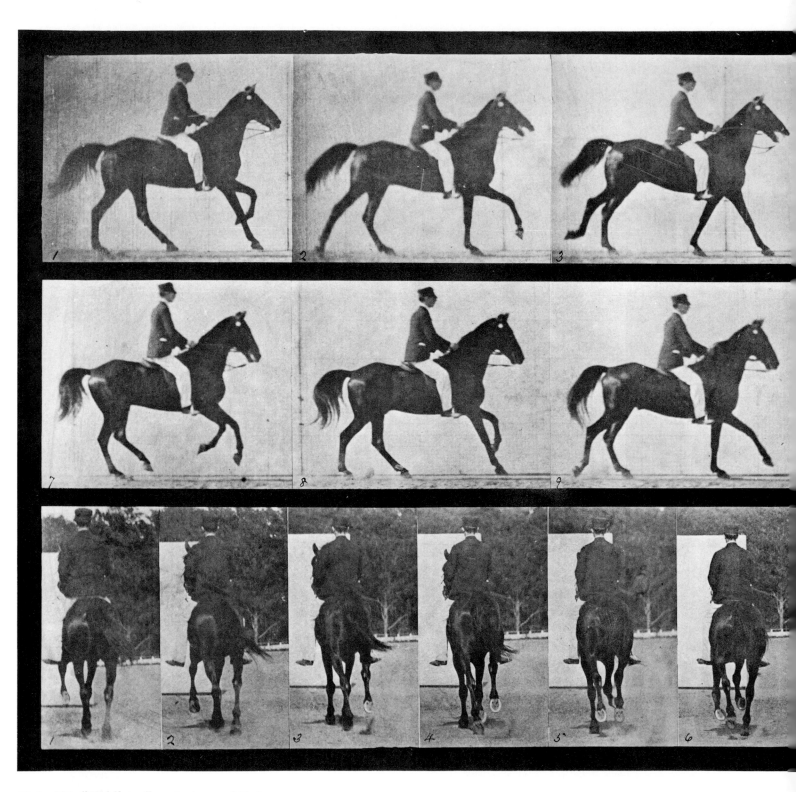

Plate 619. "Middleton" cantering, saddled.

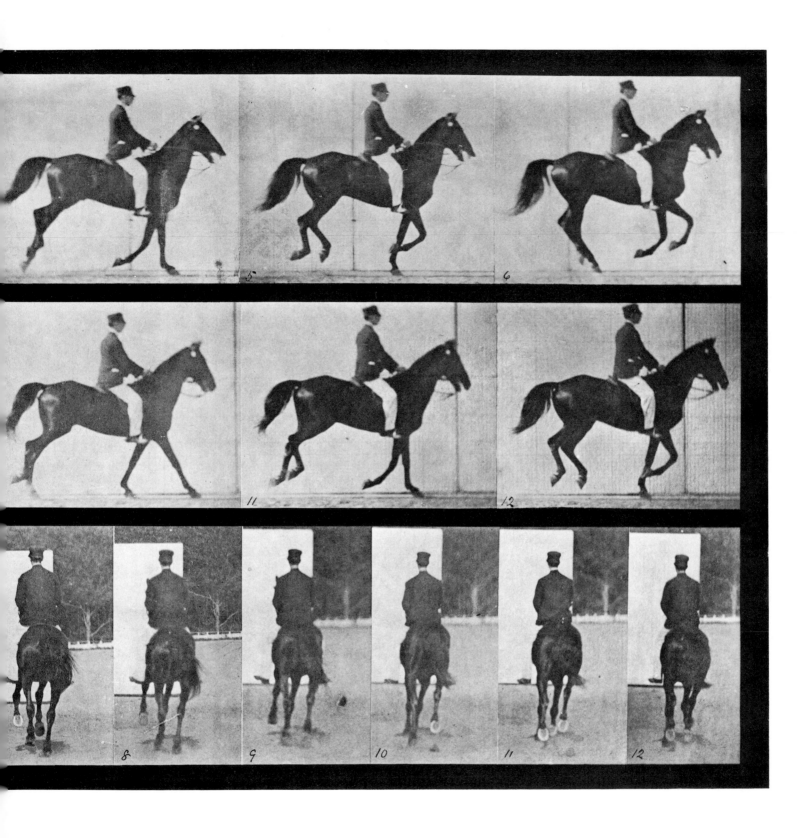

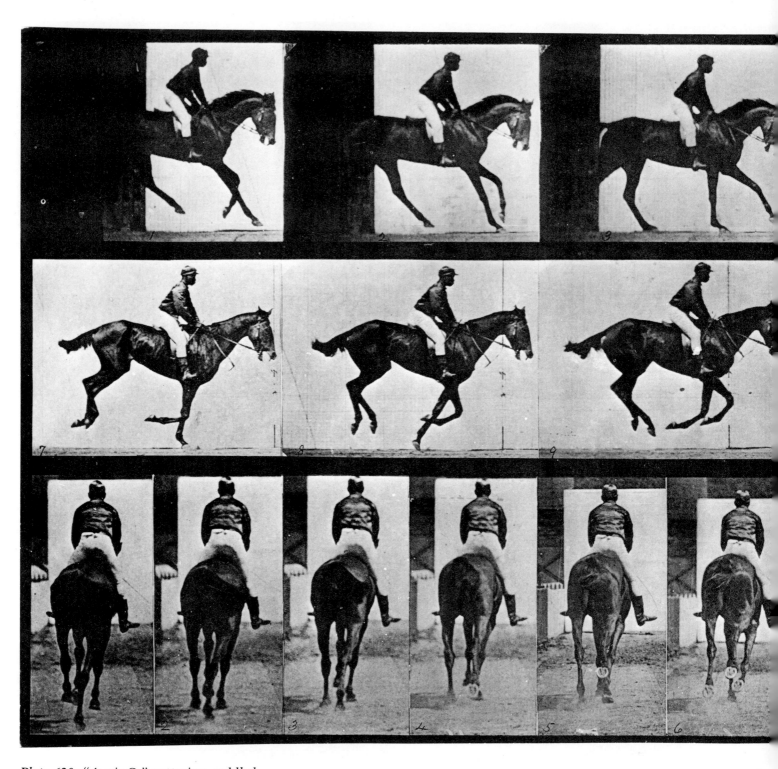

Plate 620. "Annie G." cantering, saddled.

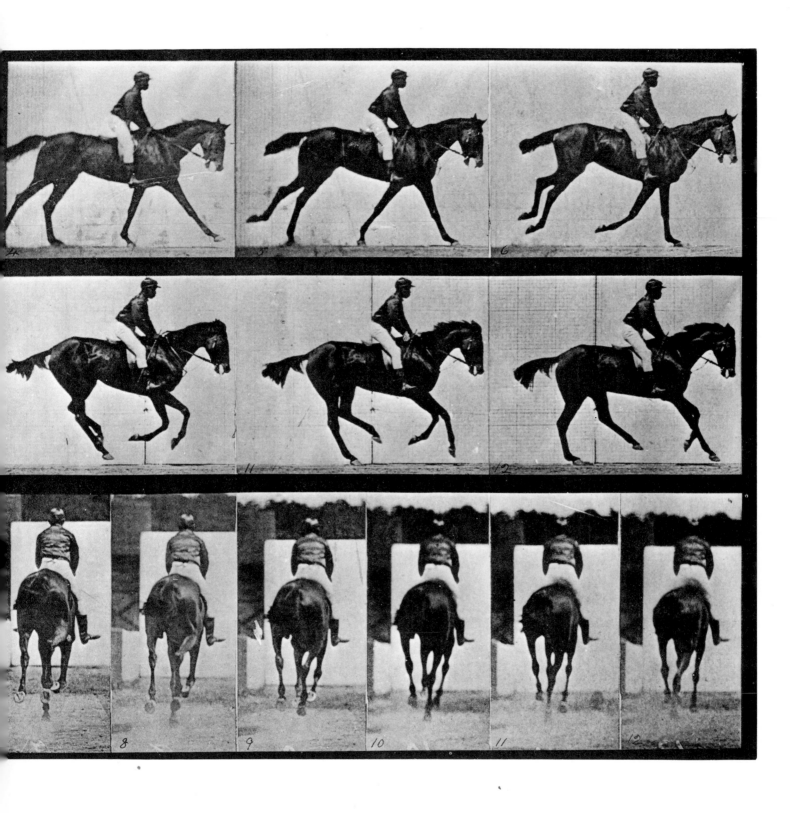

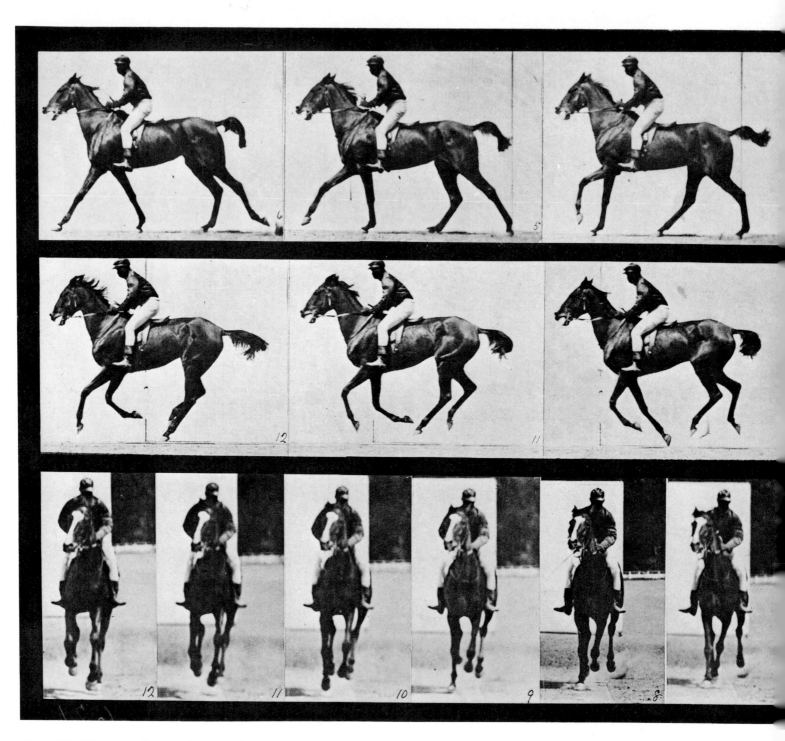

Plate 621. "Annie G." cantering, saddled.

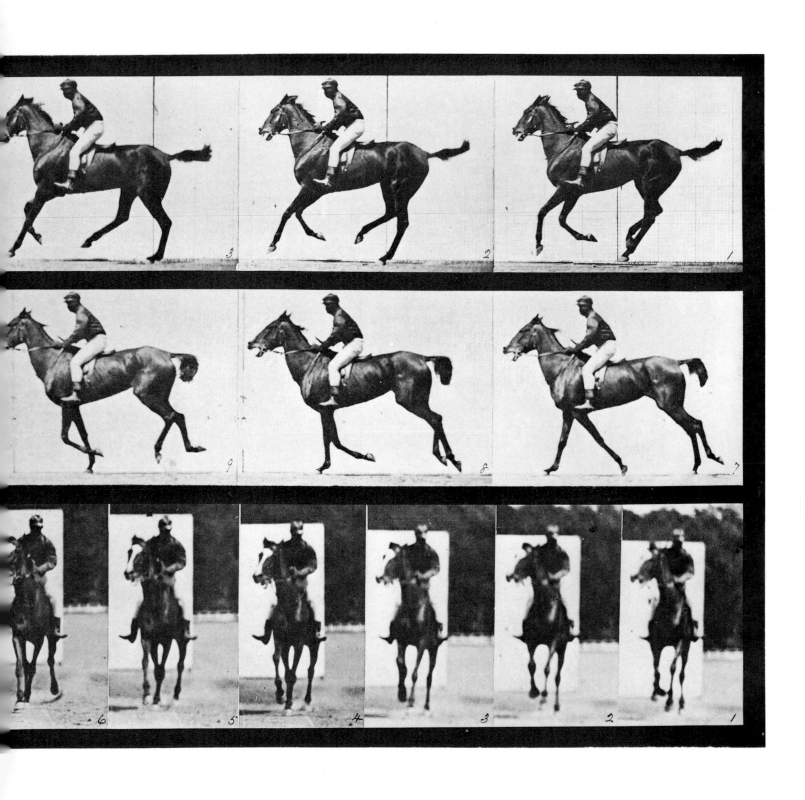

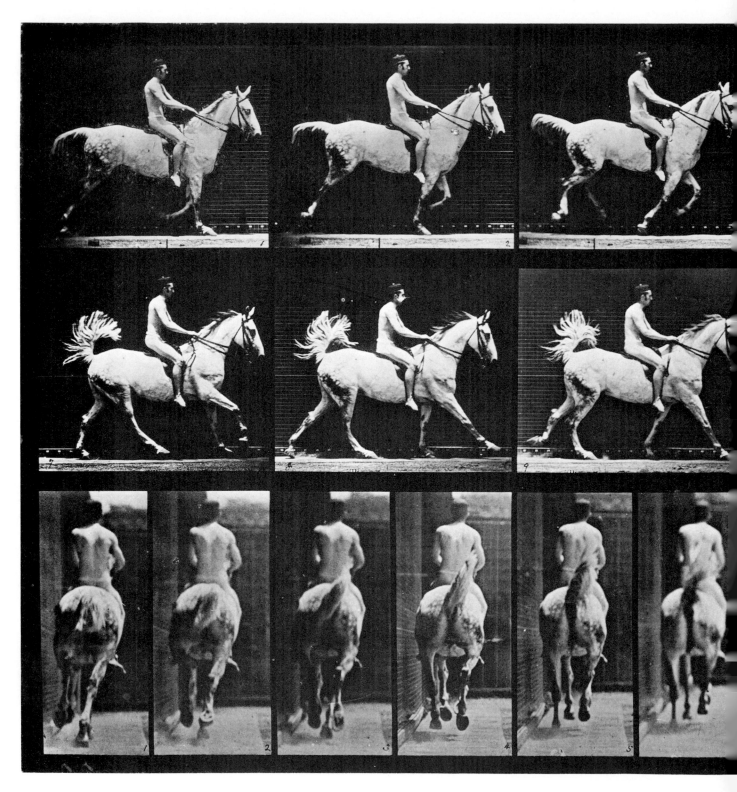

Plate 622. "Smith" cantering, saddled; rider nude.

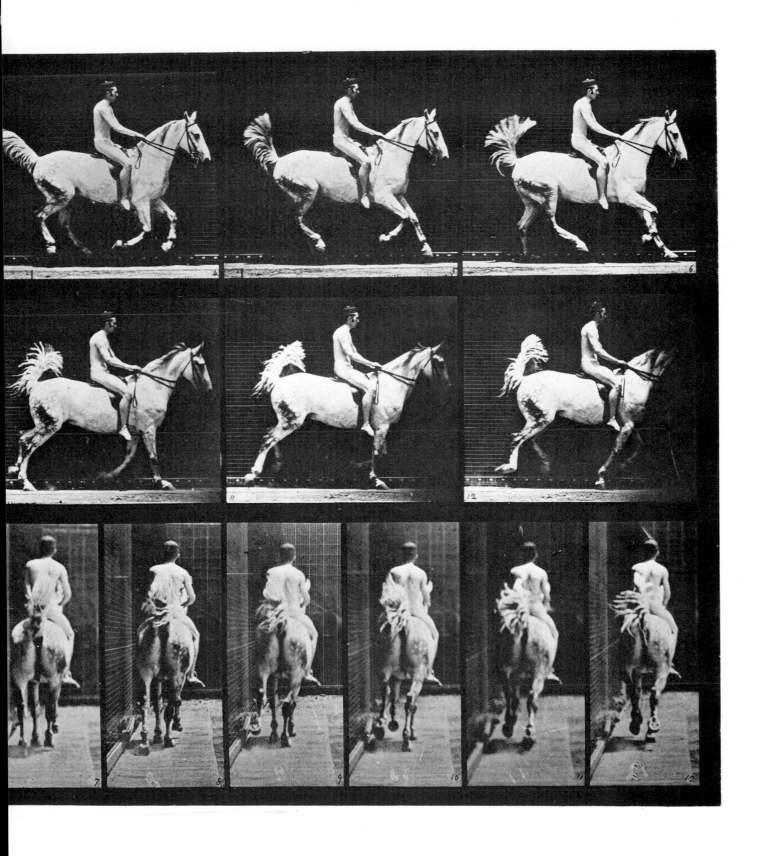

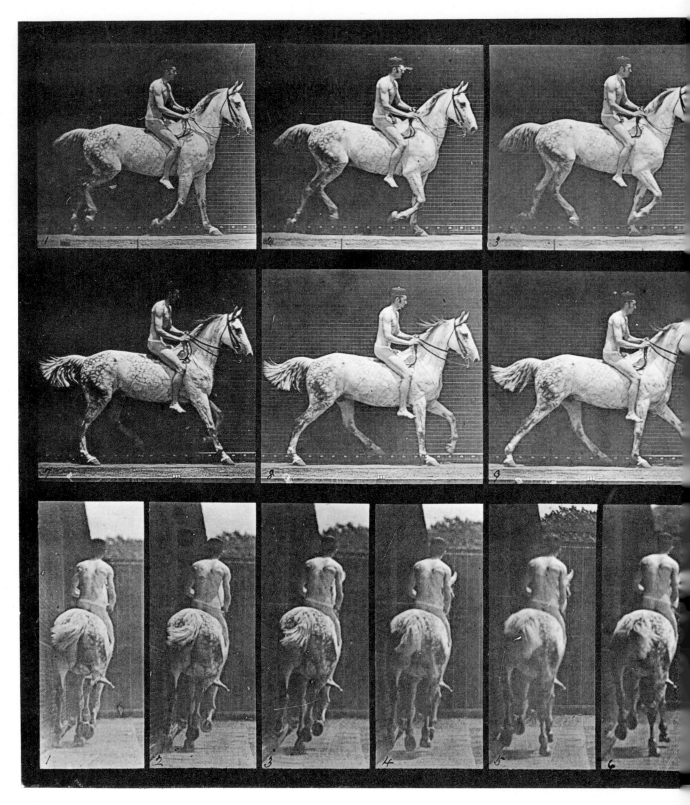

Plate 623. "Smith" cantering, bareback; rider nude.

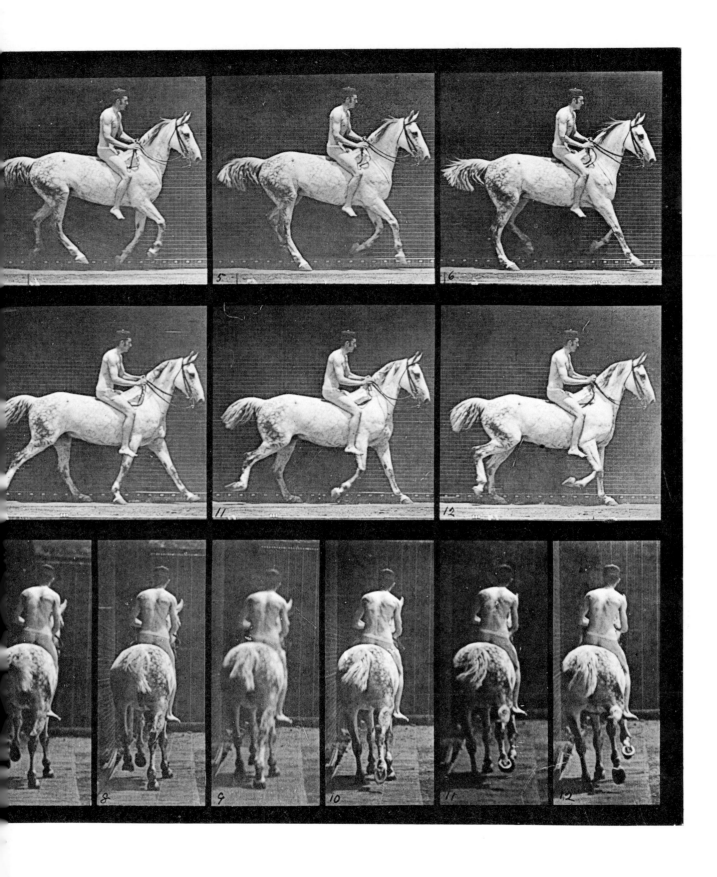

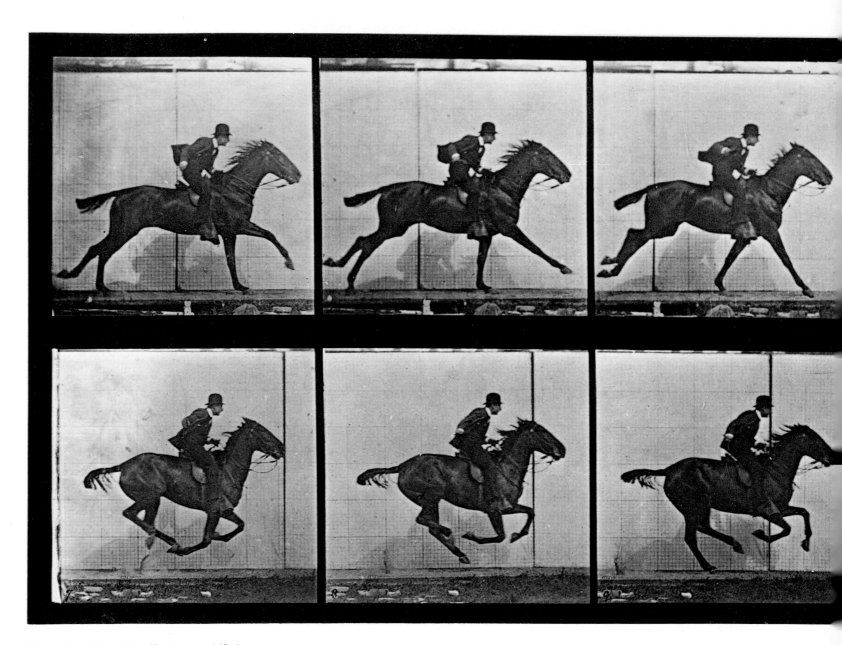

Plate 624. "Daisy" galloping, saddled.

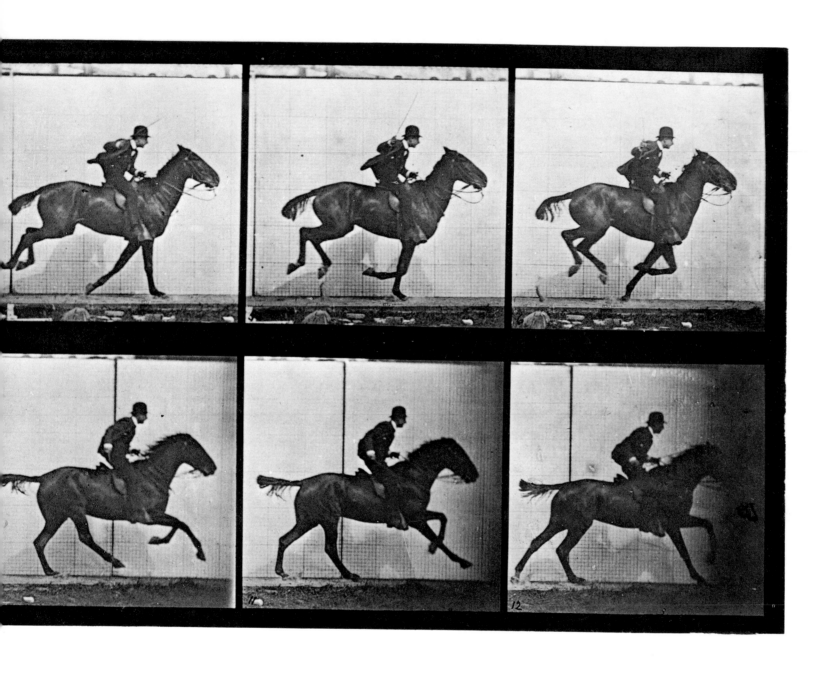

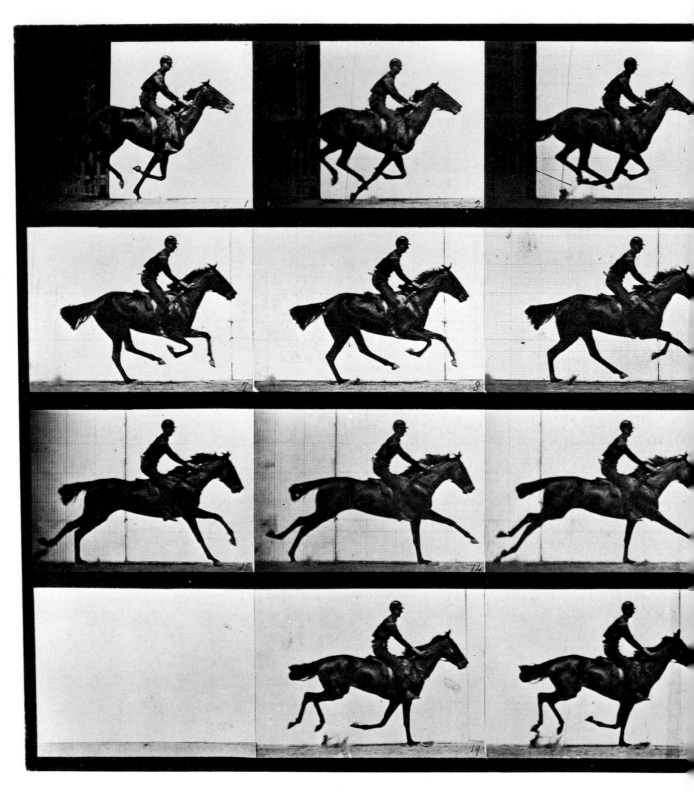

Plate 625. "Bouquet" galloping.

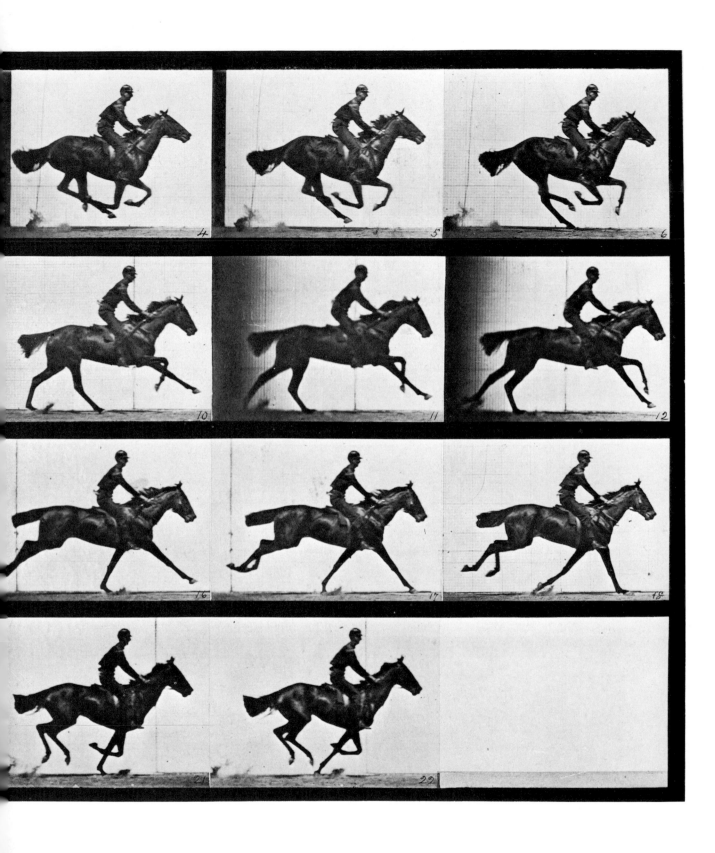

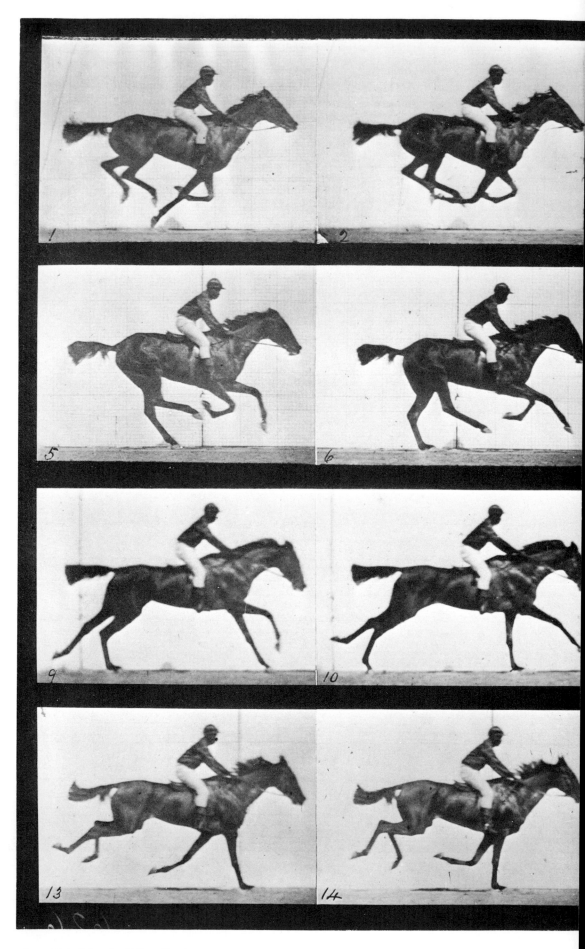

Plate 626. "Annie G." galloping.

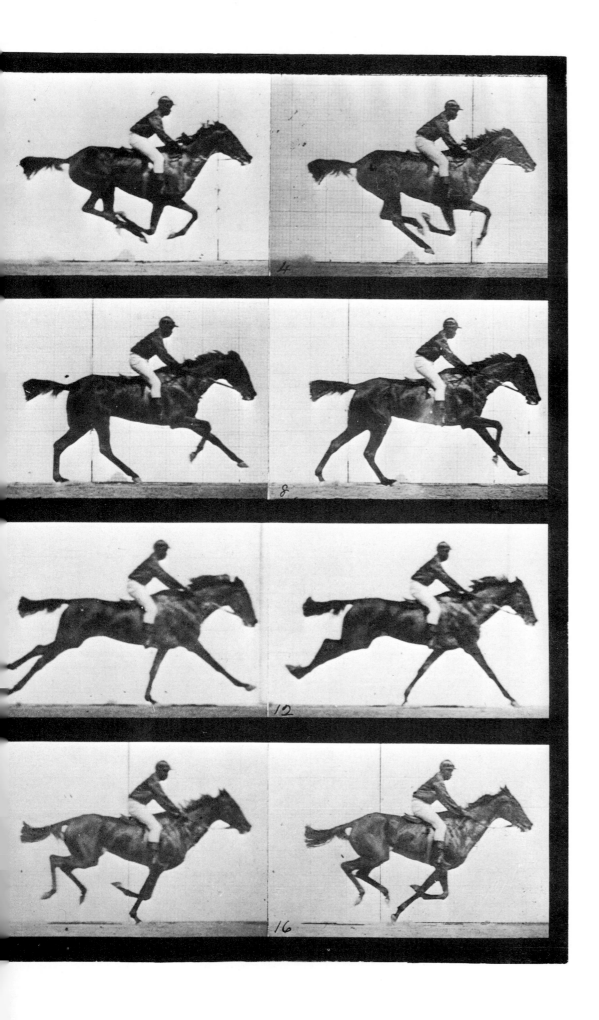

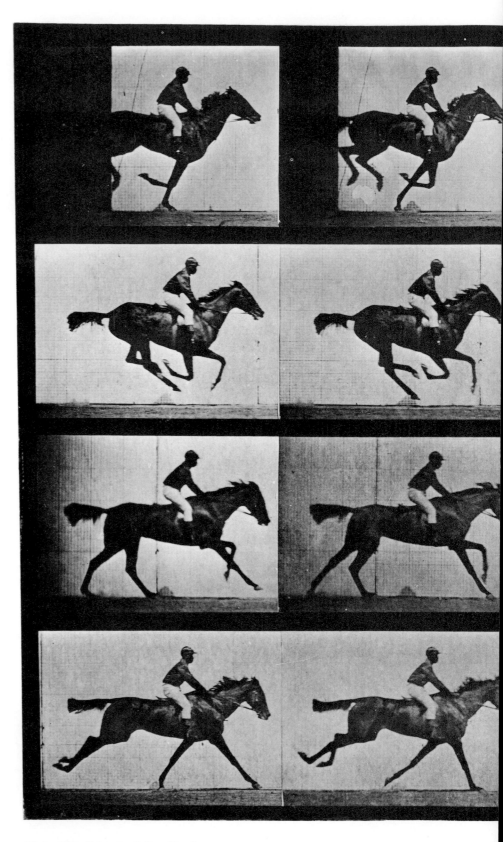

Plate 627. "Annie G." galloping.

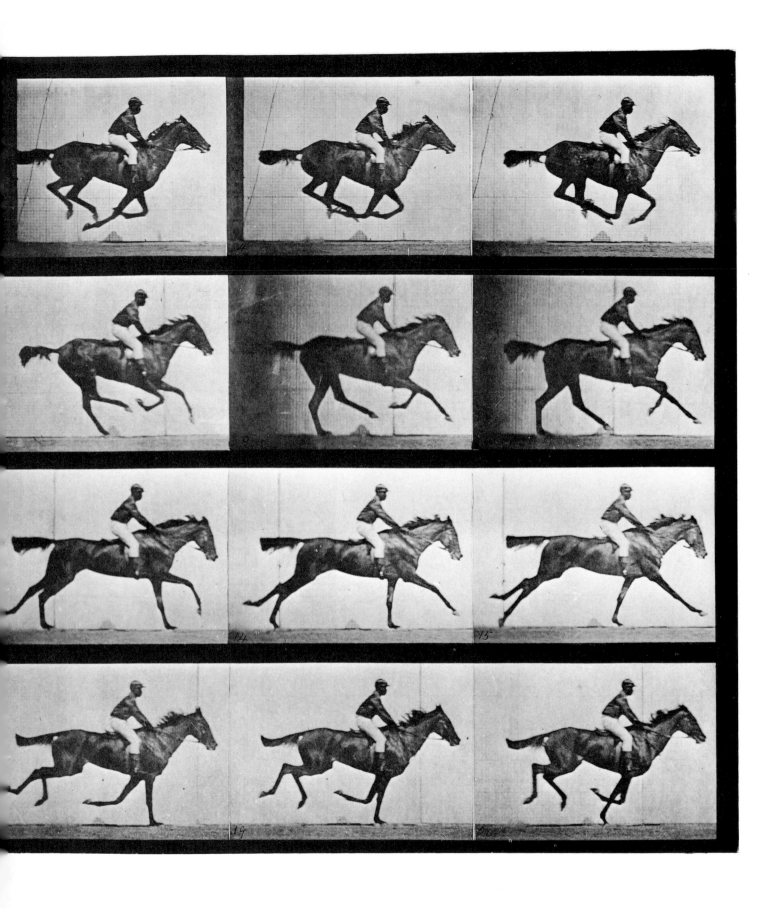

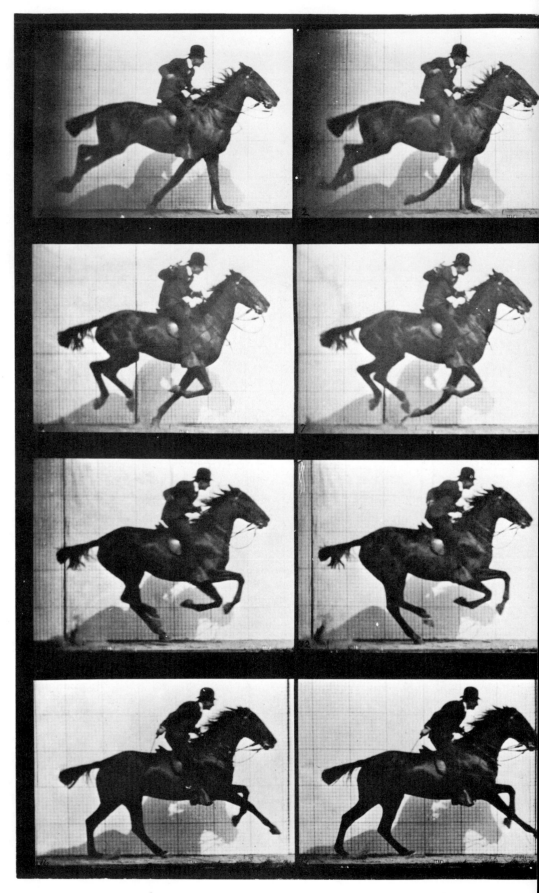

Plate 628. "Daisy" galloping.

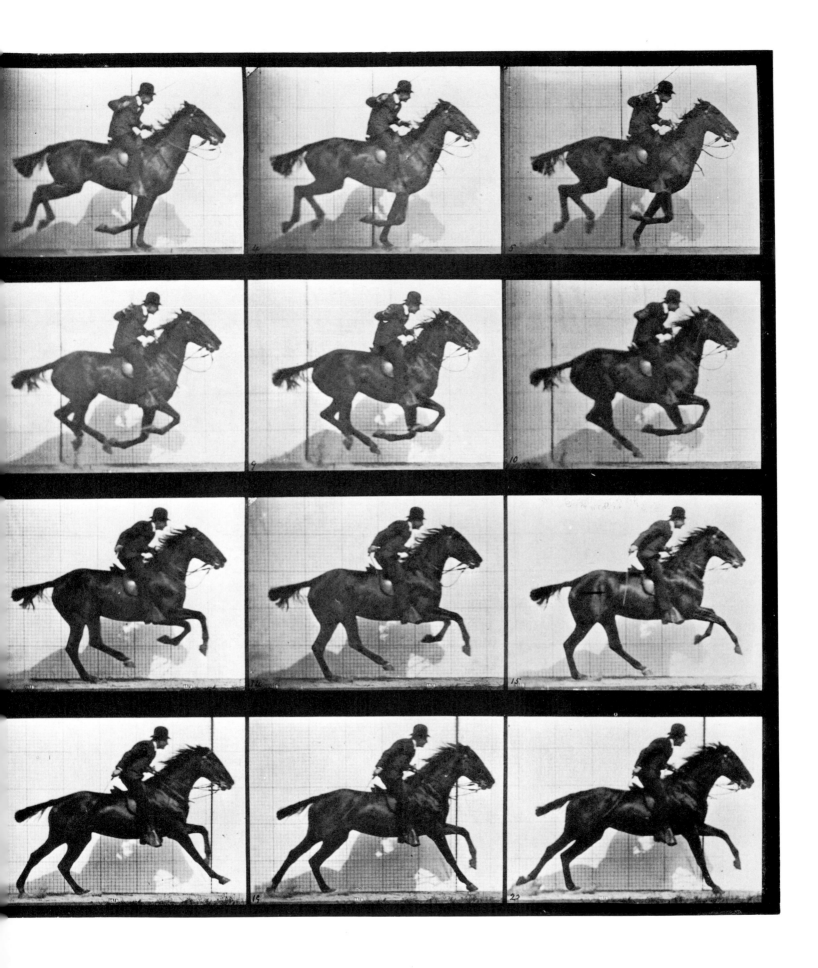

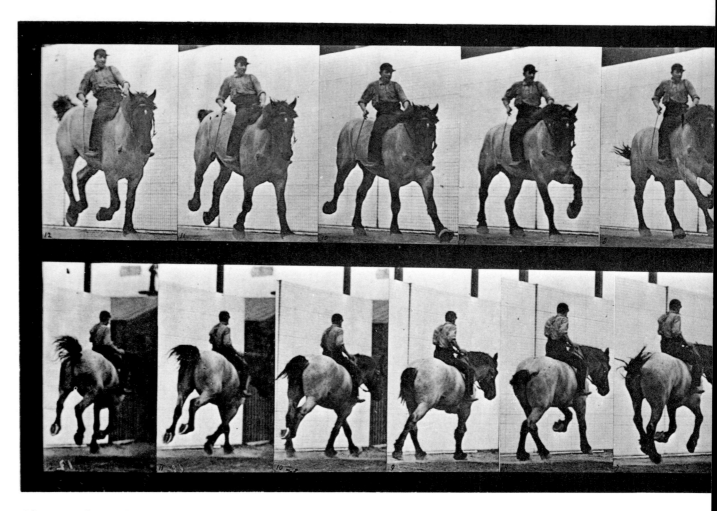

Plate 629. "Hansel" galloping, bareback.

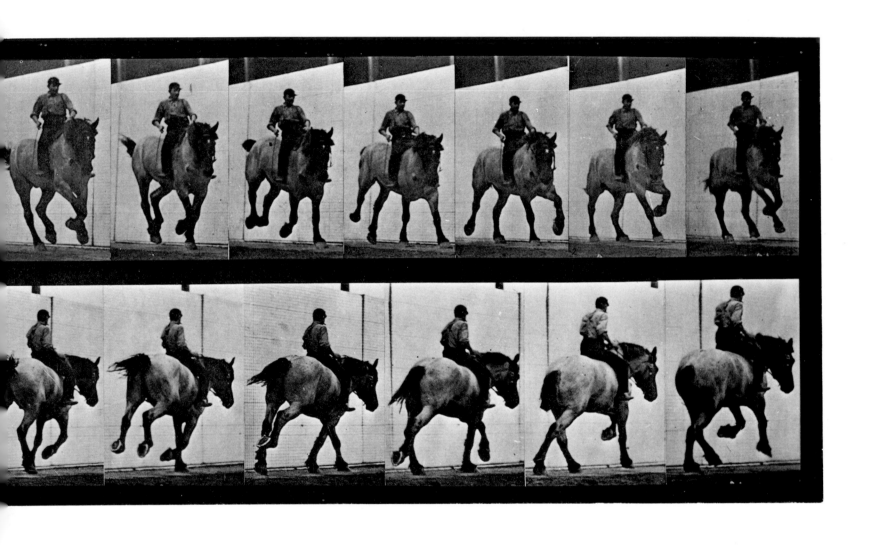

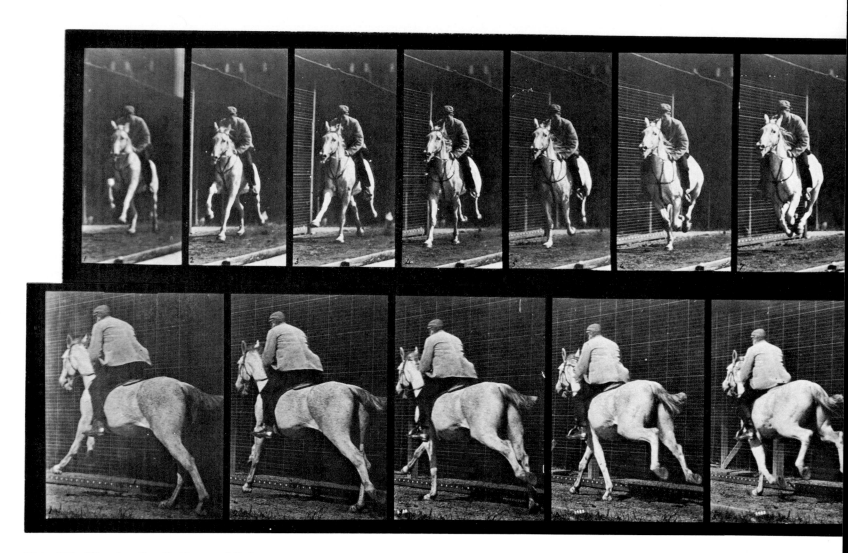

Plate 630. "Pandora" galloping, saddled.

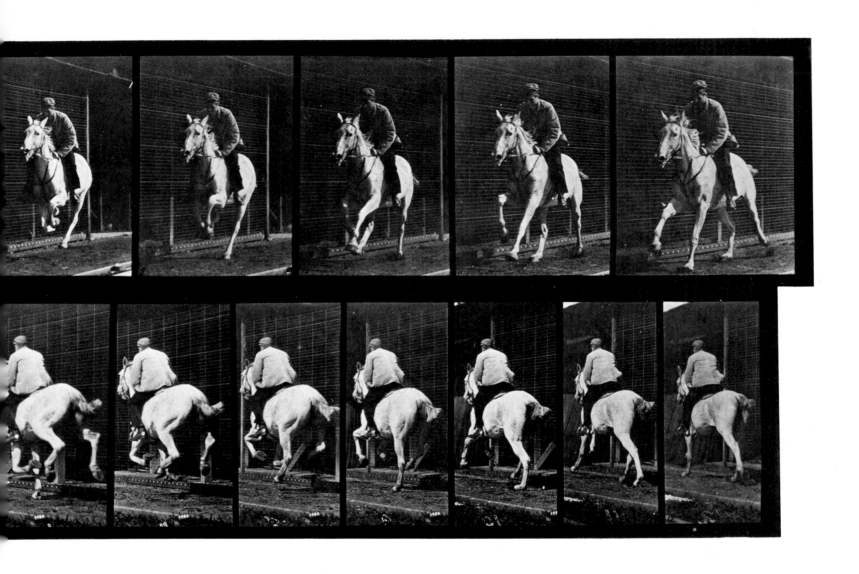

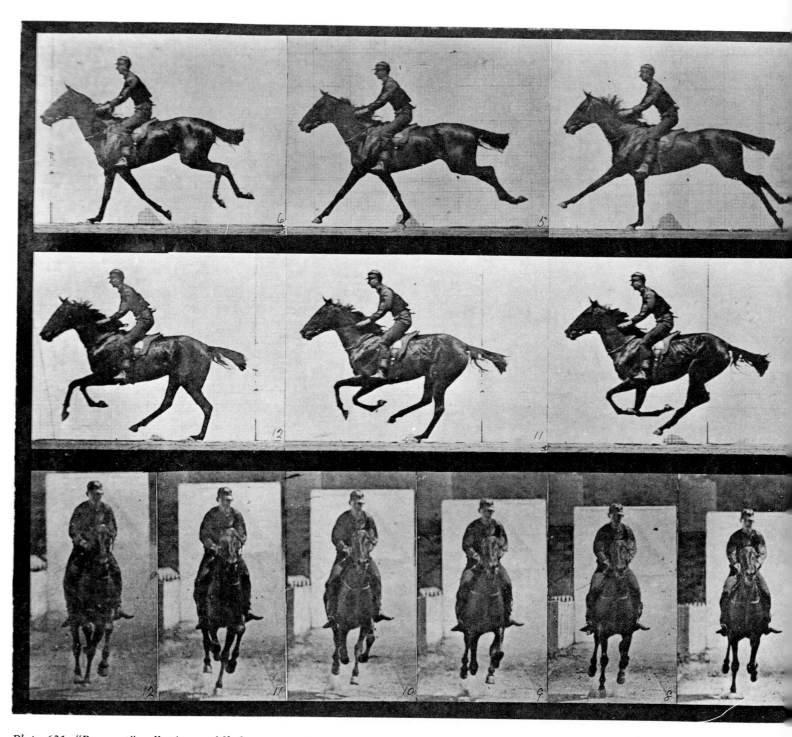

Plate 631. "Bouquet" galloping, saddled.

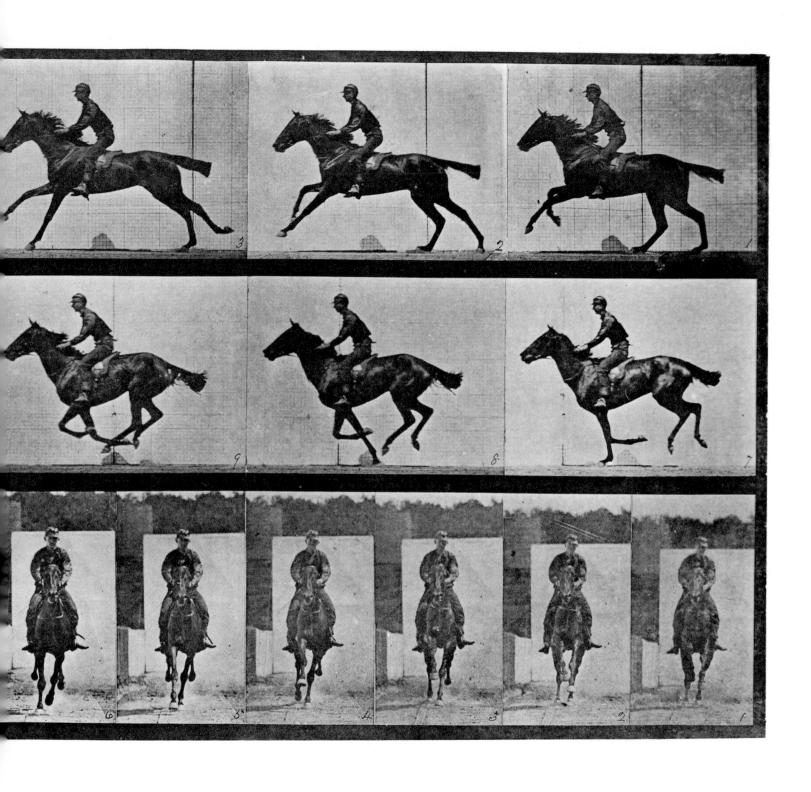

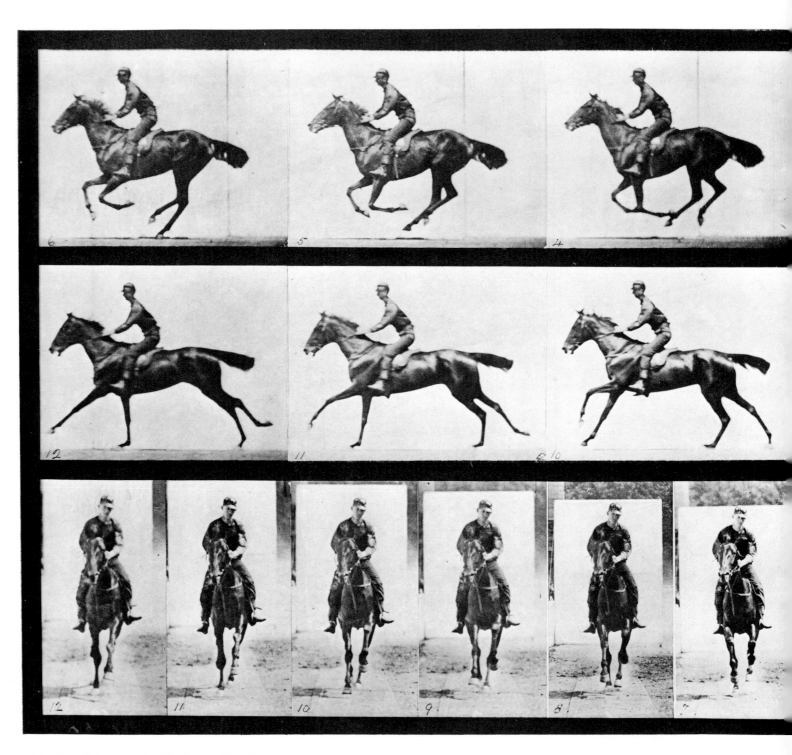

Plate 632. "Bouquet" galloping, saddled.

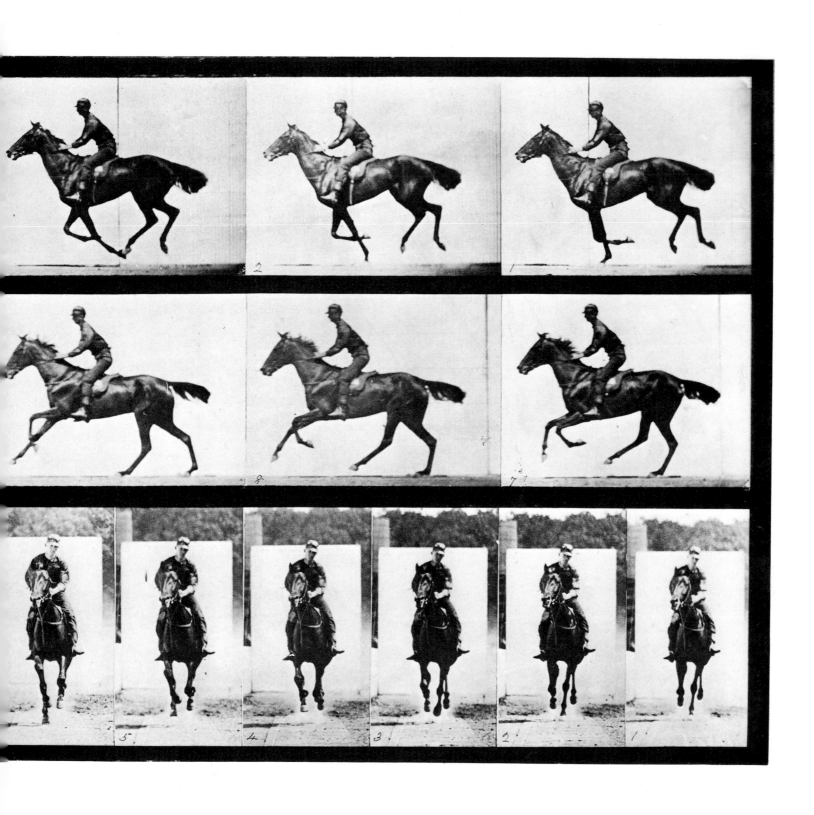

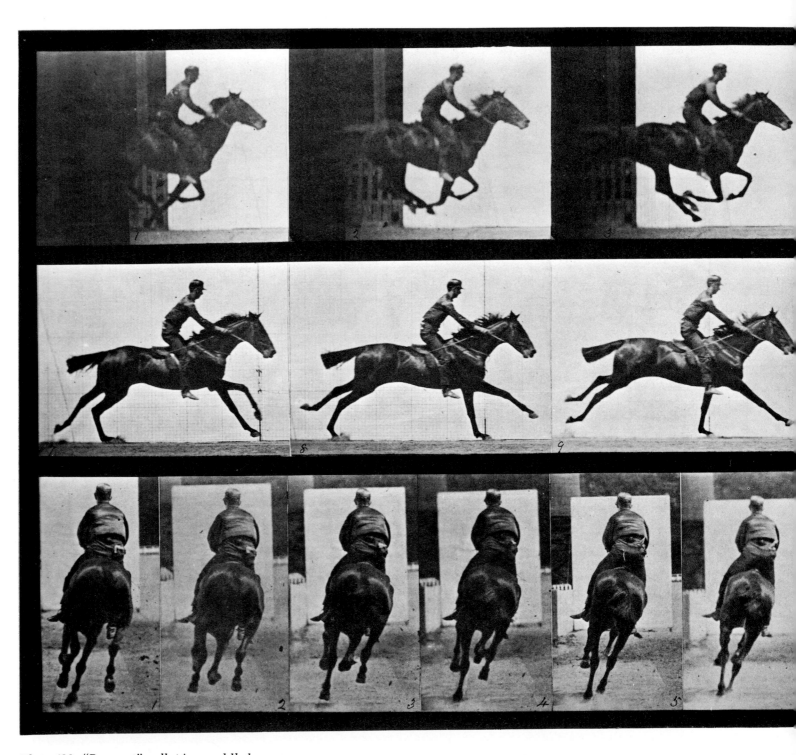

Plate 633. "Bouquet" galloping, saddled.

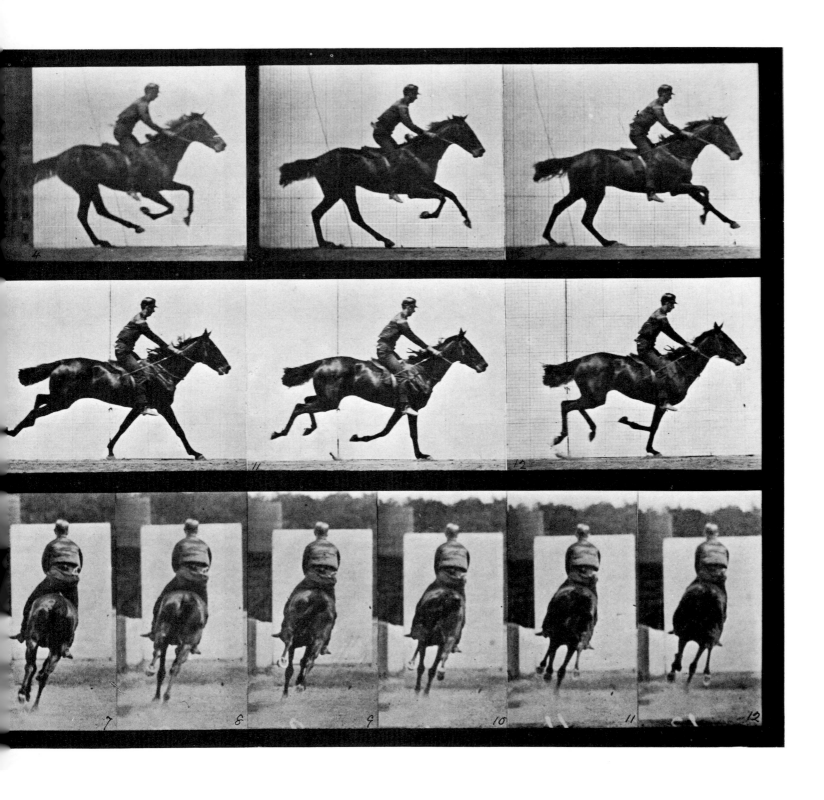

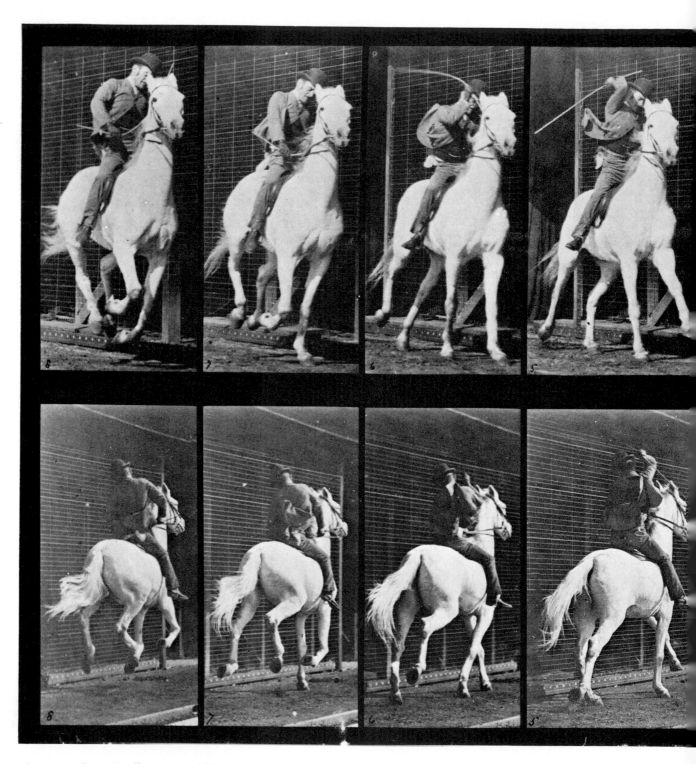

Plate 634. "Dan" galloping, saddled.

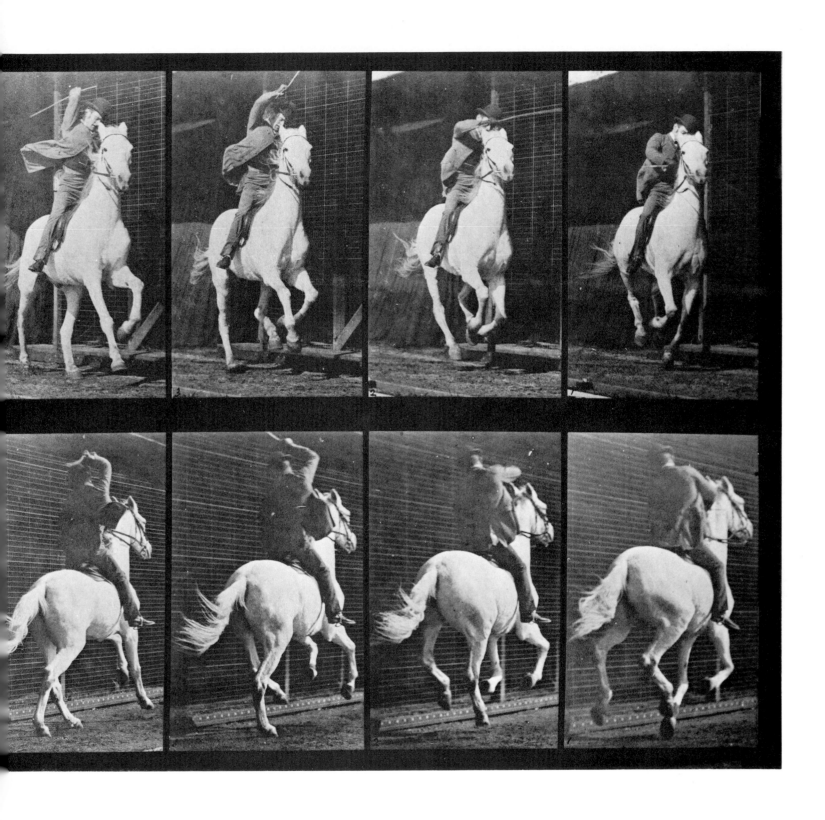

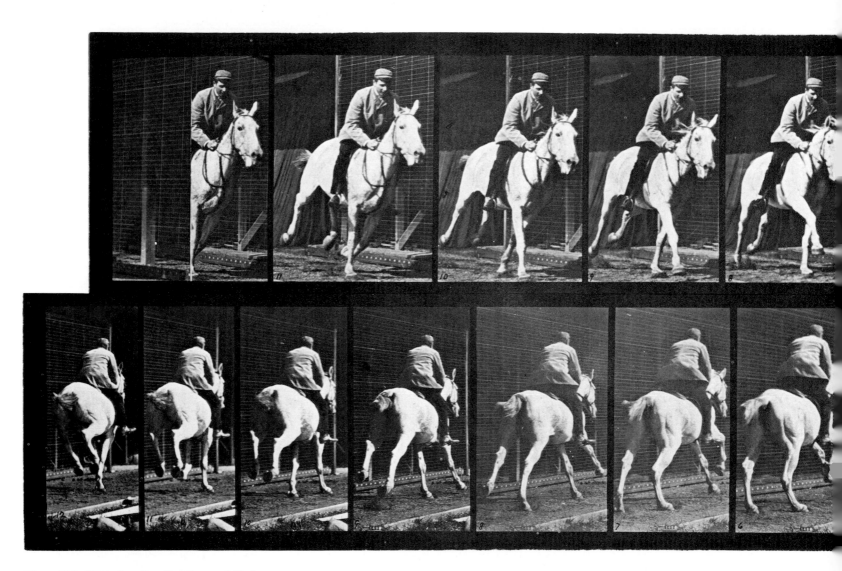

Plate 635. *"Pandora" galloping, saddled.*

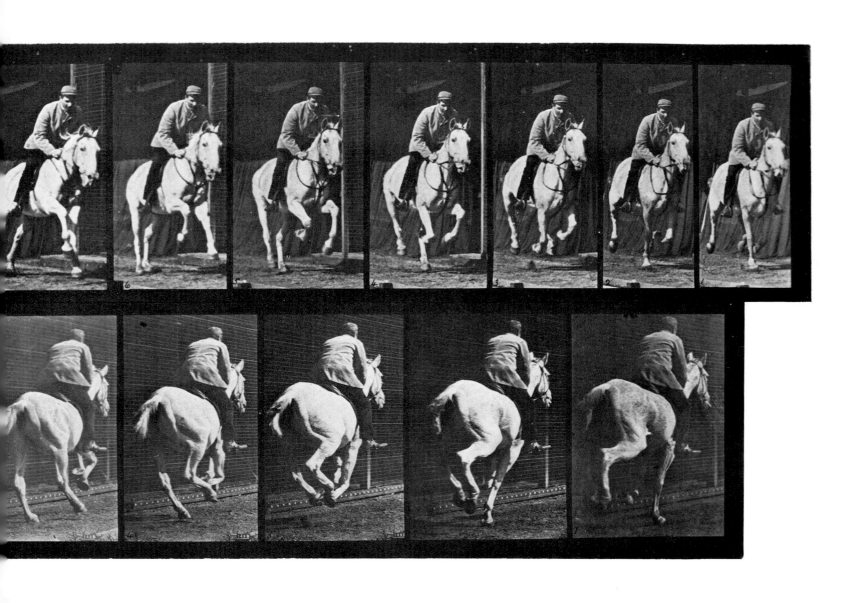

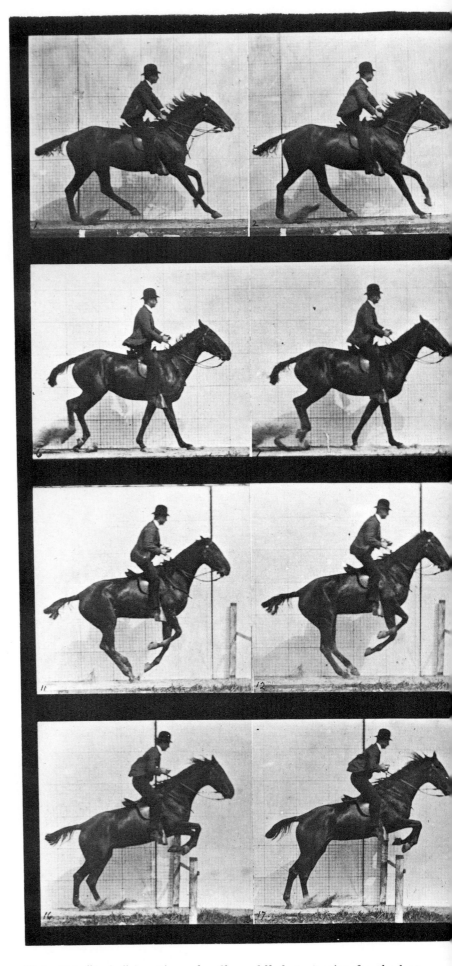

Plate 636. "Daisy" jumping a hurdle, saddled, preparing for the leap.

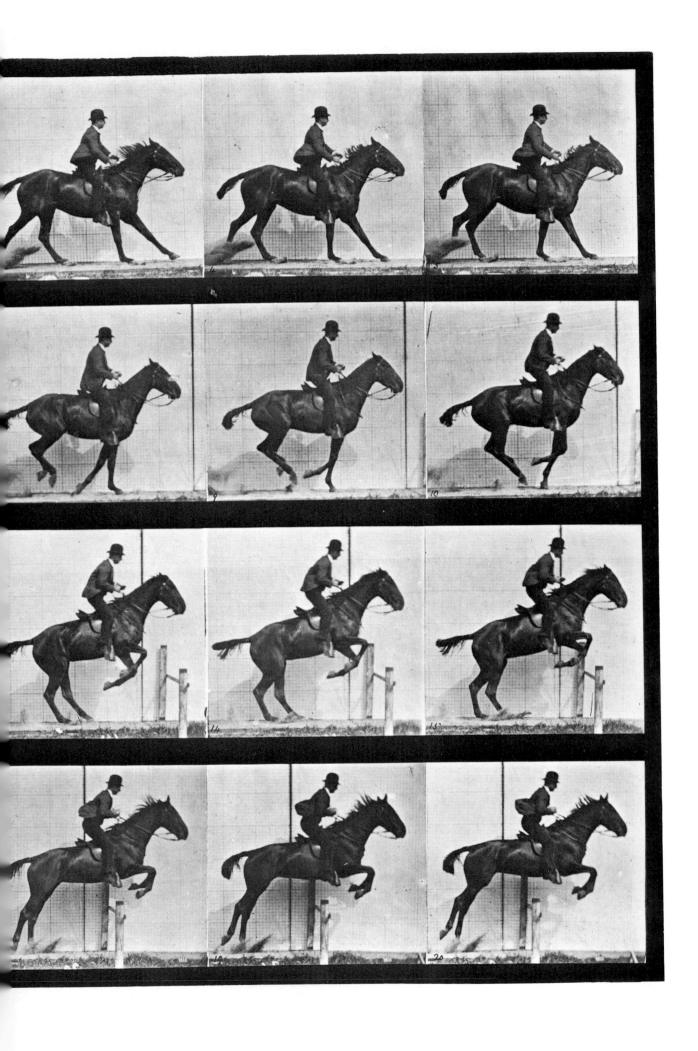

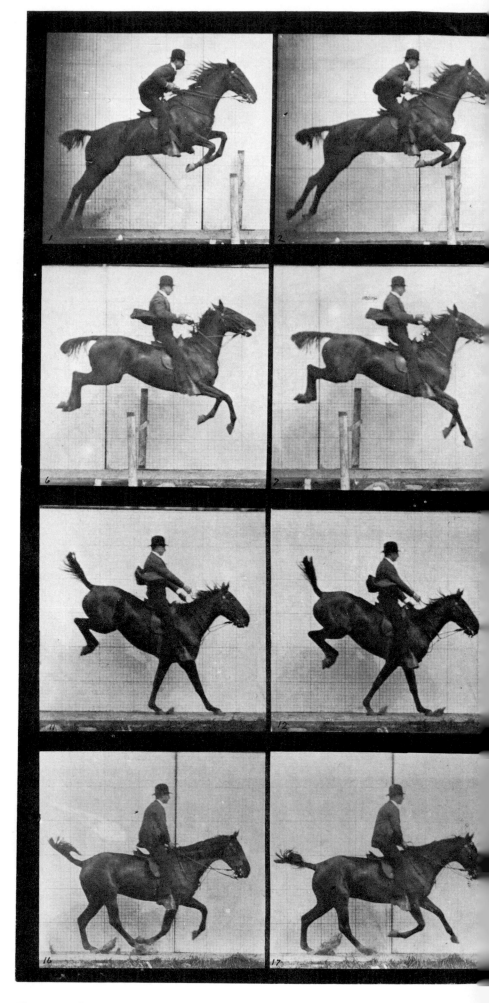

Plate 637. "Daisy" jumping a hurdle, saddled, clearing, landing and recovering.

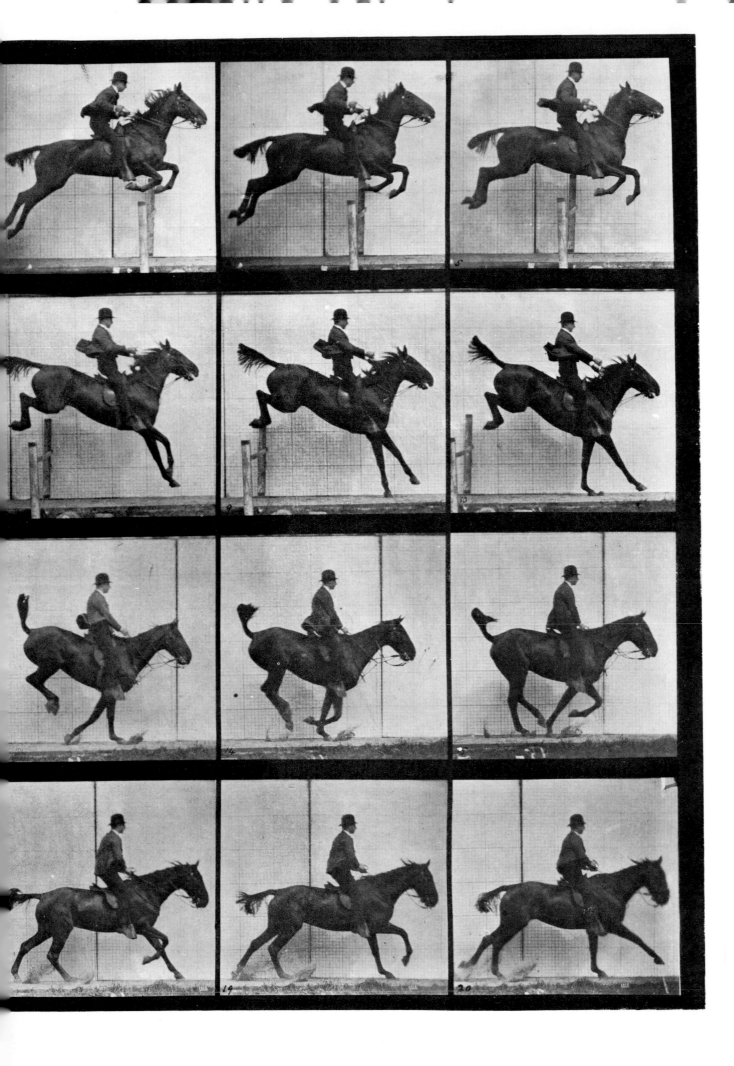

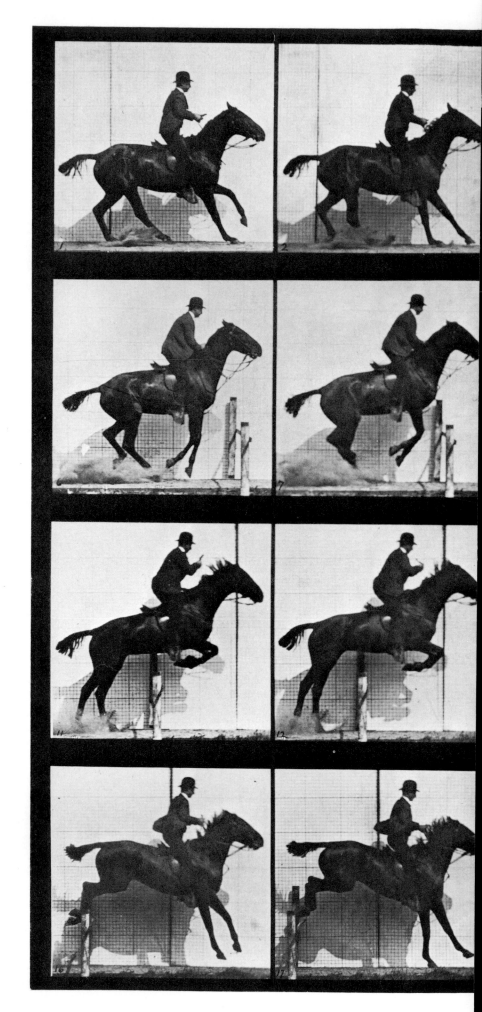

Plate 638. "Daisy" jumping a hurdle, saddled.

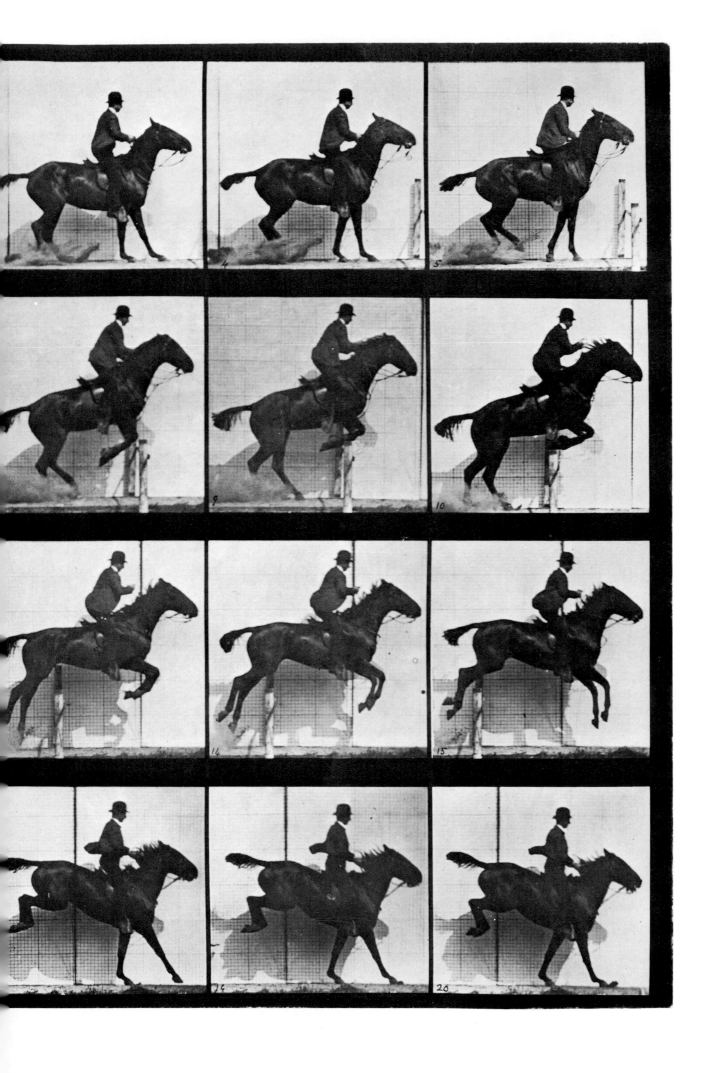

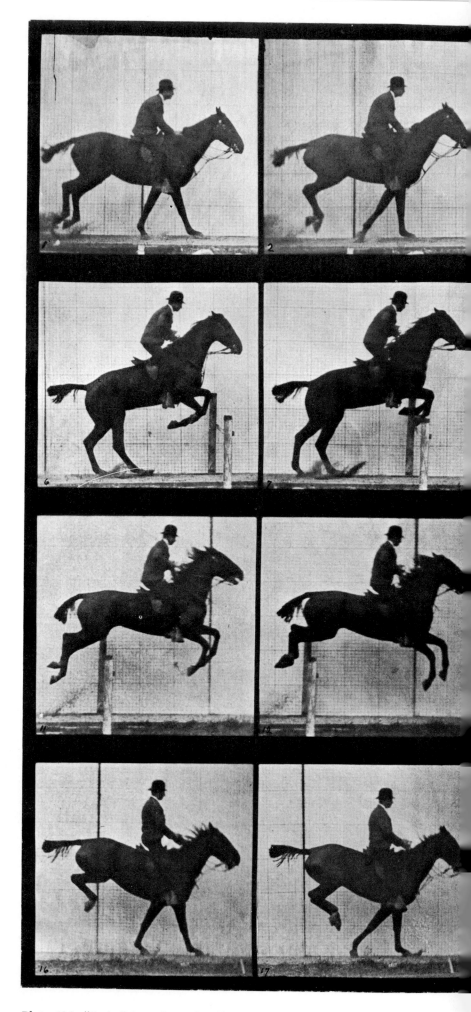

Plate 639. "Daisy" jumping a hurdle, saddled.

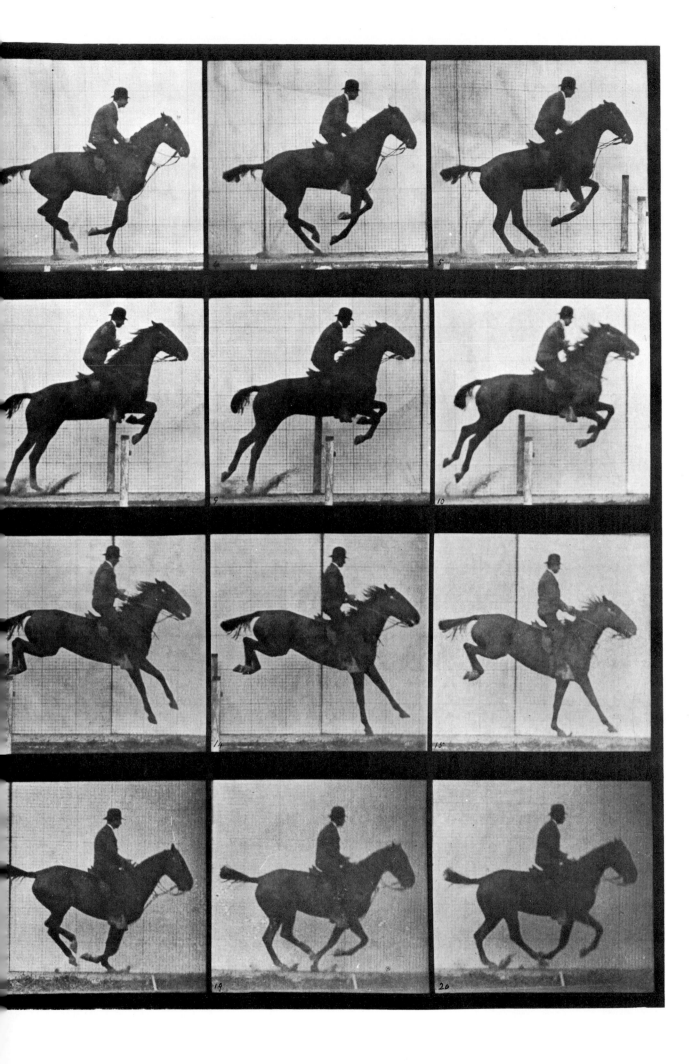

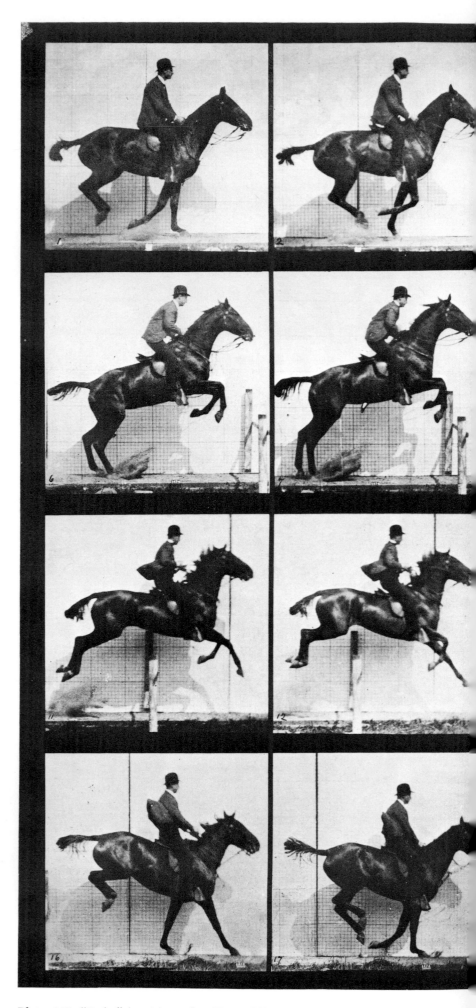

Plate 640. "Daisy" jumping a hurdle, saddled.

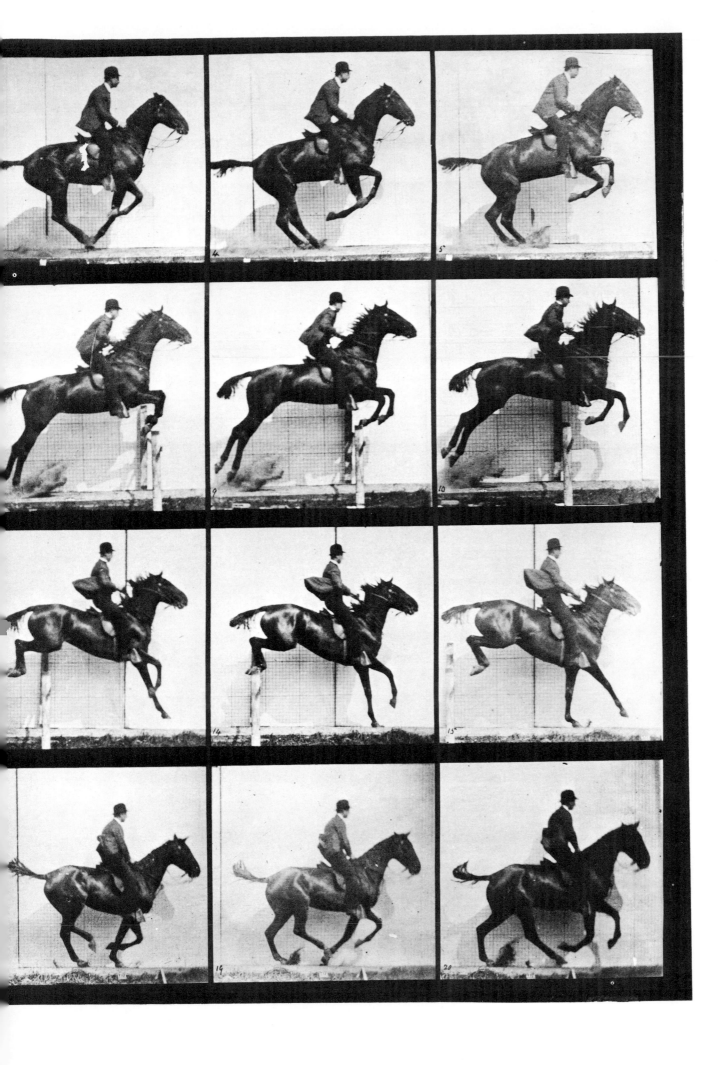

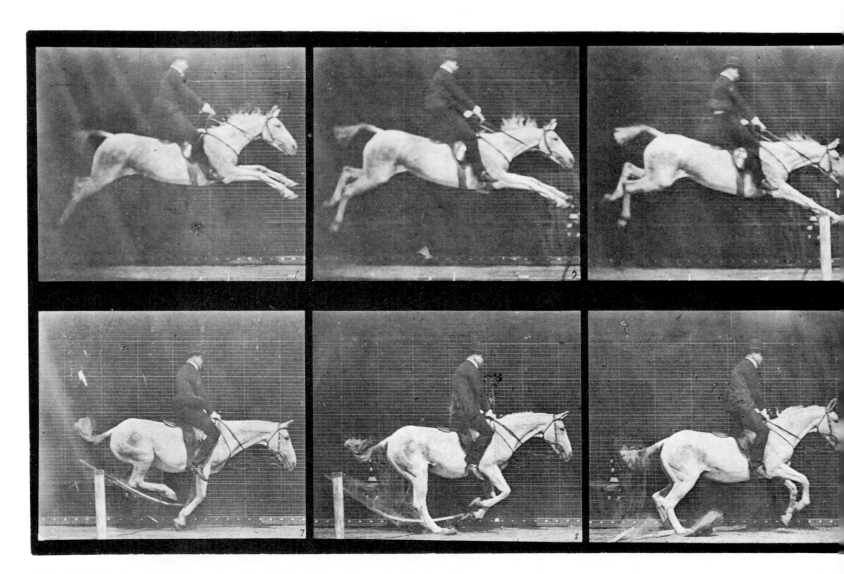

Plate 641. "Pandora" jumping a hurdle, saddled, knocking over the hurdle and landing.

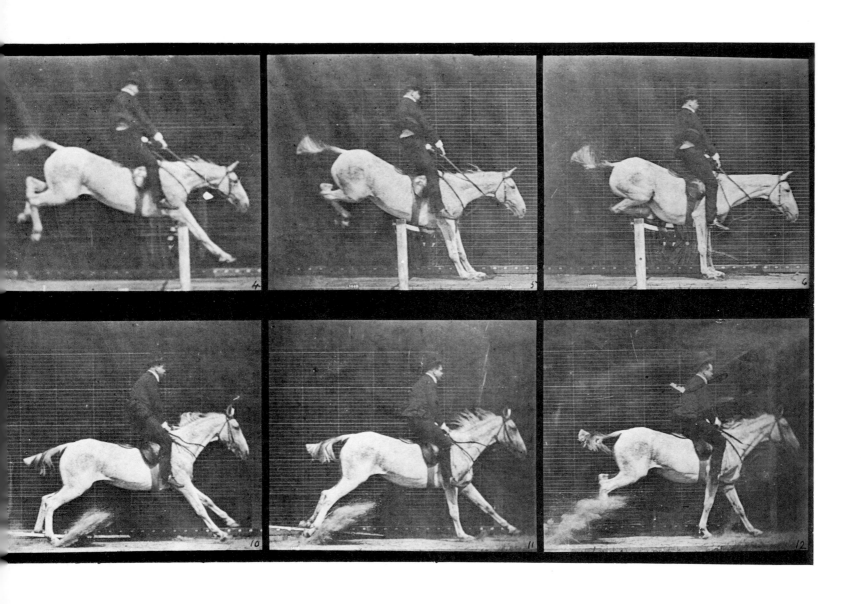

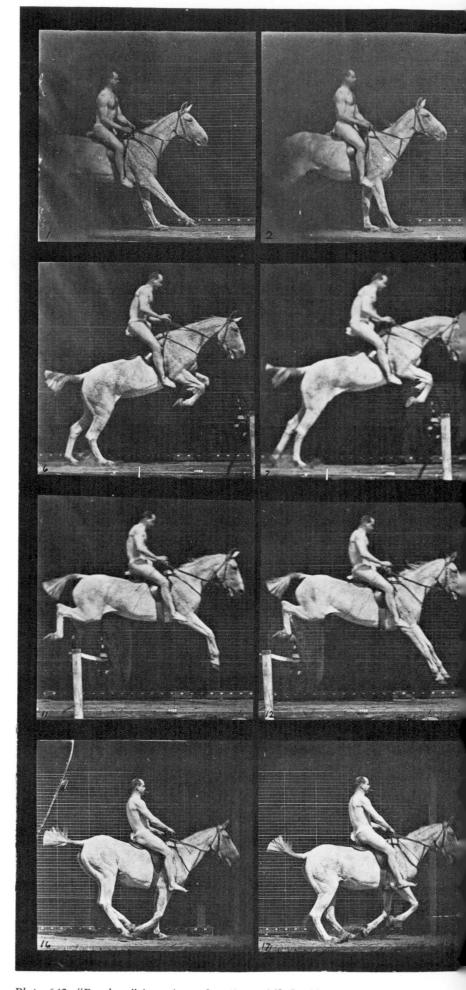

Plate 642. "Pandora" jumping a hurdle, saddled; rider nude.

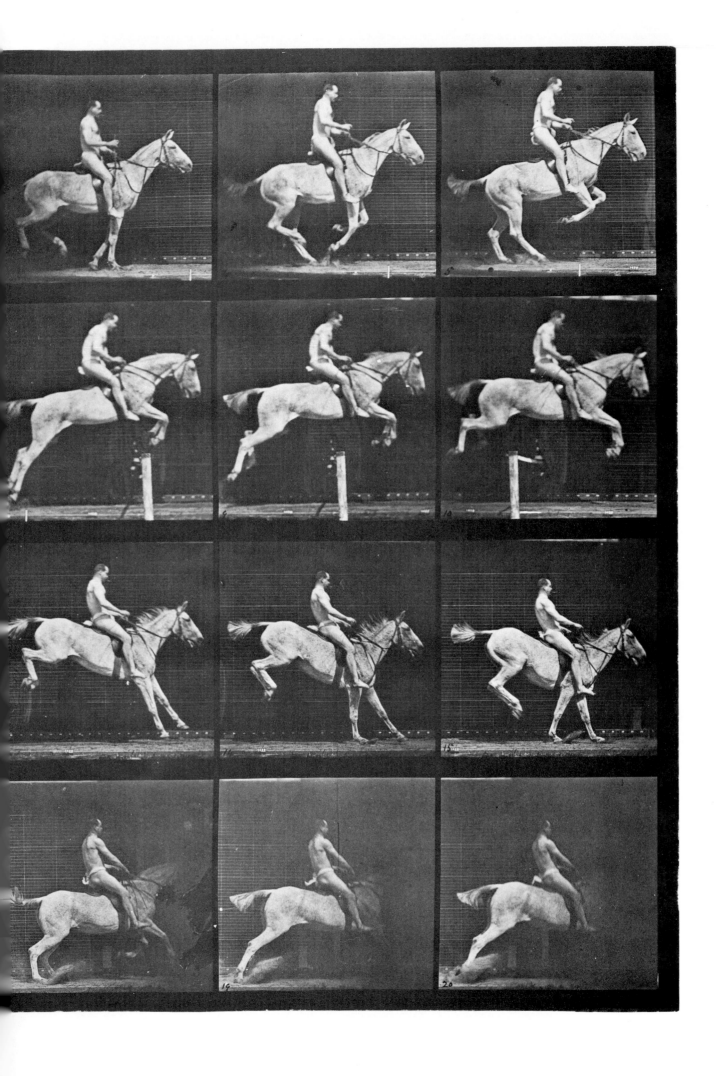

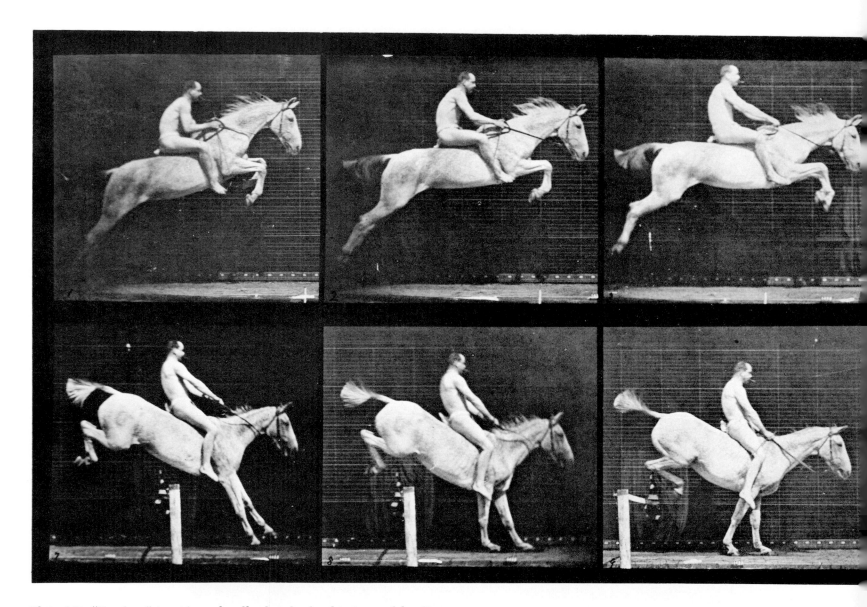

Plate 643. "Pandora" jumping a hurdle, bareback, clearing and landing; rider nude.

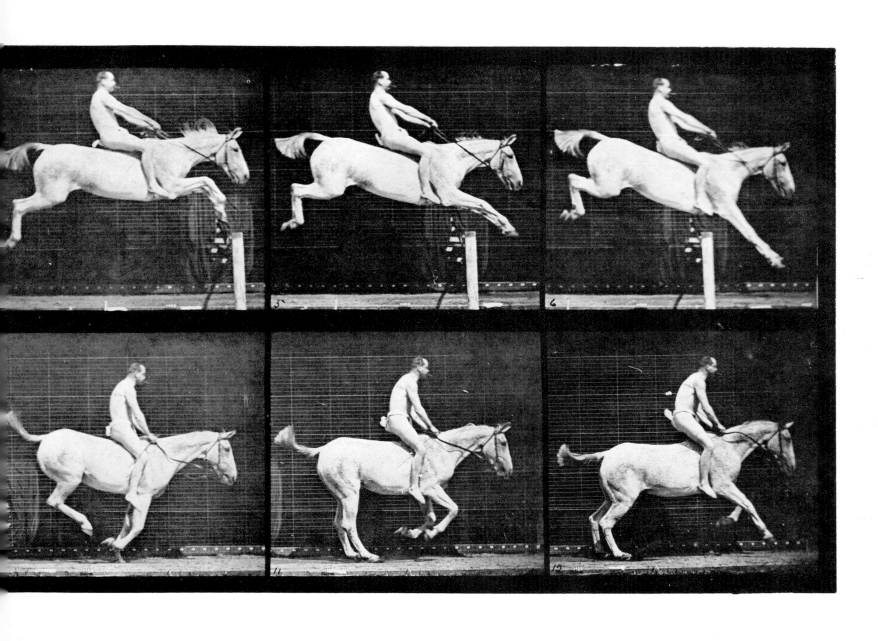

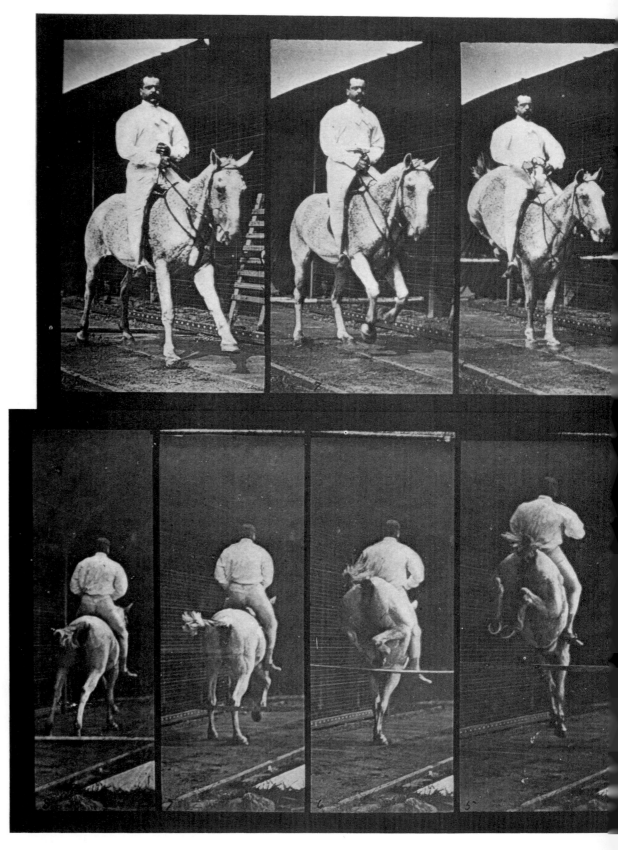

Plate 644. "Pandora" jumping a hurdle, saddled, clearing, landing and knocking over the hurdle; rider.

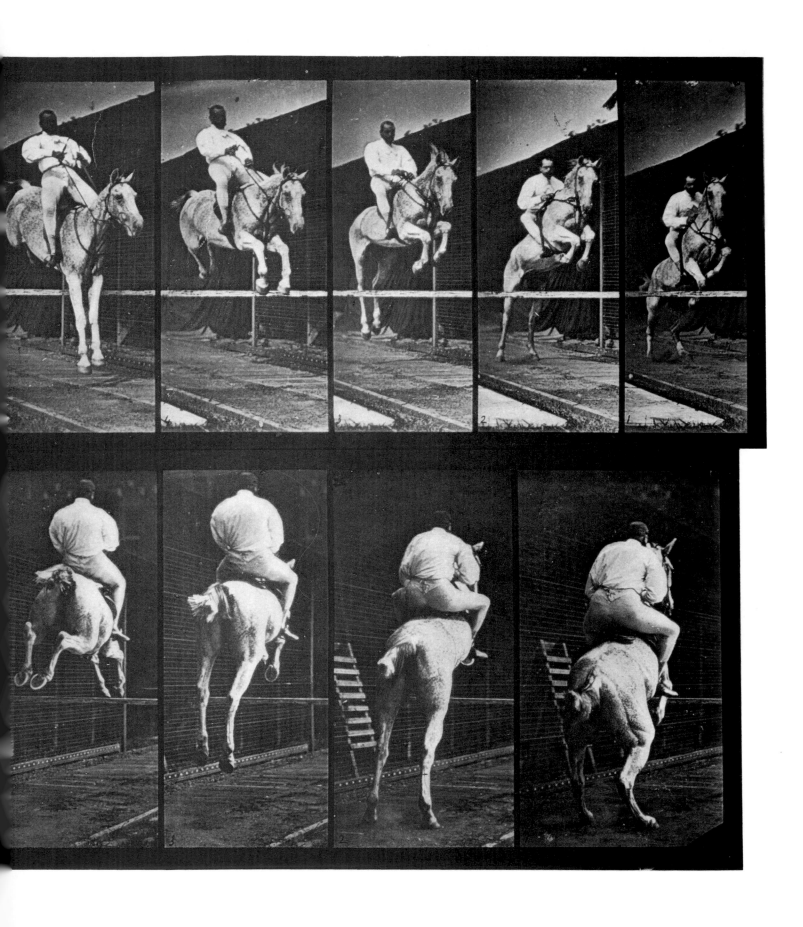

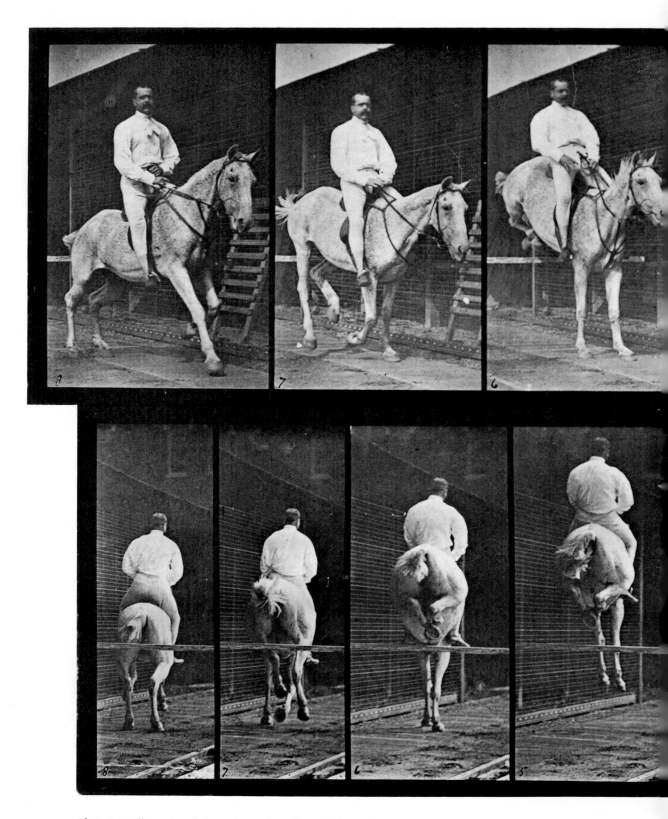

Plate 645. "Pandora" jumping a hurdle, saddled, clearing and landing.

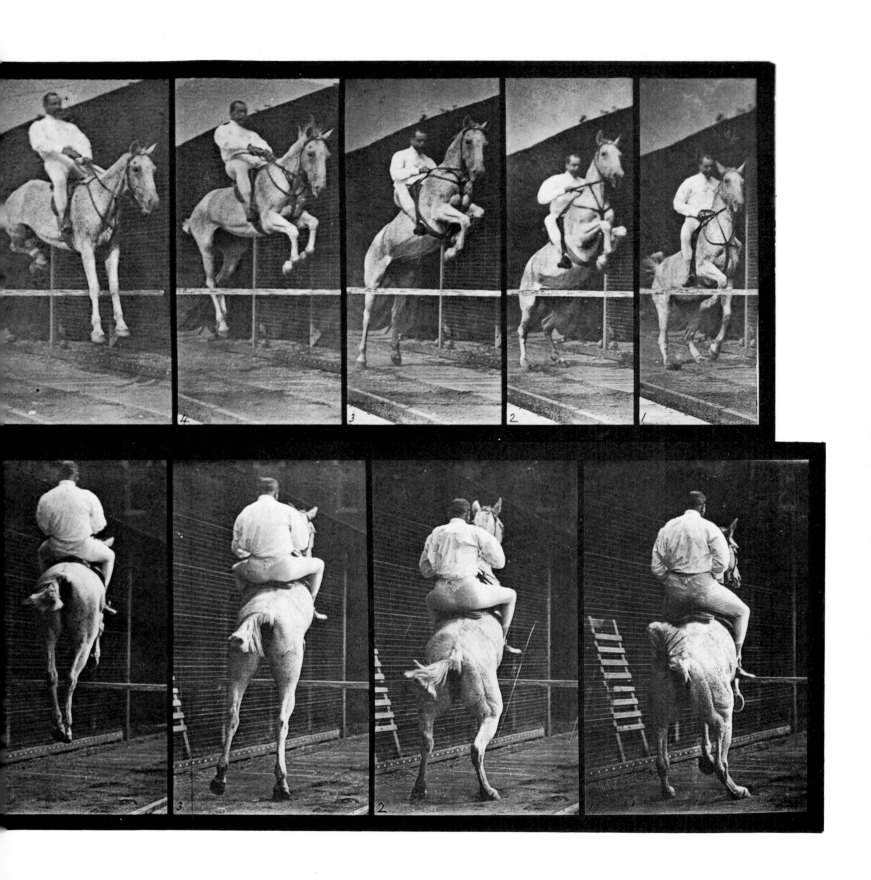

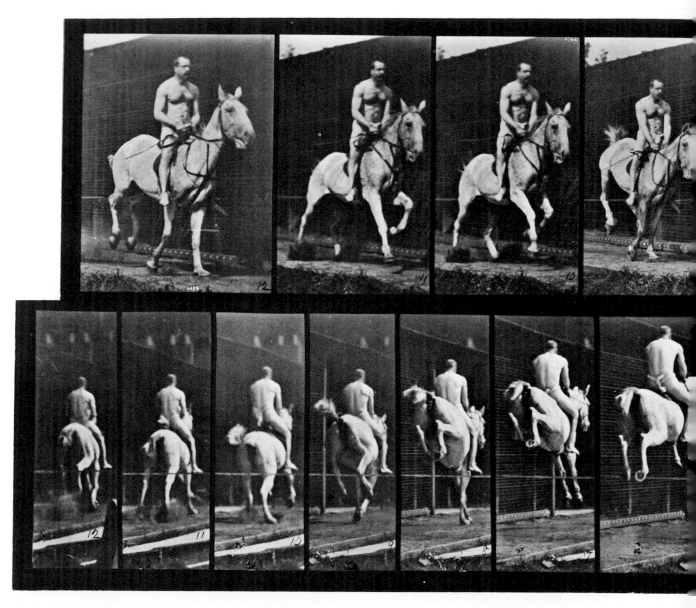

Plate 646. "Pandora" jumping a hurdle, saddled; rider nude.

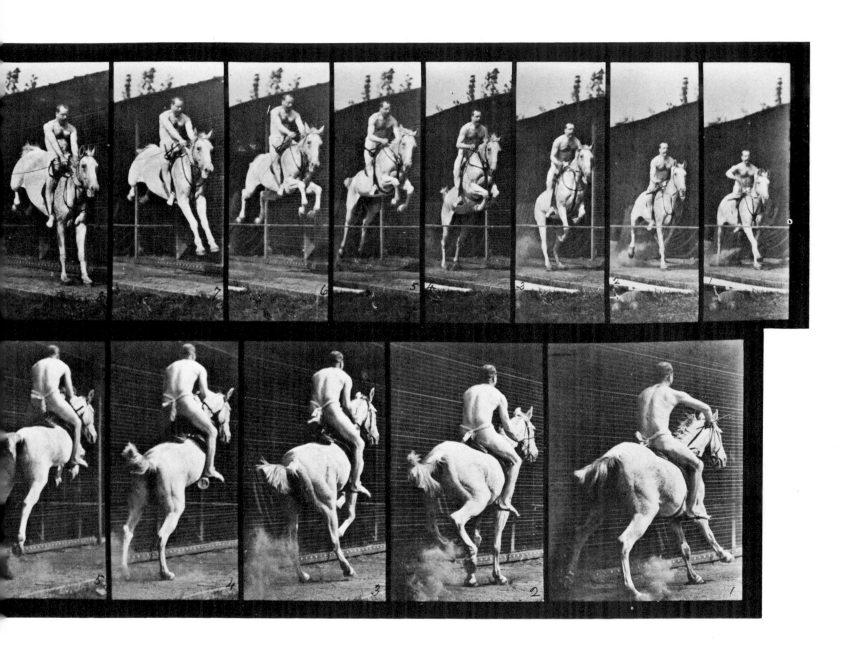

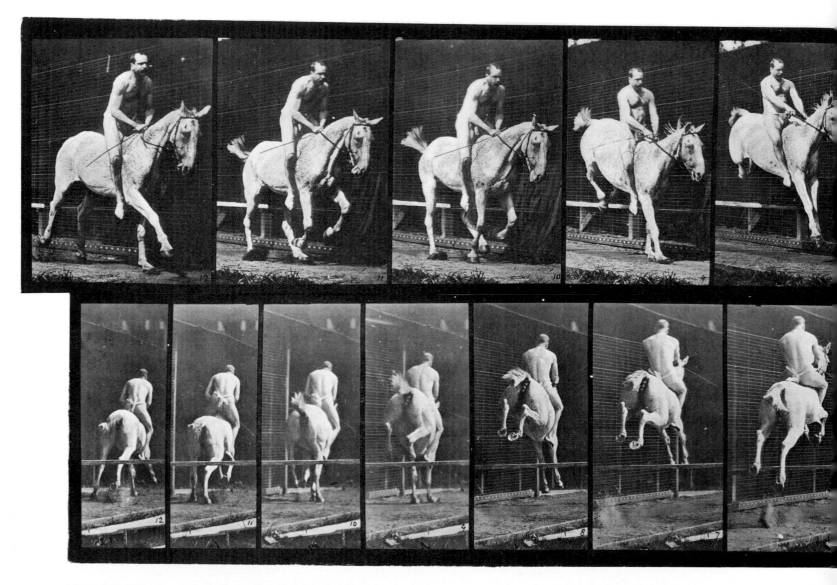

Plate 647. "Pandora" jumping a hurdle, bareback; rider nude.

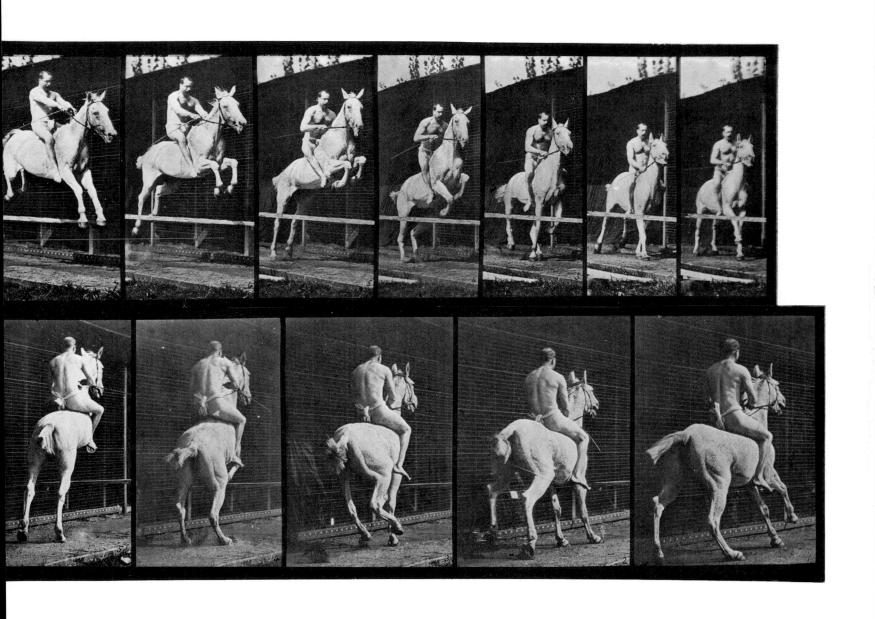

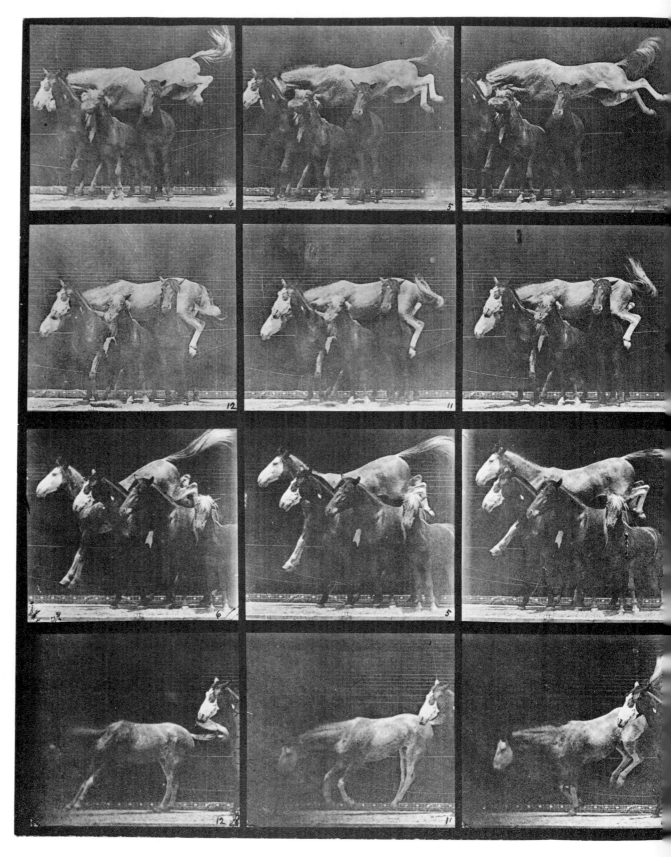

Plate 648. "Hornet" jumping over three horses.

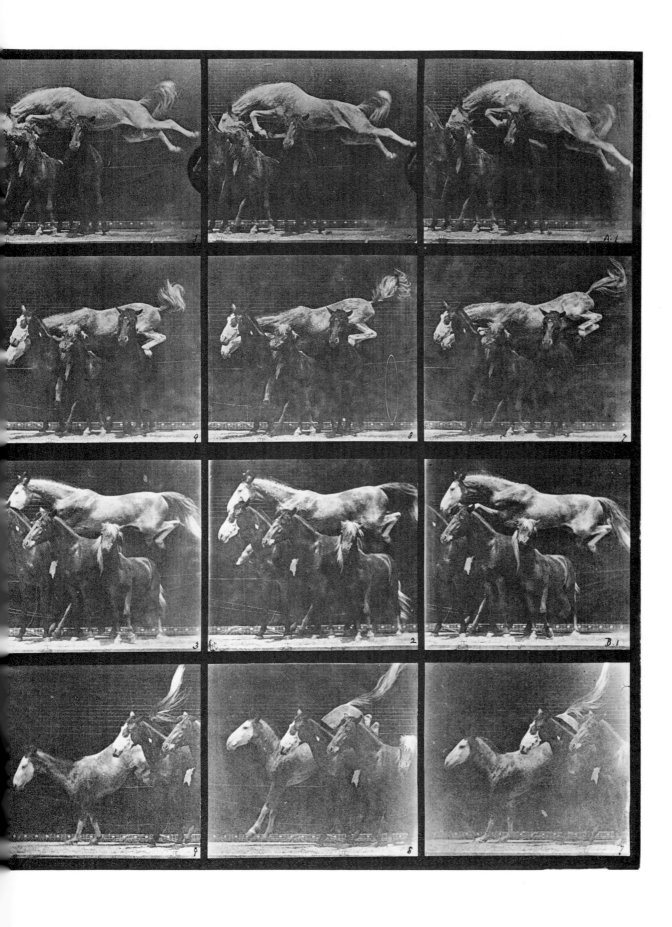

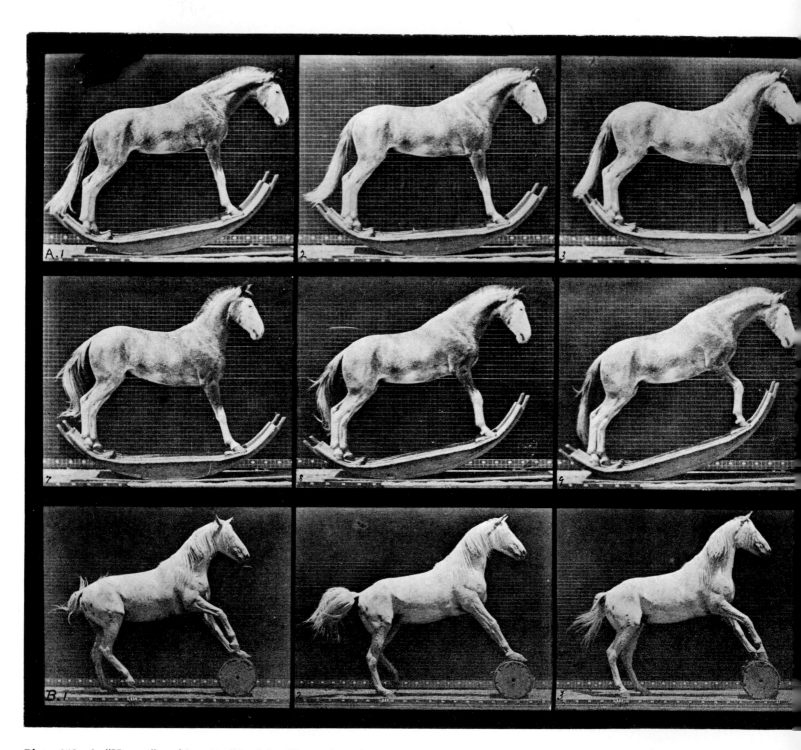

Plate 649. A: "Hornet" rocking. B: "Eagle" rolling a barrel.

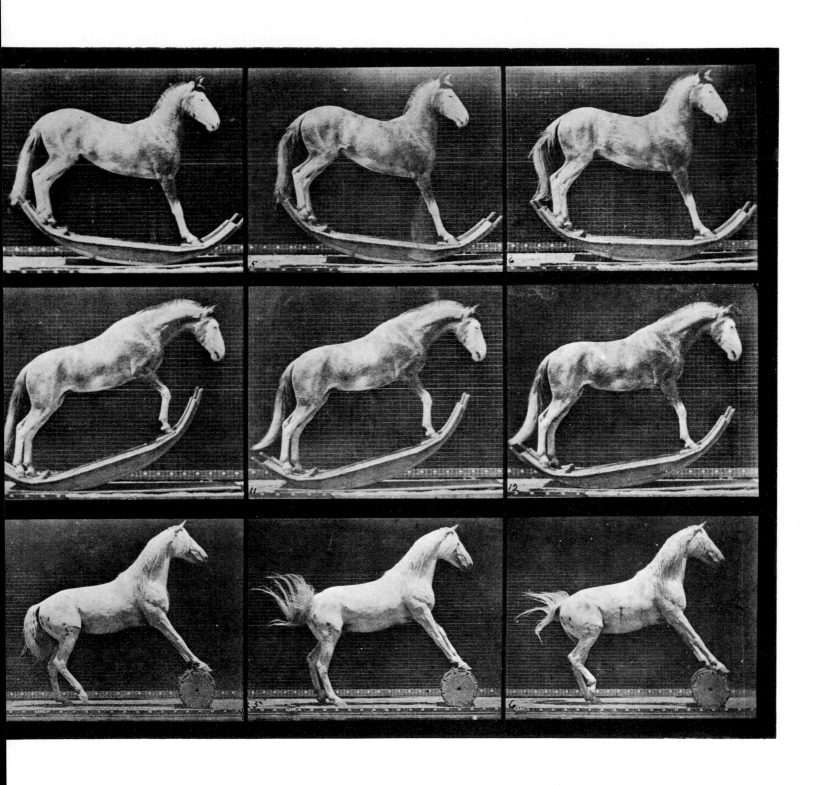

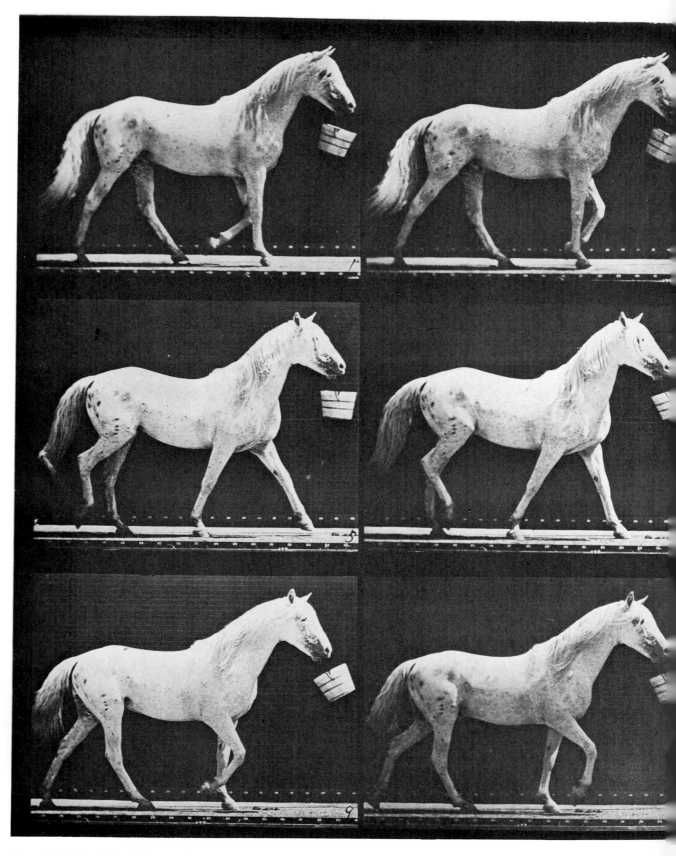

Plate 650. "Eagle" walking with a bucket in mouth.

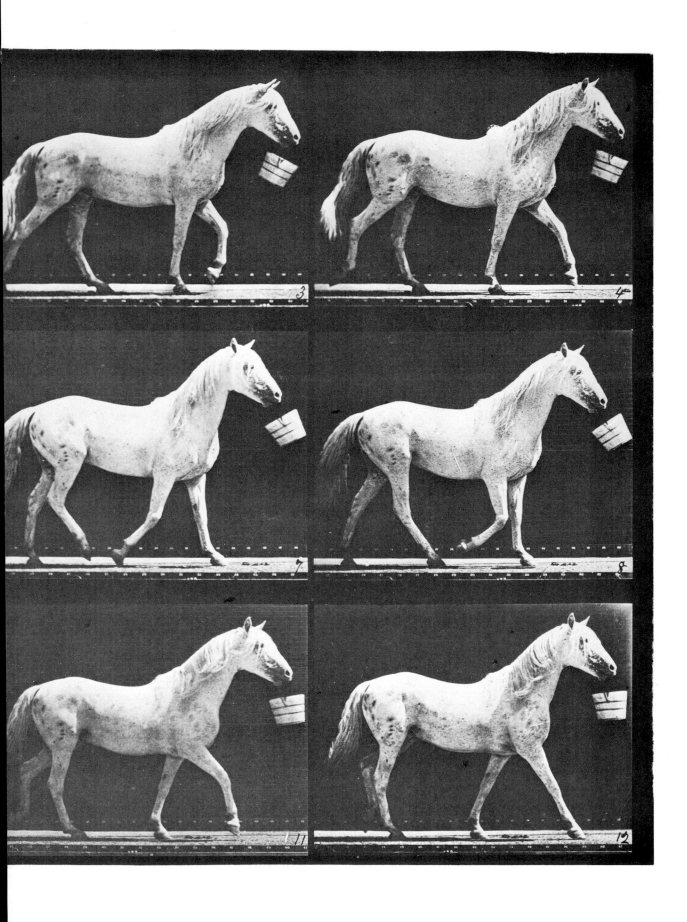

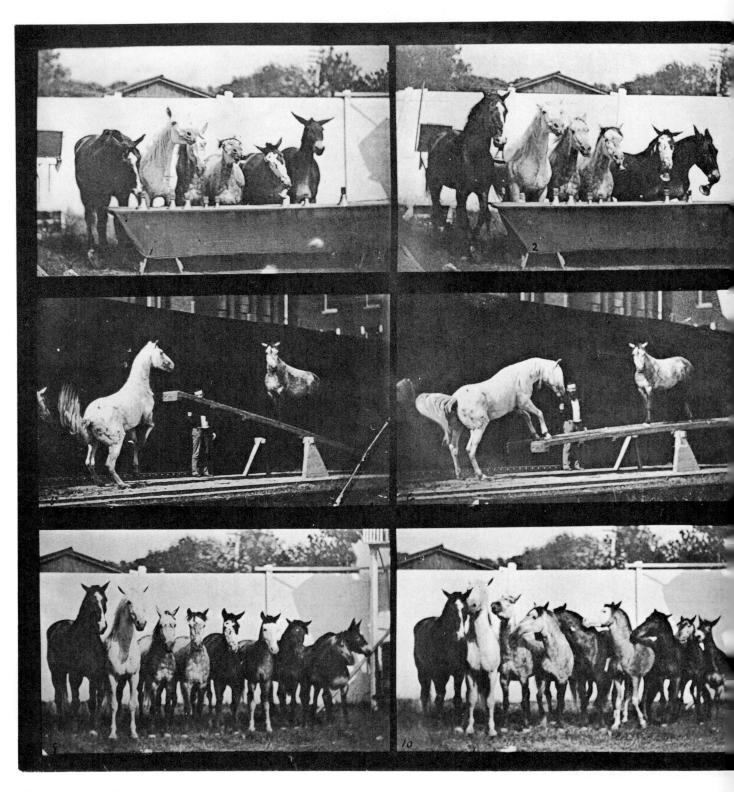

Plate 651. A: Bell ringing. B: Teeter board. C: Military drill.

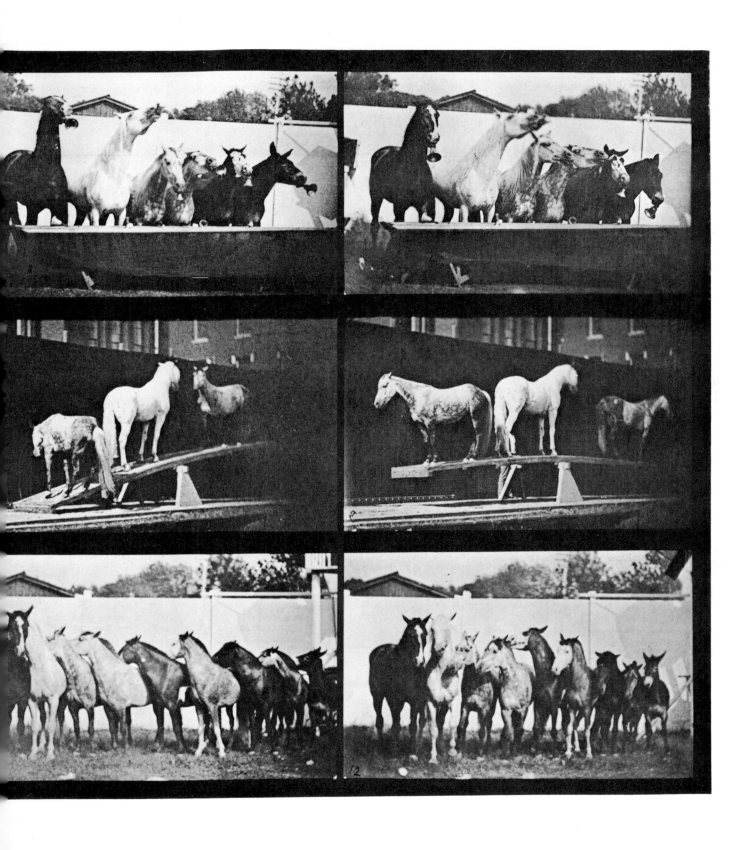

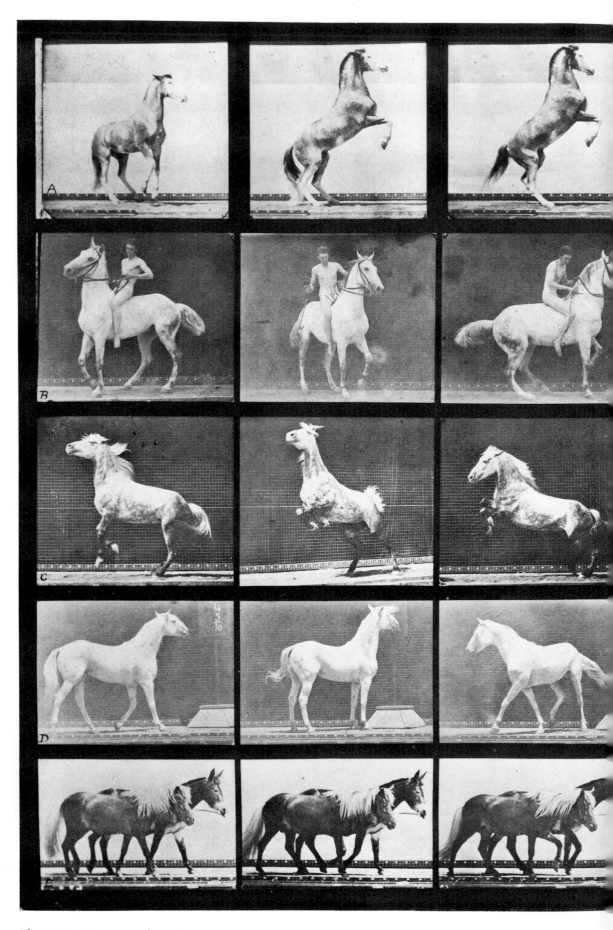

Plate 652. Horses rearing, etc.

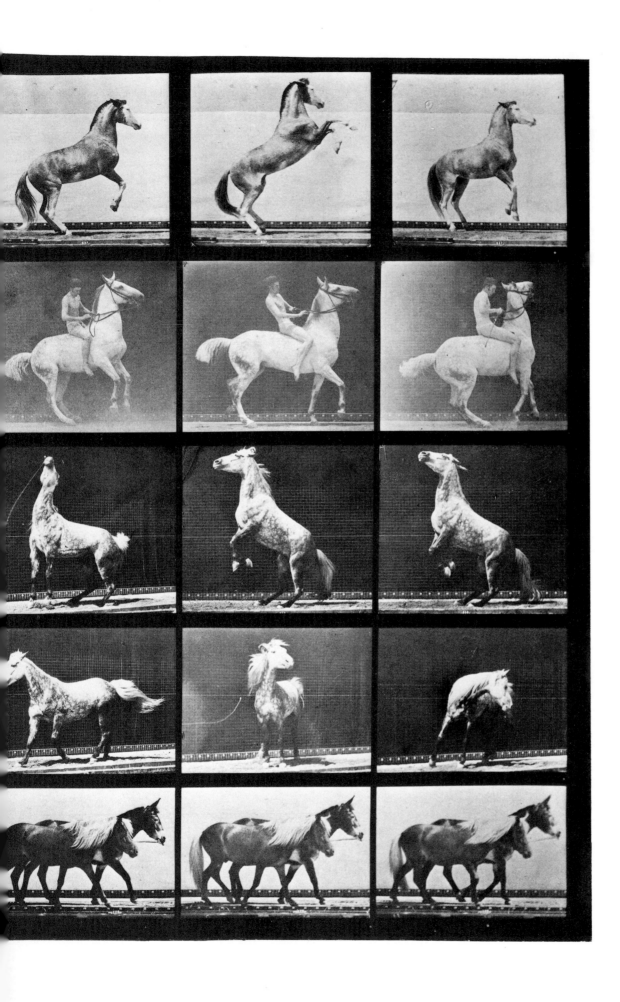

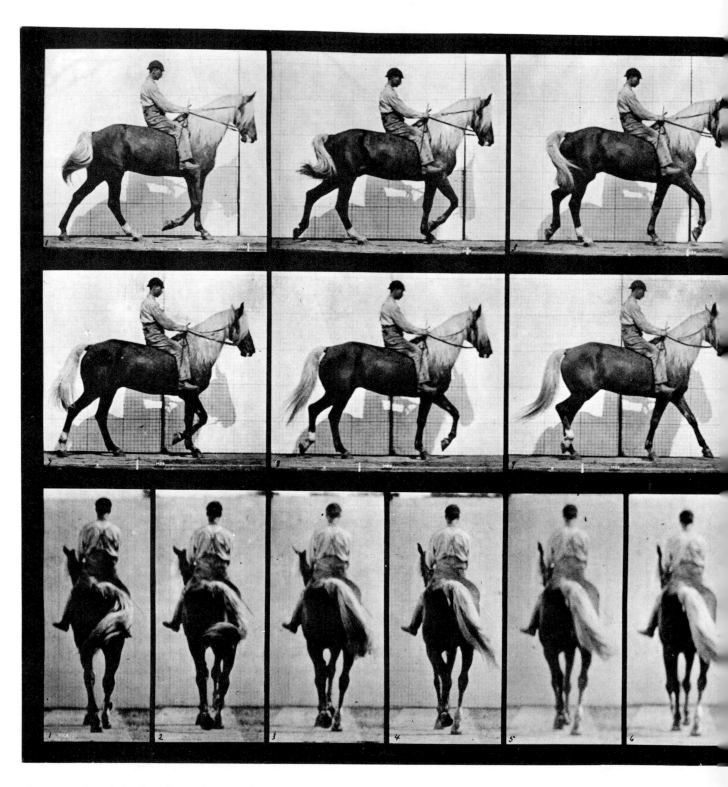

Plate 653. "Buckskin" walking, lame right front foot.

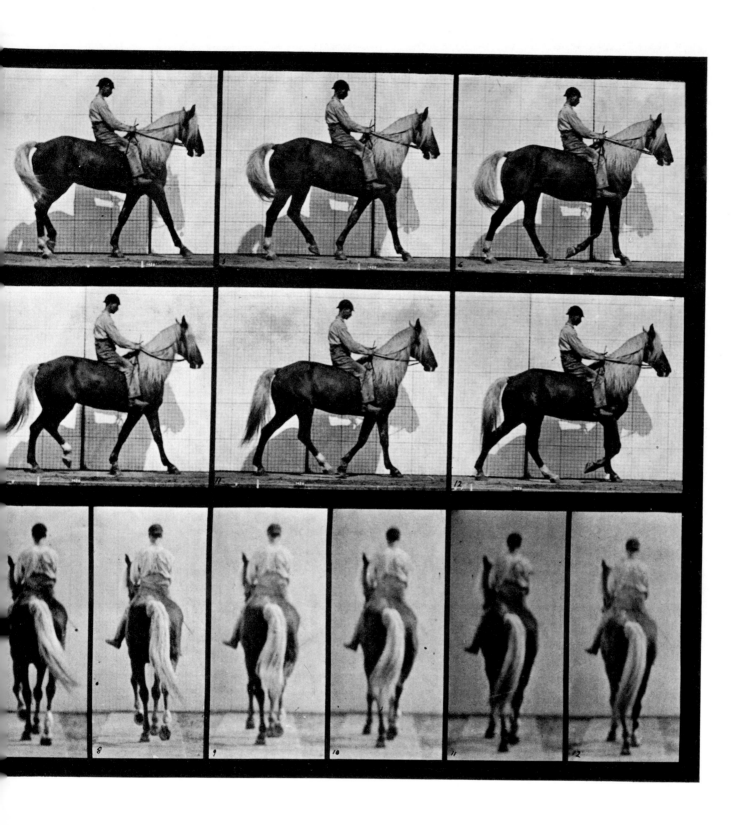

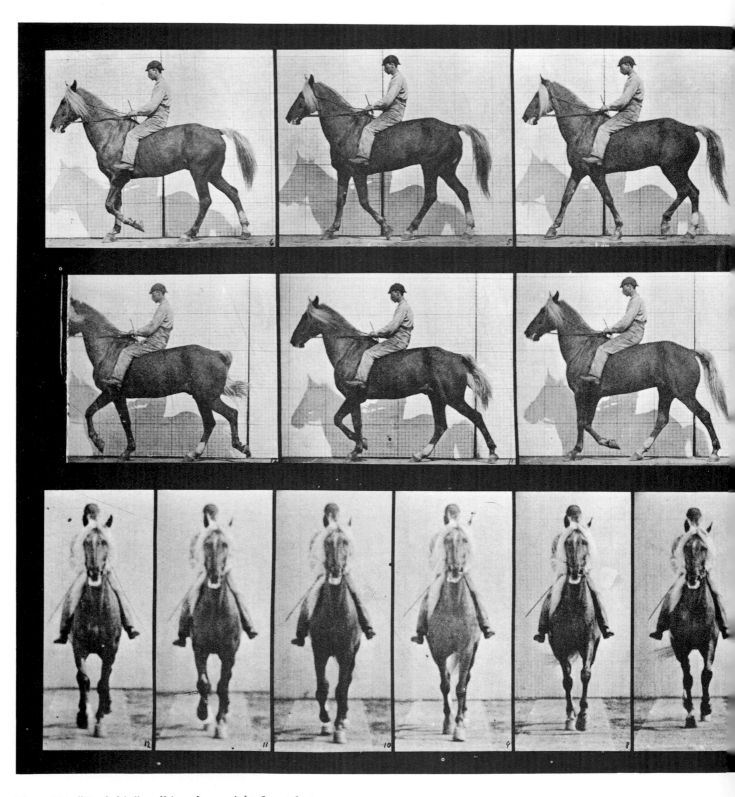

Plate 654. "Buckskin" walking, lame right front foot.

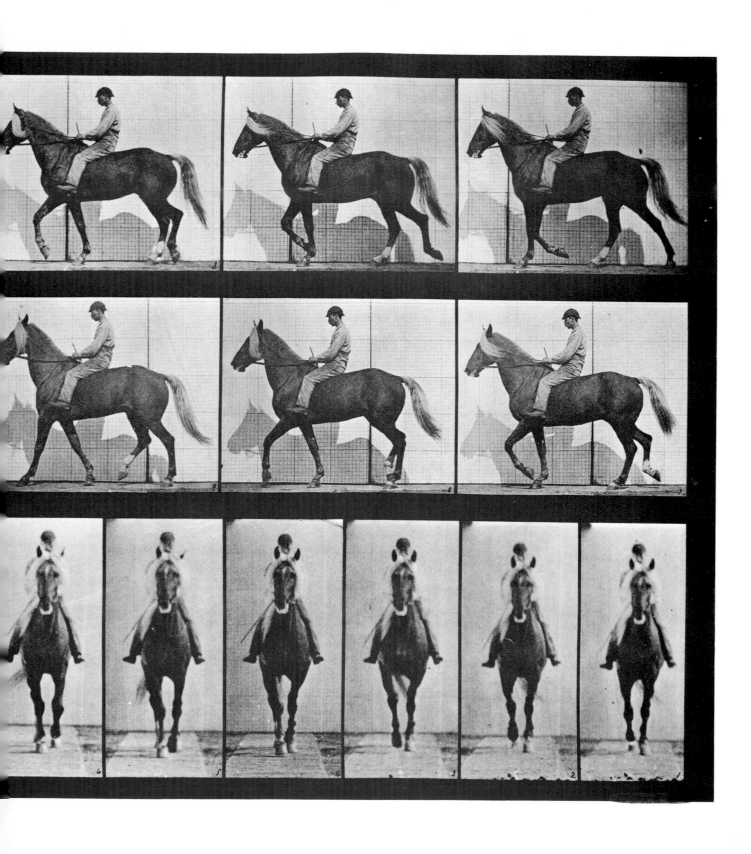

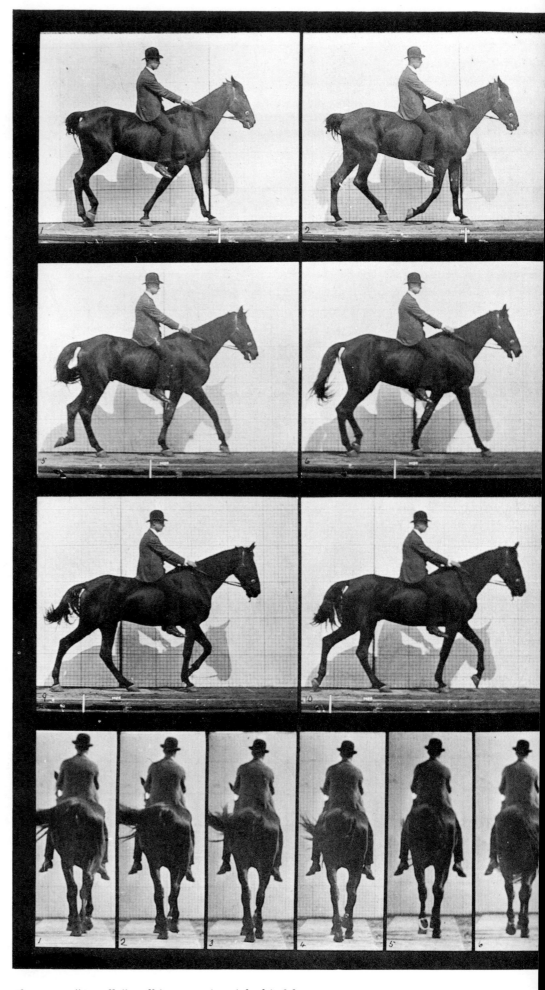

Plate 655. "Gazelle" walking, spavin, right hind leg.

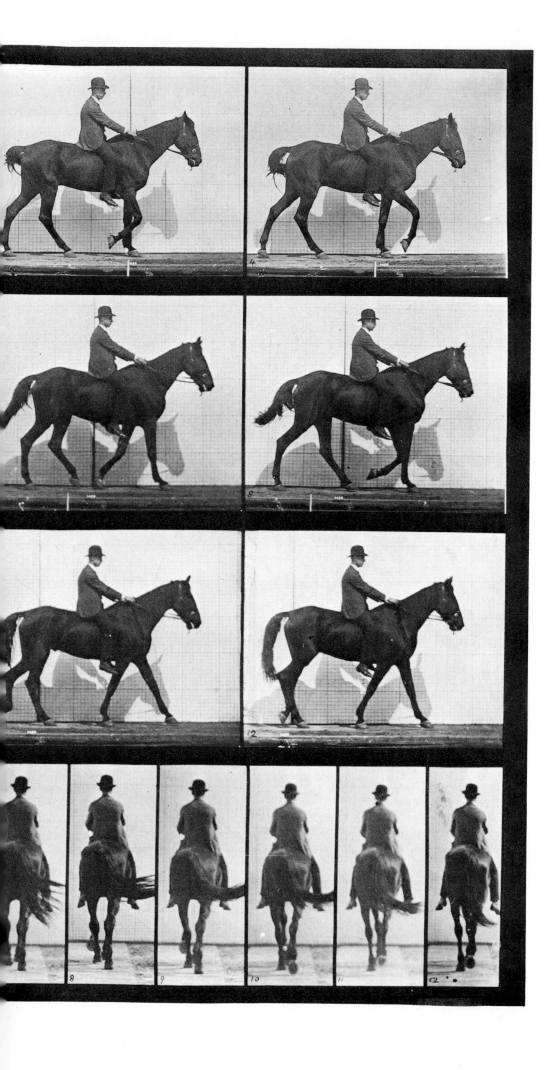

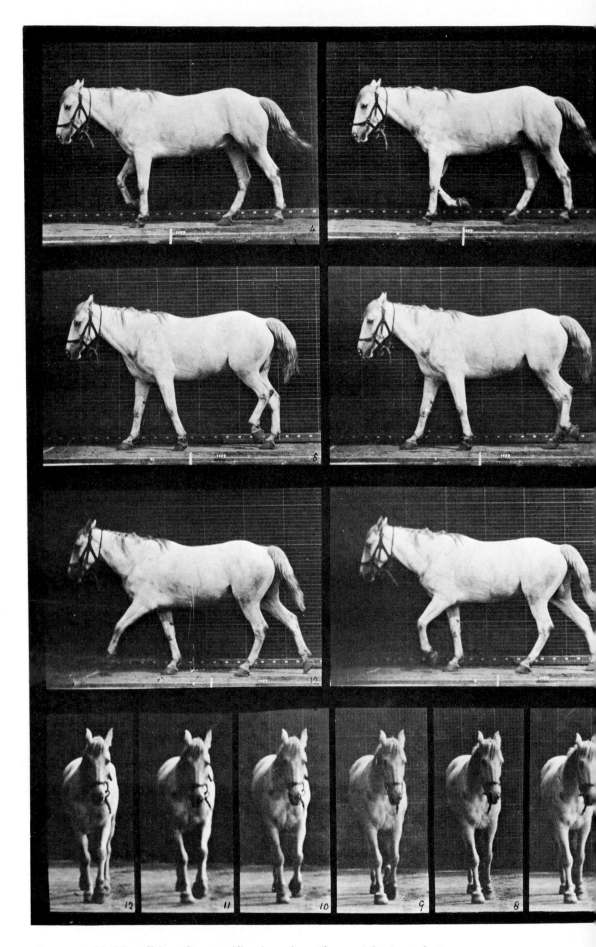

Plate 656. "Bob" *walking, free, ossification of cartilage, right front foot.*

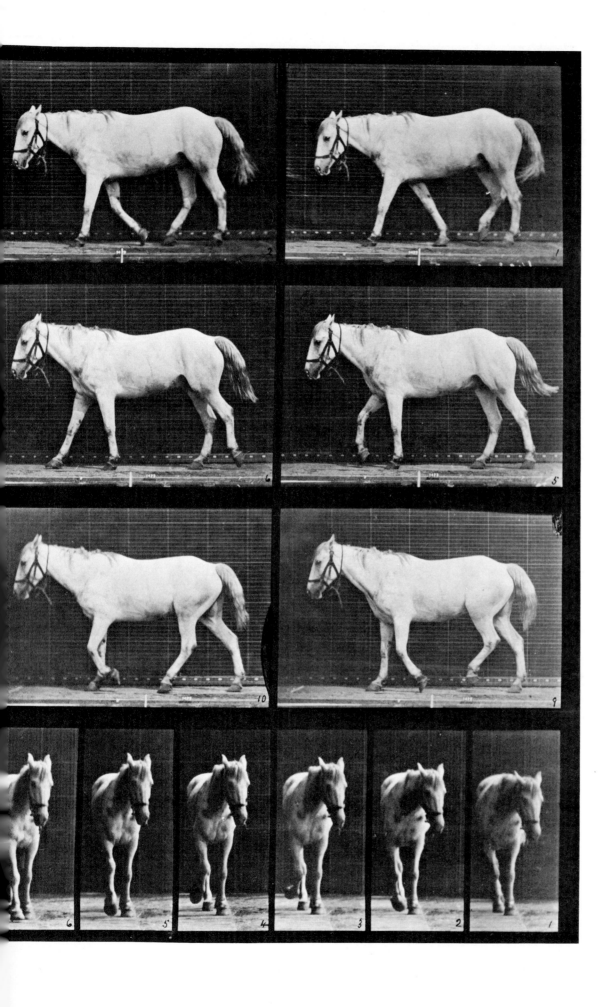

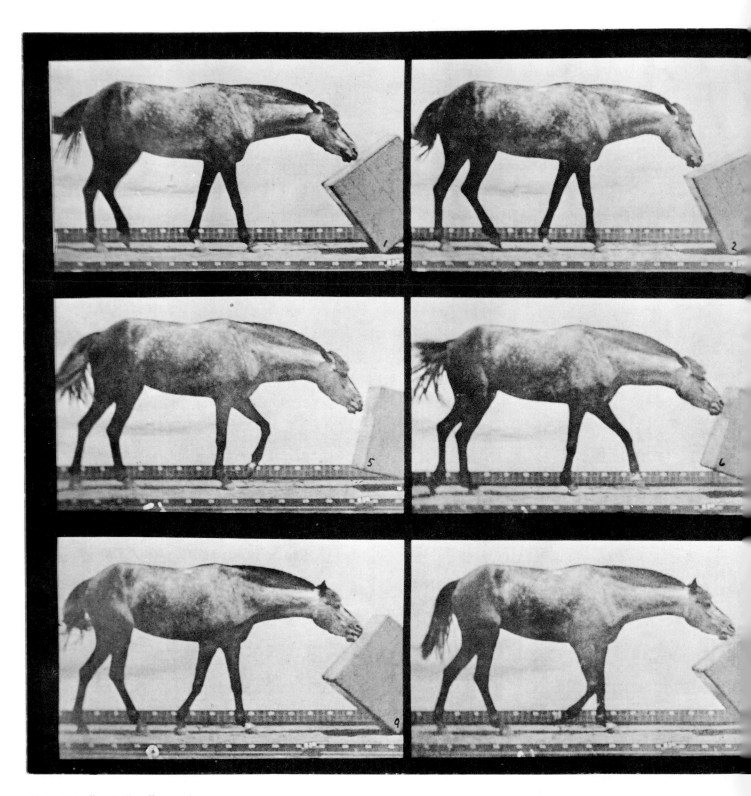

Plate 657. "Lotta" rolling a box.

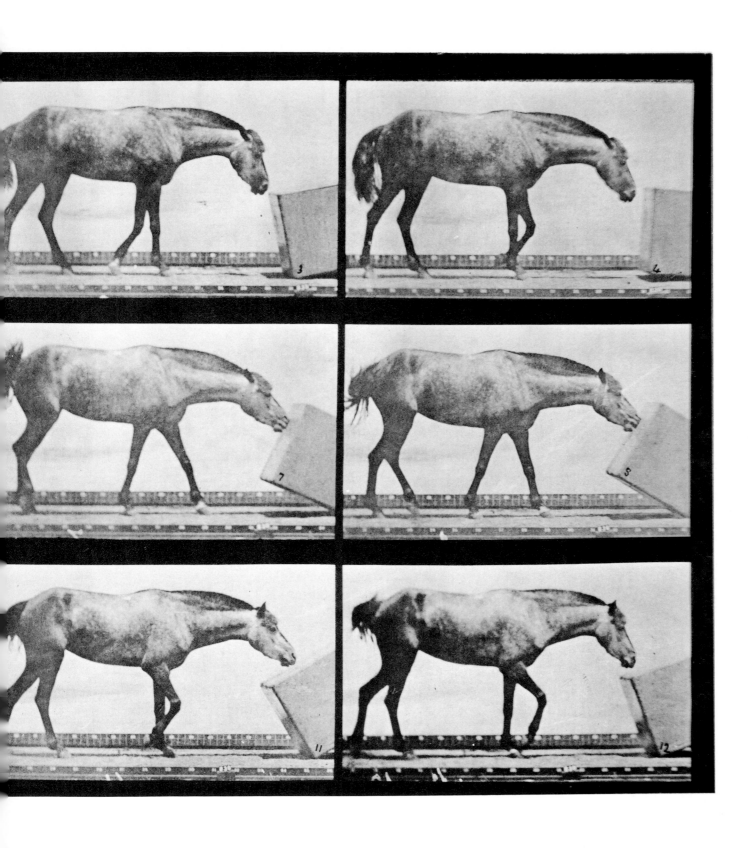

Volume 10
DOMESTIC ANIMALS

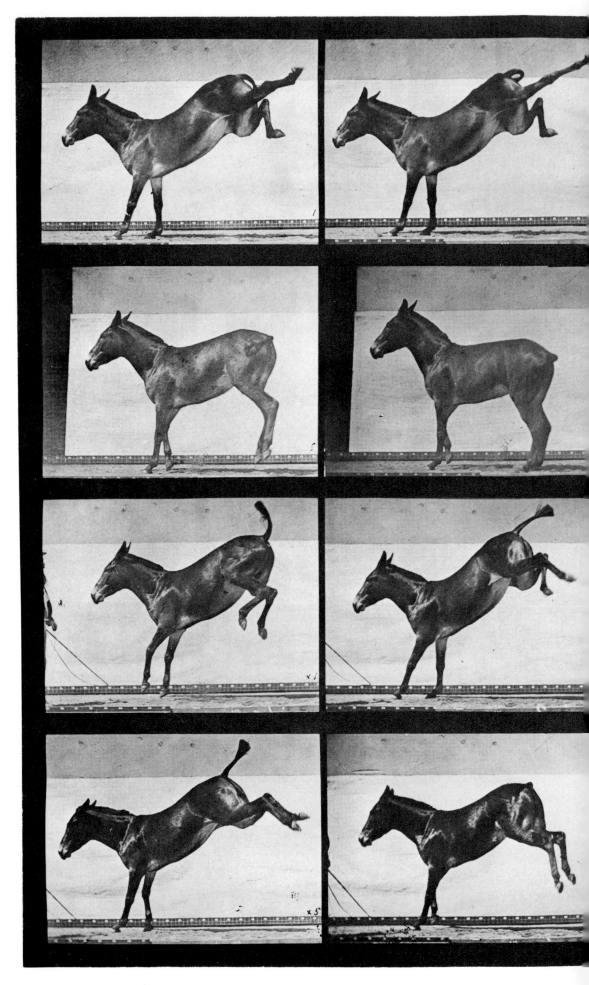

Plate 658. "Ruth" kicking.

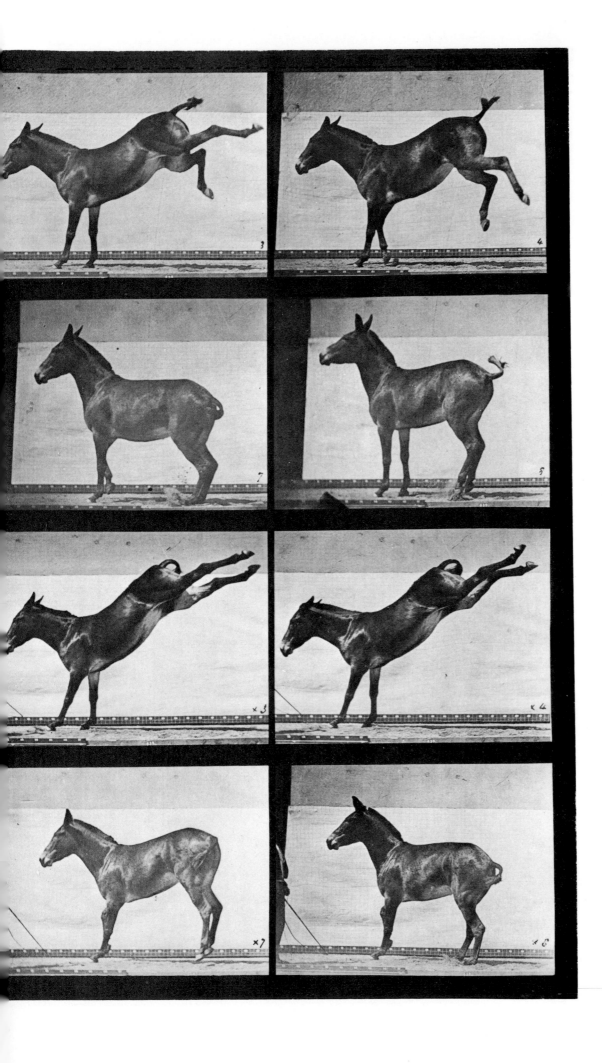

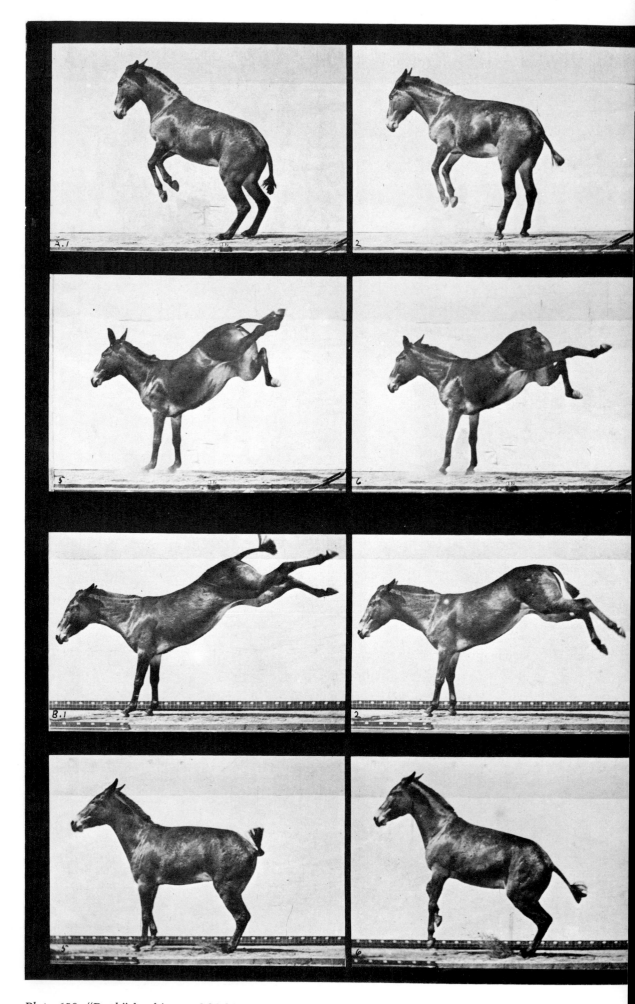

Plate 659. "Ruth" bucking and kicking.

1336 DOMESTIC ANIMALS

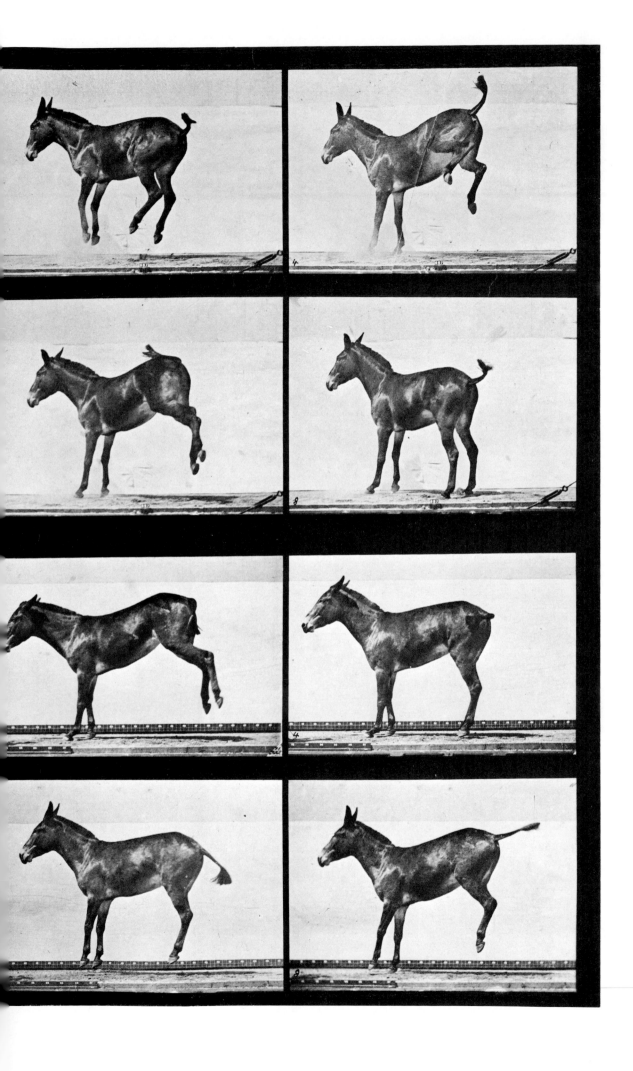

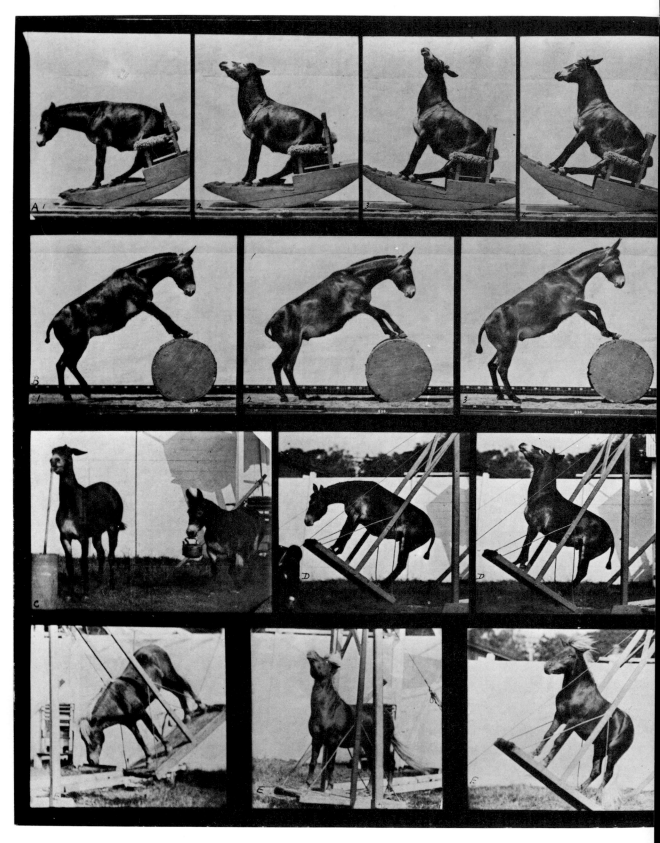

Plate 660. "Denver," miscellaneous performances.

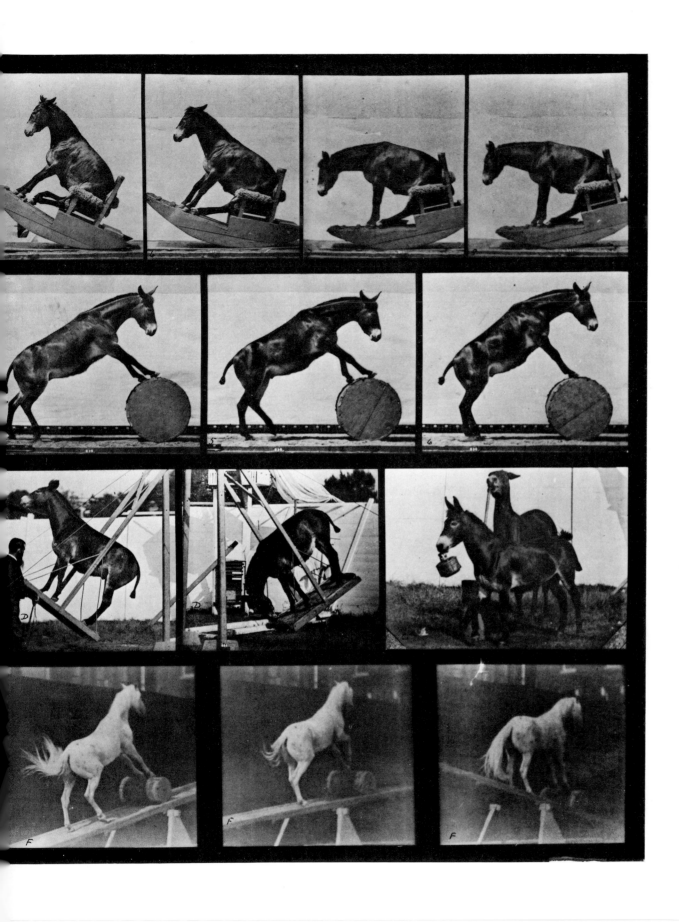

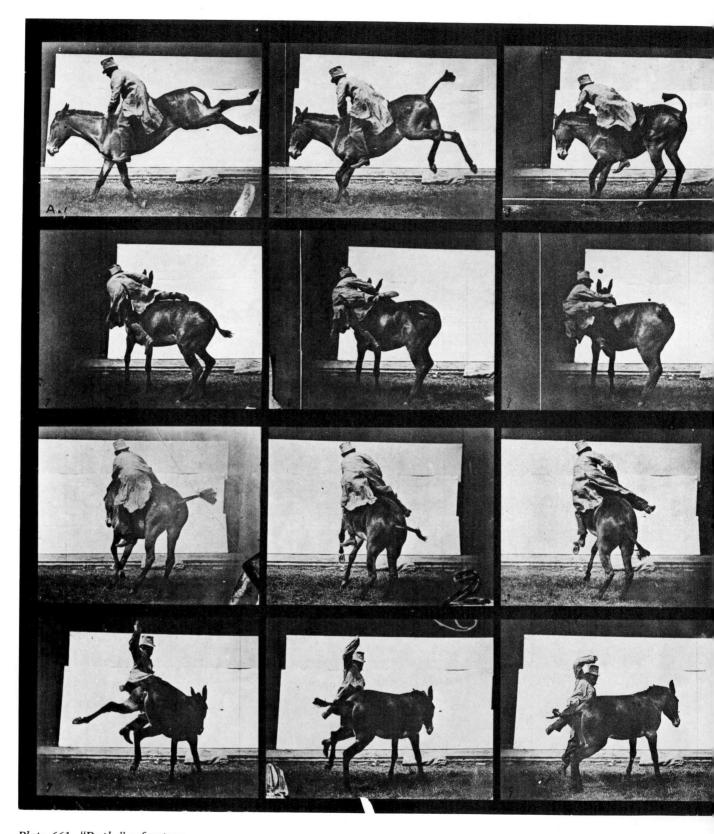

Plate 661. "Ruth," *refractory.*

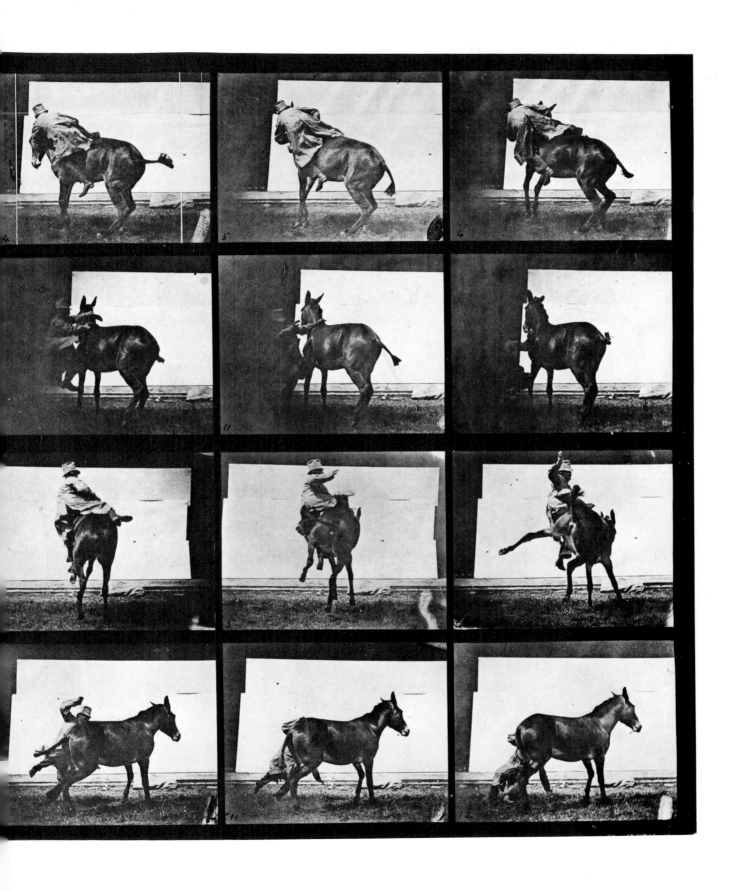

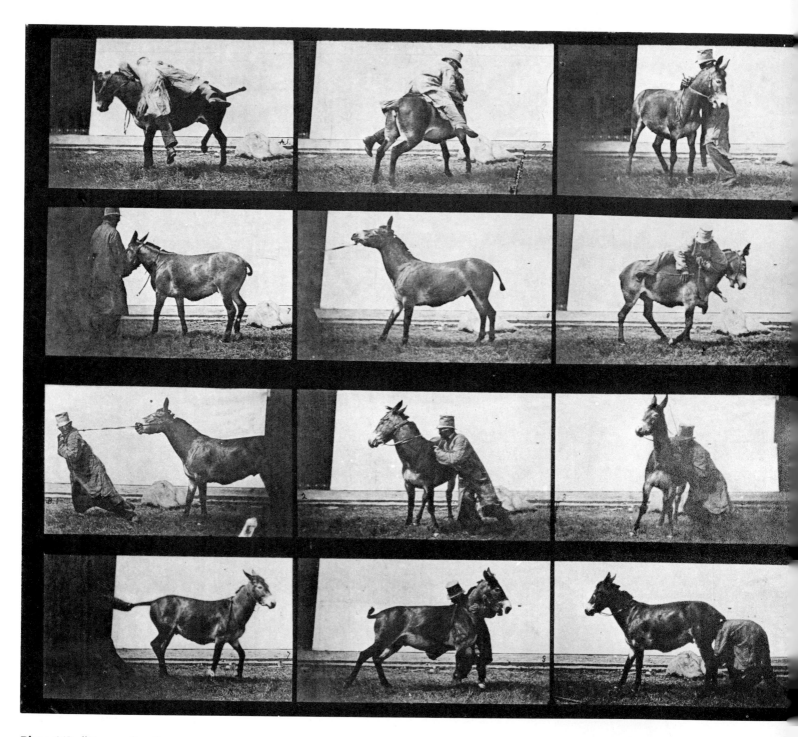

Plate 662. "Denver," refractory.

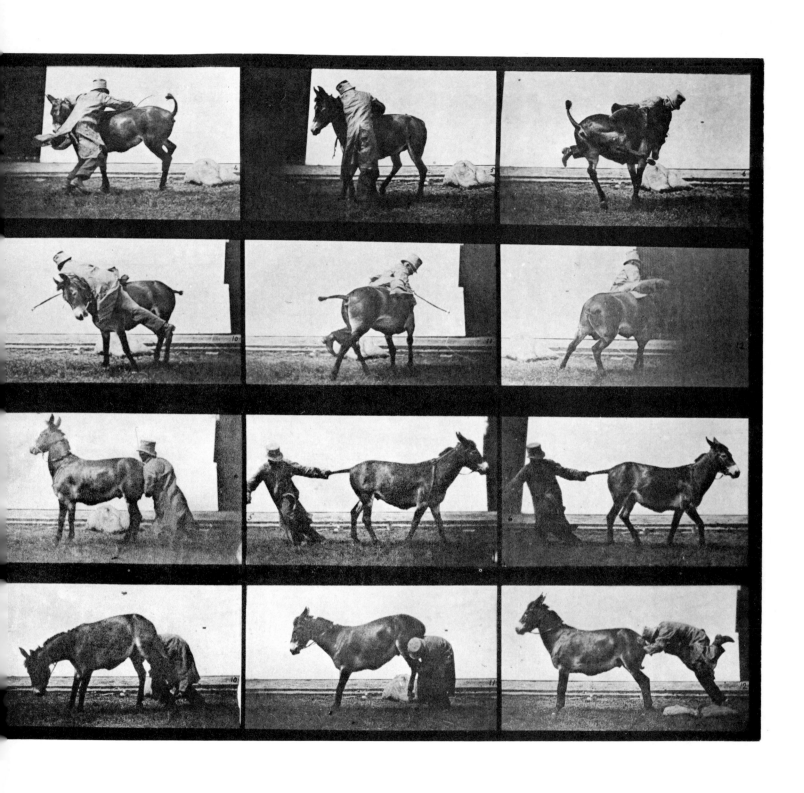

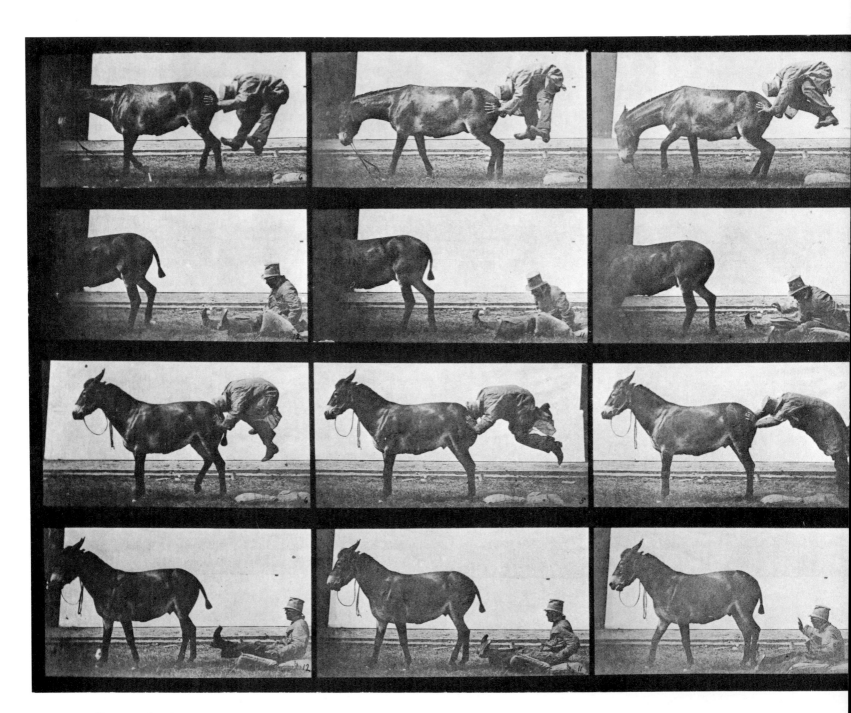

Plate 663. "Denver," refractory.

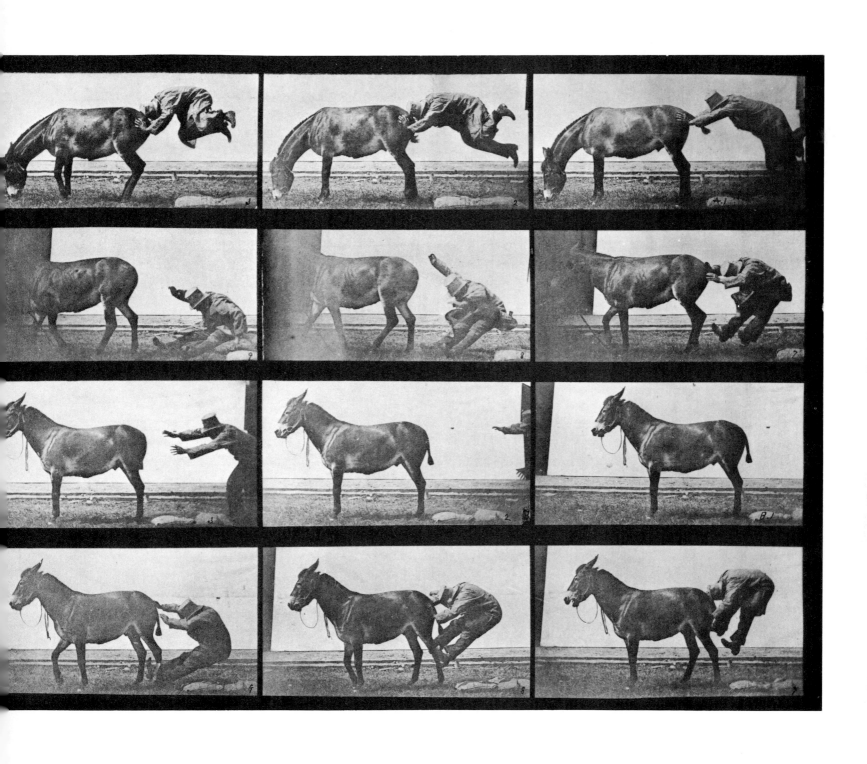

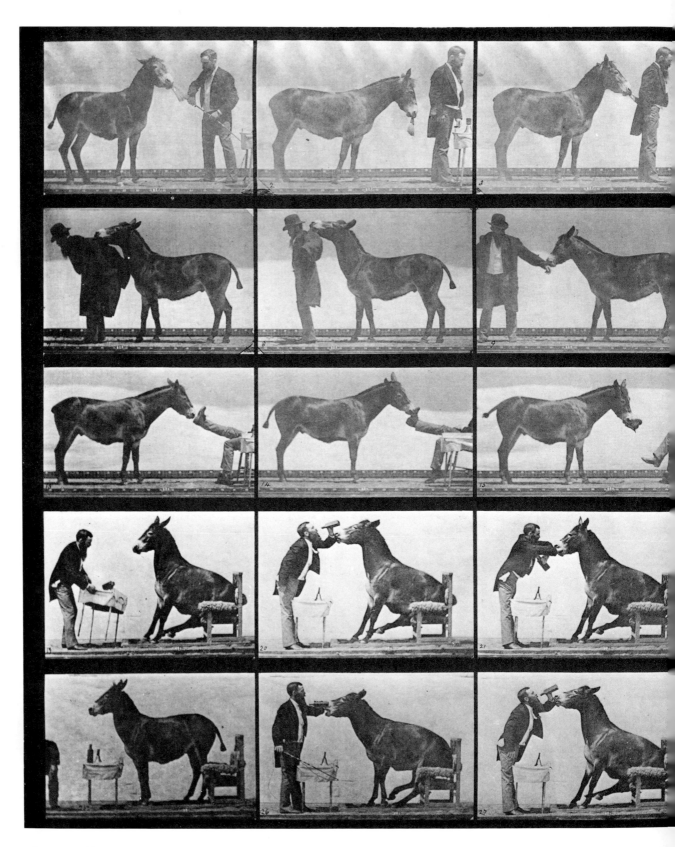

Plate 664. "Denver," various performances, at a table, etc.

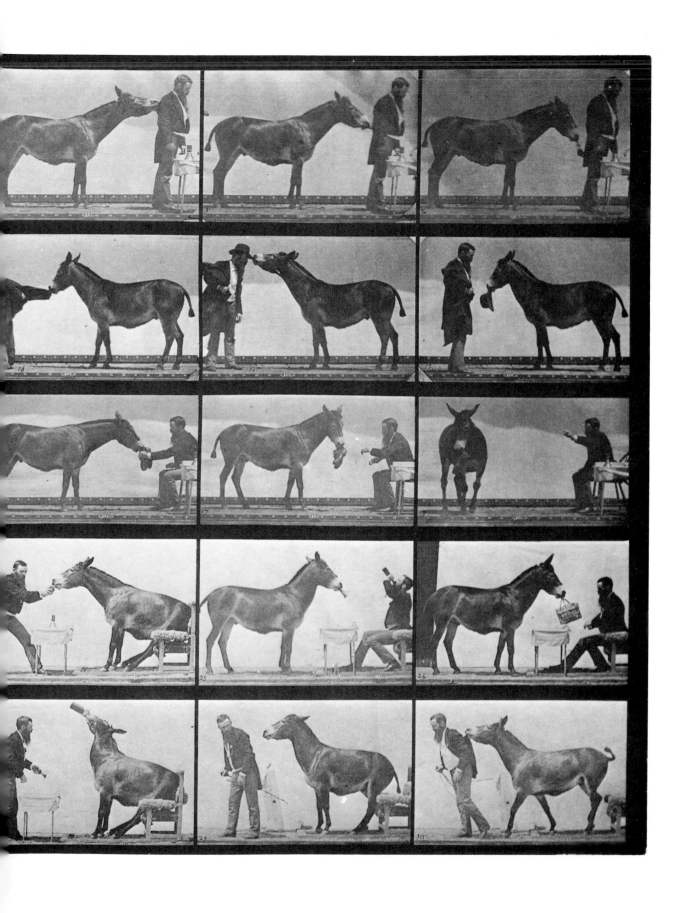

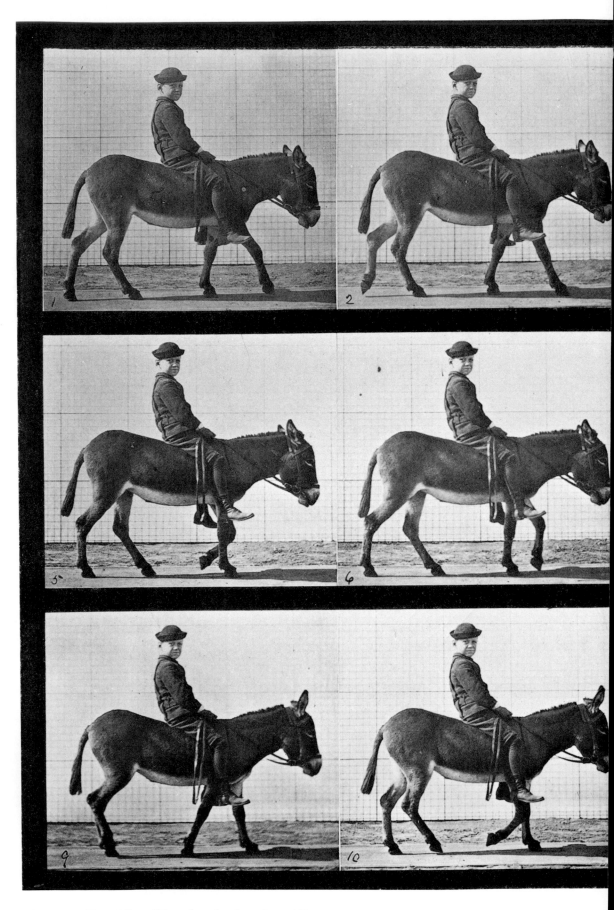

Plate 665. "Jennie" walking, bareback; a boy riding.

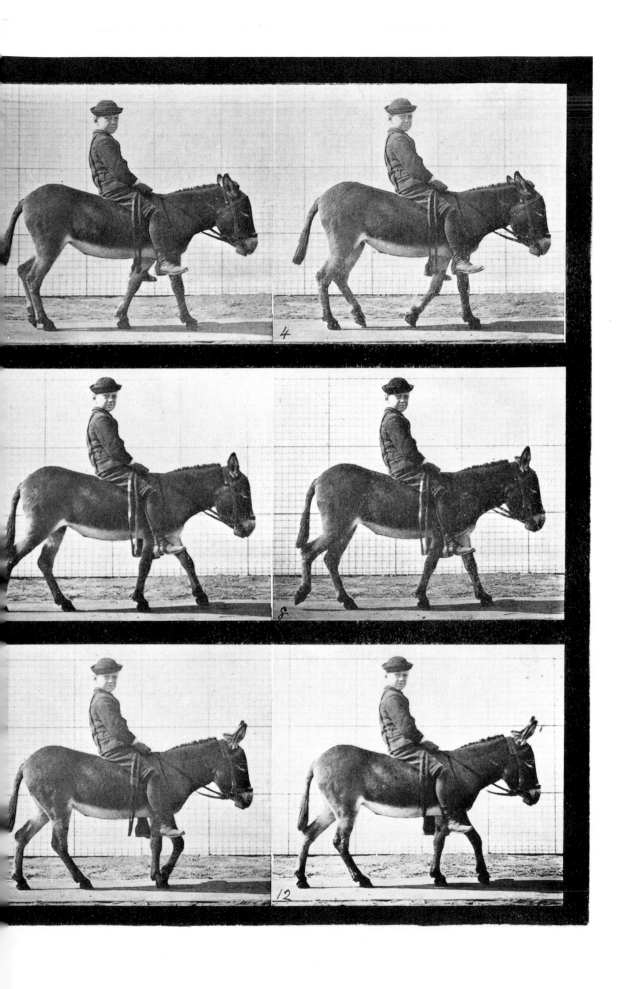

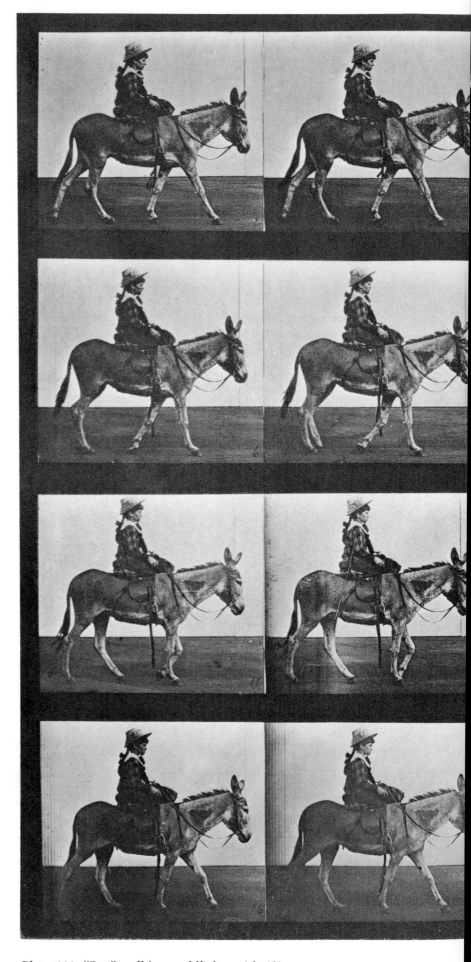

Plate 666. "Zoo" walking, saddled; a girl riding.

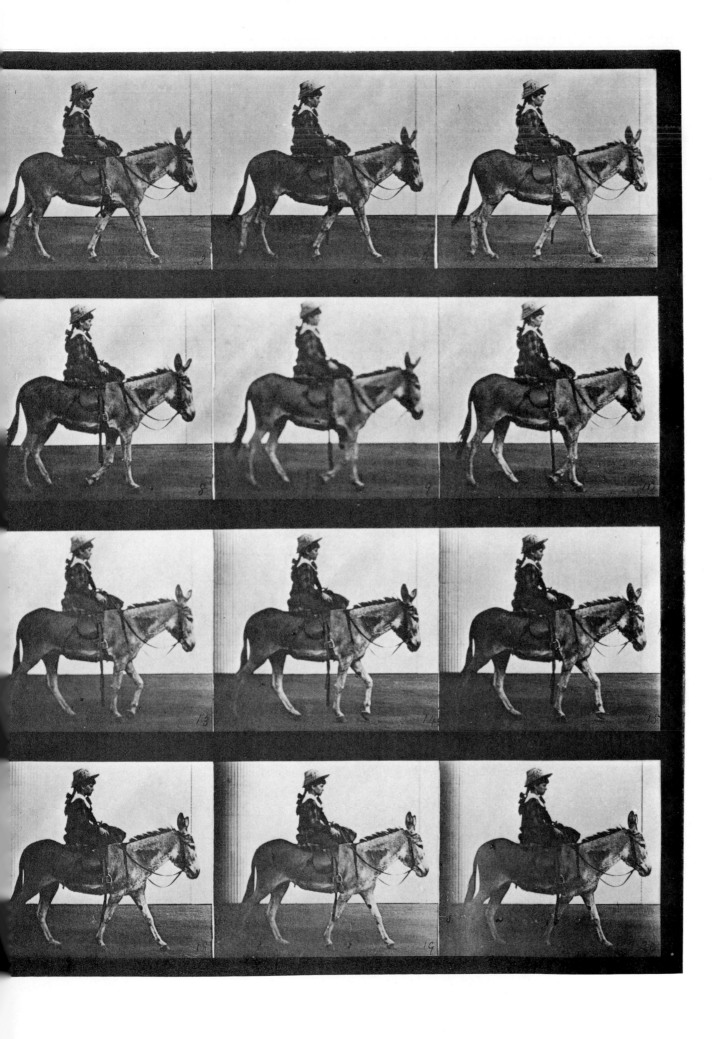

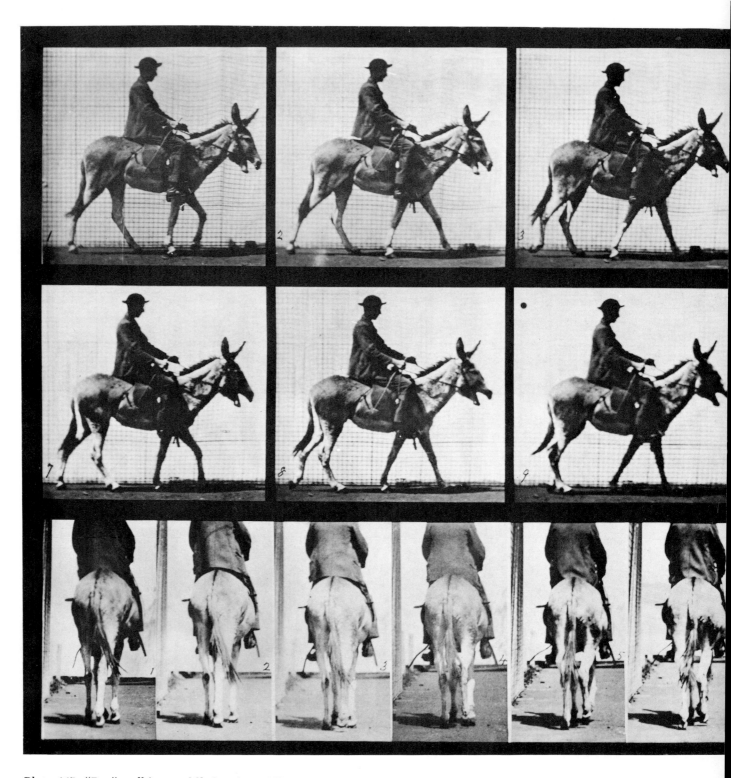

Plate 667. "Zoo" walking, saddled; a boy riding.

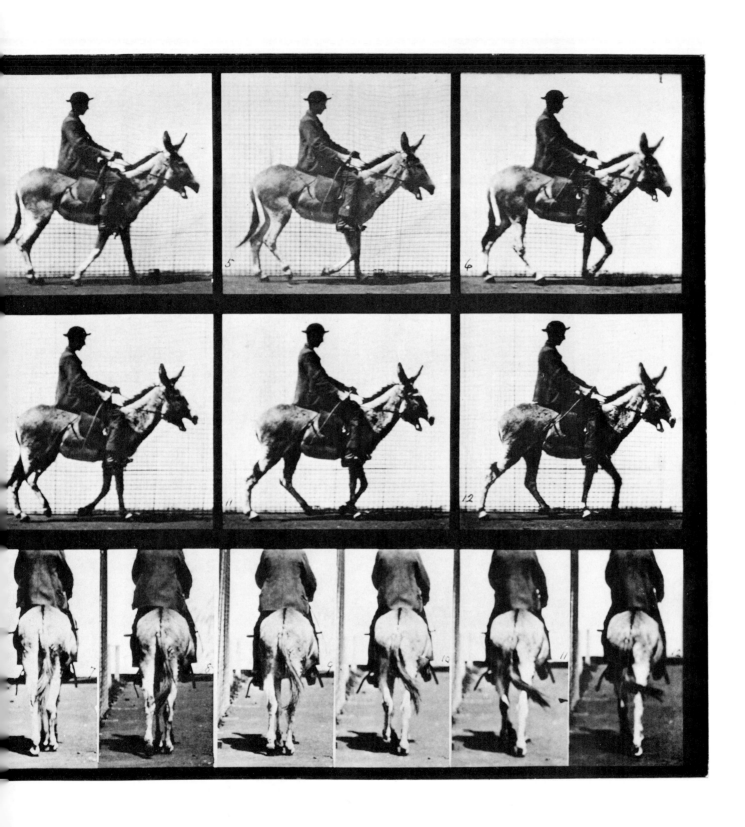

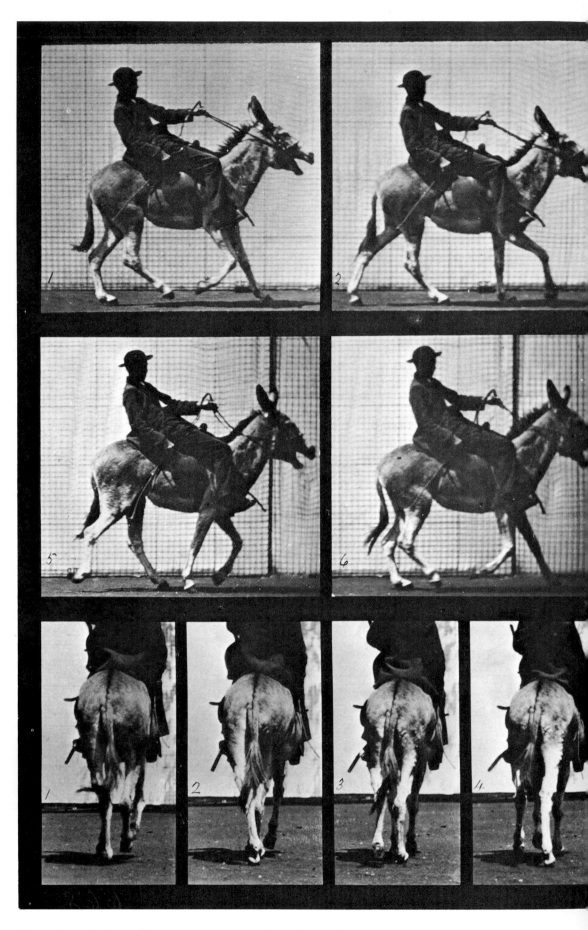

Plate 668. "Zoo" ambling, irregular, saddled; a boy riding.

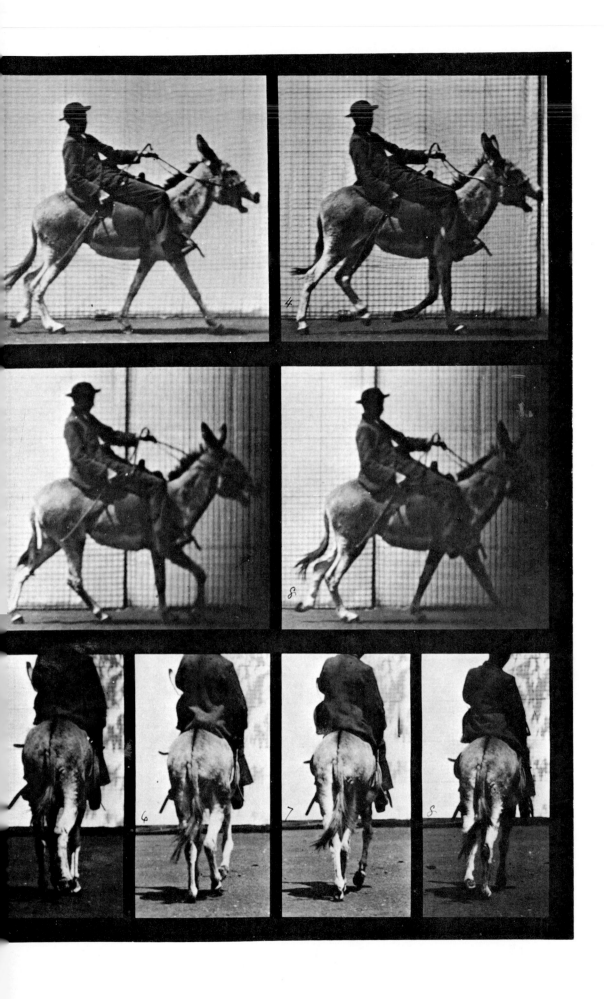

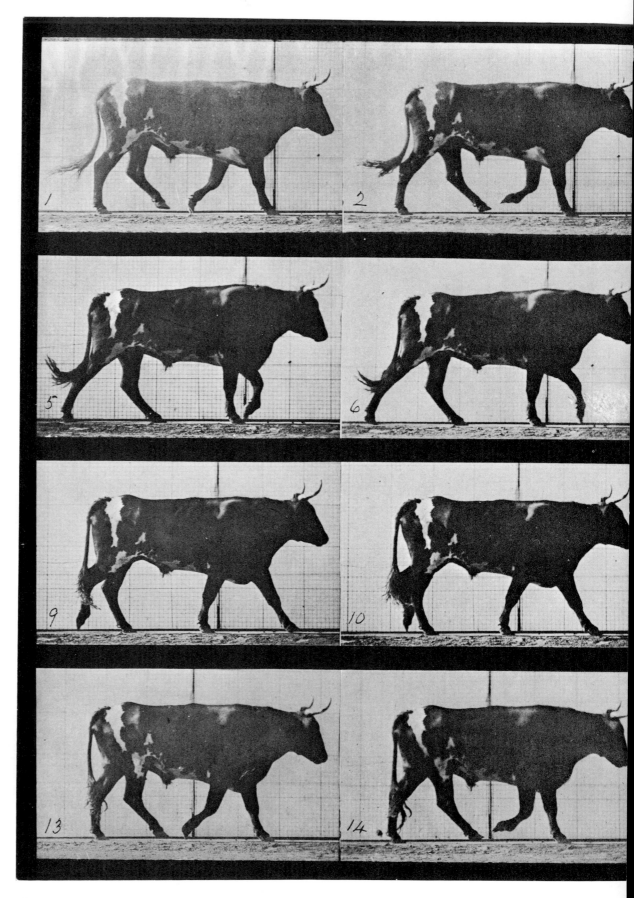

Plate 669. Ox walking.

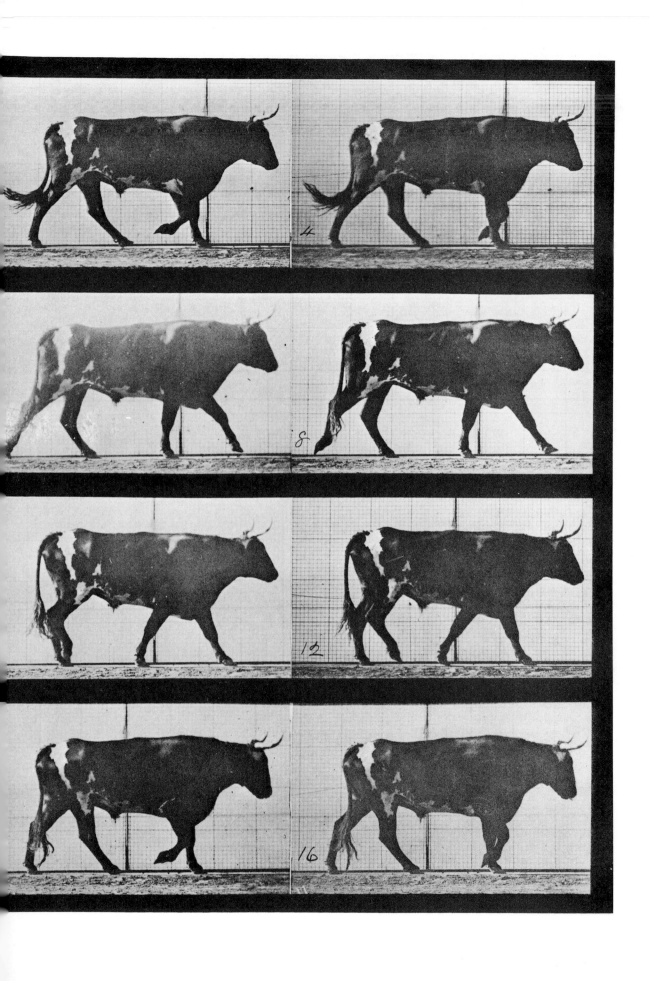

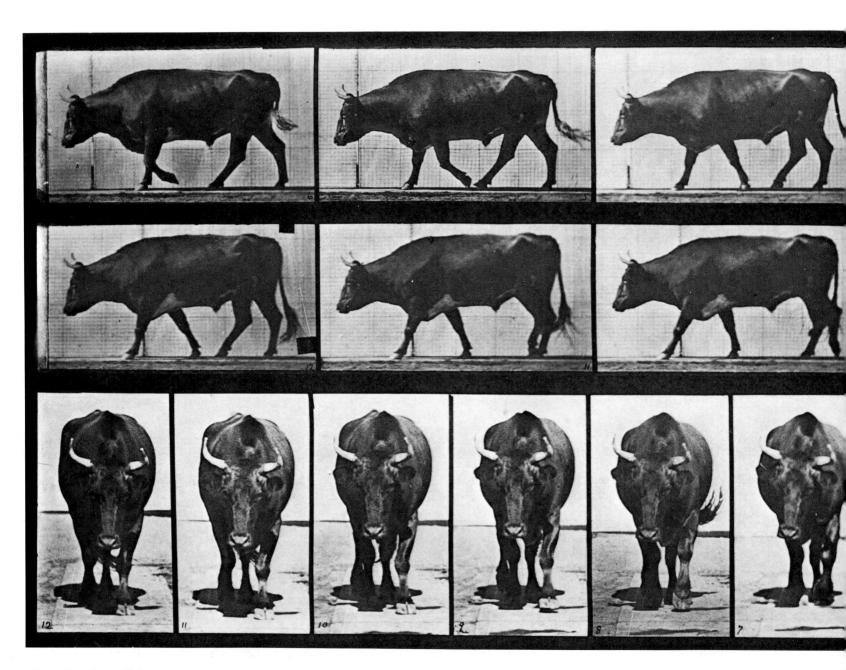

Plate 670. Ox walking.

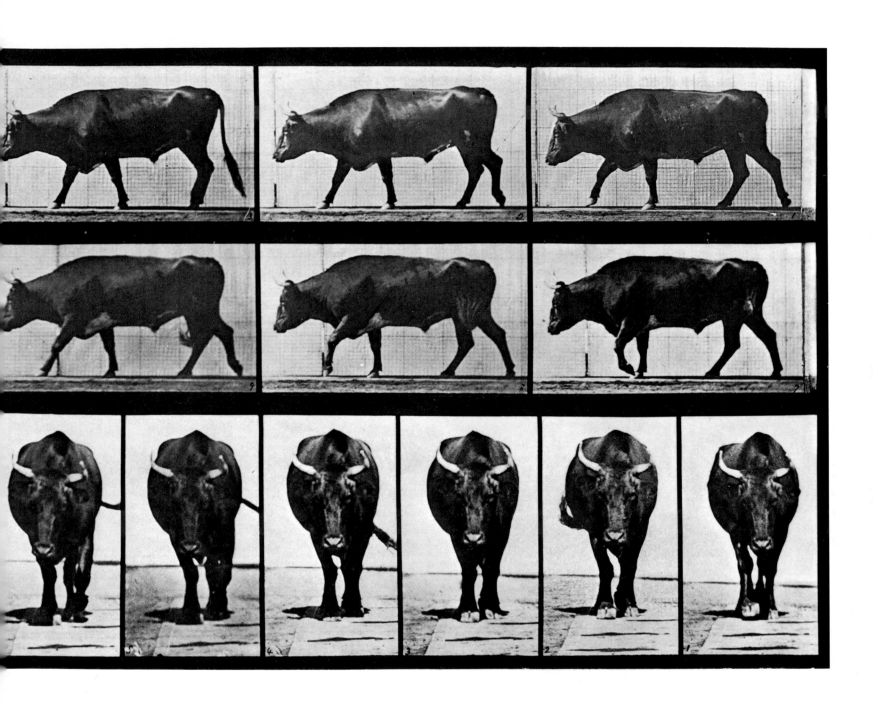

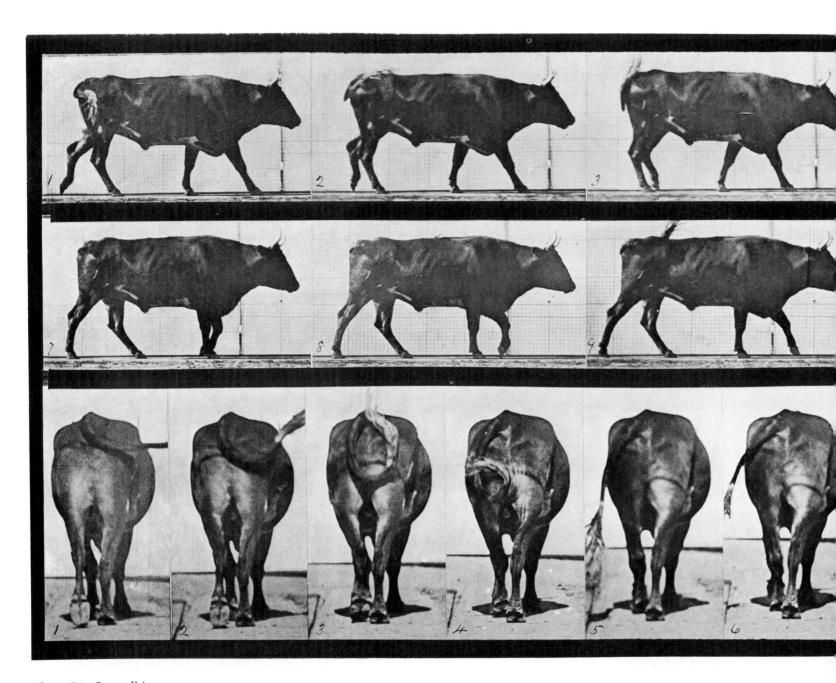

Plate 671. Ox walking.

1360 DOMESTIC ANIMALS

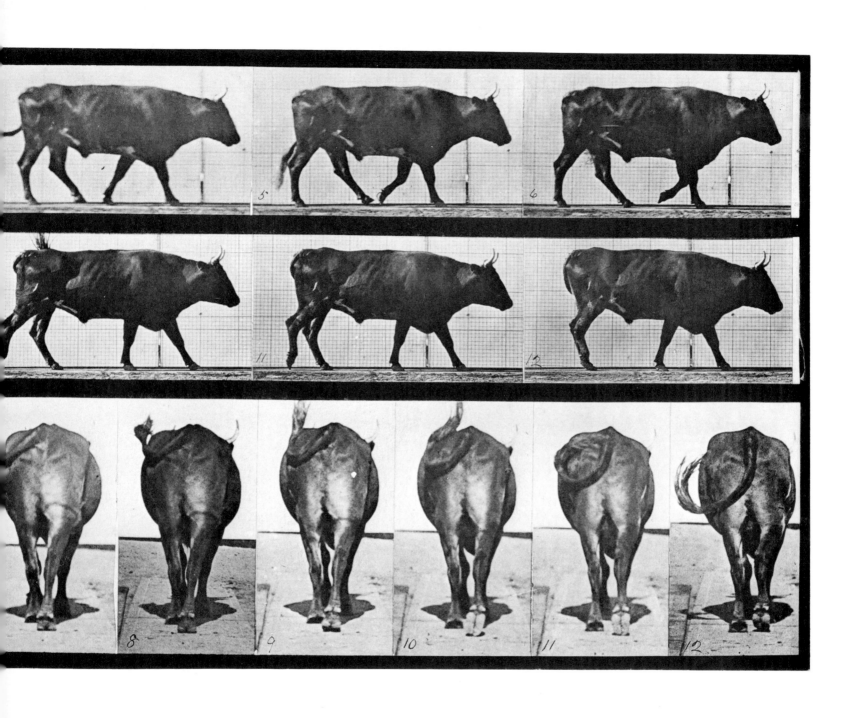

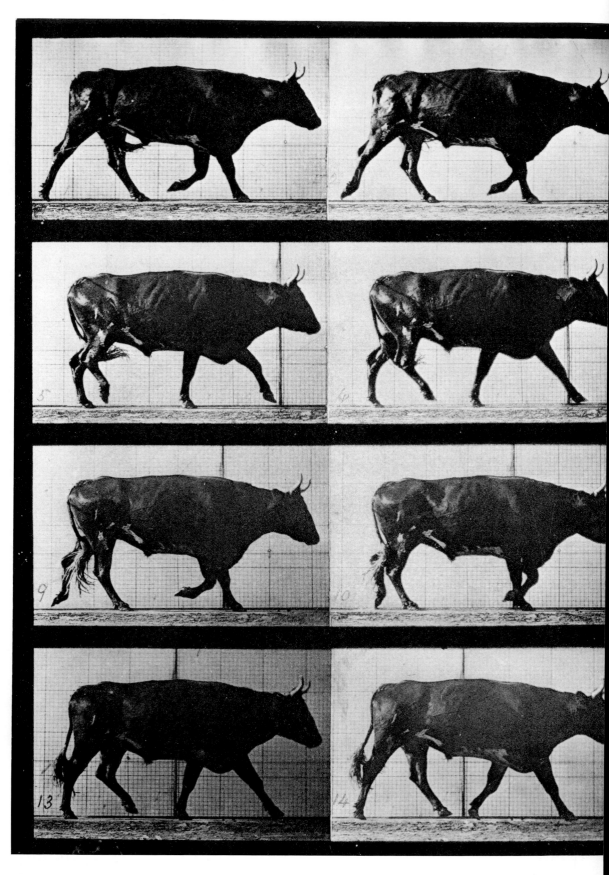

Plate 672. Ox trotting.

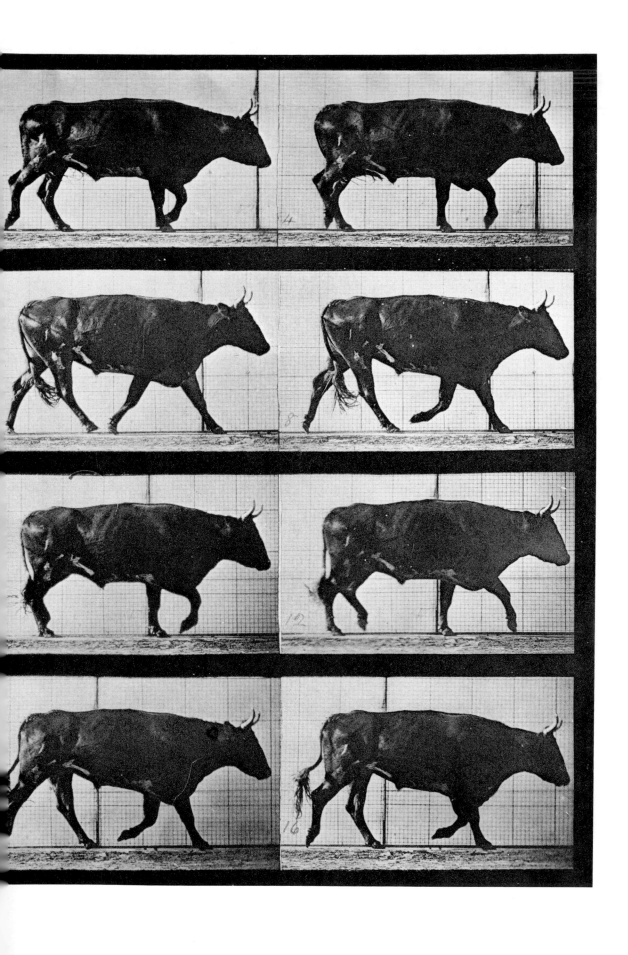

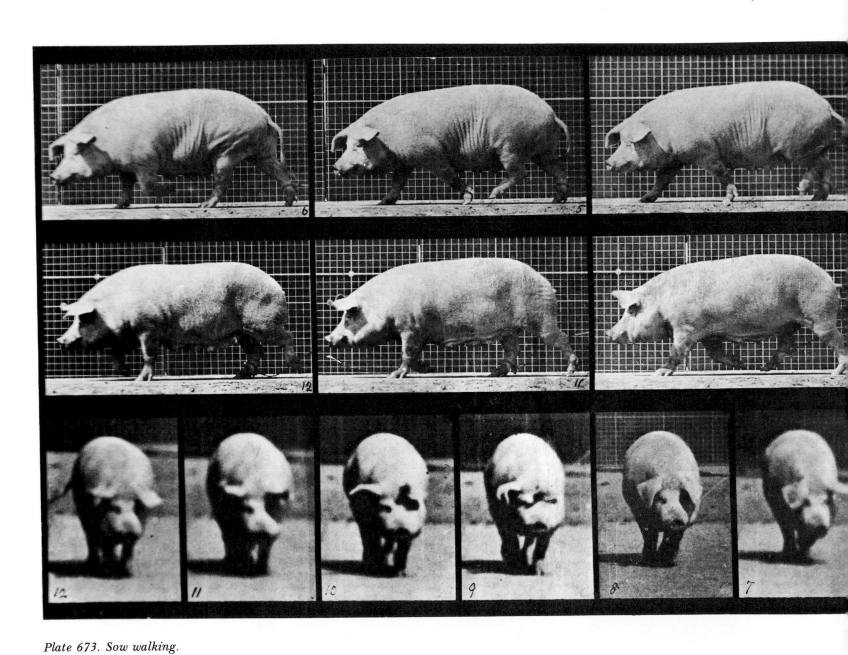

Plate 673. Sow walking.

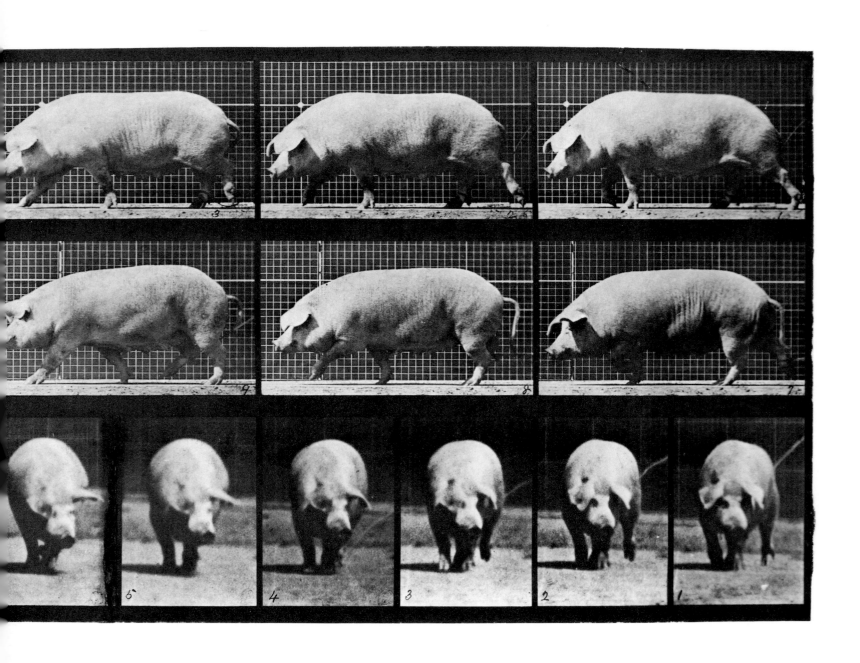

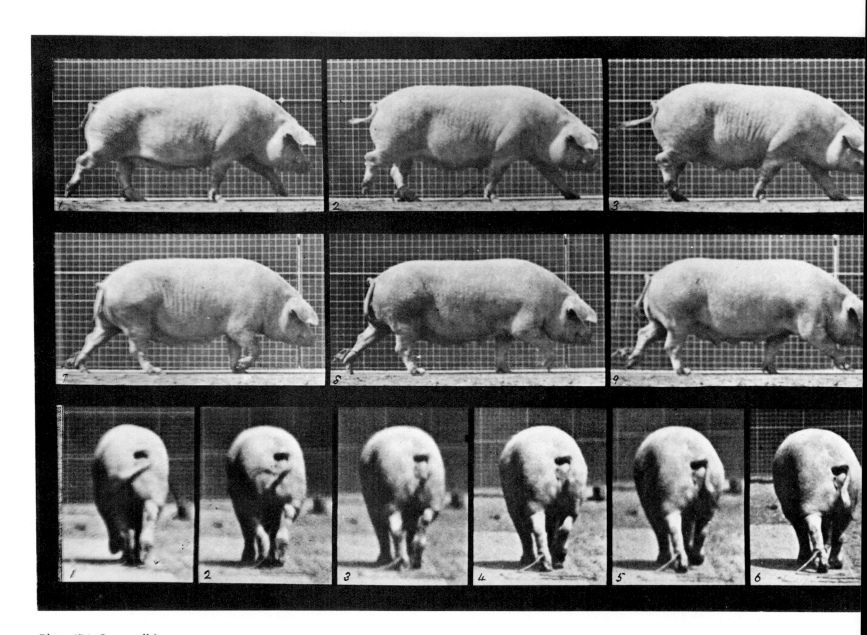

Plate 674. Sow walking.

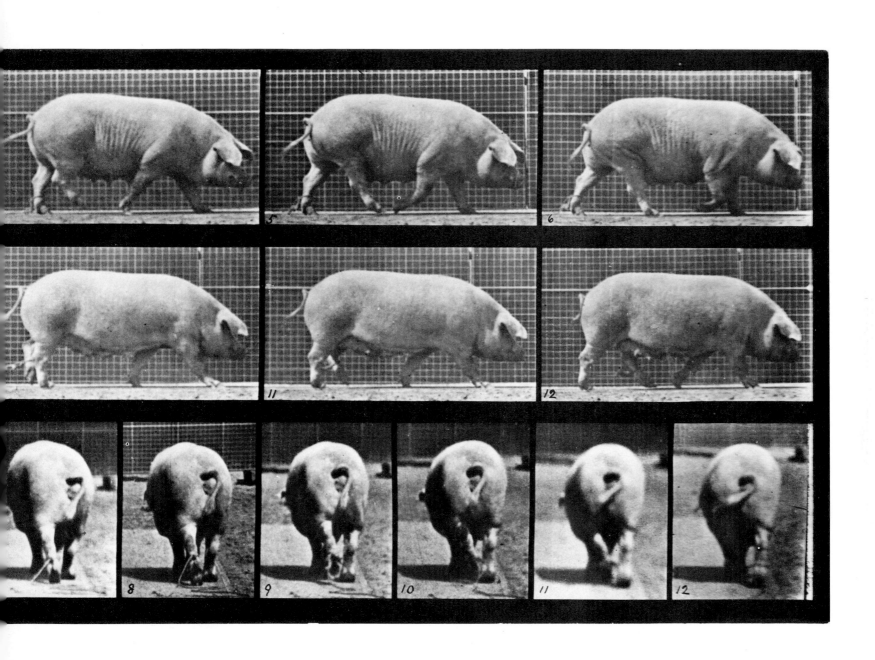

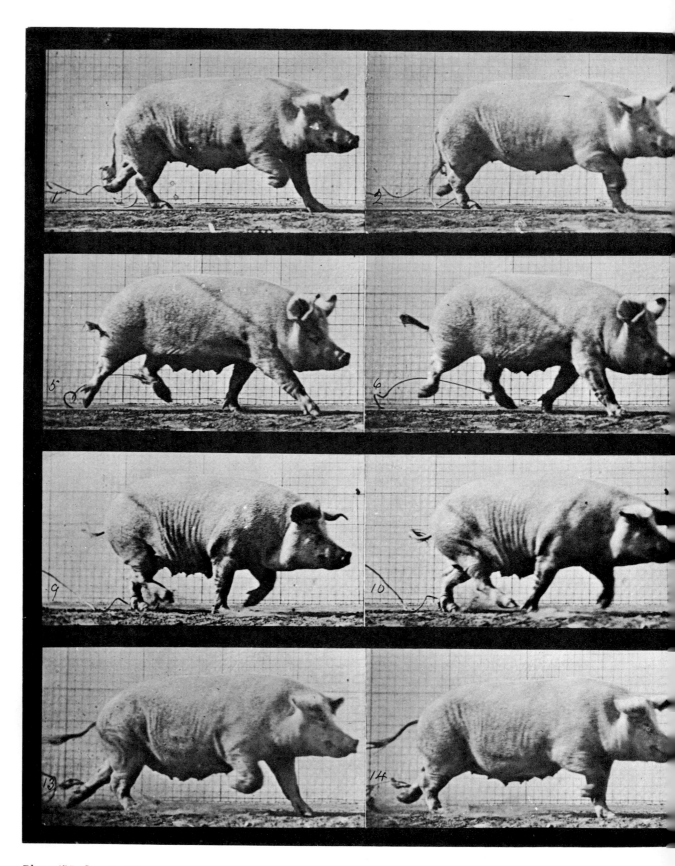

Plate 675. Sow trotting.

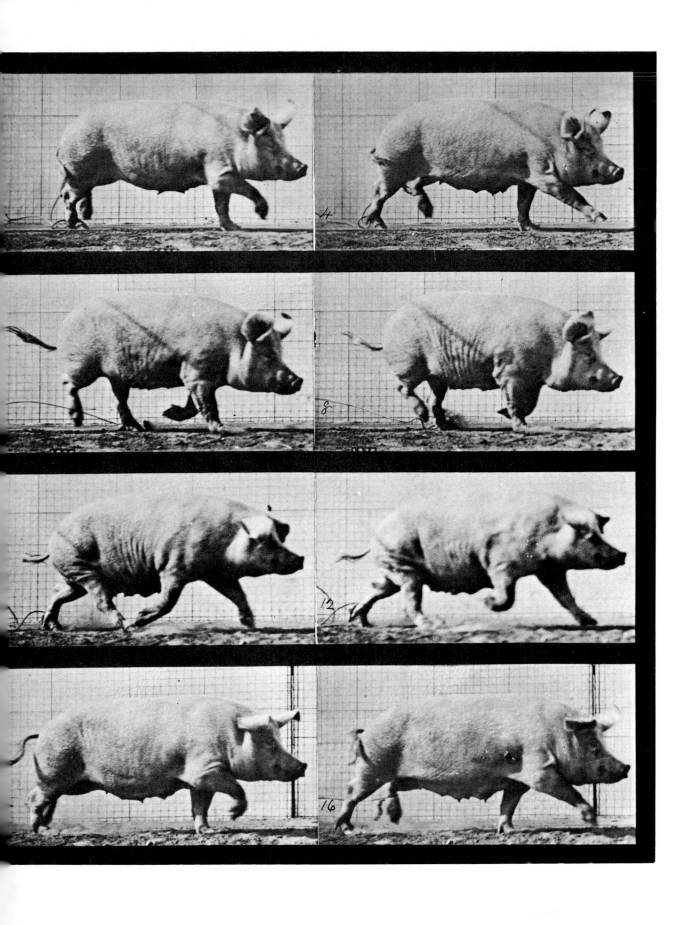

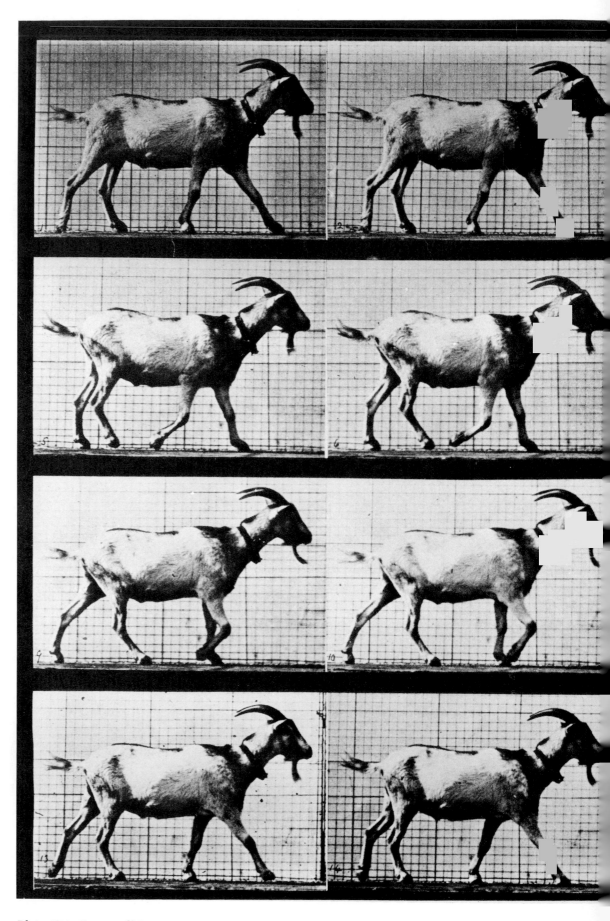

Plate 676. Goat walking.

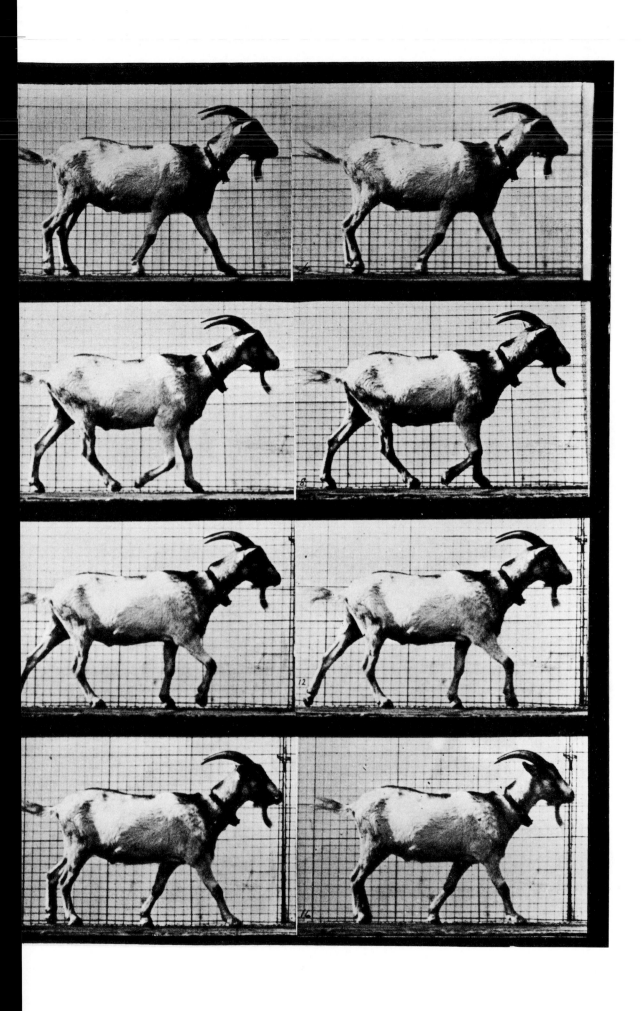

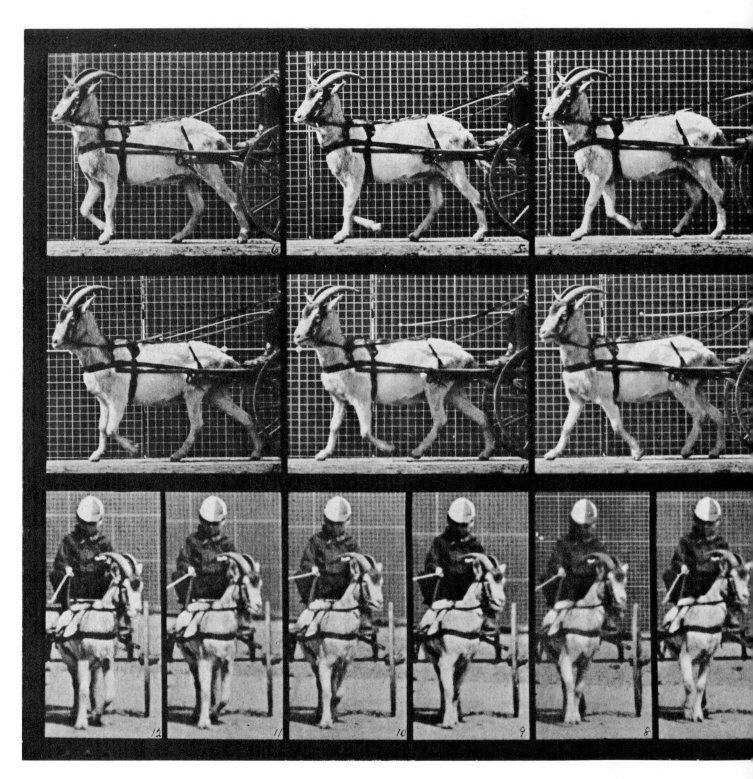

Plate 677. Goat walking, harnessed to a sulky.

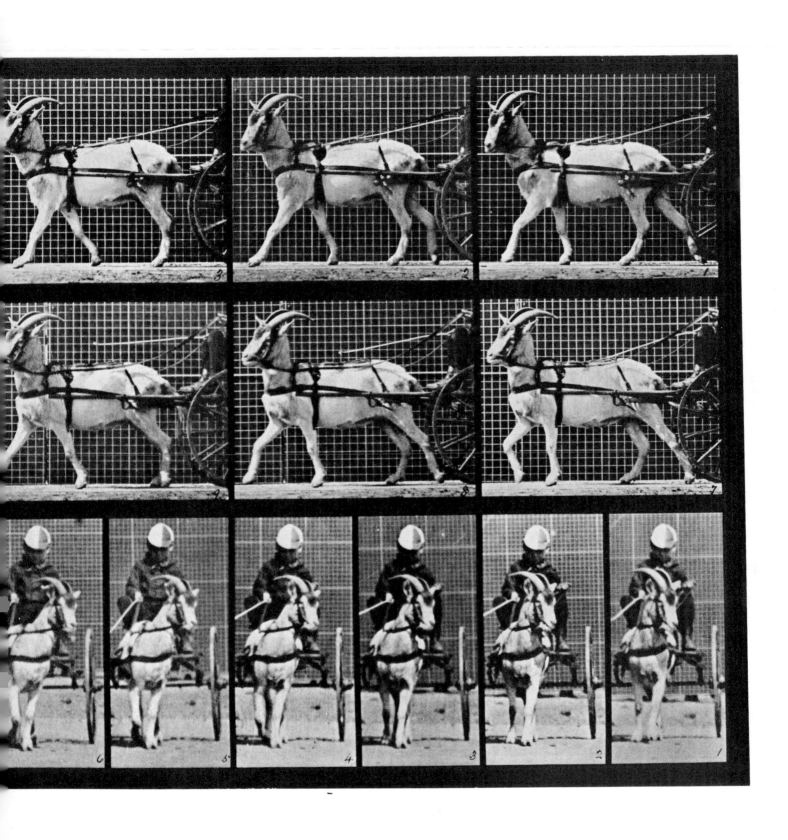

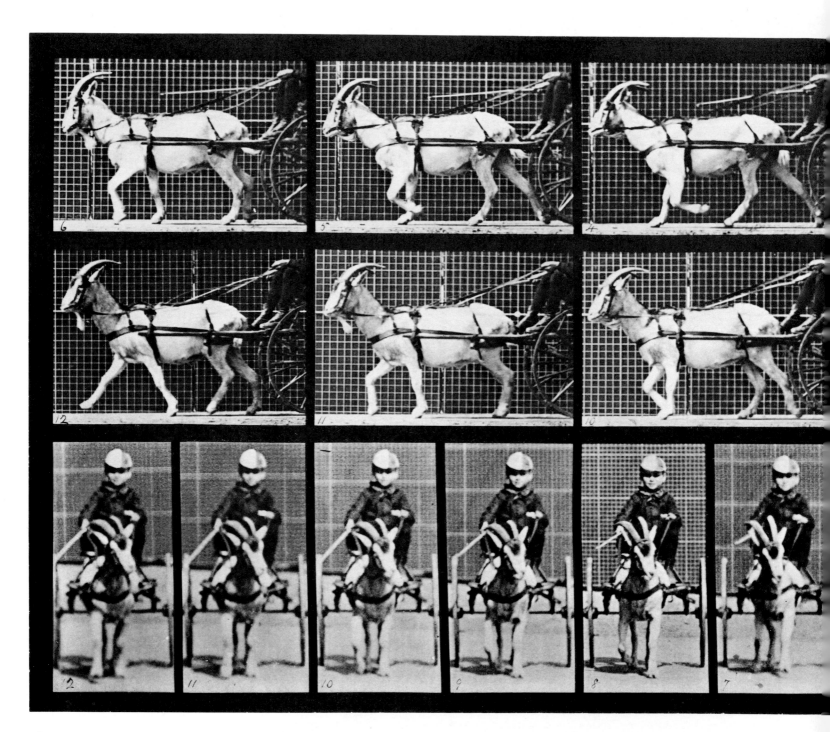

Plate 678. Goat trotting, harnessed to a sulky.

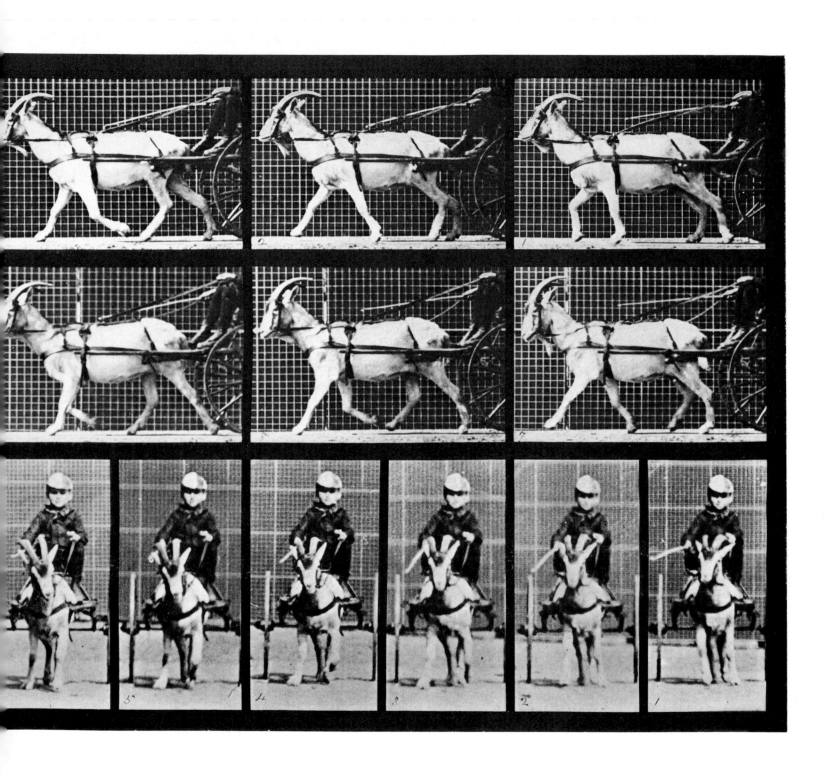

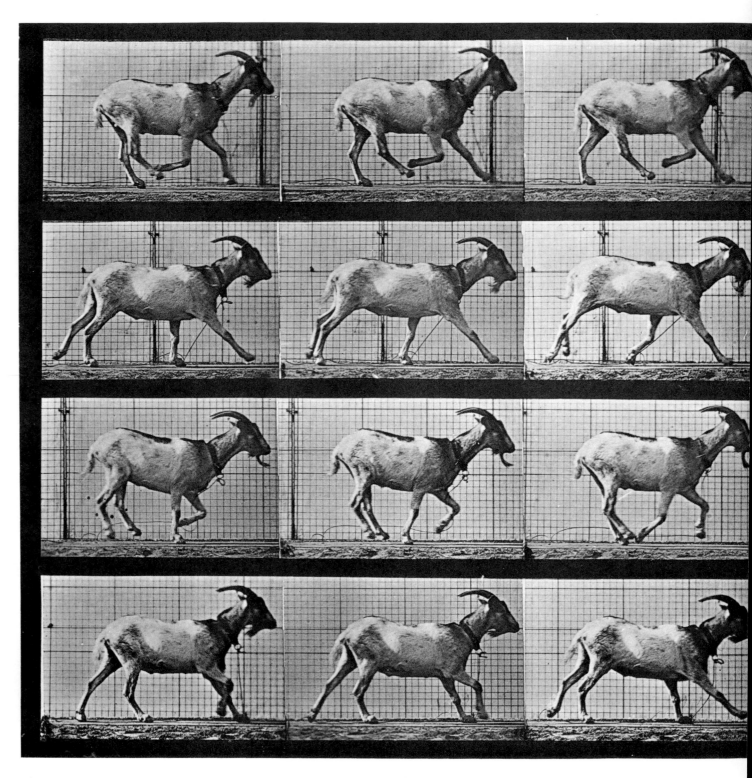

Plate 679. Goat galloping.

1376

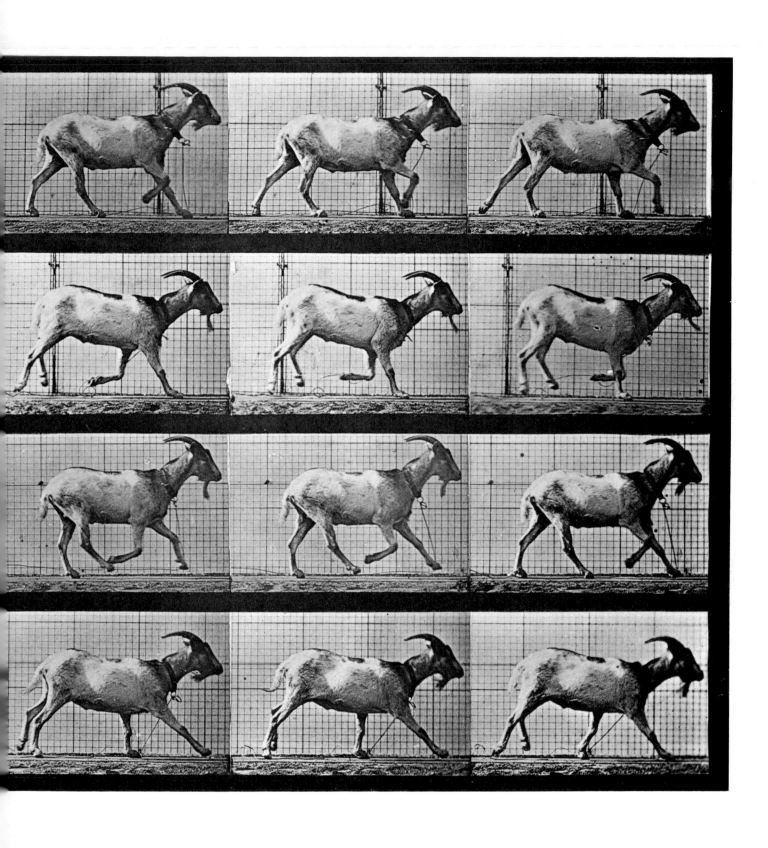

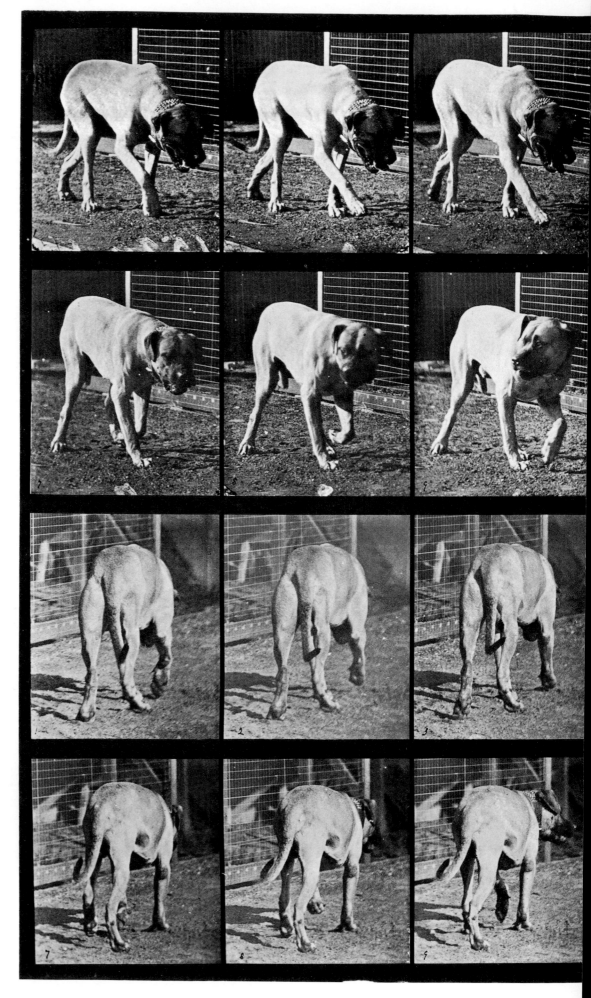

Plate 703. "Dread" walking, interrrupted.

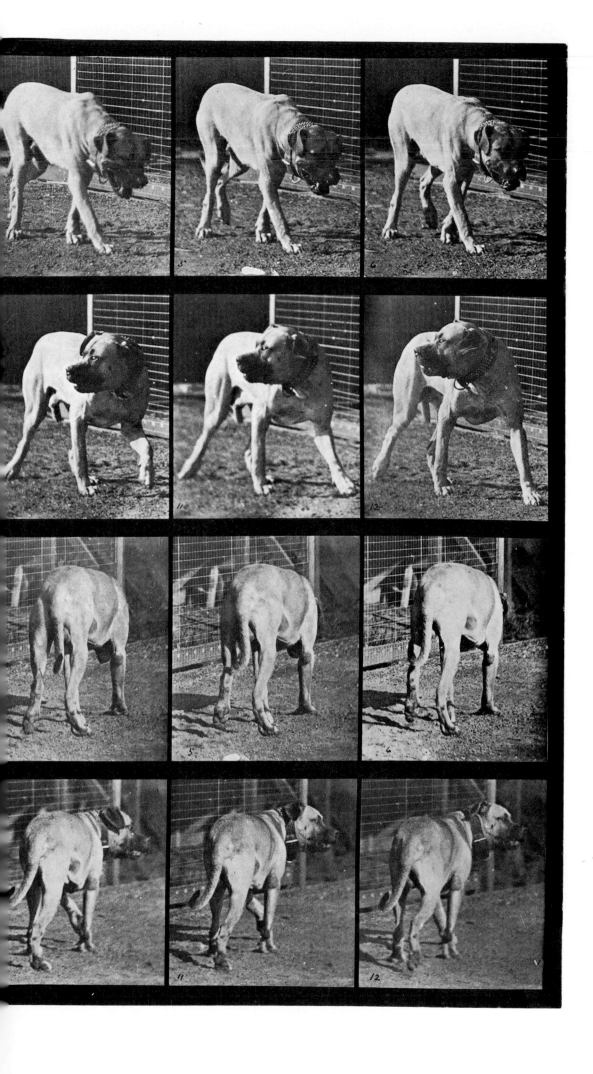

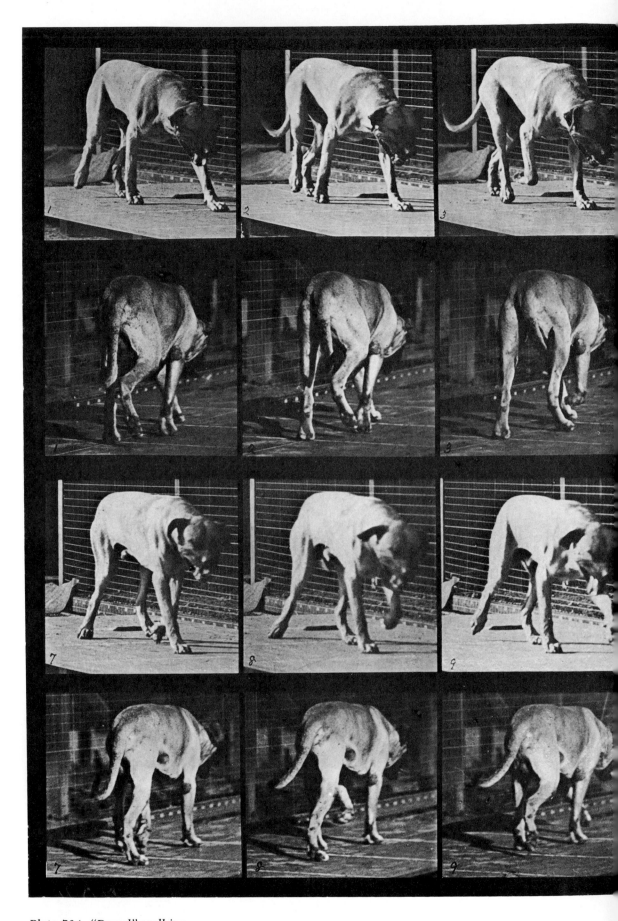

Plate 704. "Dread" walking.

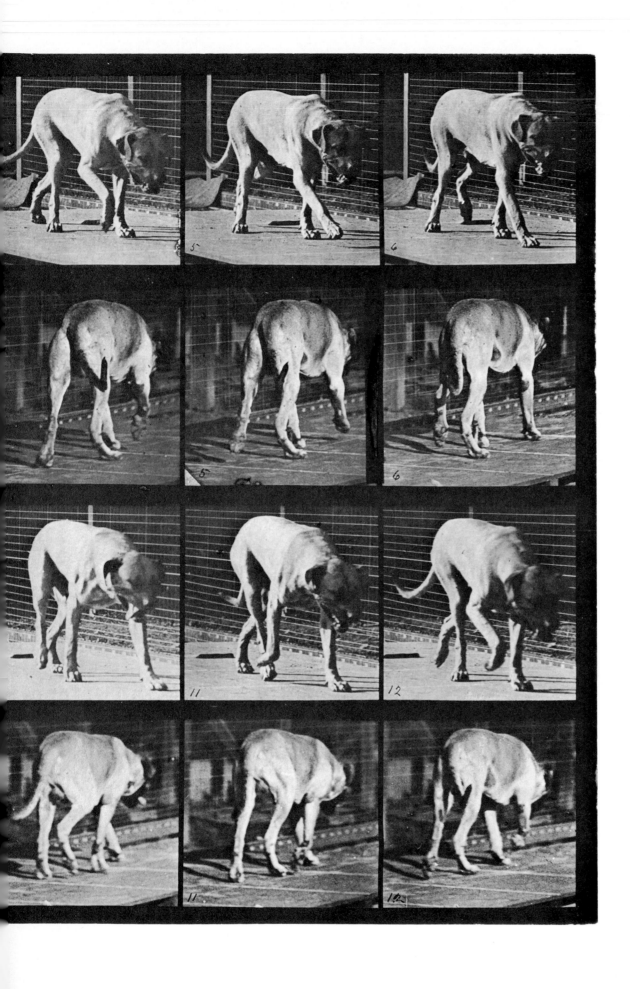

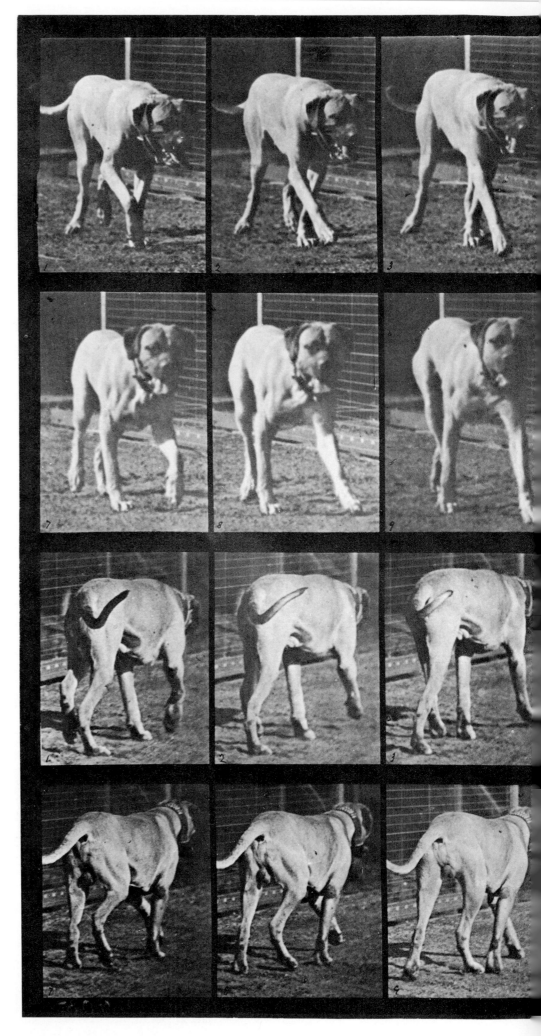

Plate 705. "Dread" trotting.

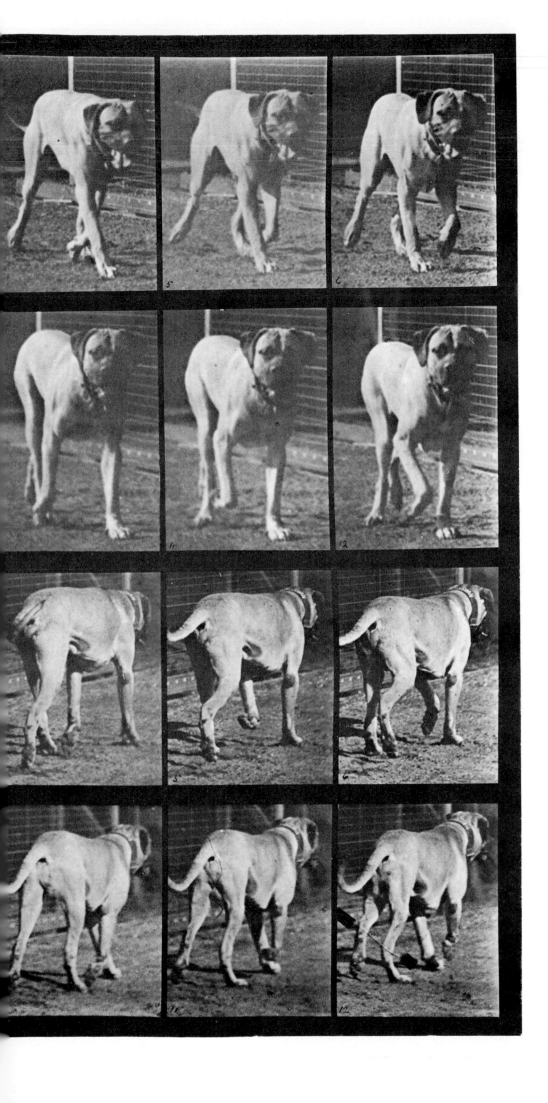

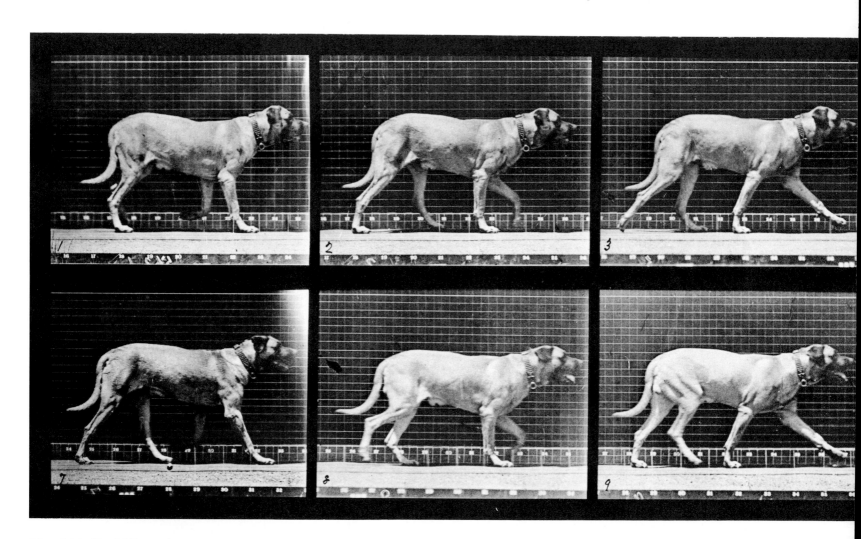

Plate 706. "Smith" trotting.

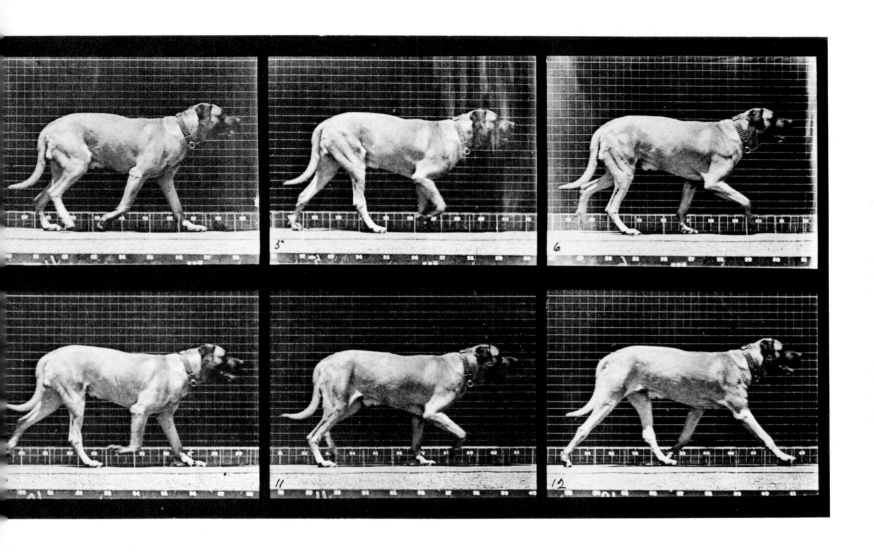

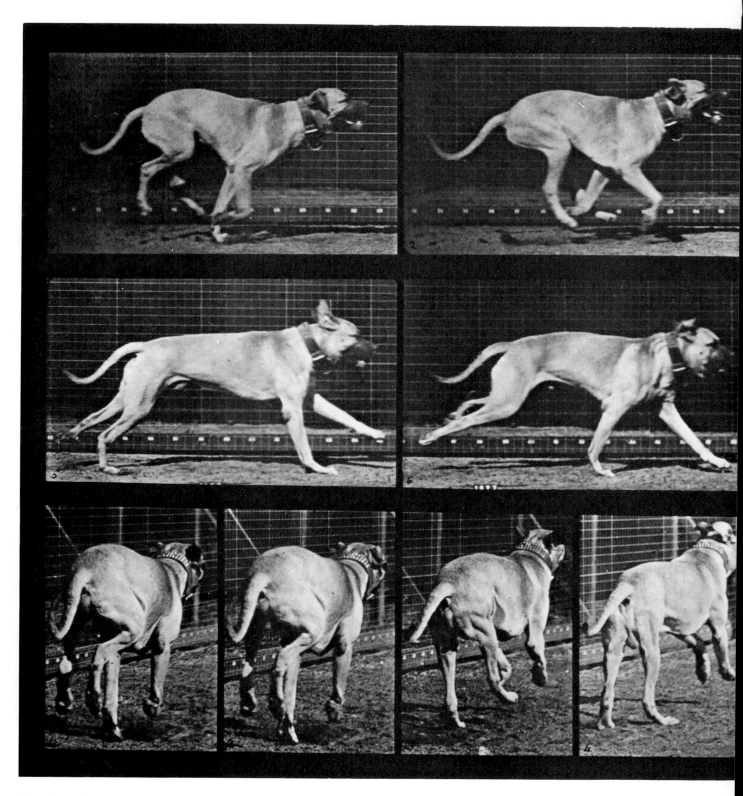

Plate 707. "Dread" galloping.

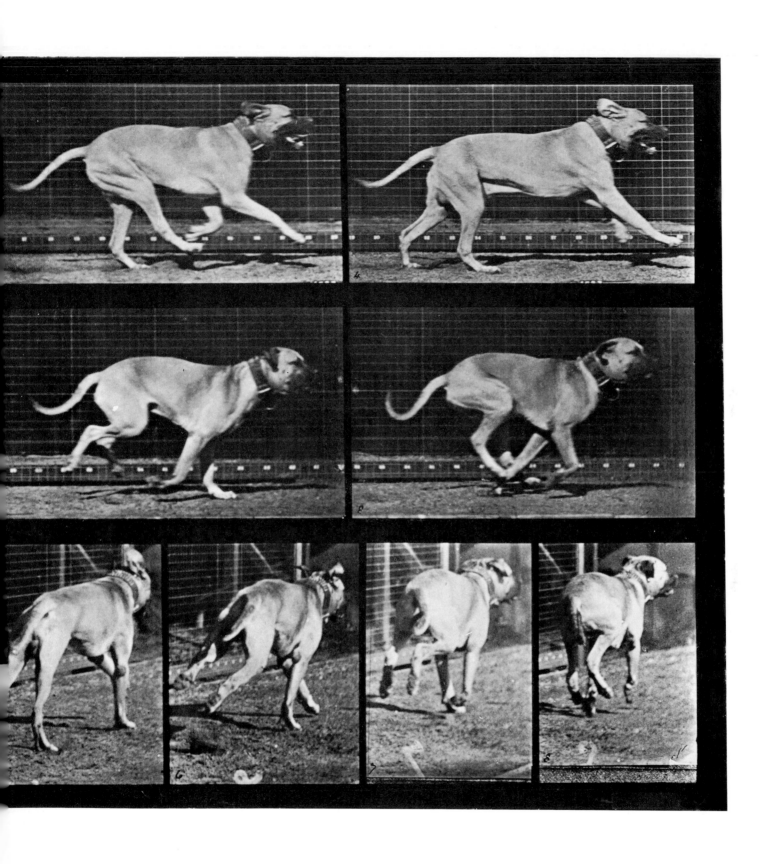

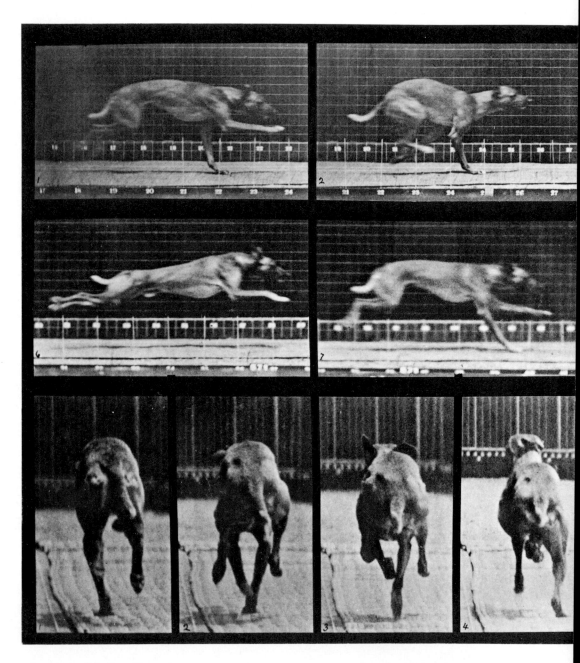

Plate 708. "Ike" galloping.

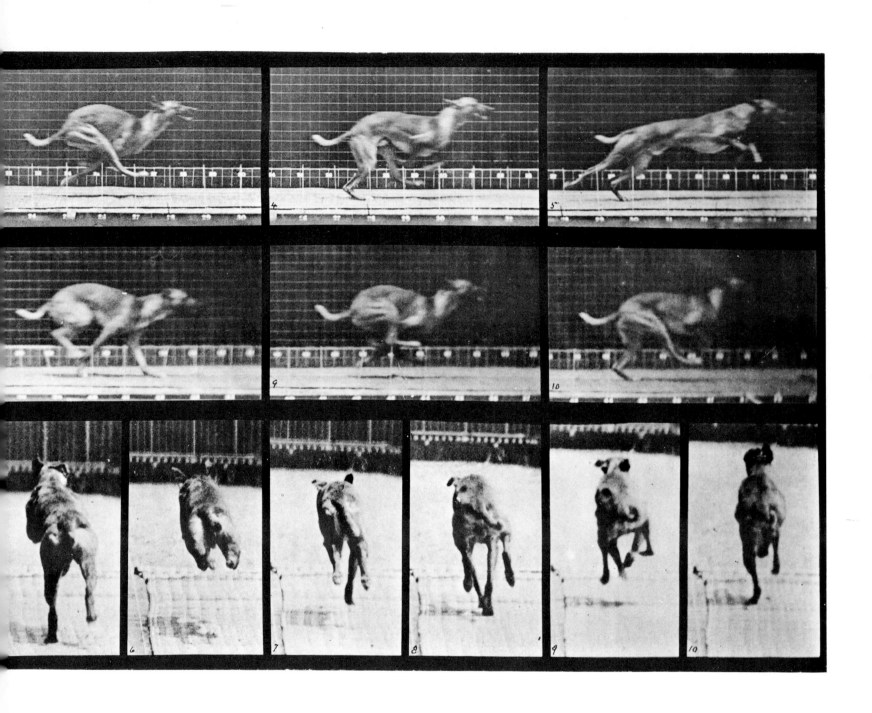

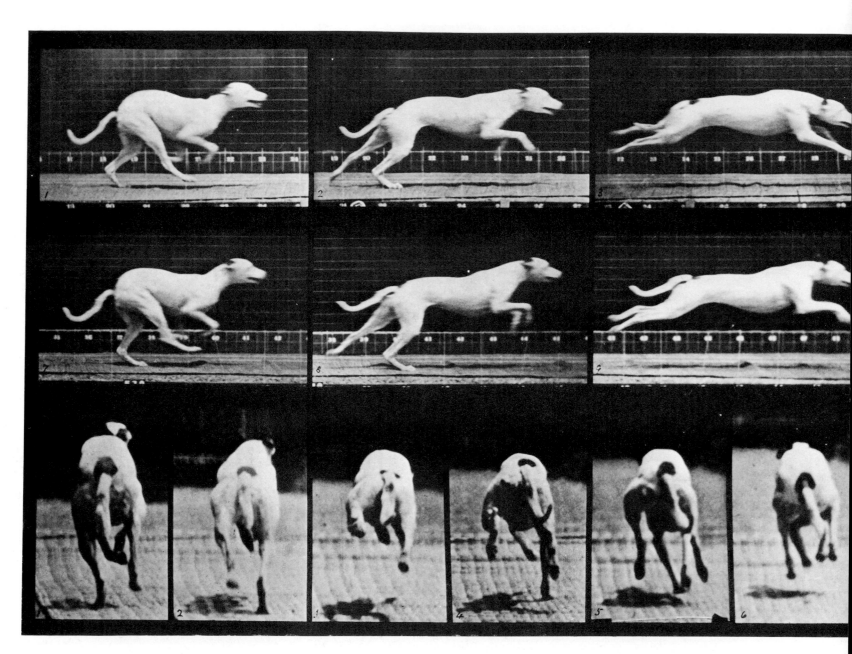

Plate 709. "Maggie" galloping.

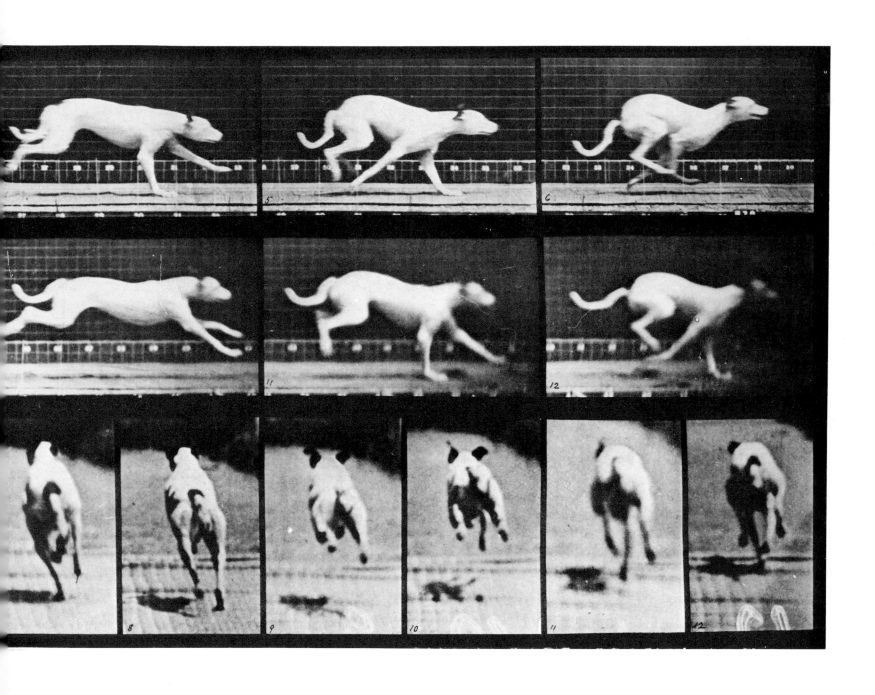

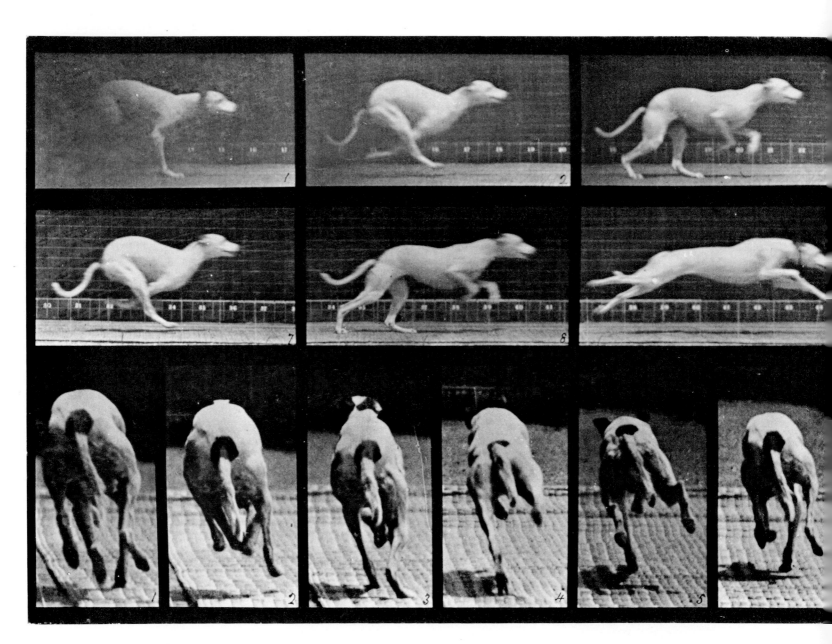

Plate 710. "Maggie" galloping.

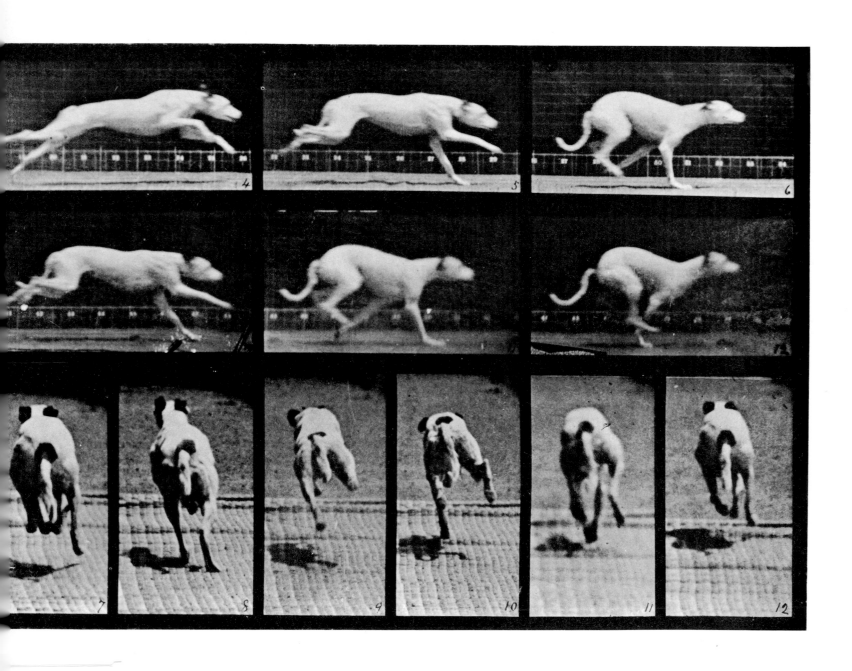

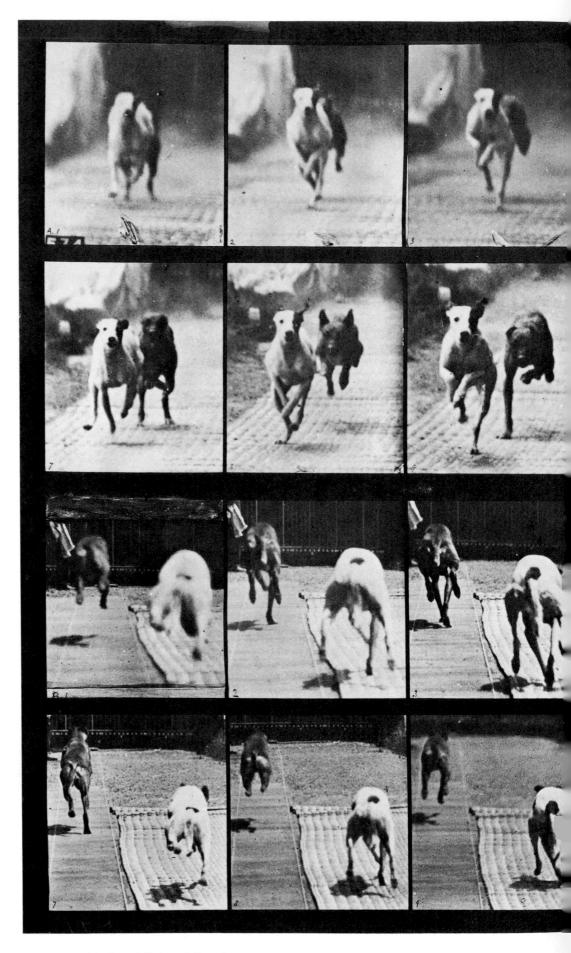

Plate 711. "Ike" and "Maggie" racing.

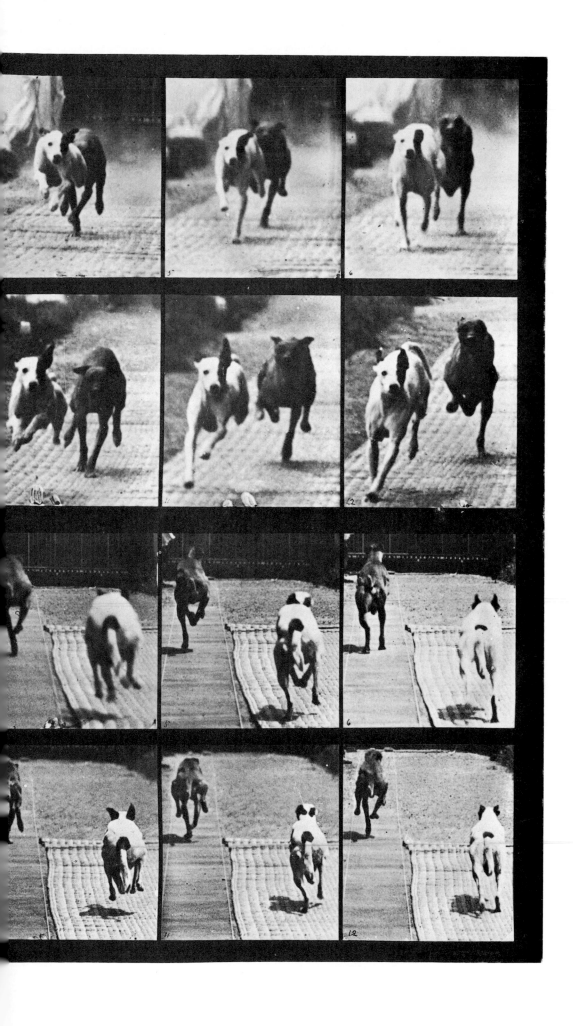

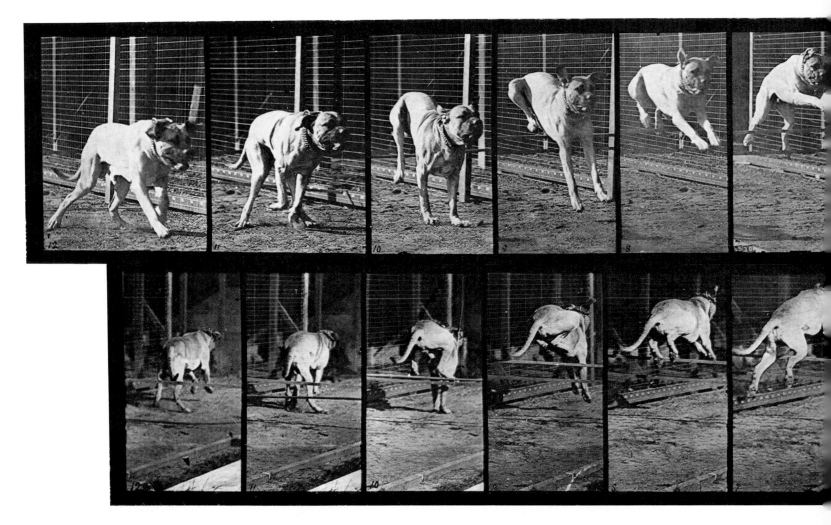

Plate 712. "Dread" jumping hurdle.

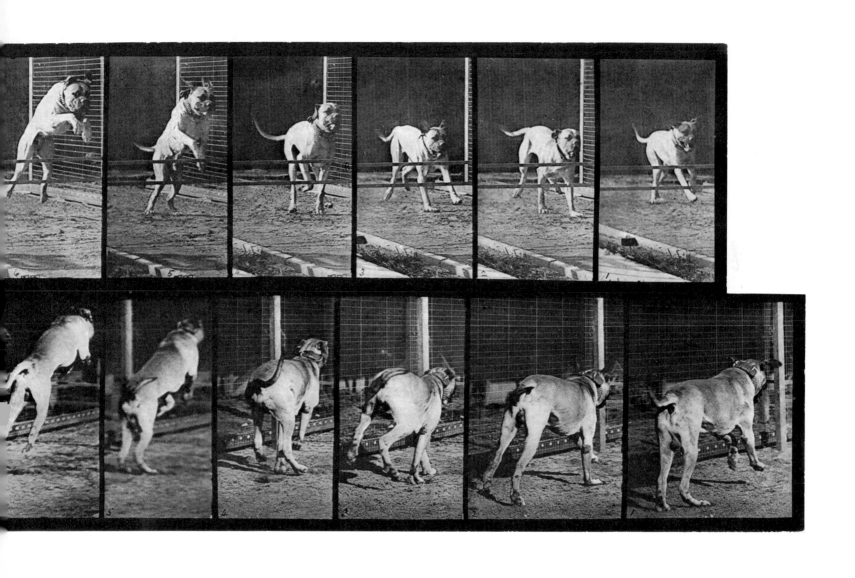

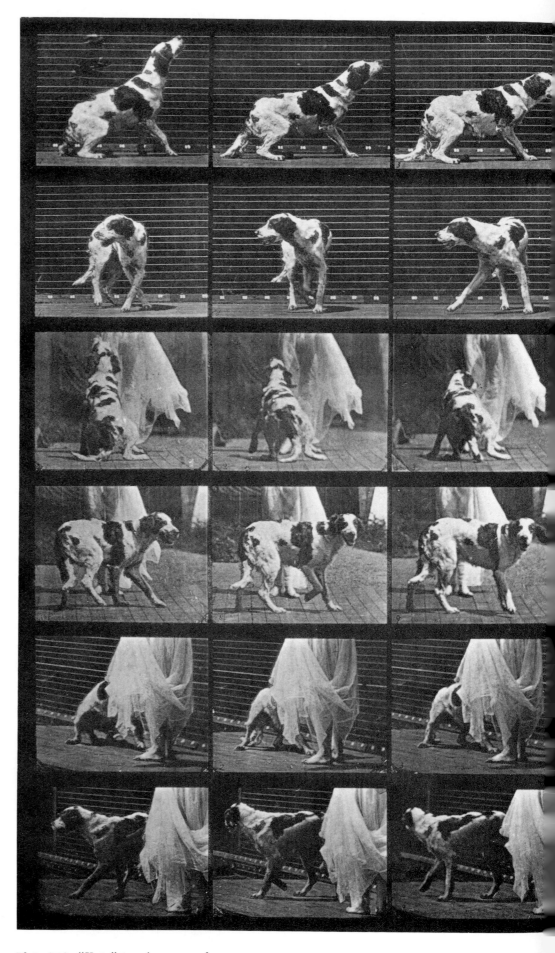

Plate 713. "Kate" turning around.

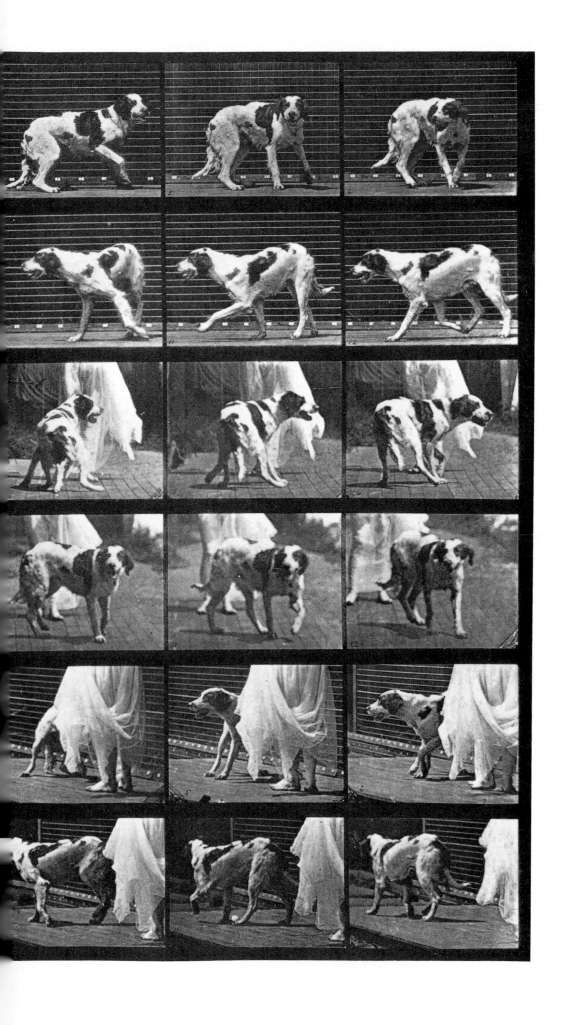

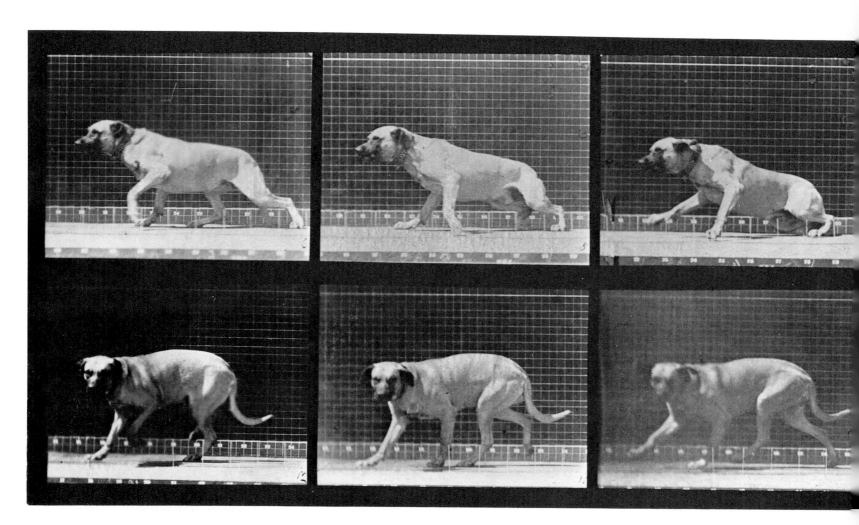

Plate 714. "Smith" aroused by a torpedo.

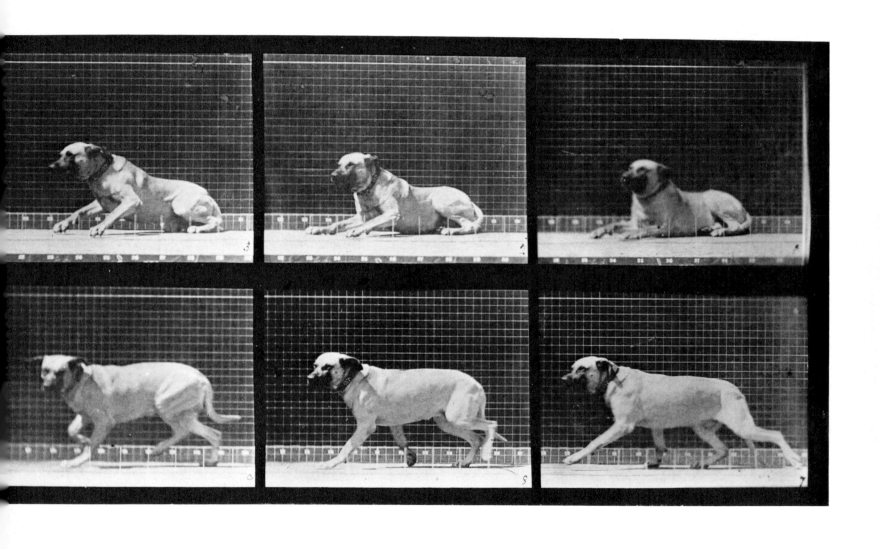

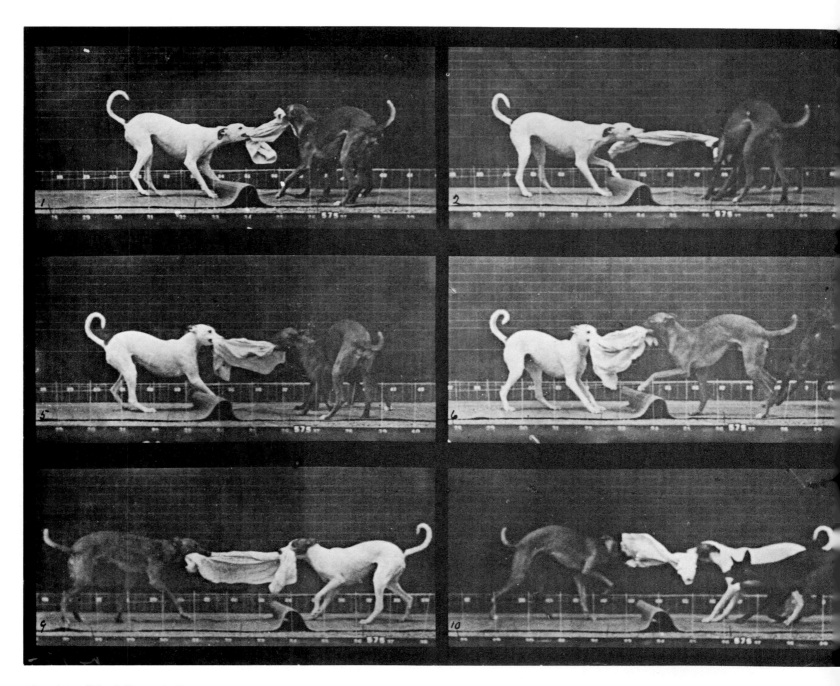

Plate 715. "Ike," "Maggie," etc. tugging at a towel.

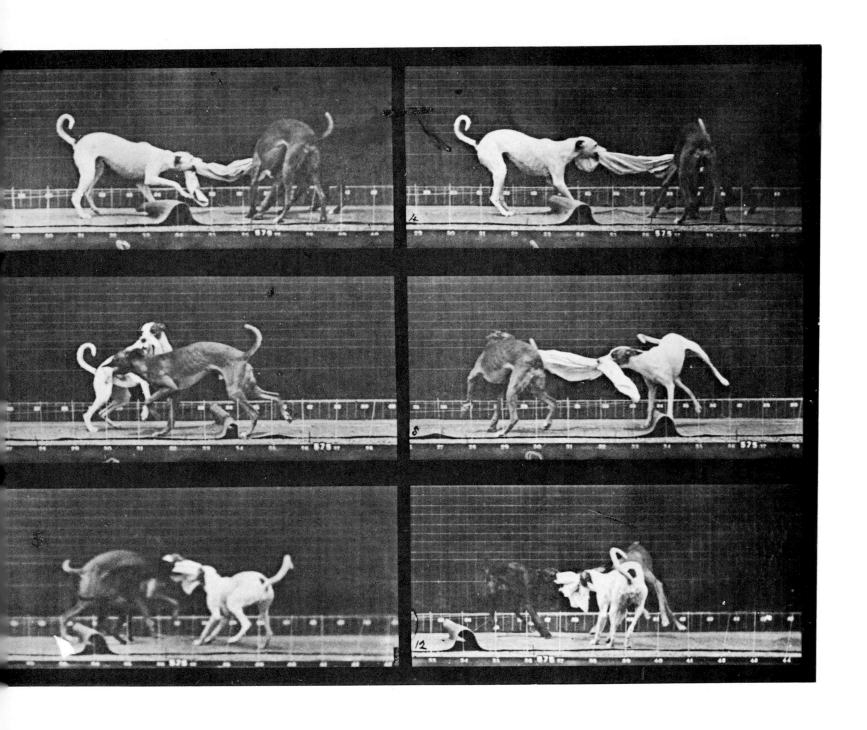

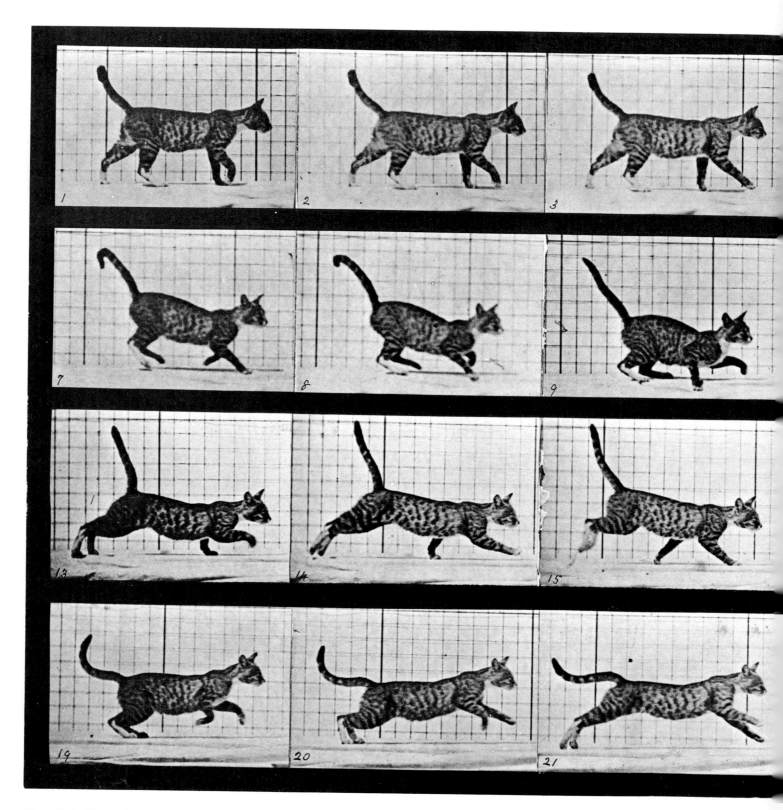

Plate 716. Cat walking, changing to a gallop.

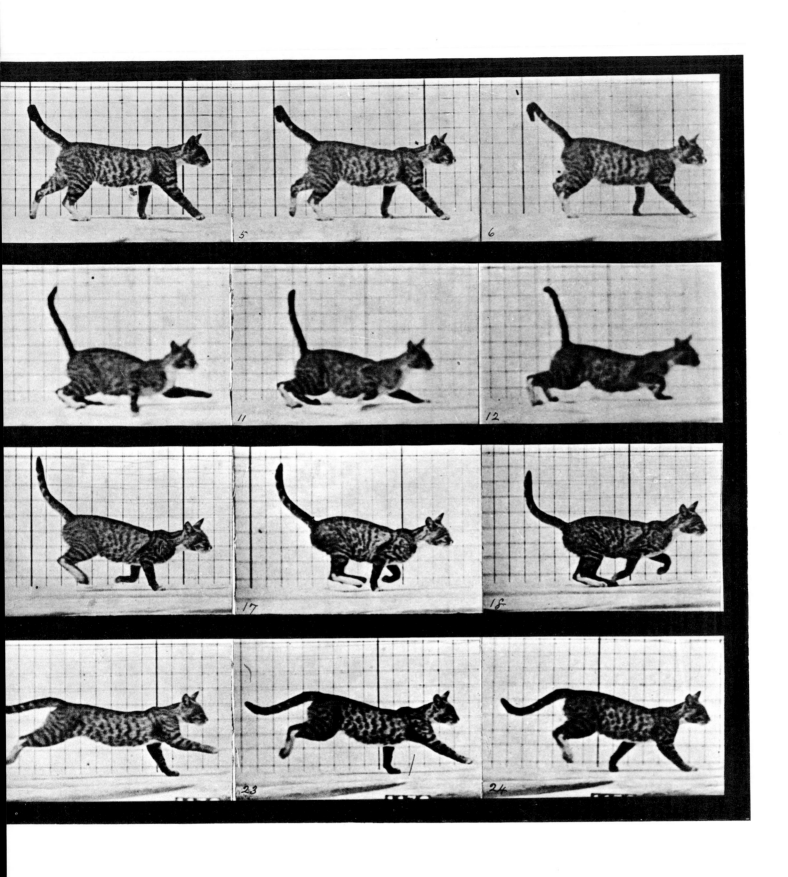

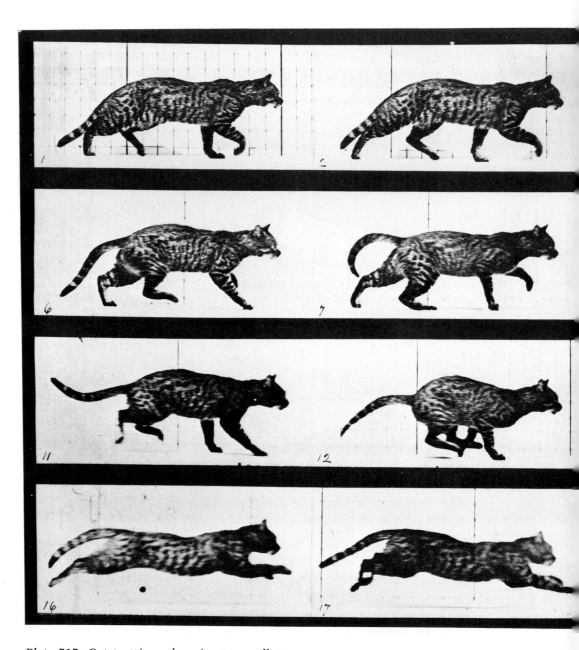

Plate 717. Cat trotting, changing to a gallop.

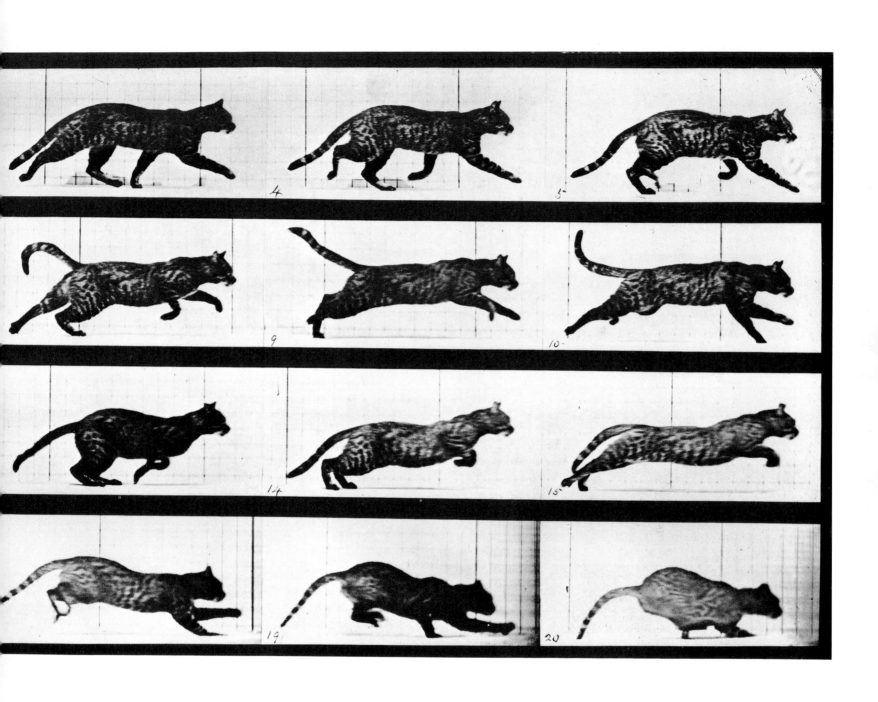

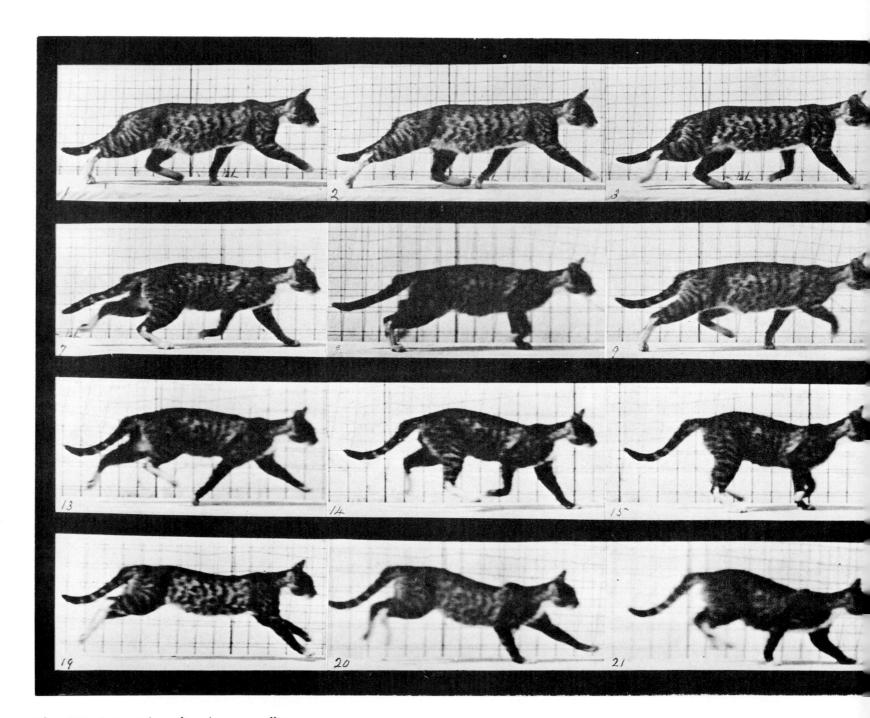

Plate 718. Cat trotting, changing to a gallop.

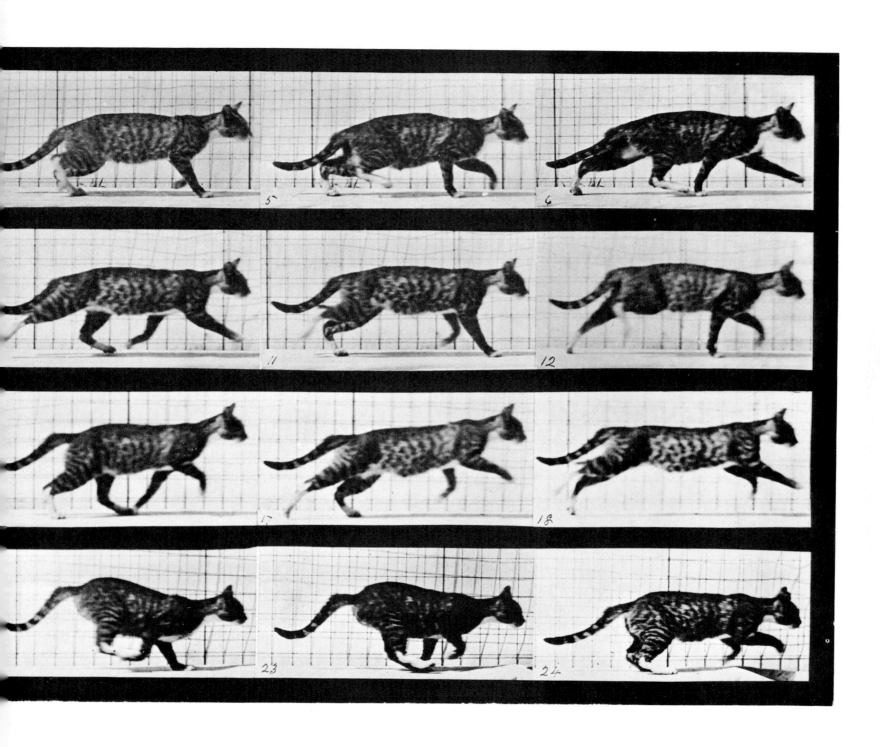

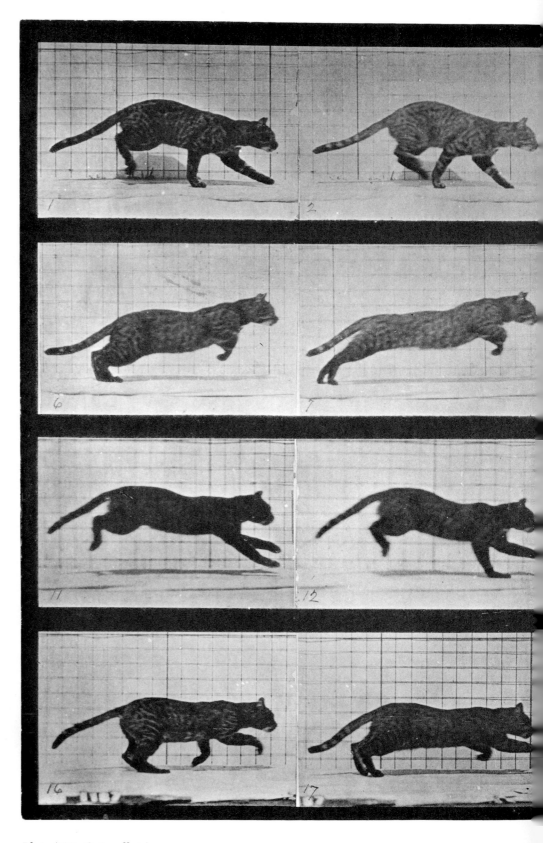

Plate 719. Cat galloping.

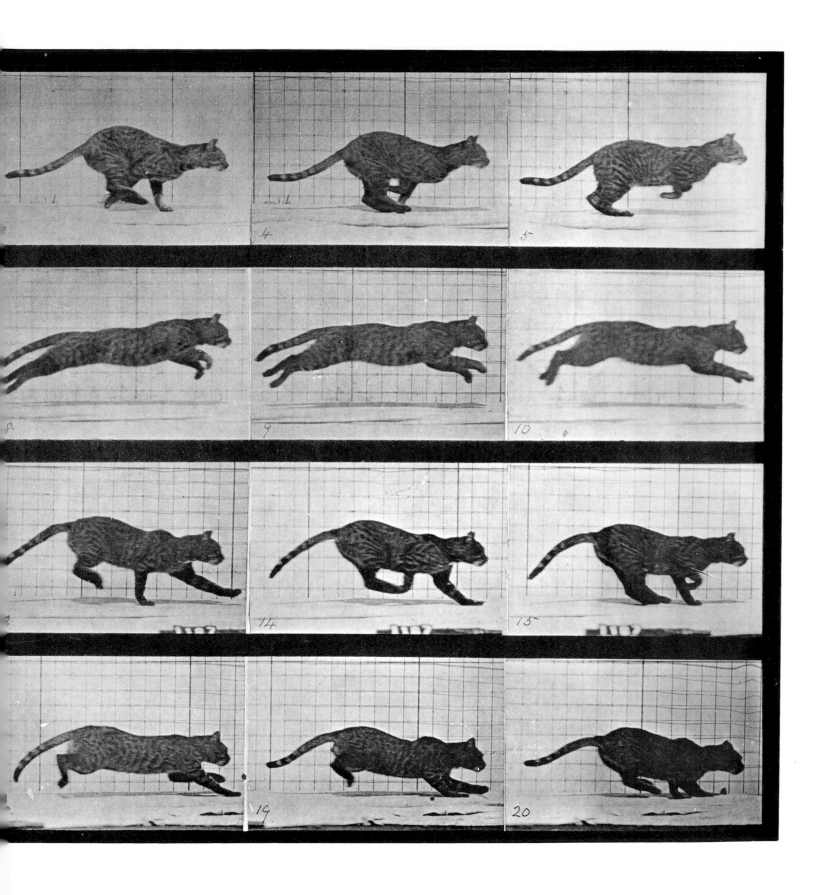

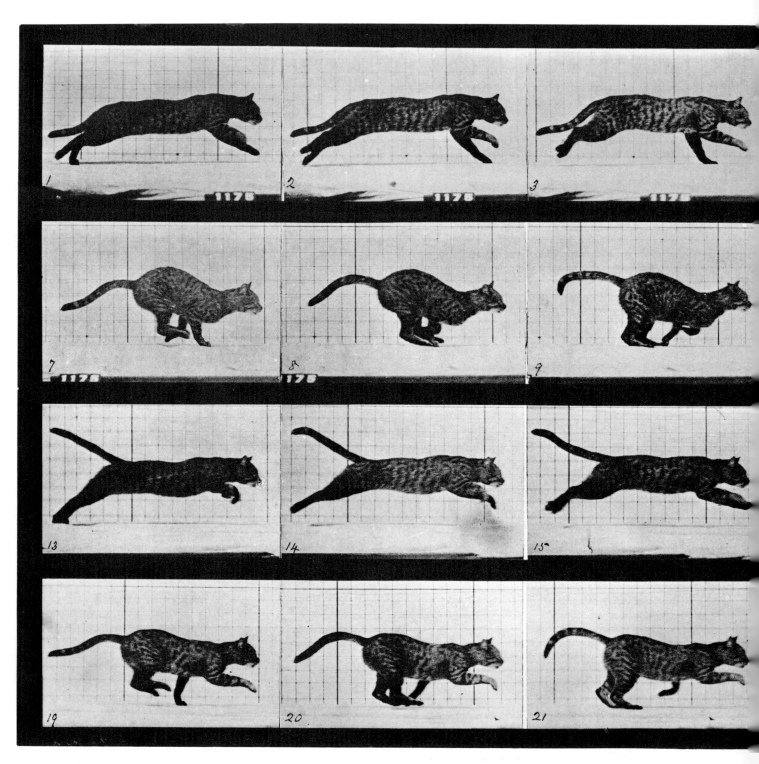

Plate 720. Cat galloping.

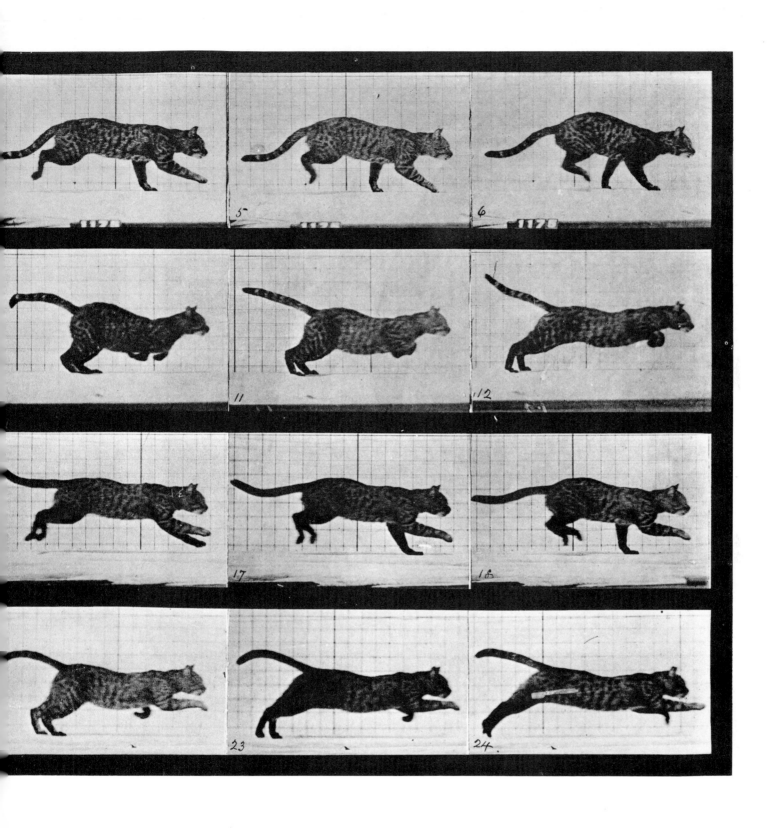

Volume 11

WILD ANIMALS
&
BIRDS

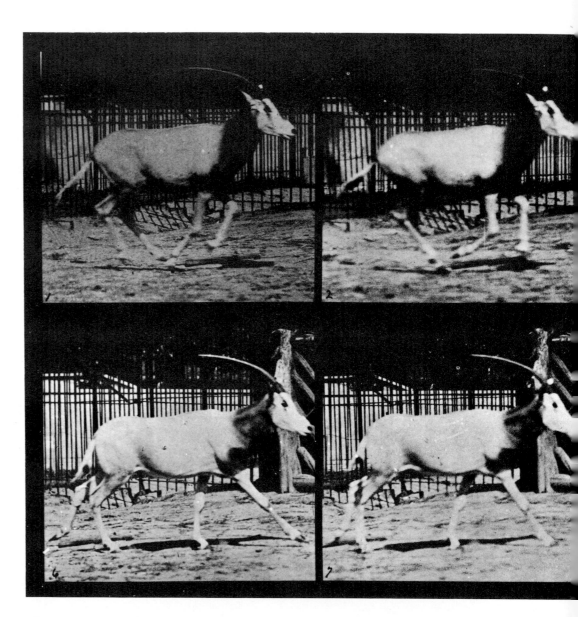

Plate 680. Oryx galloping.

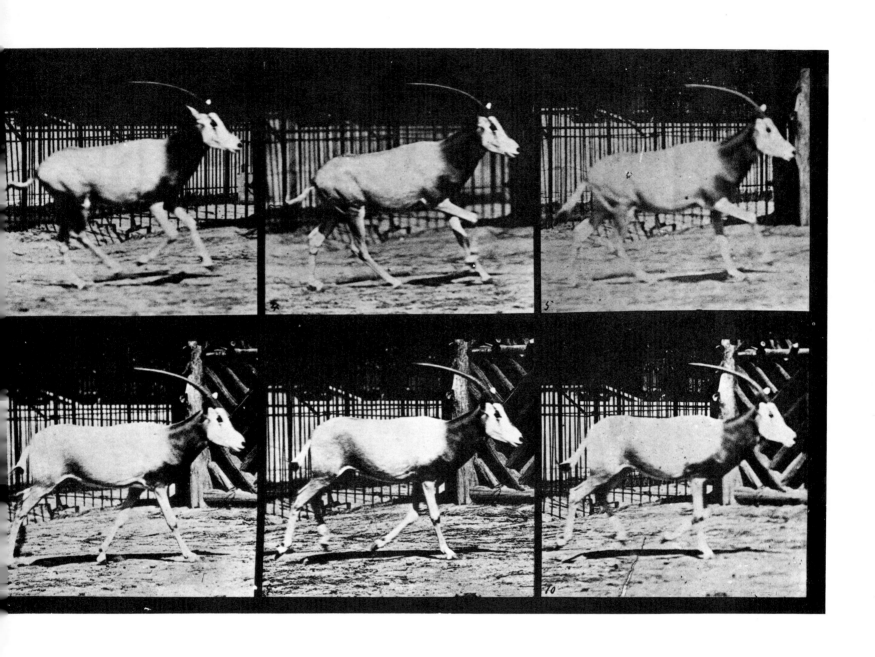

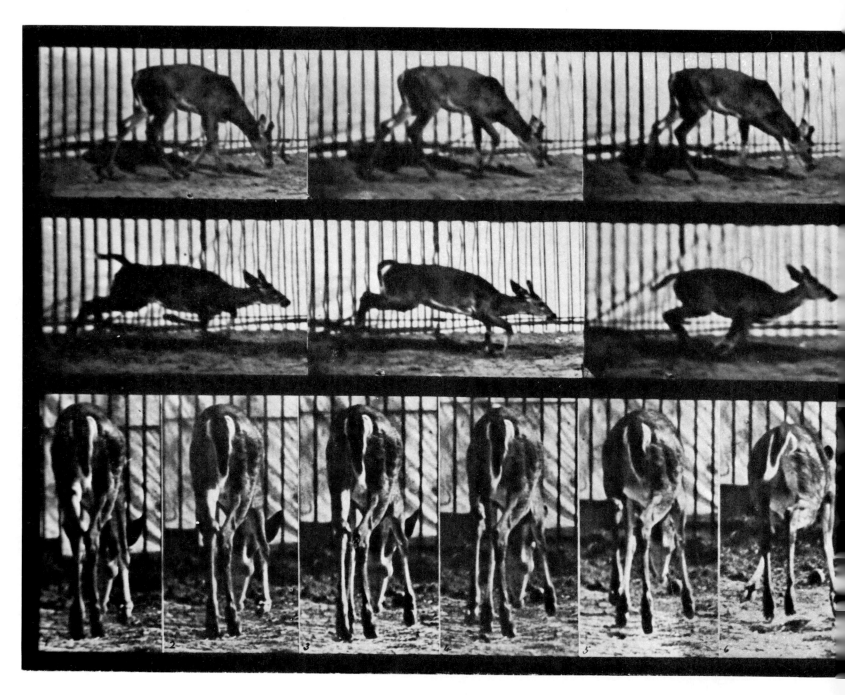

Plate 681. Virginia deer, buck, walking, startled to a gallop.

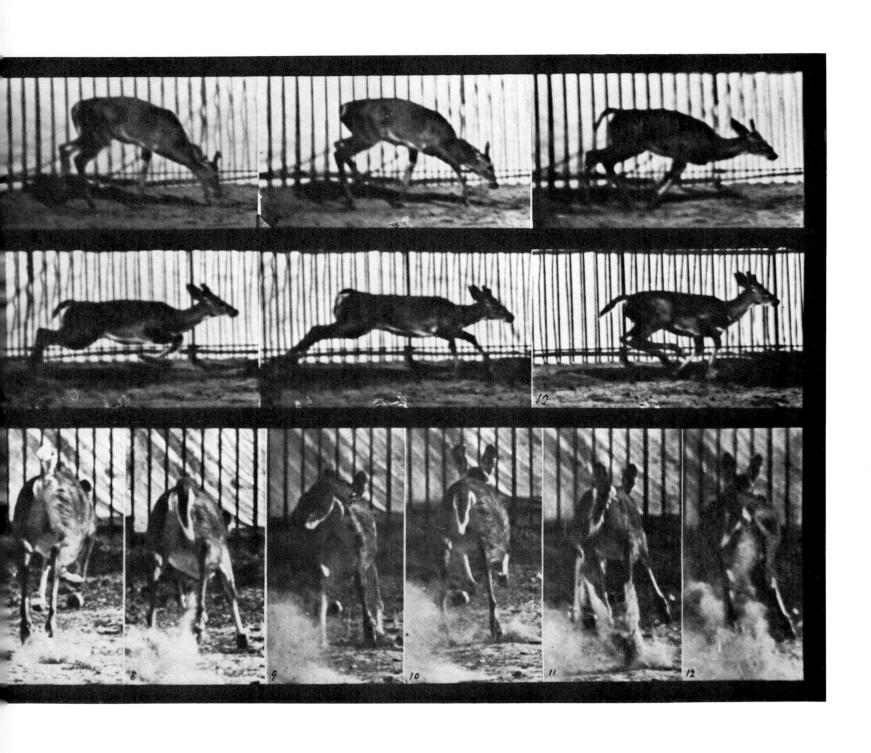

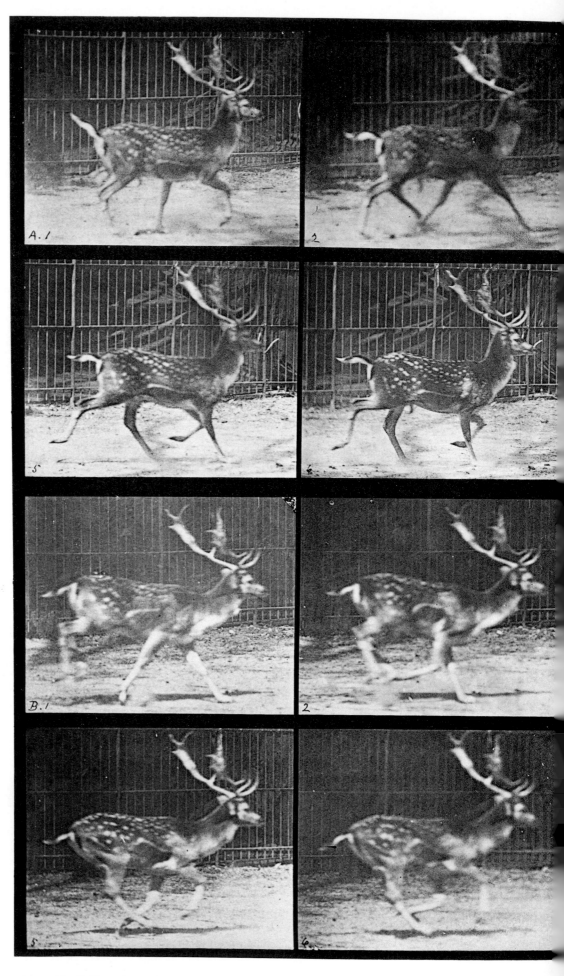

Plate 682. *Fallow deer, buck. A: Trotting. B: Galloping.*

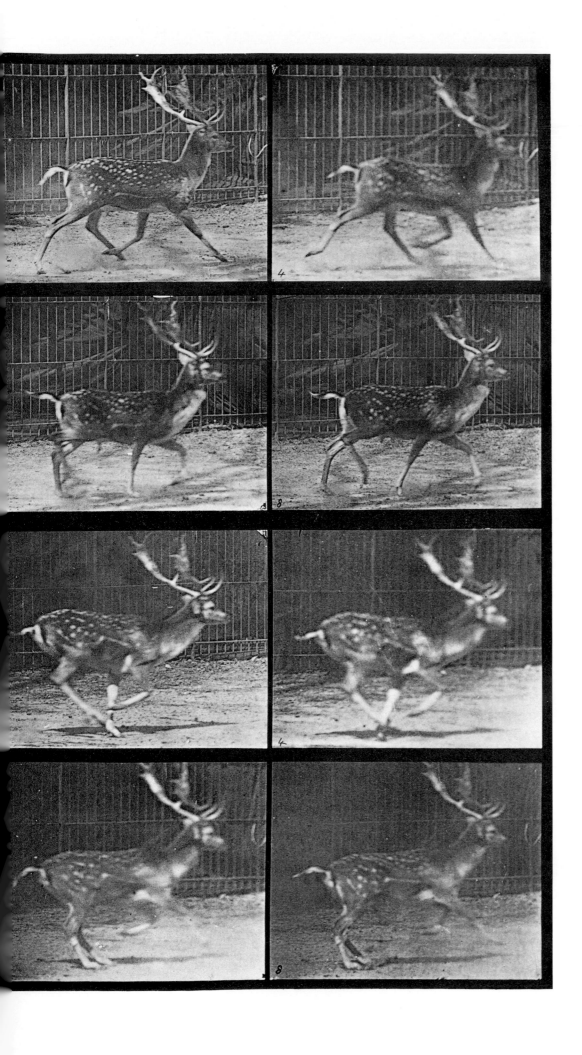

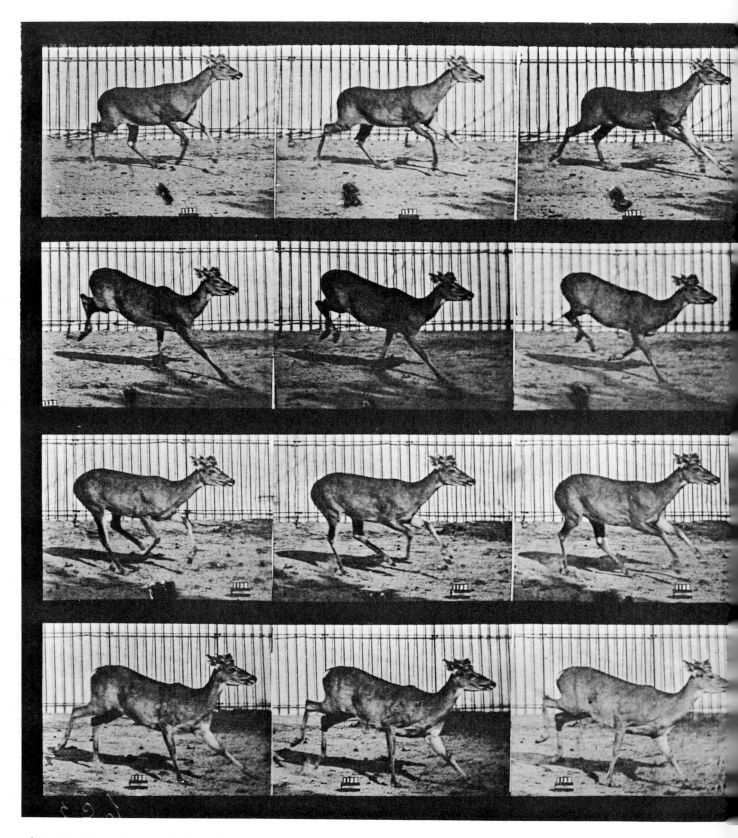

Plate 683. Virginia deer, buck, galloping.

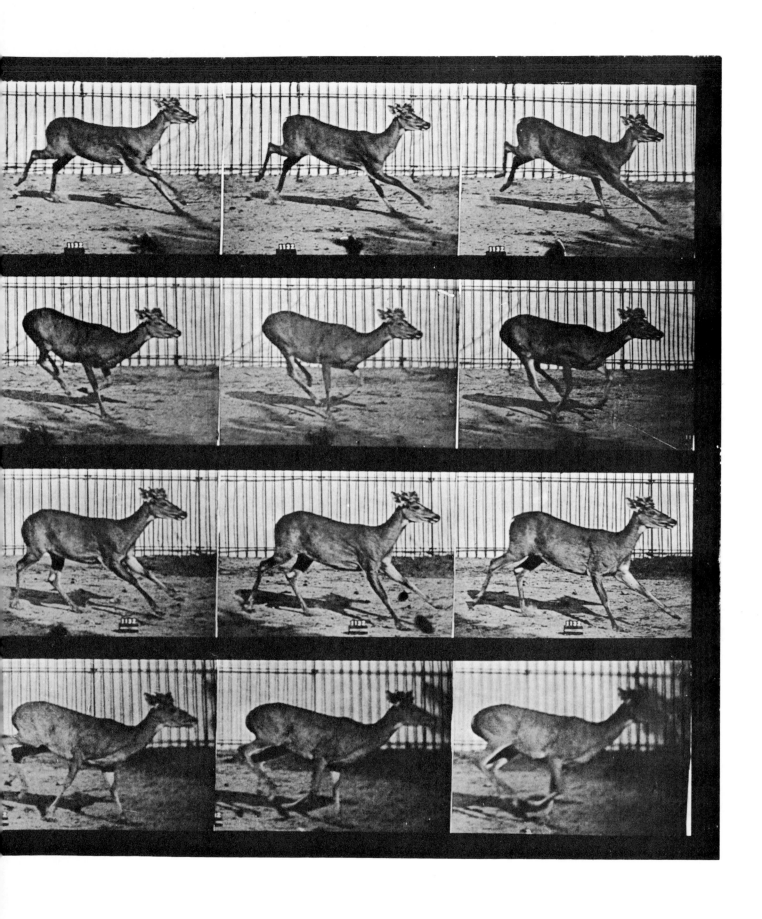

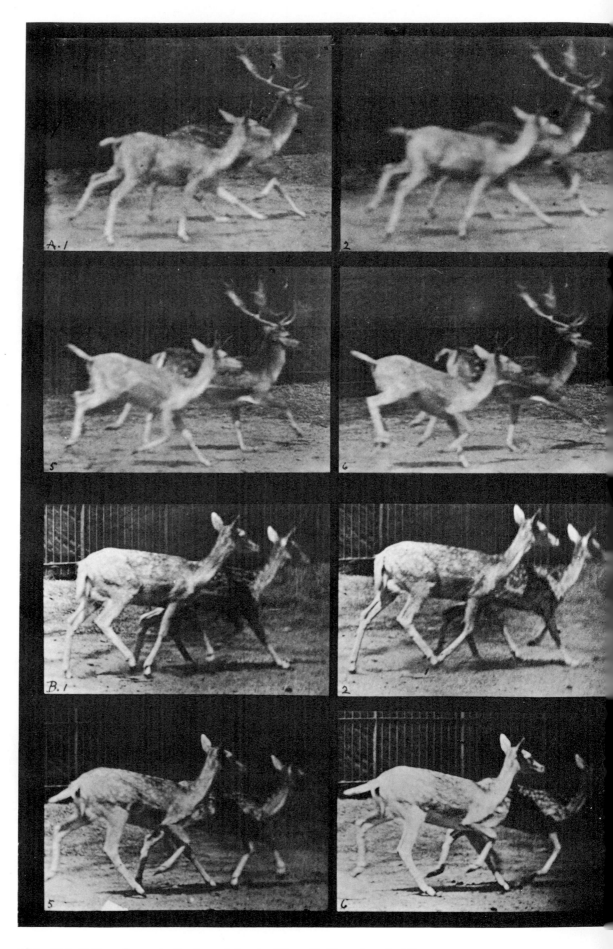

Plate 684. Fallow deer. A: Buck and doe trotting. B: Two does trotting.

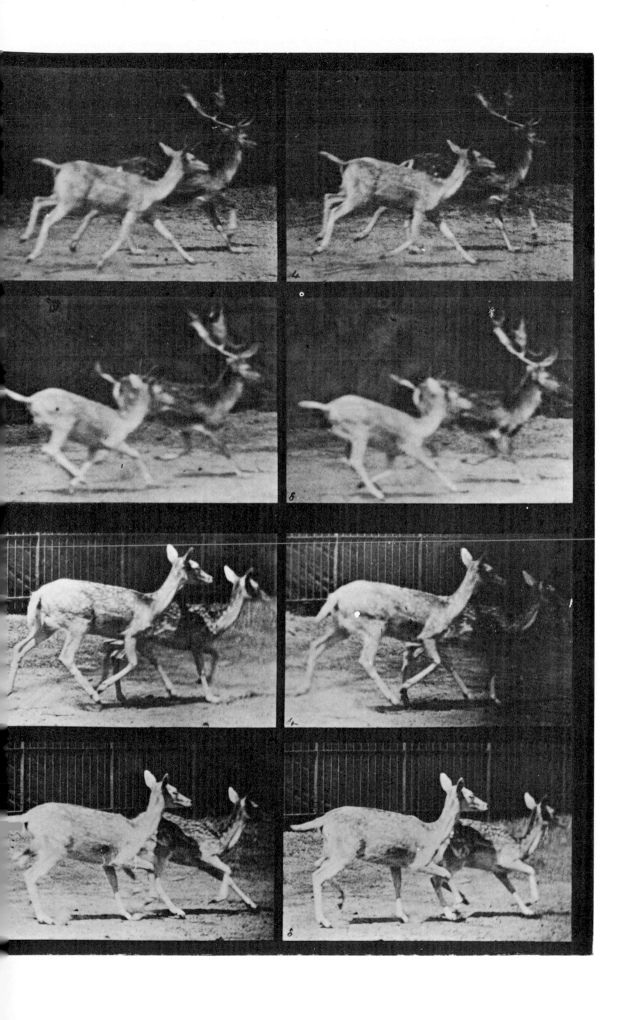

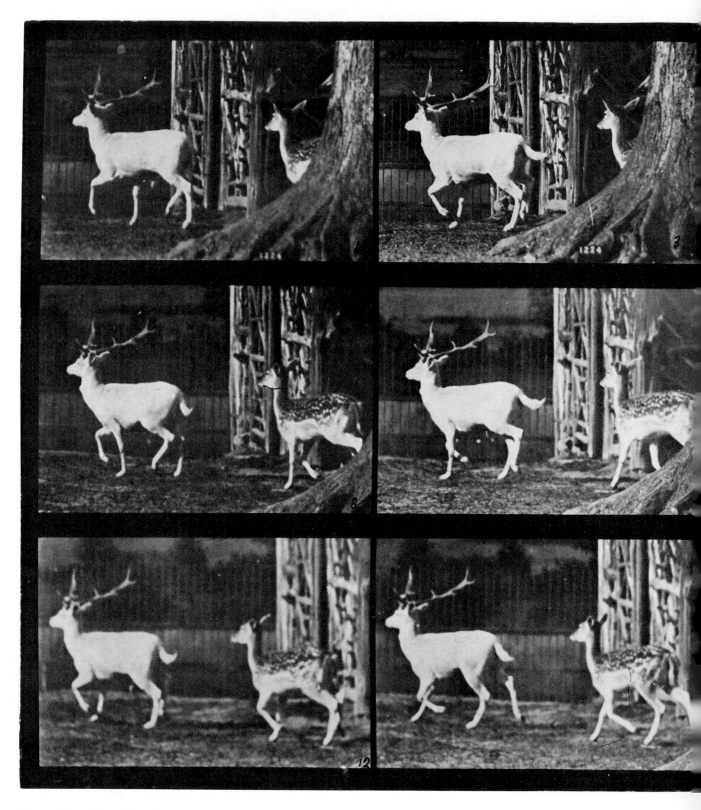

Plate 685. Fallow deer, buck and doe, trotting.

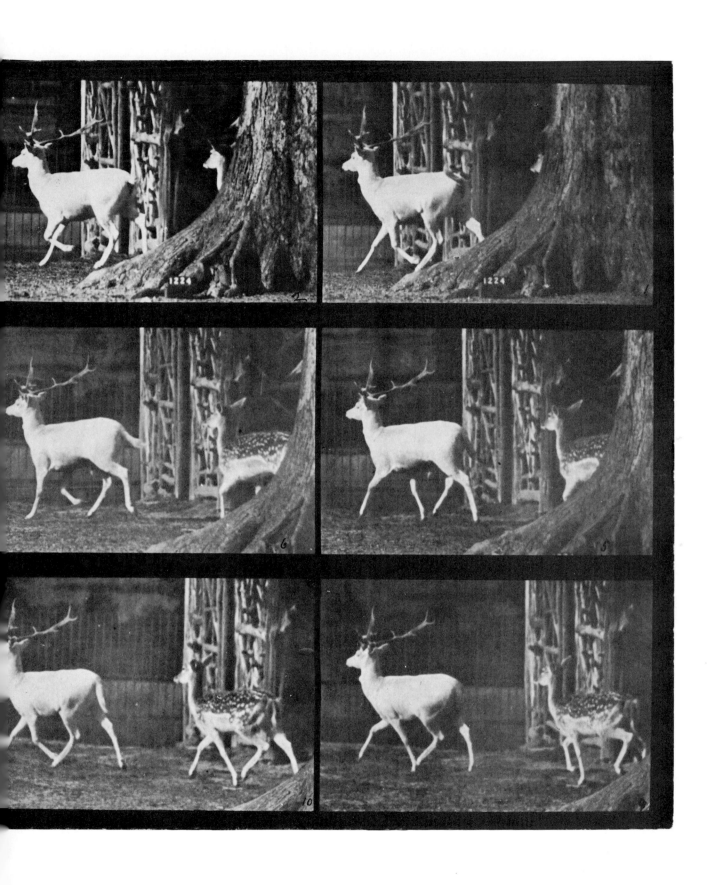

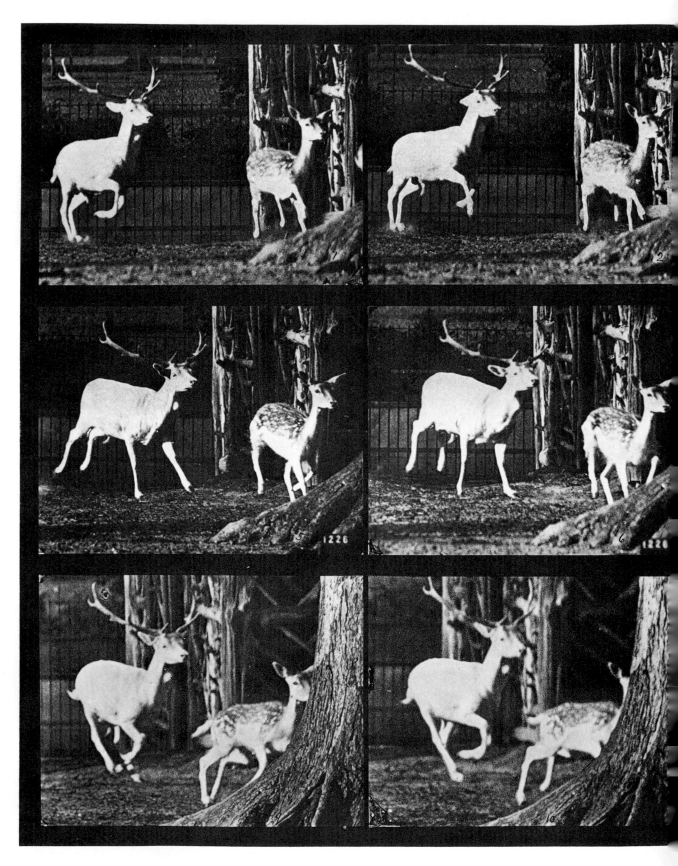

Plate 686. Fallow deer, buck and doe, galloping.

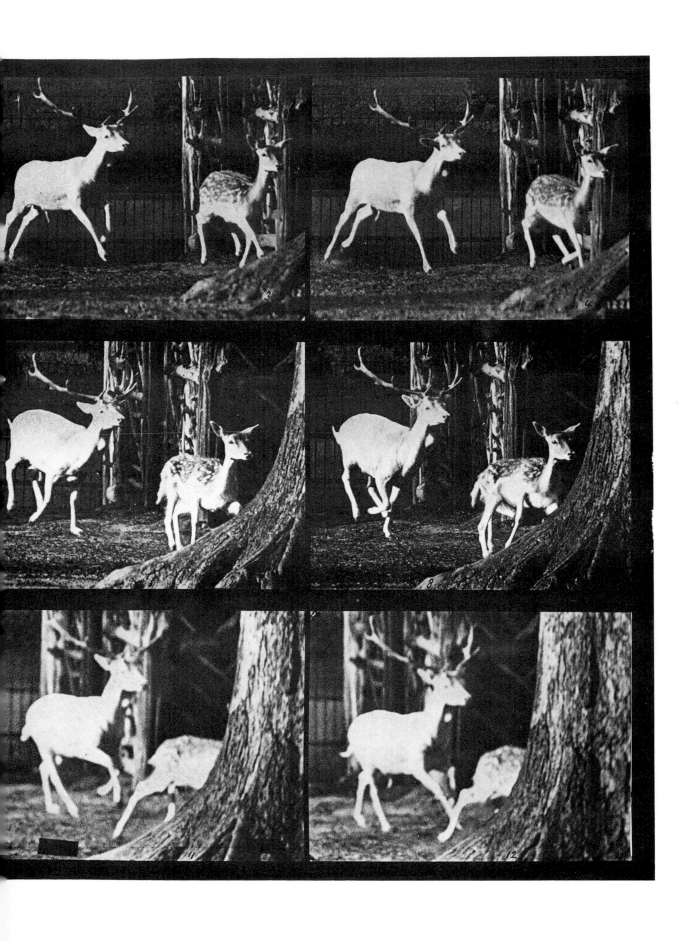

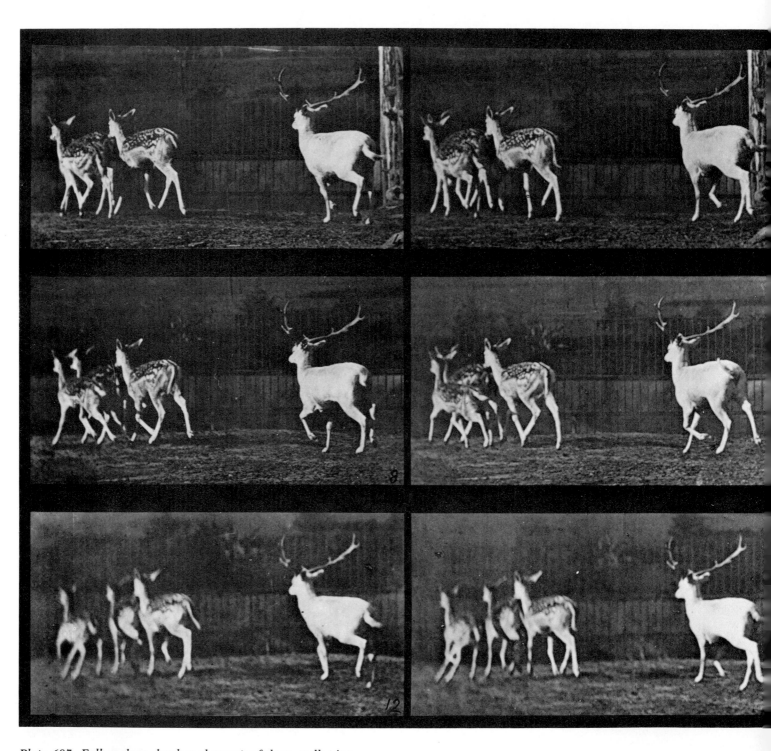

Plate 687. Fallow deer, buck and group of does, galloping.

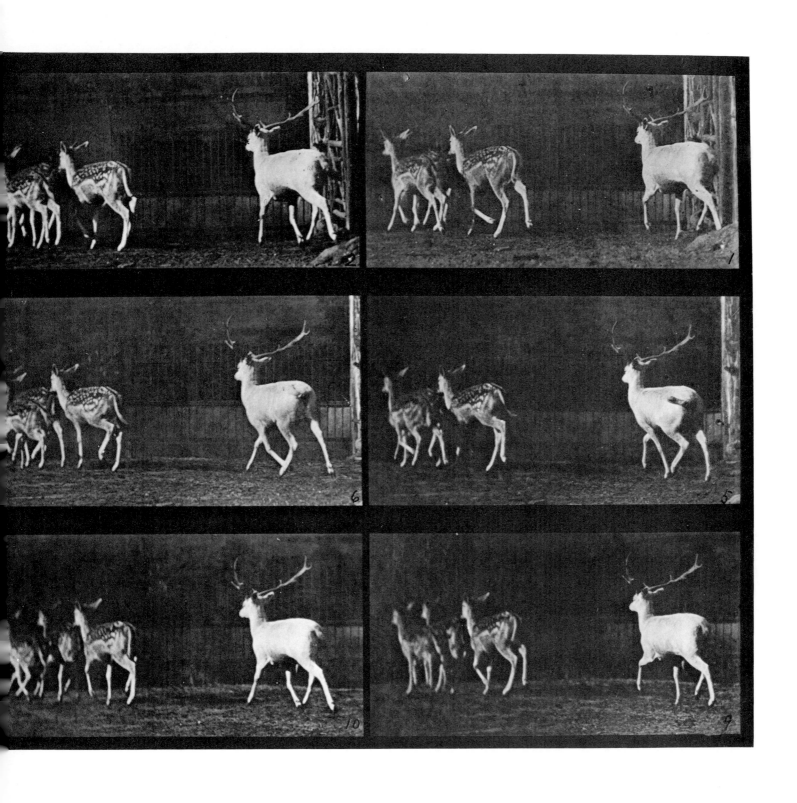

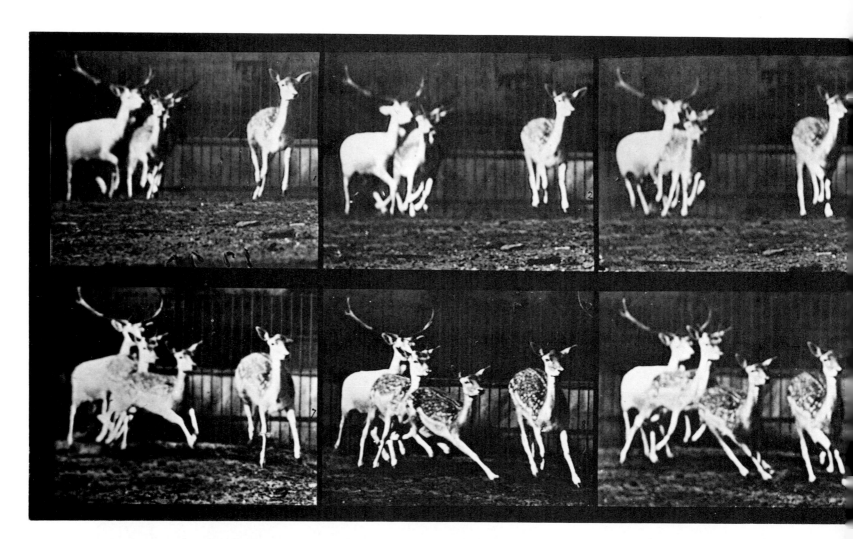

Plate 688. Fallow deer, buck and group of does, galloping.

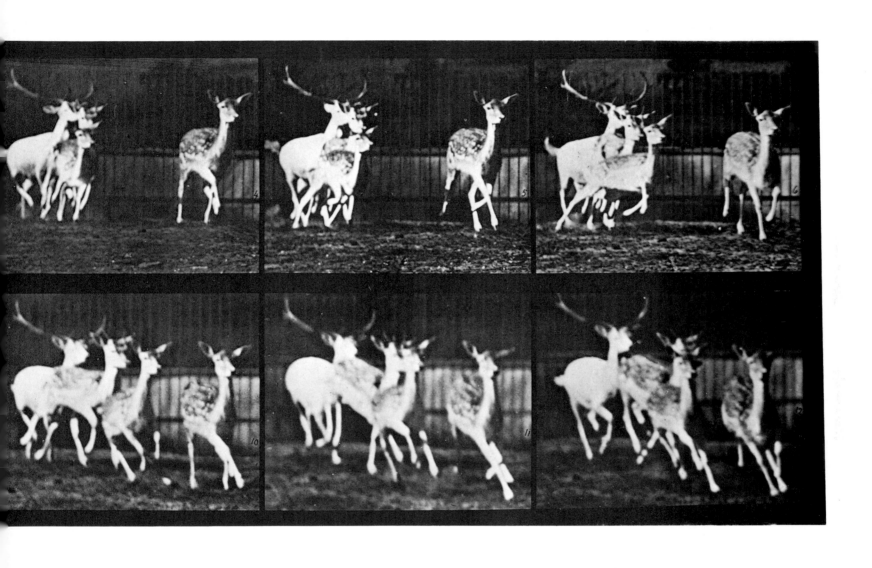

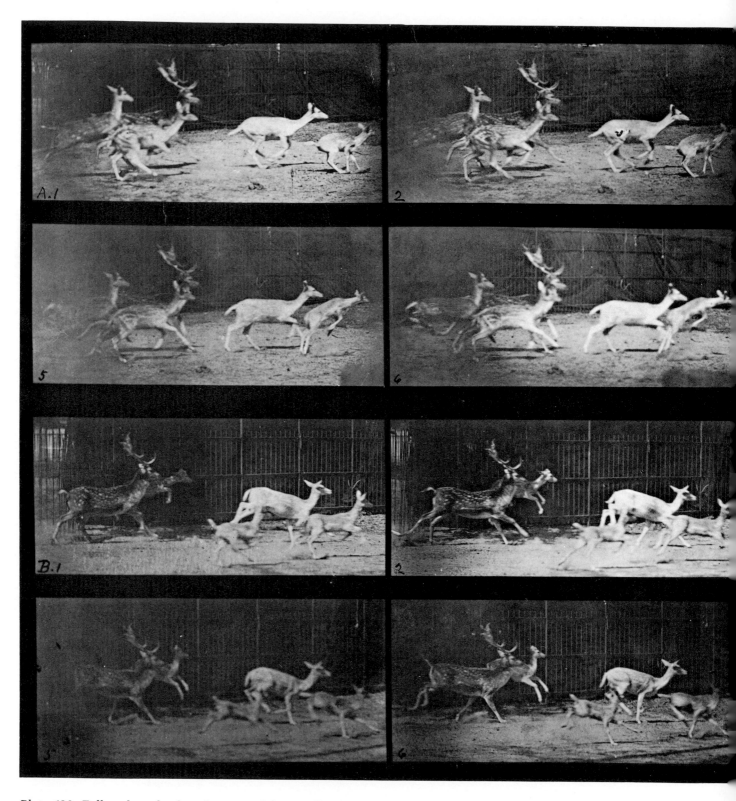

Plate 689. Fallow deer, buck and group of does, galloping.

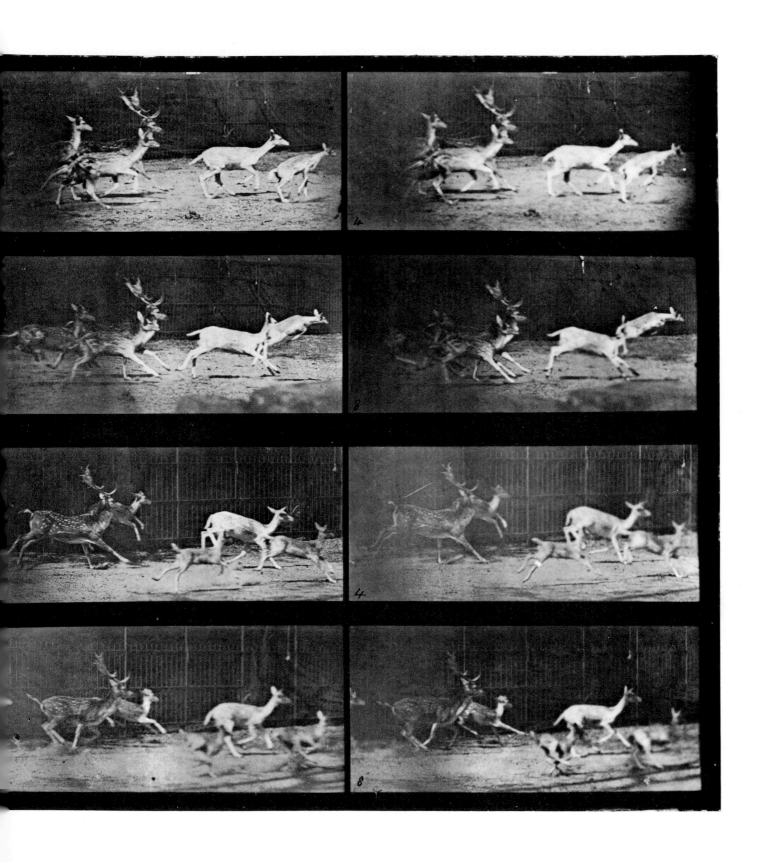

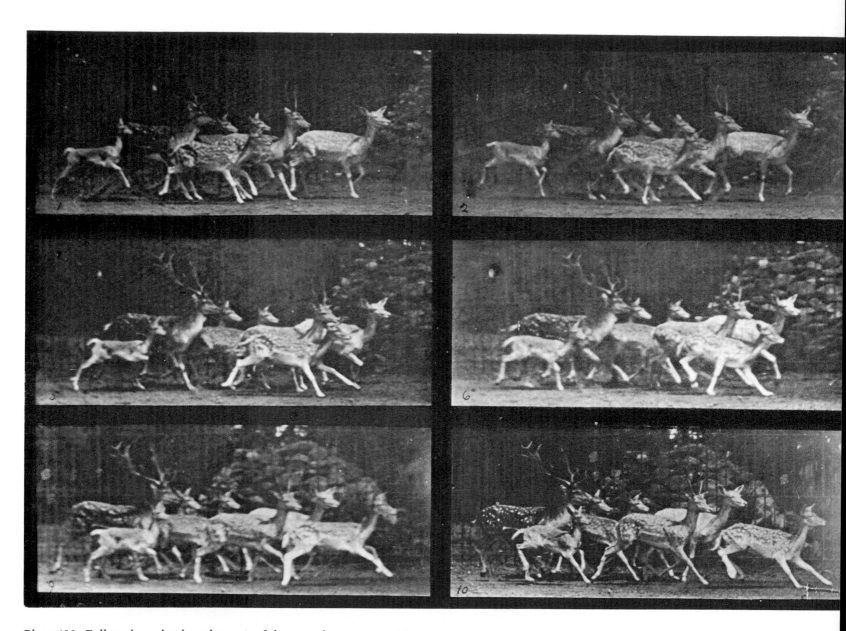

Plate 690. Fallow deer, buck and group of does, various movements.

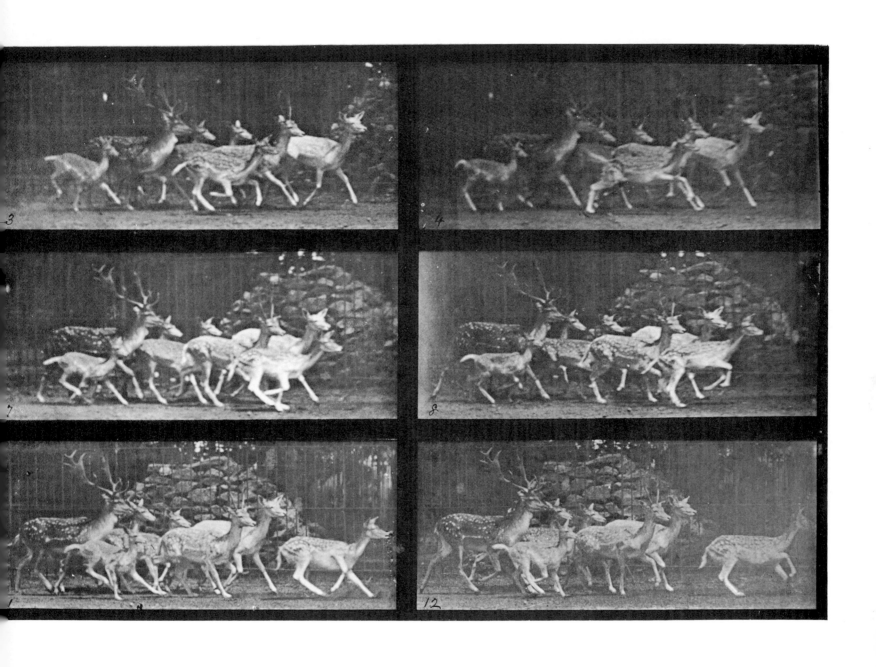

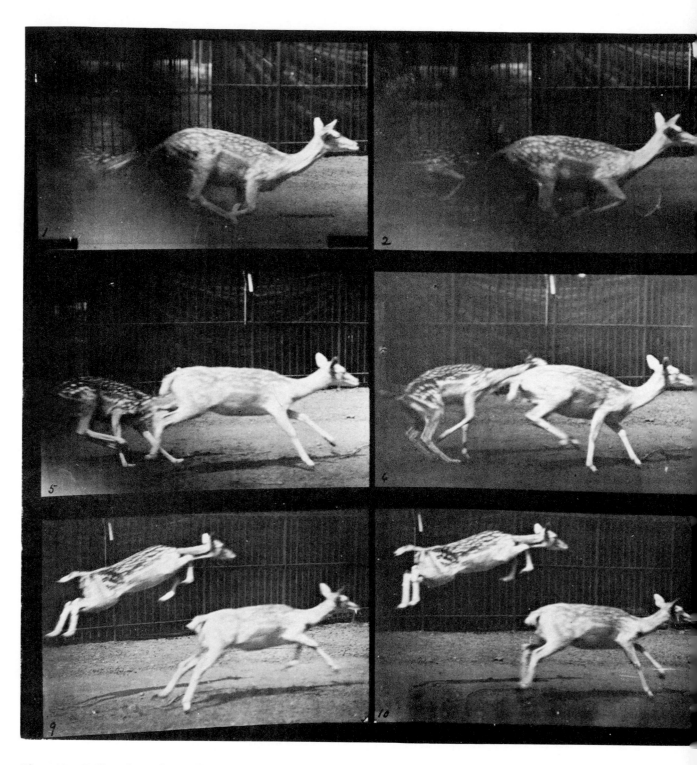

Plate 691. Fallow deer, doe galloping and kid jumping.

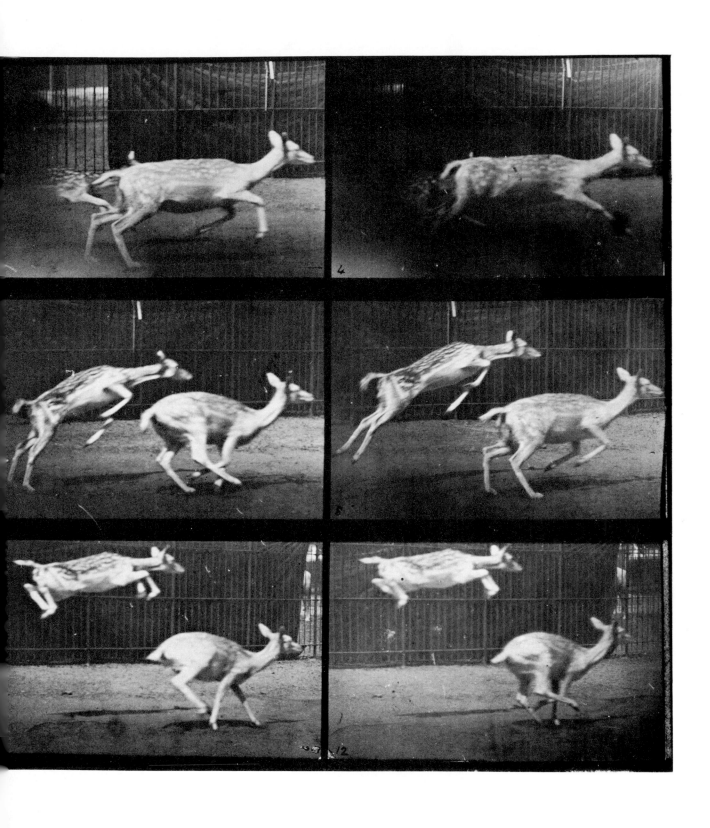

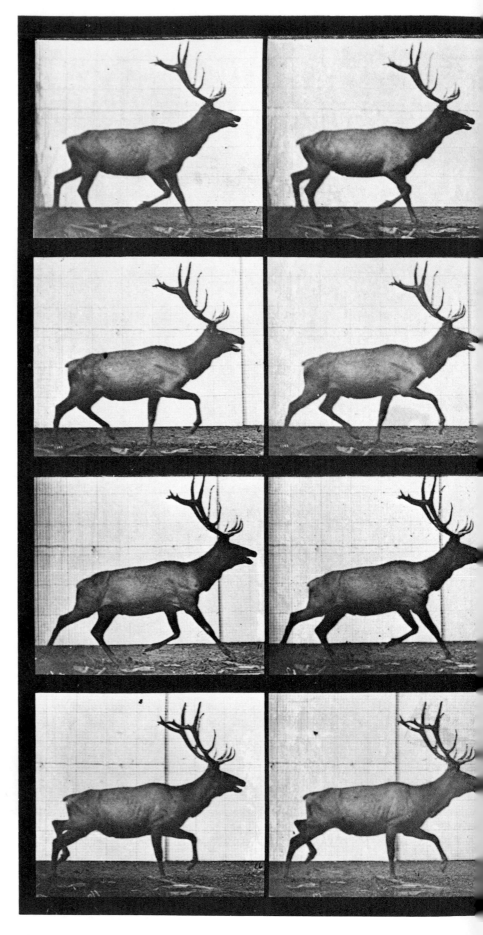

Plate 692. Elk trotting.

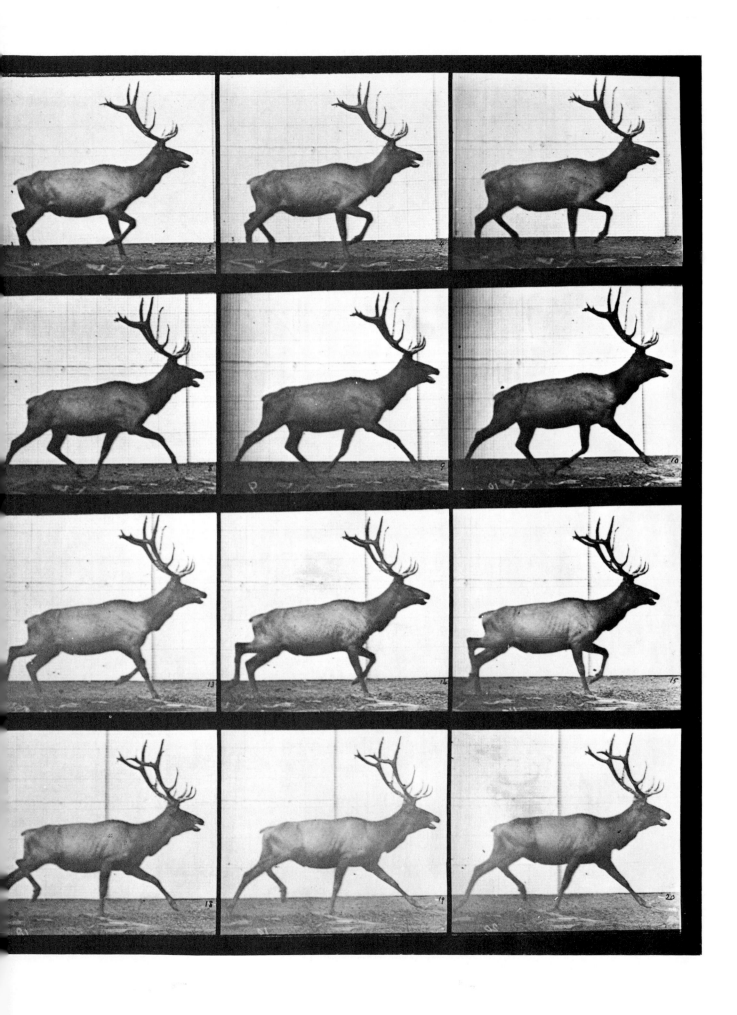

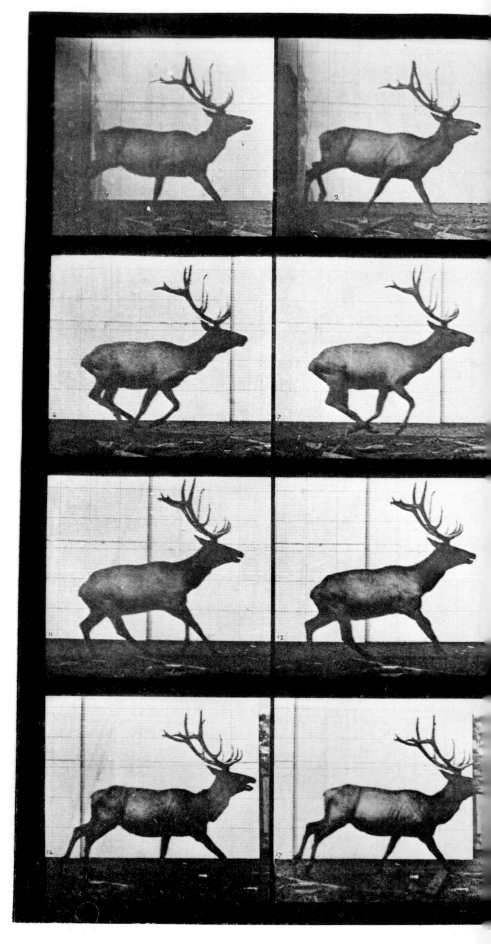

Plate 693. Elk galloping.

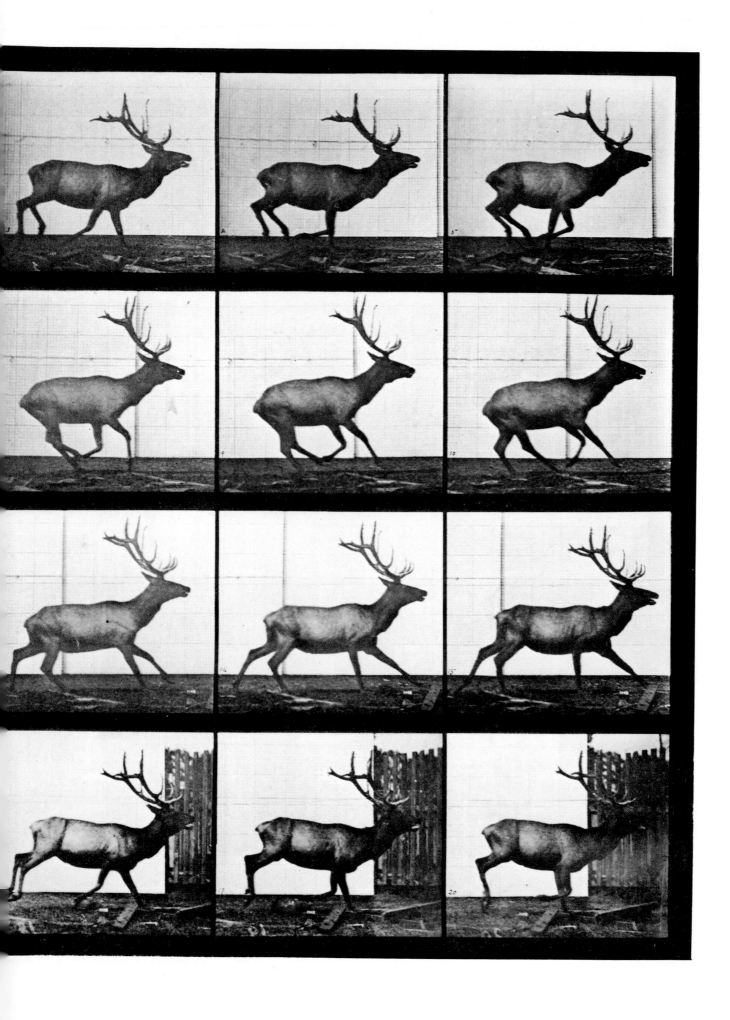

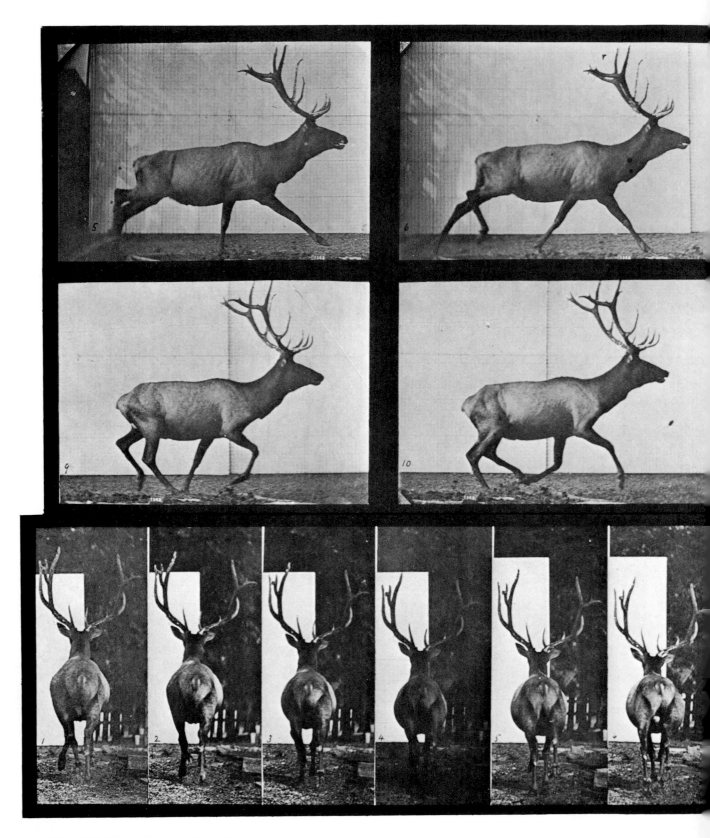

Plate 694. Elk galloping, irregular.

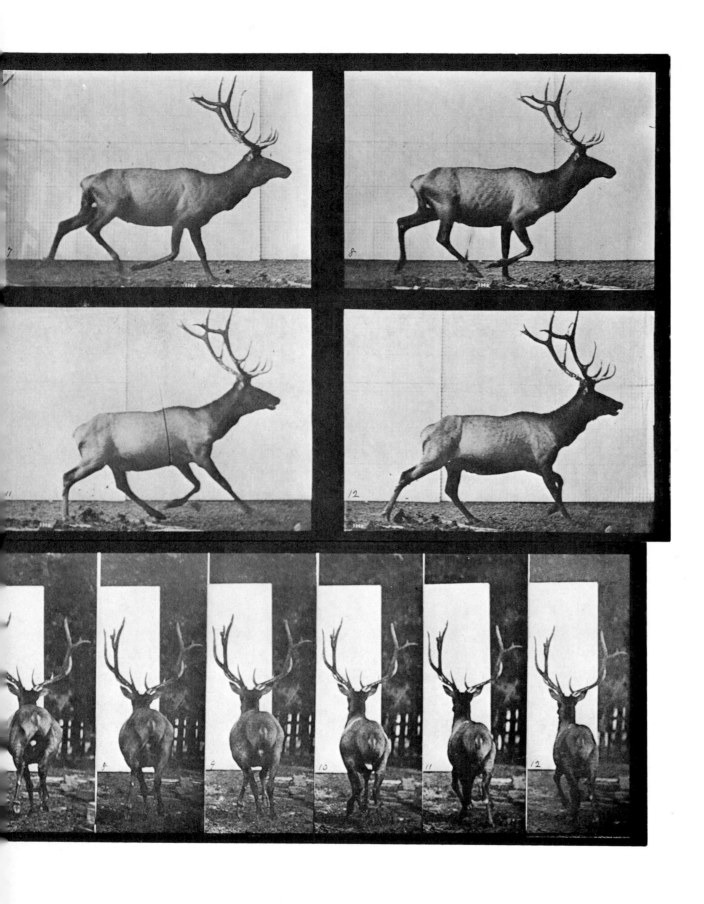

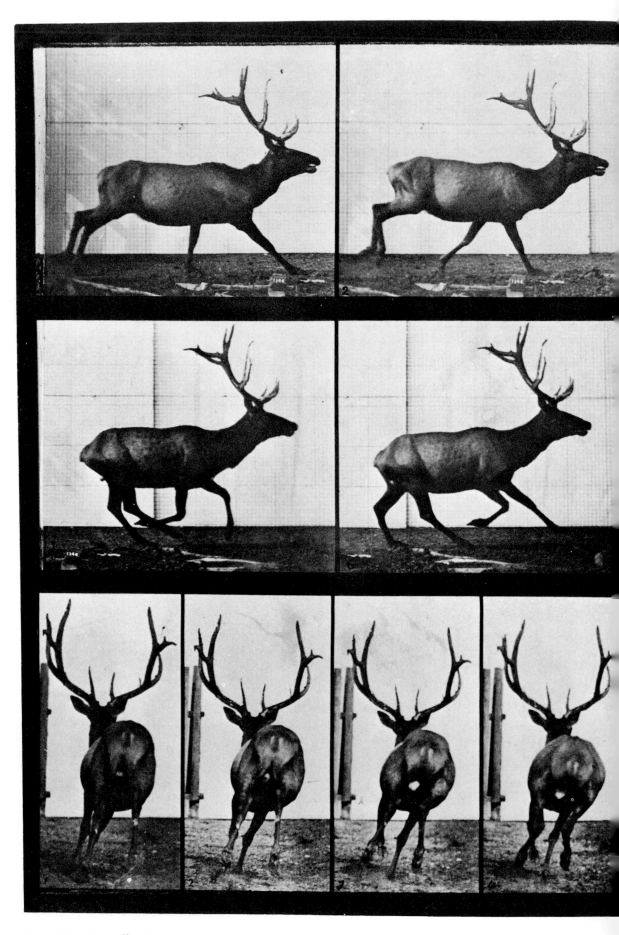

Plate 695. Elk galloping.

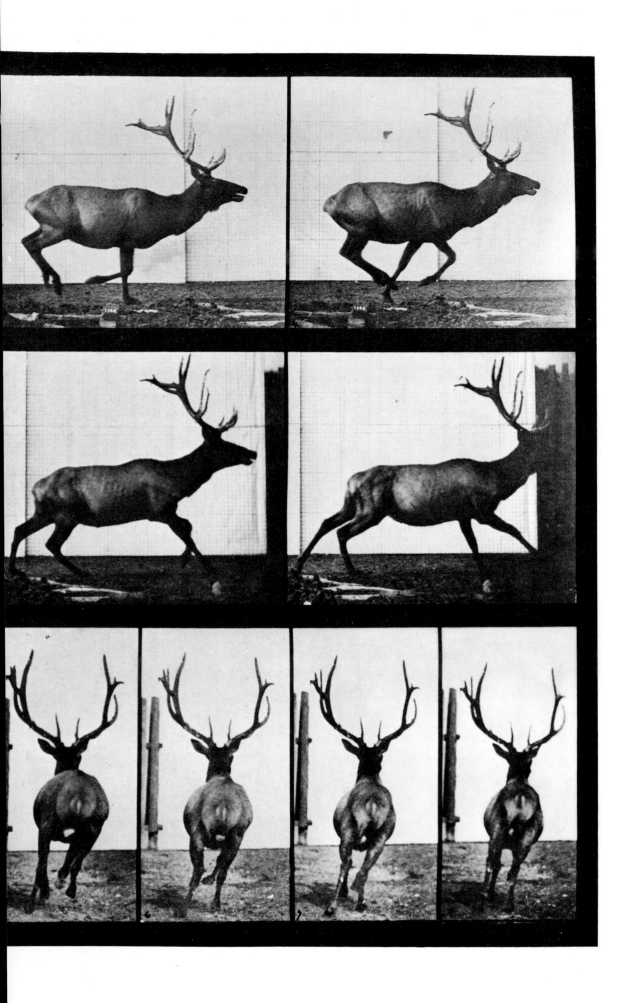

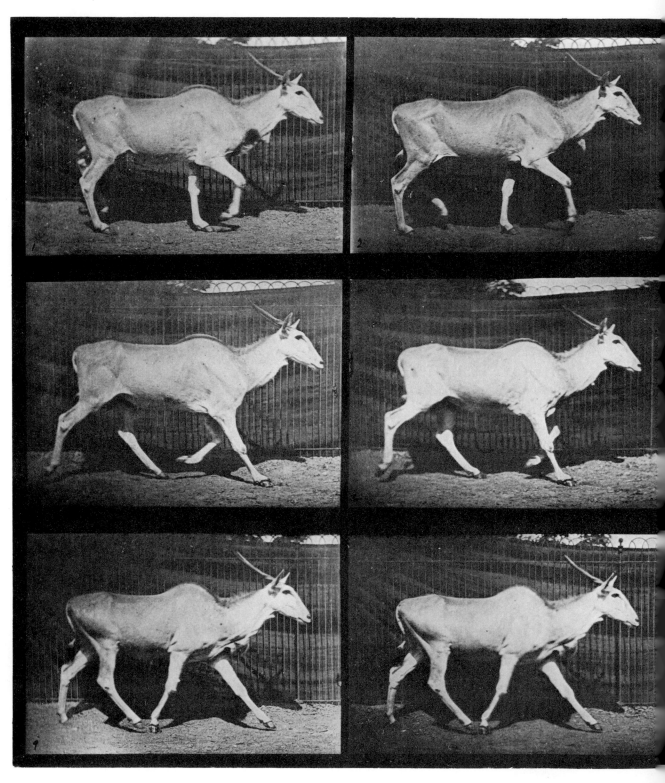

Plate 696. Eland trotting.

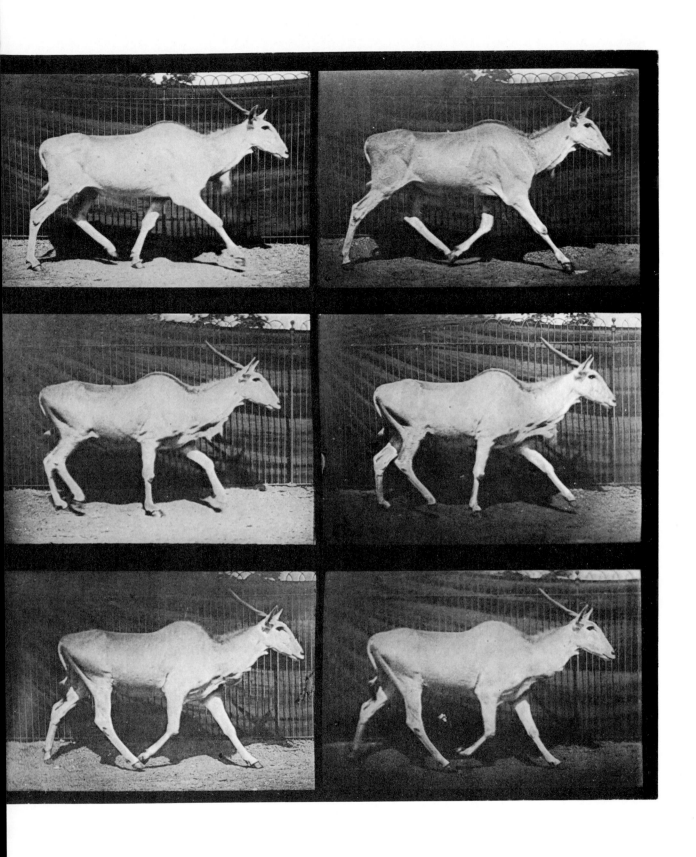

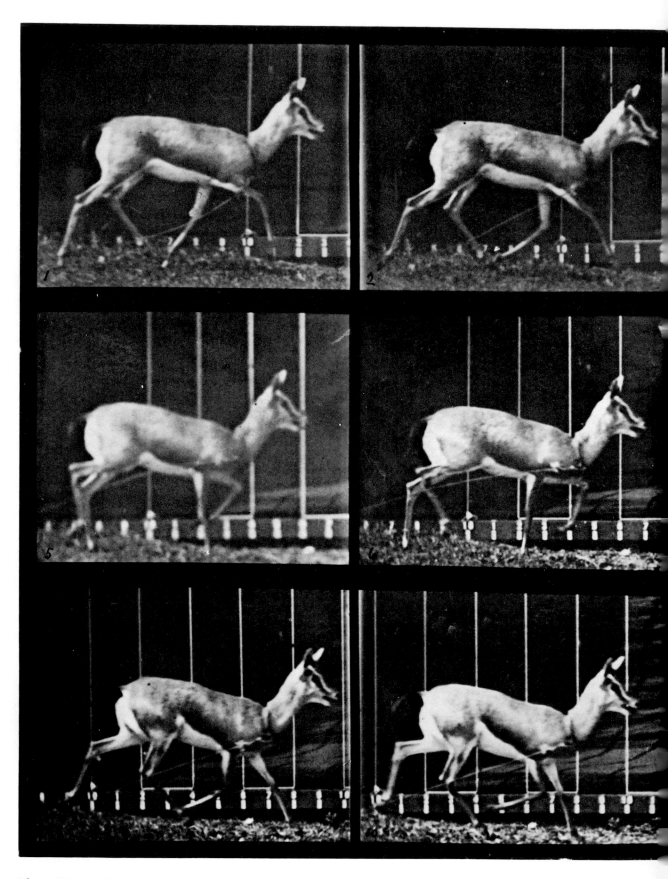

Plate 697. Antelope trotting.

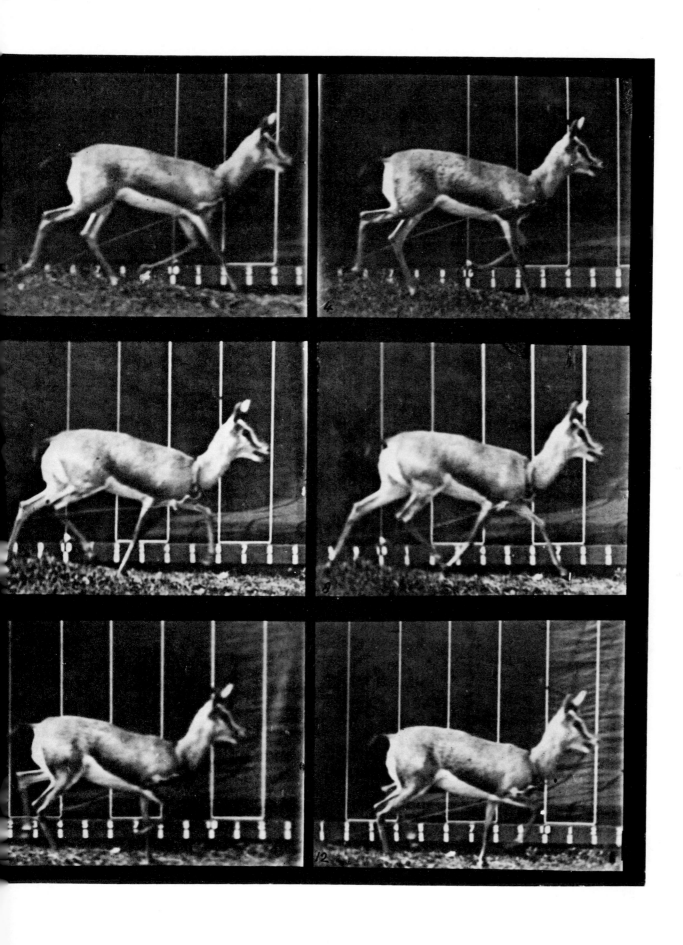

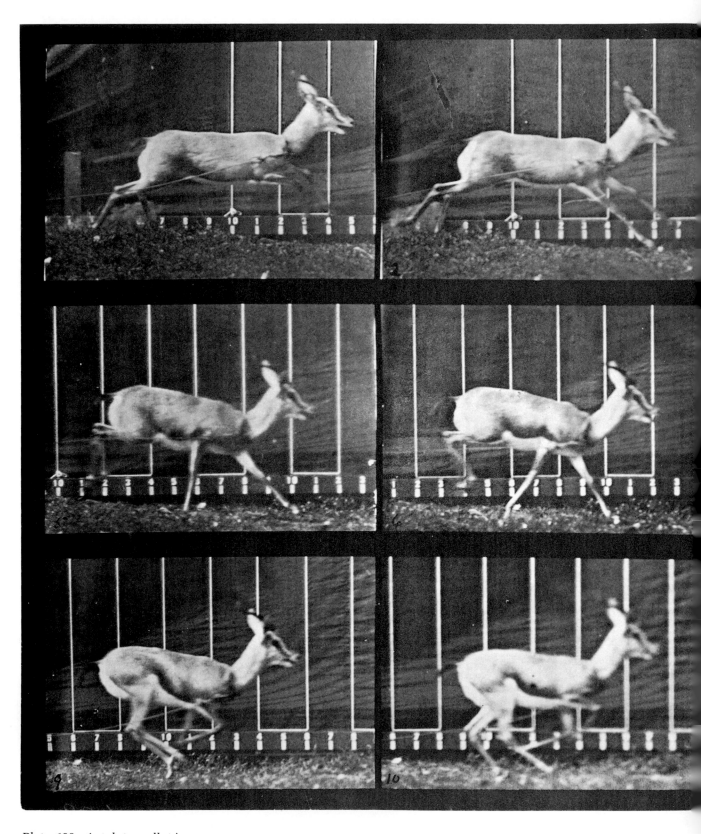

Plate 698. Antelope galloping.

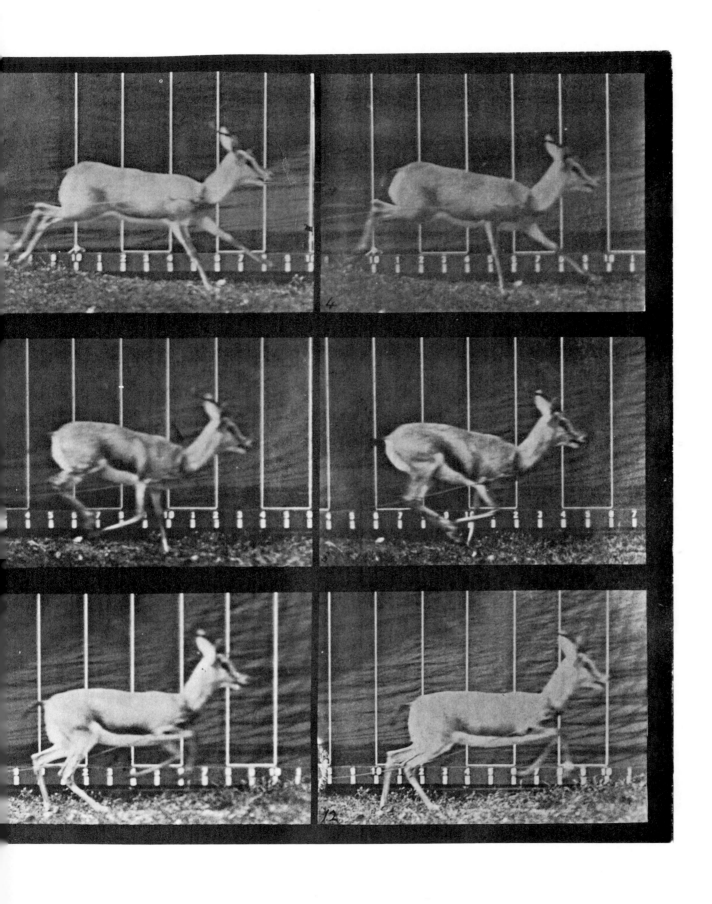

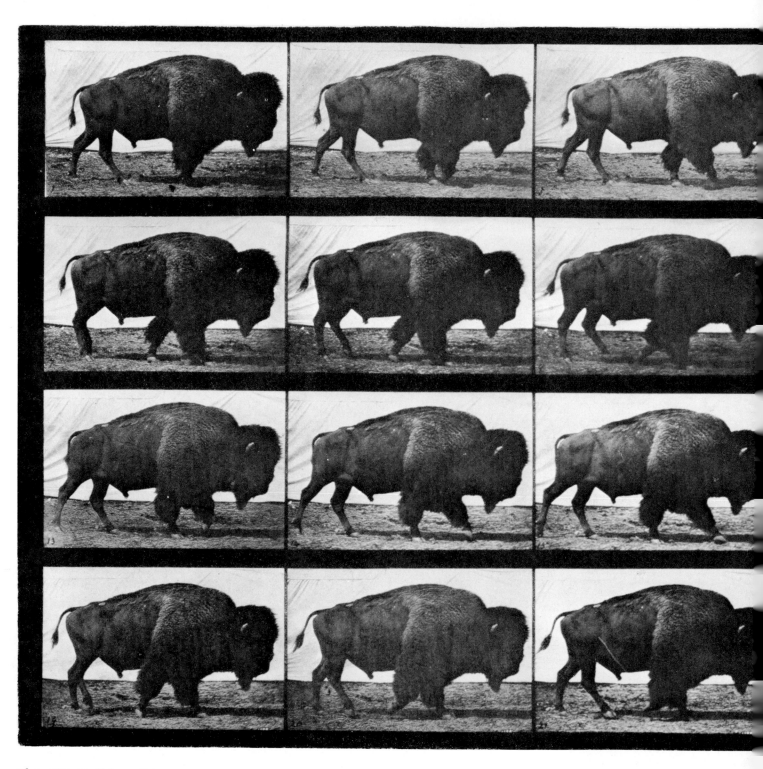

Plate 699. Buffalo walking.

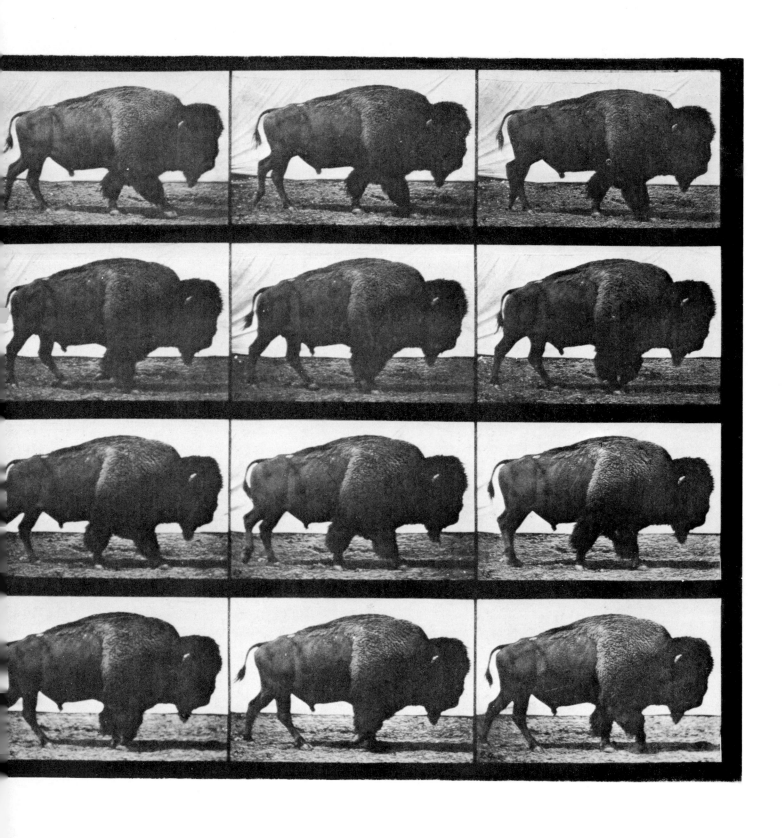

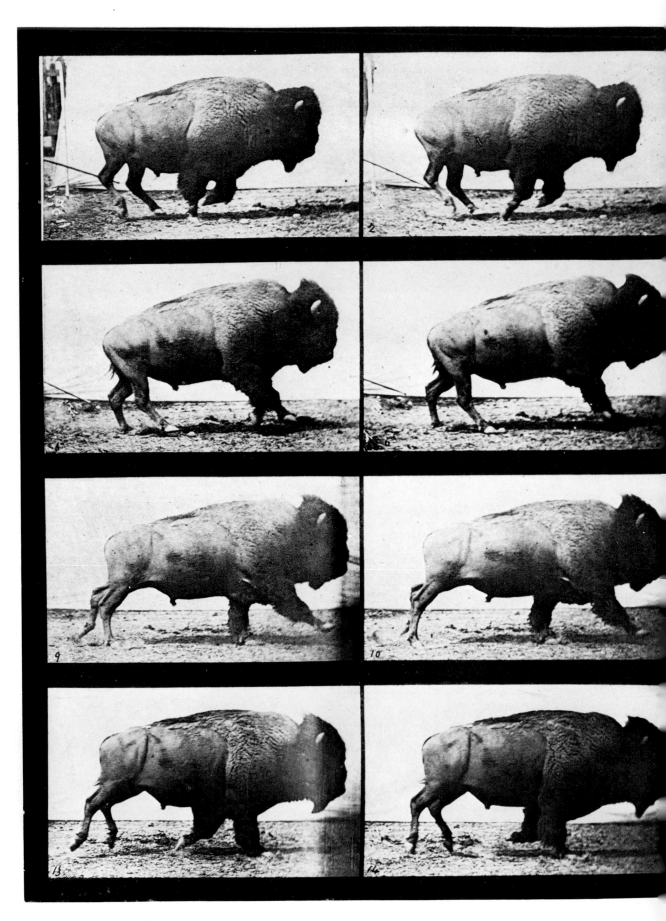

Plate 700. Buffalo galloping.

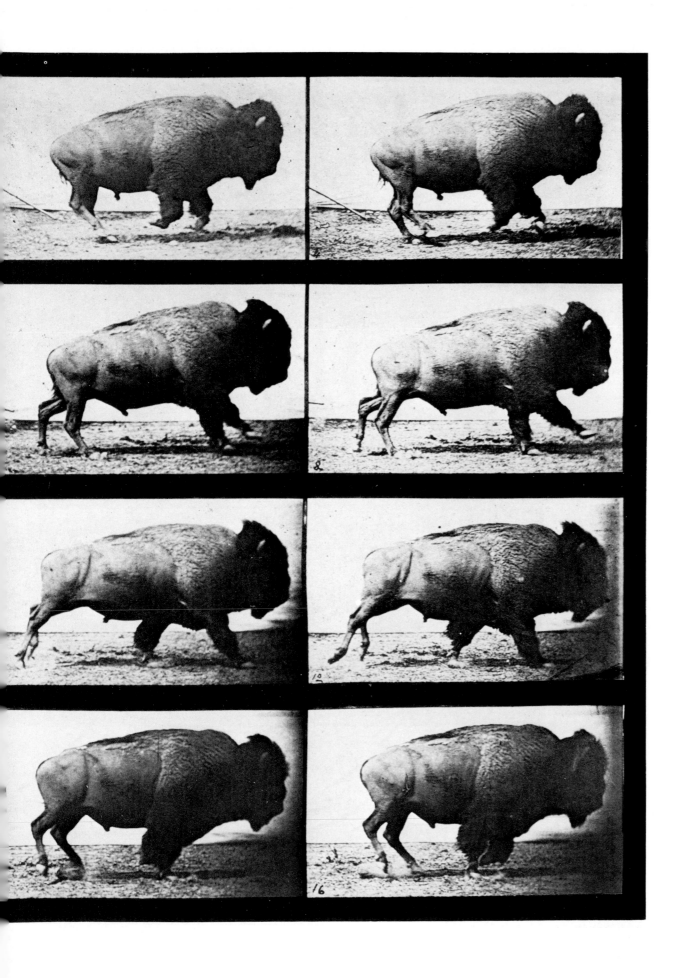

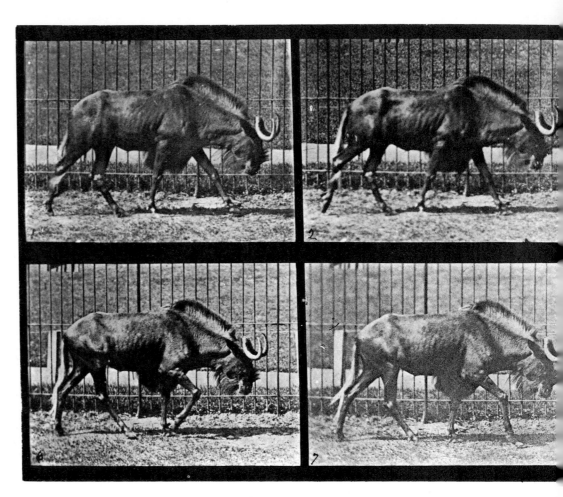

Plate 701. Gnu walking.

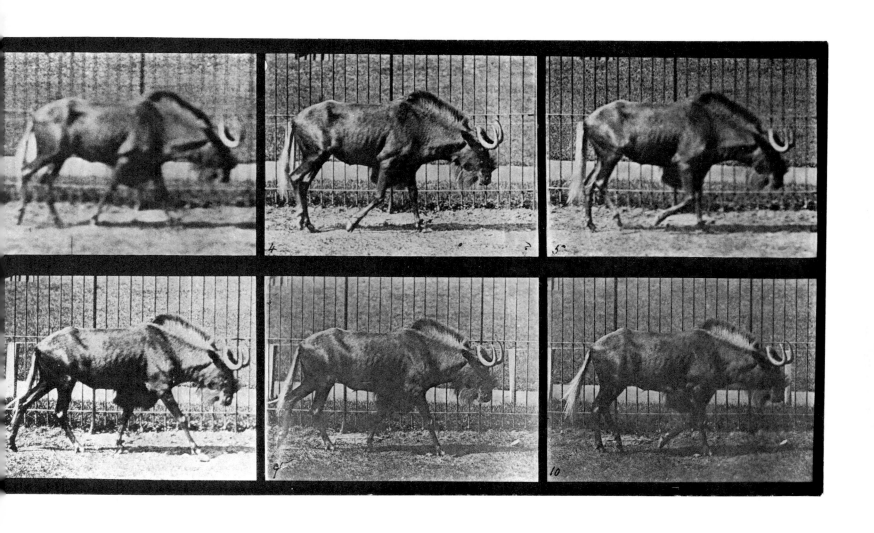

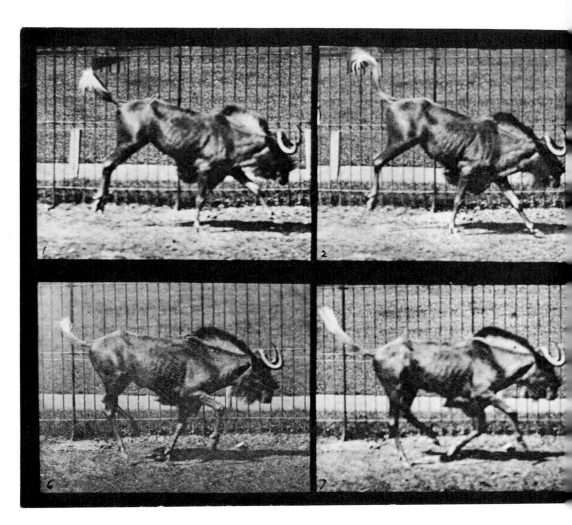

Plate 702. Gnu bucking and galloping.

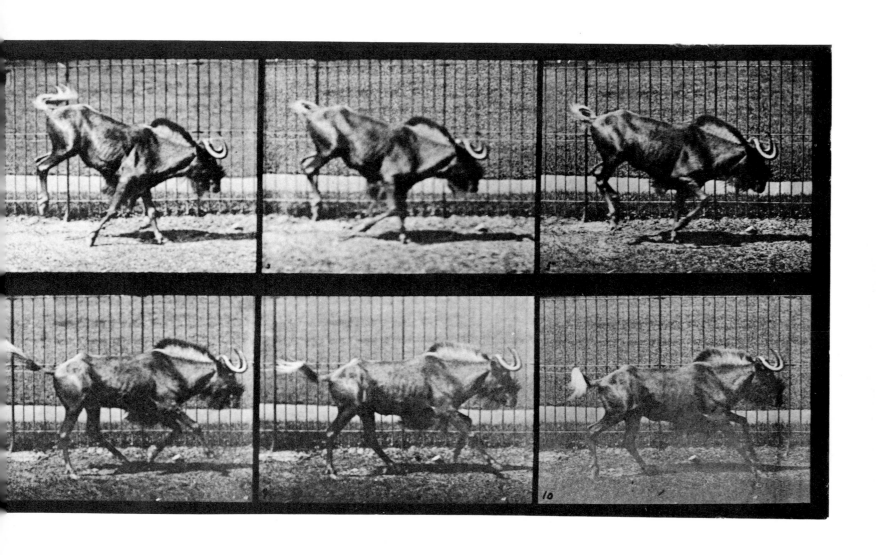

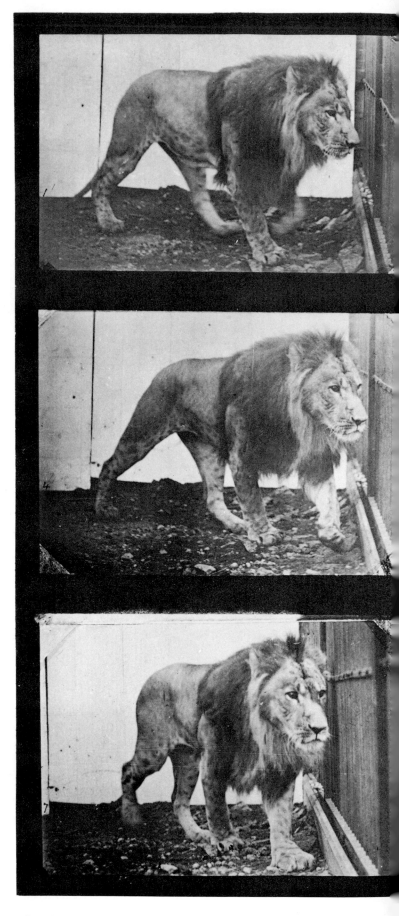

Plate 721. Lion walking.

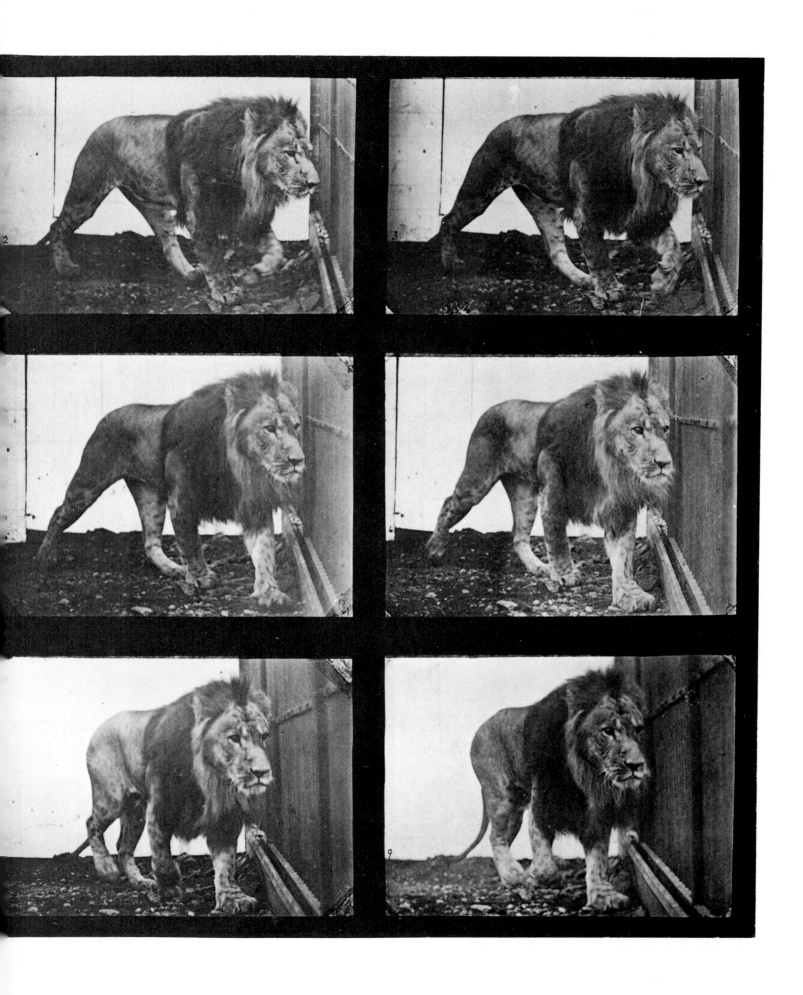

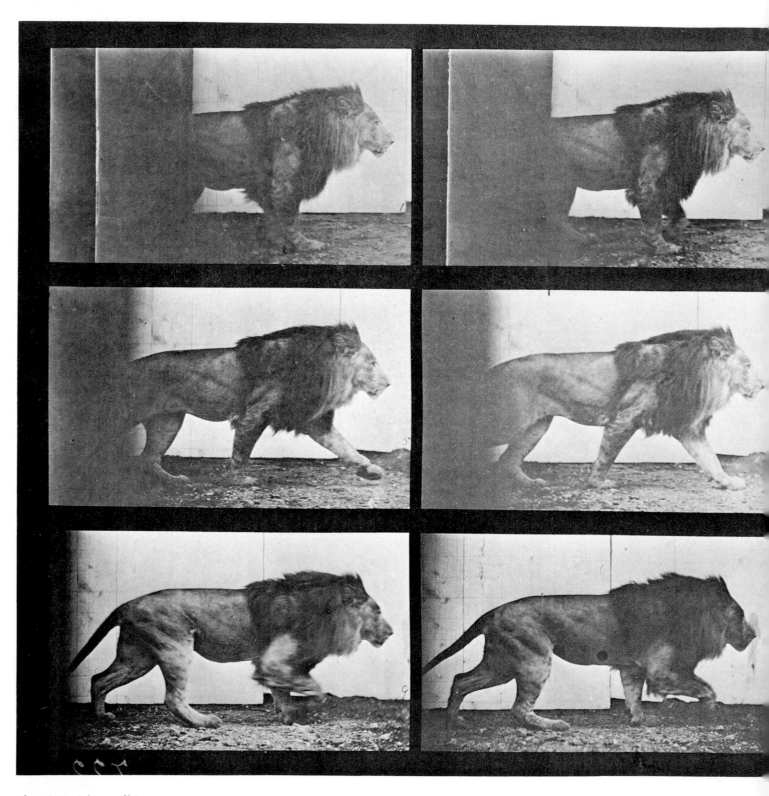

Plate 722. Lion walking.

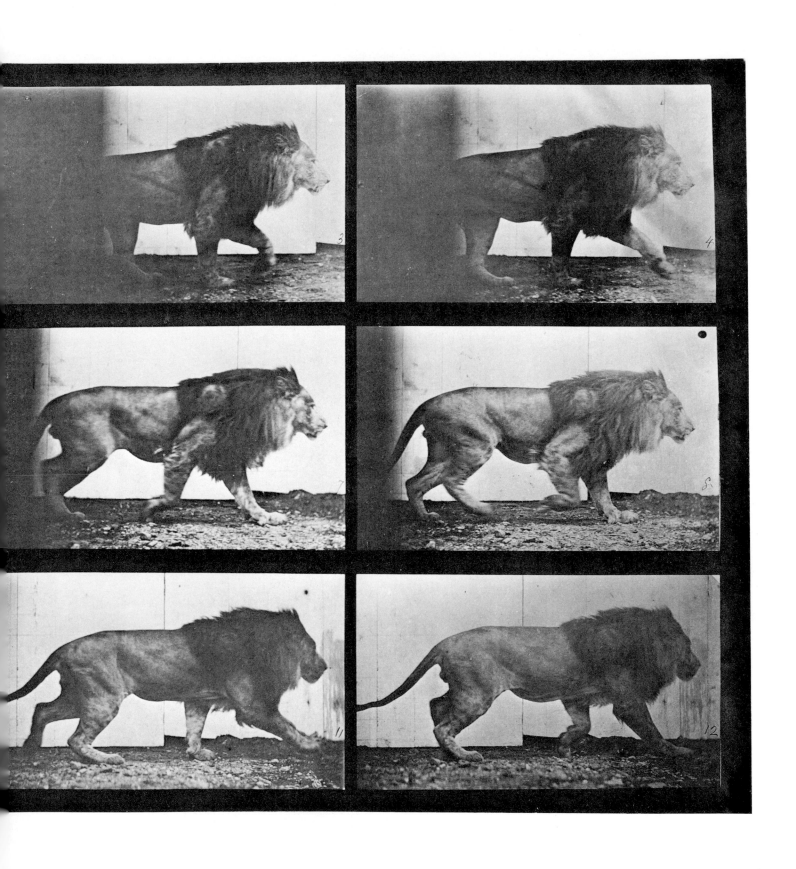

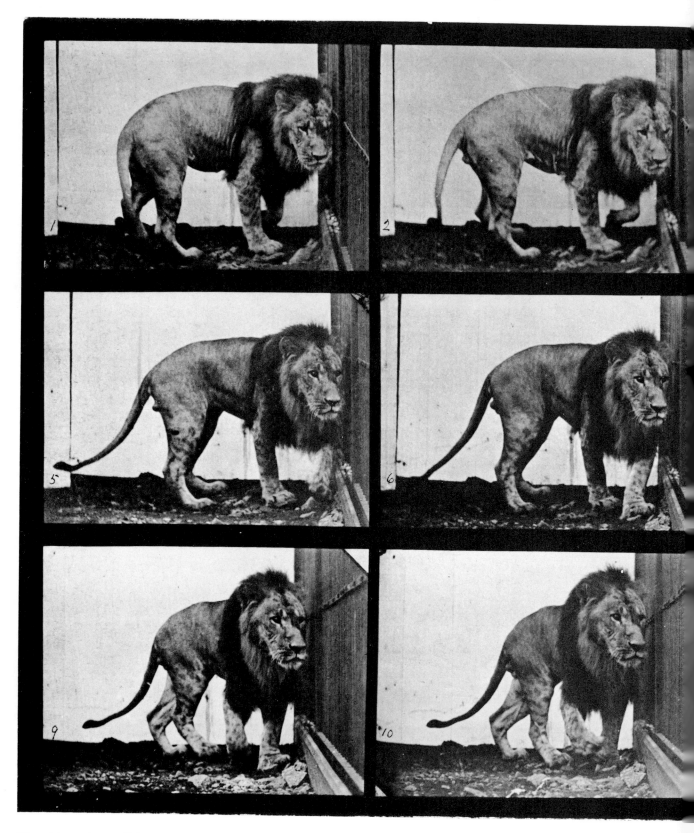

Plate 723. Lion walking and turning around.

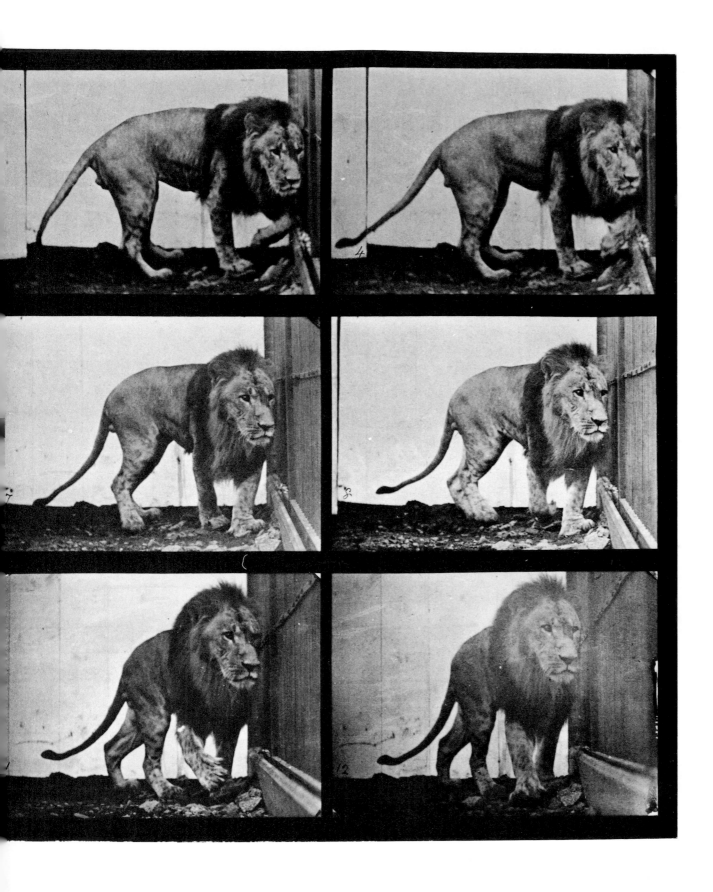

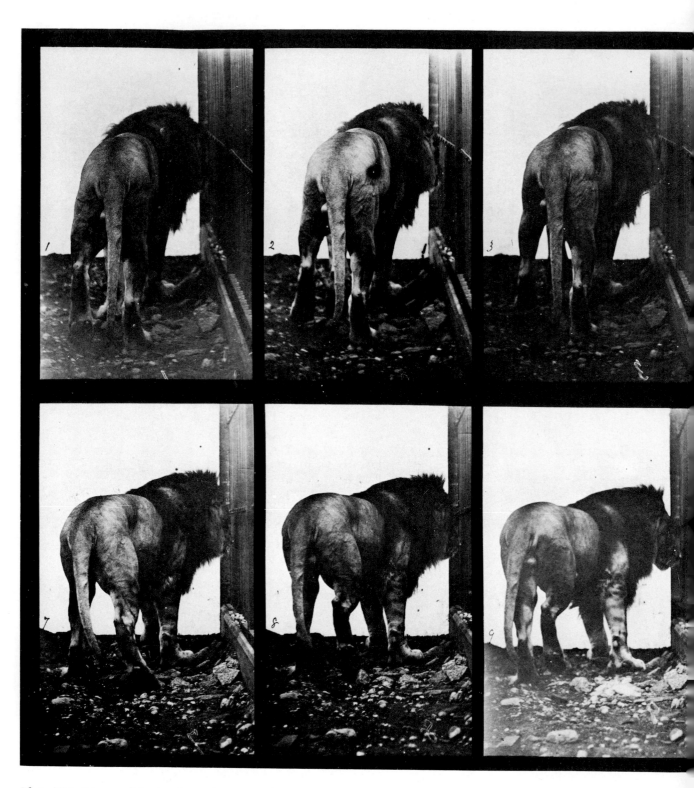

Plate 724. Lion walking and turning around.

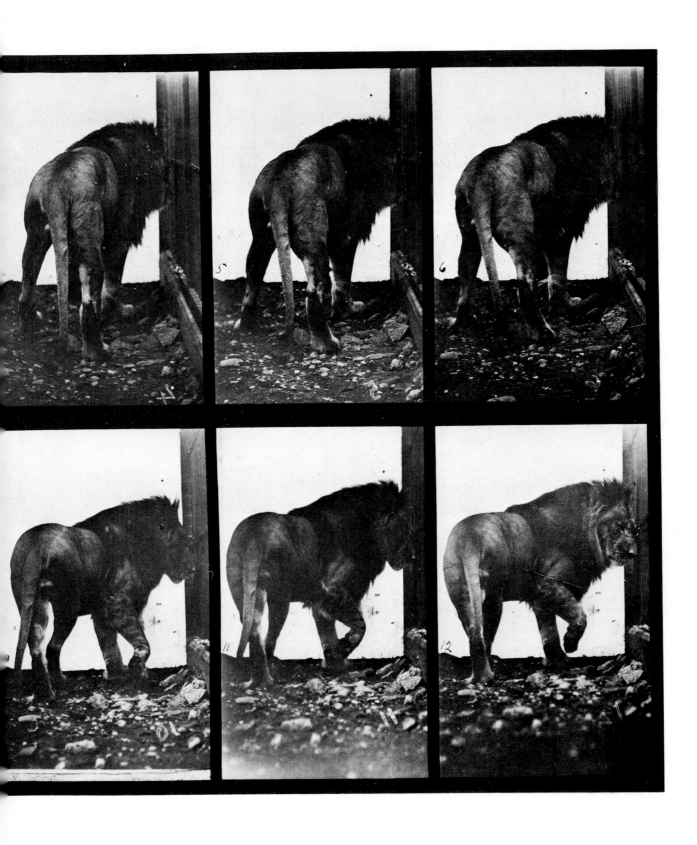

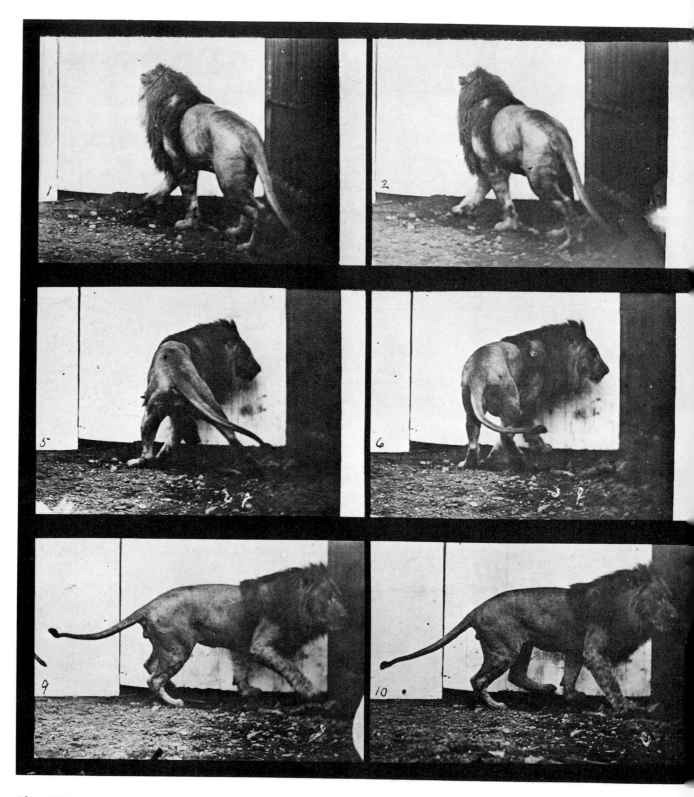

Plate 725. Lion walking and turning around.

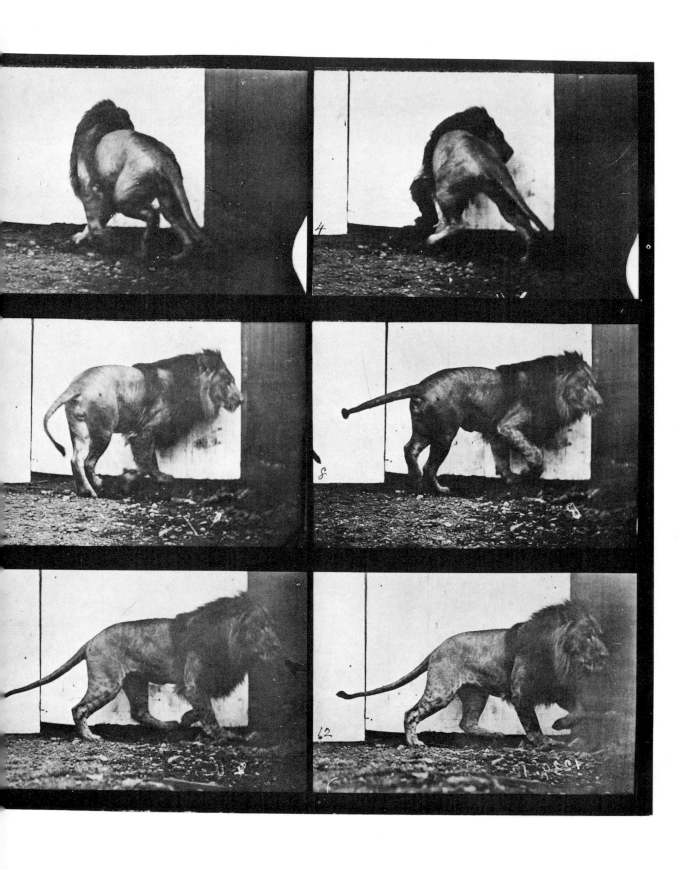

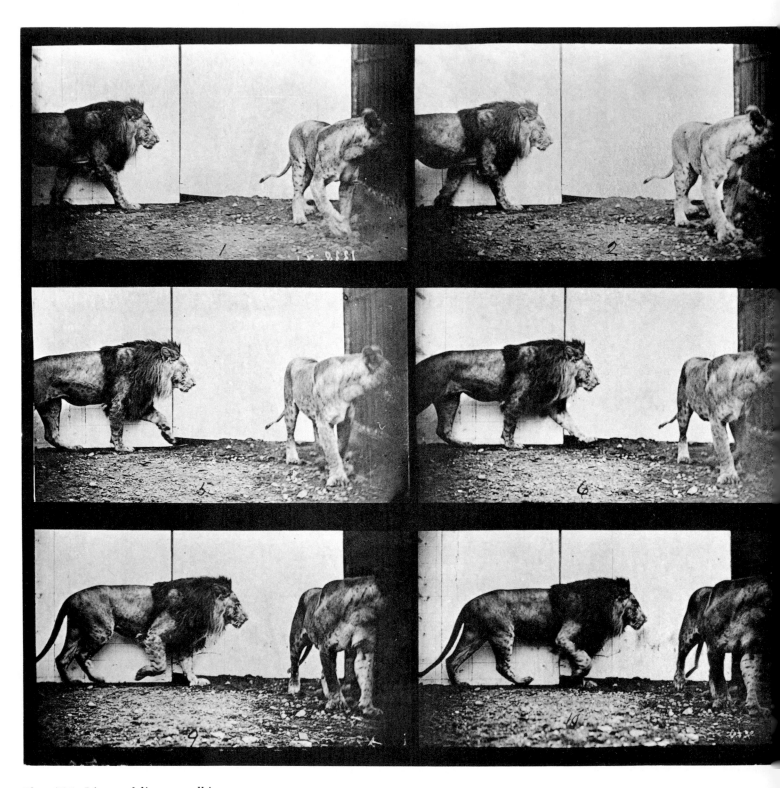

Plate 726. Lion and lioness walking.

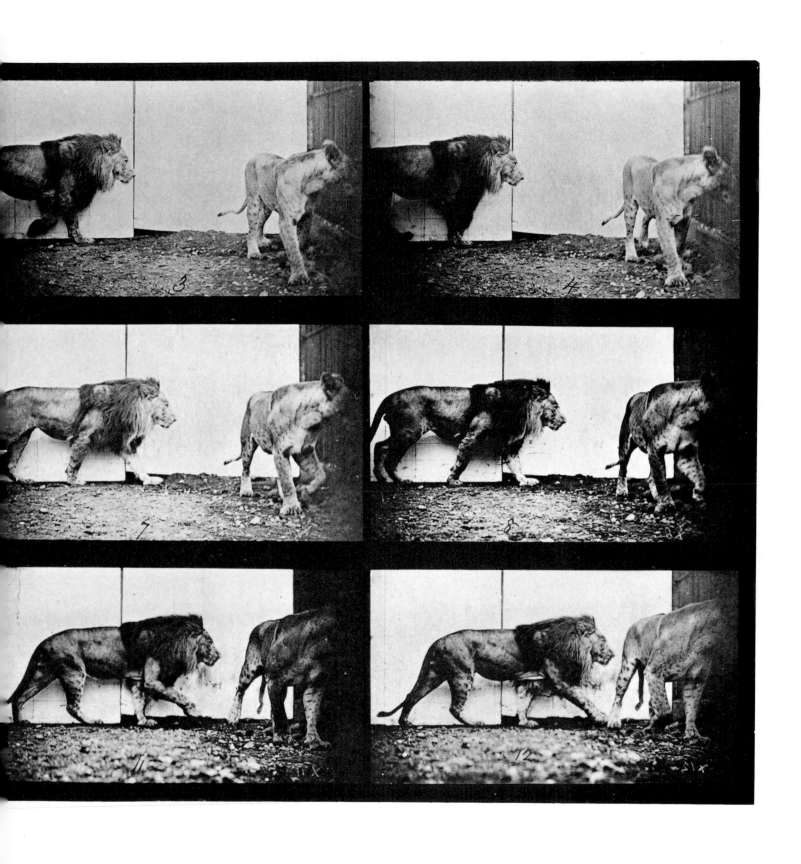

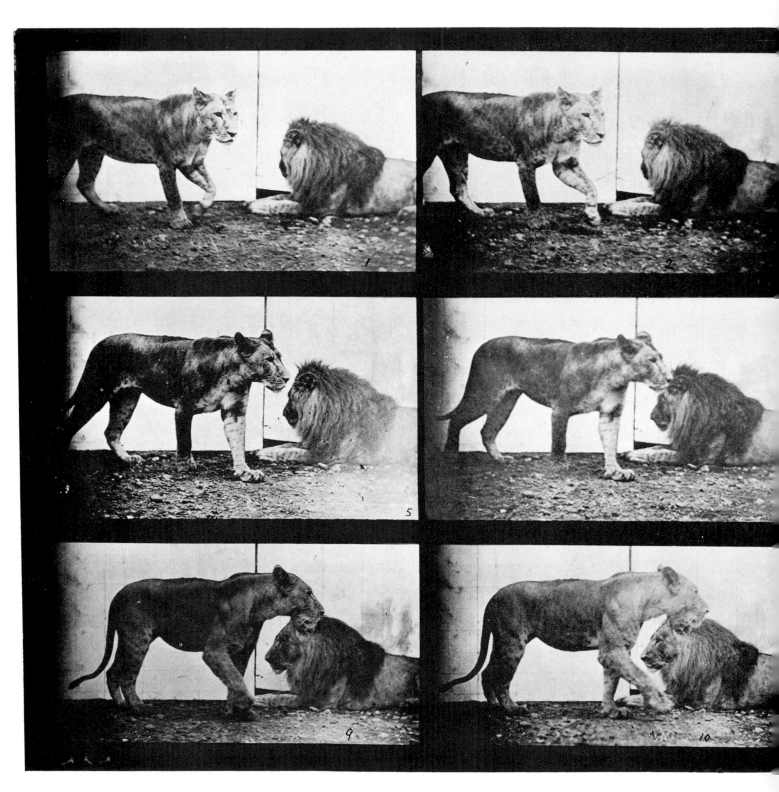

Plate 727. Lioness walking and lion lying down.

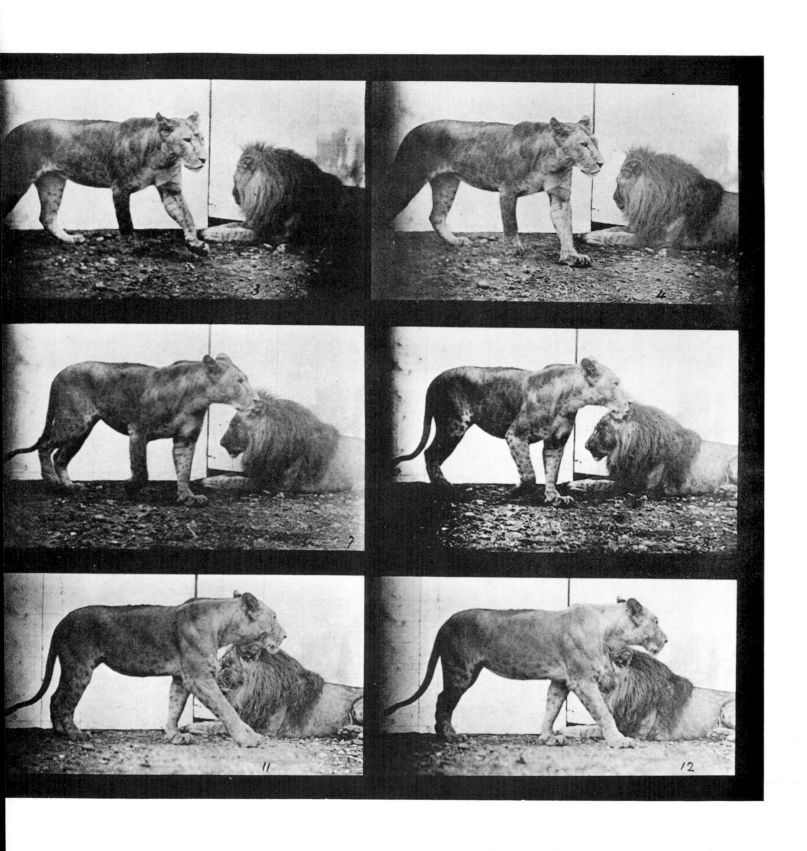

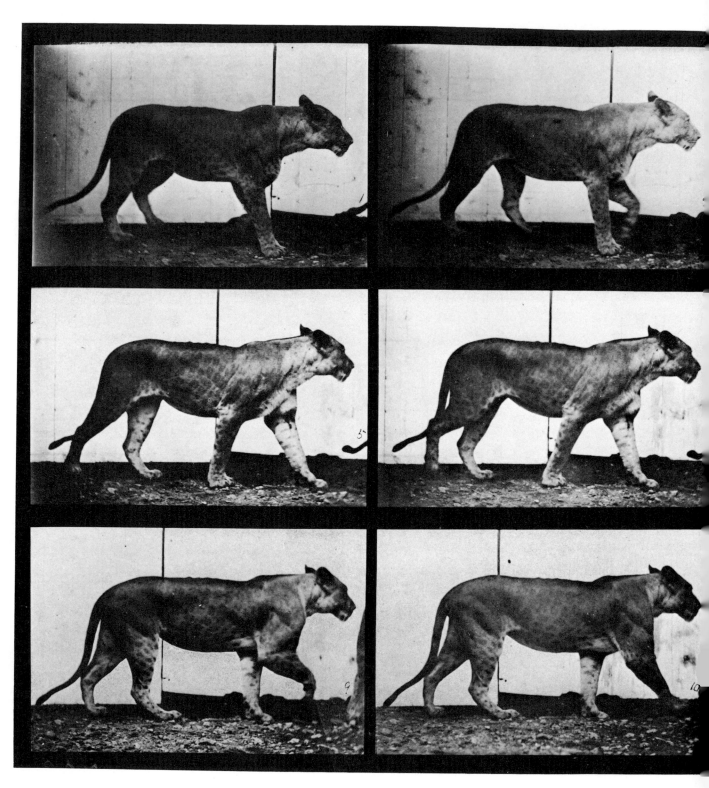

Plate 728. Lioness walking.

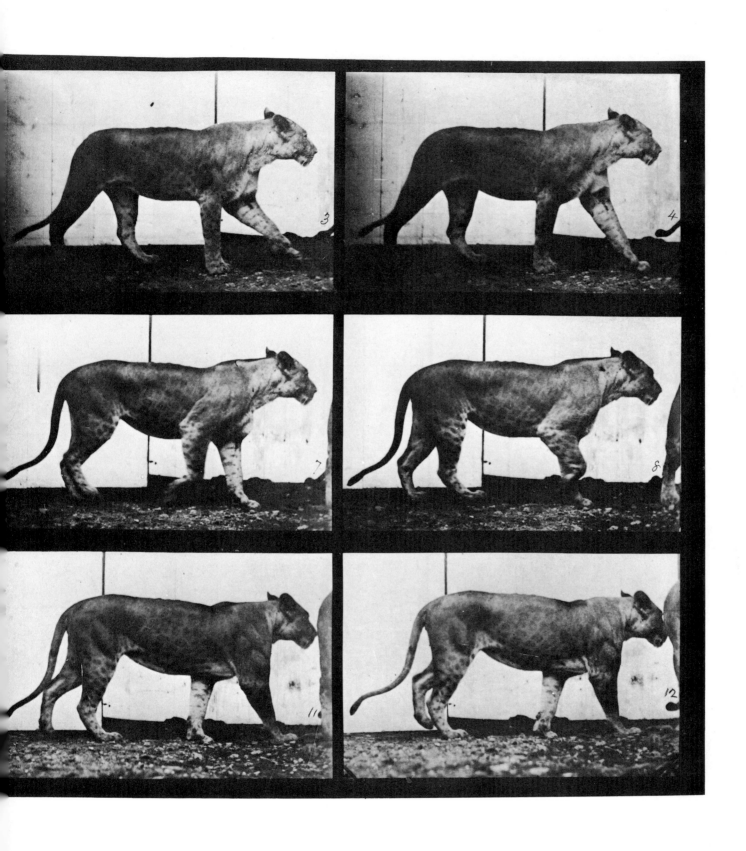

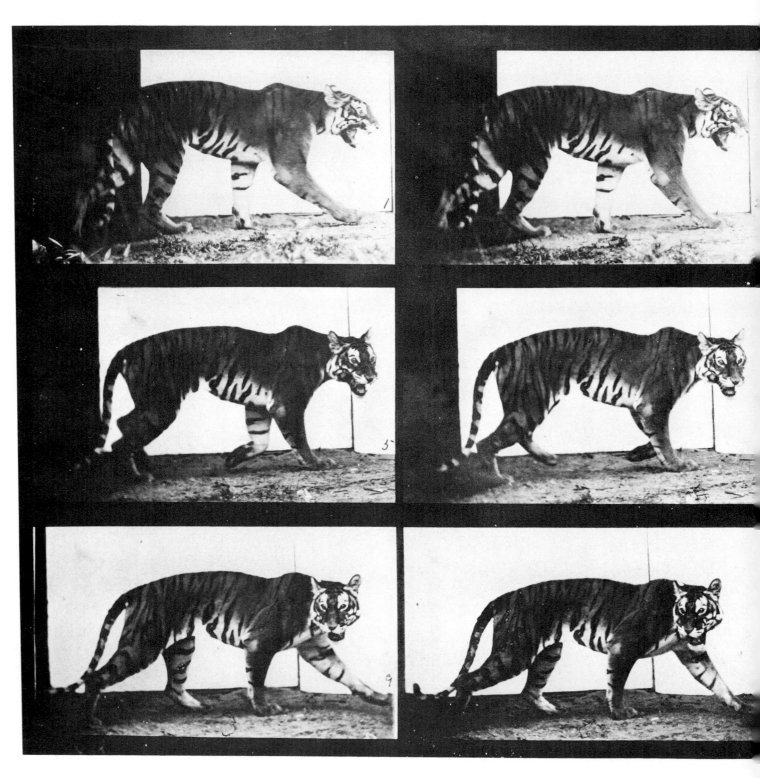

Plate 729. Tigress walking.

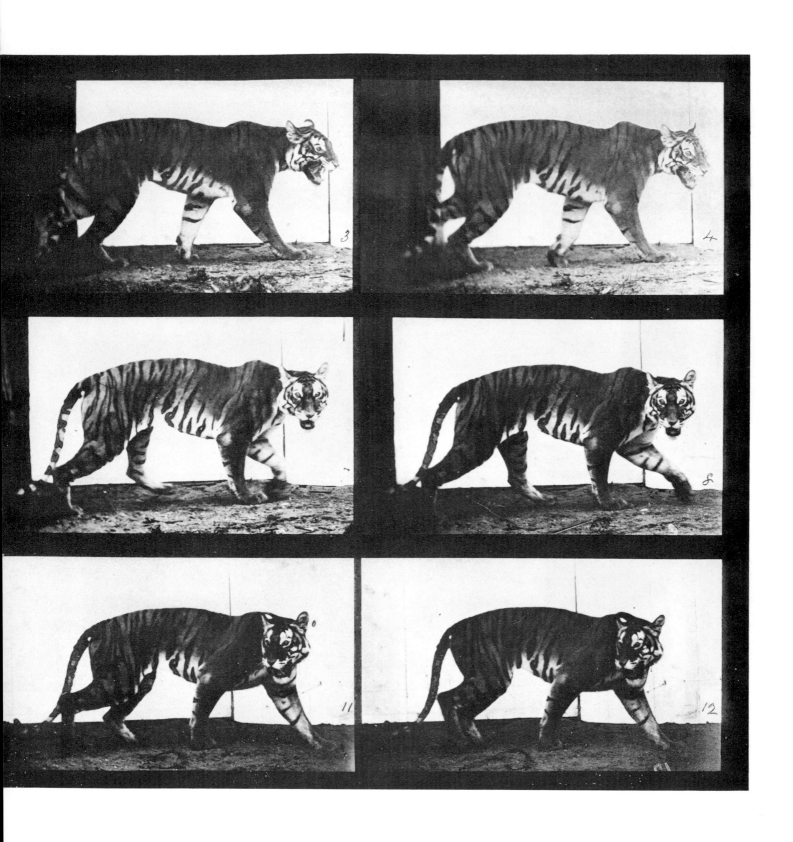

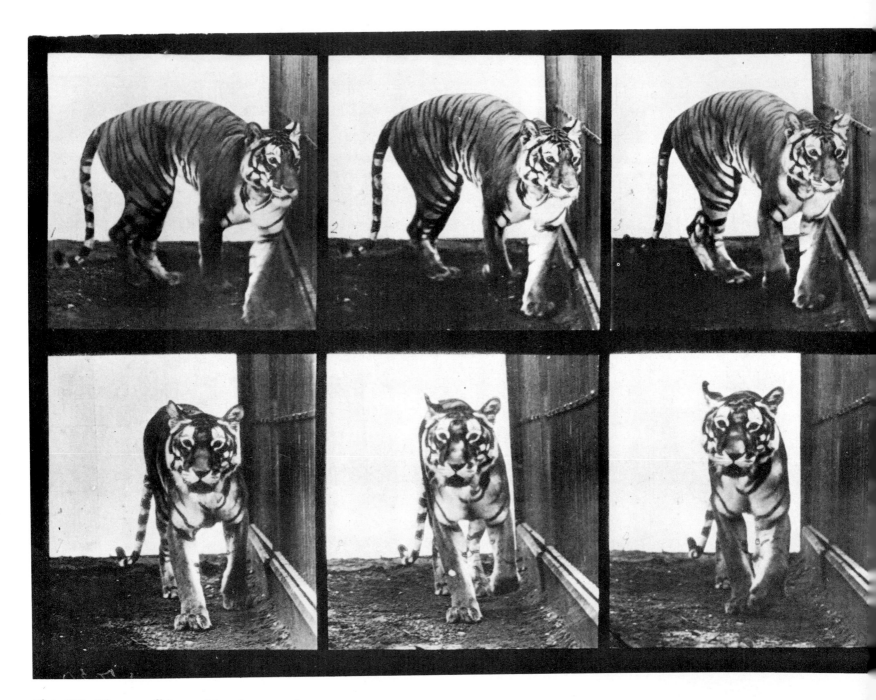

Plate 730. Tigress walking and turning around.

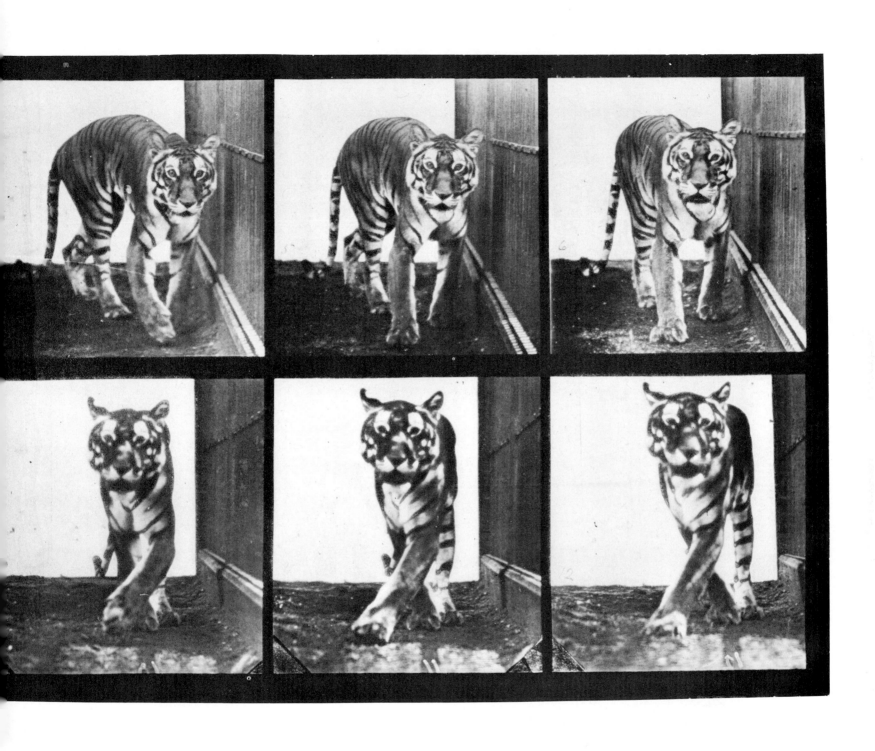

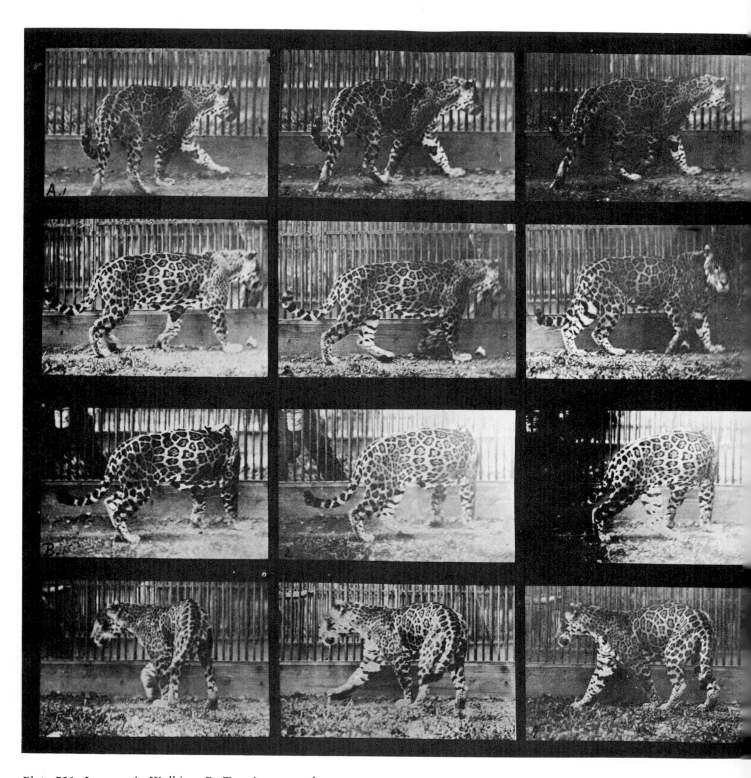

Plate 731. Jaguar. A: Walking. B: Turning around.

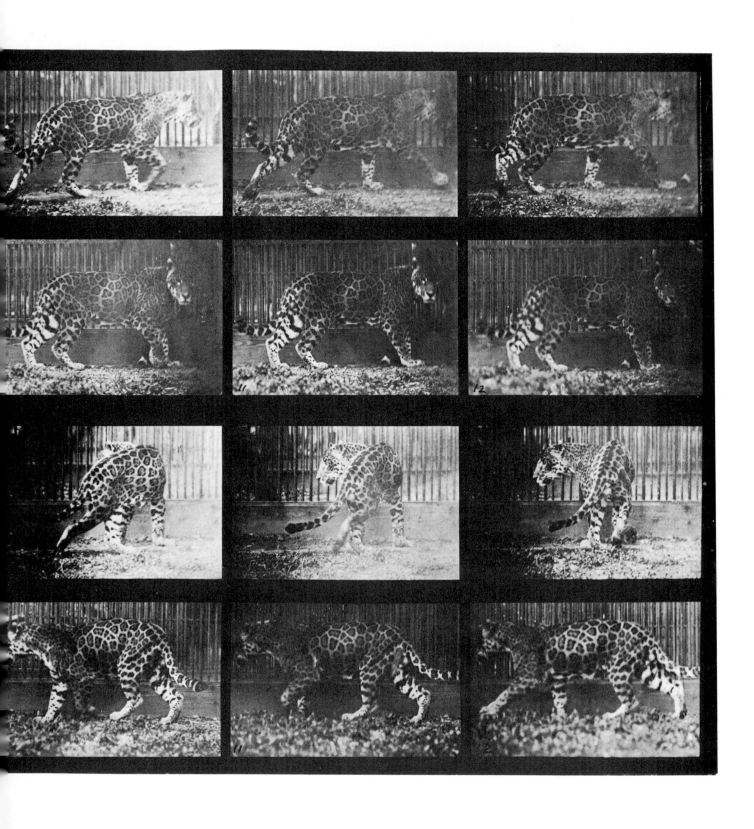

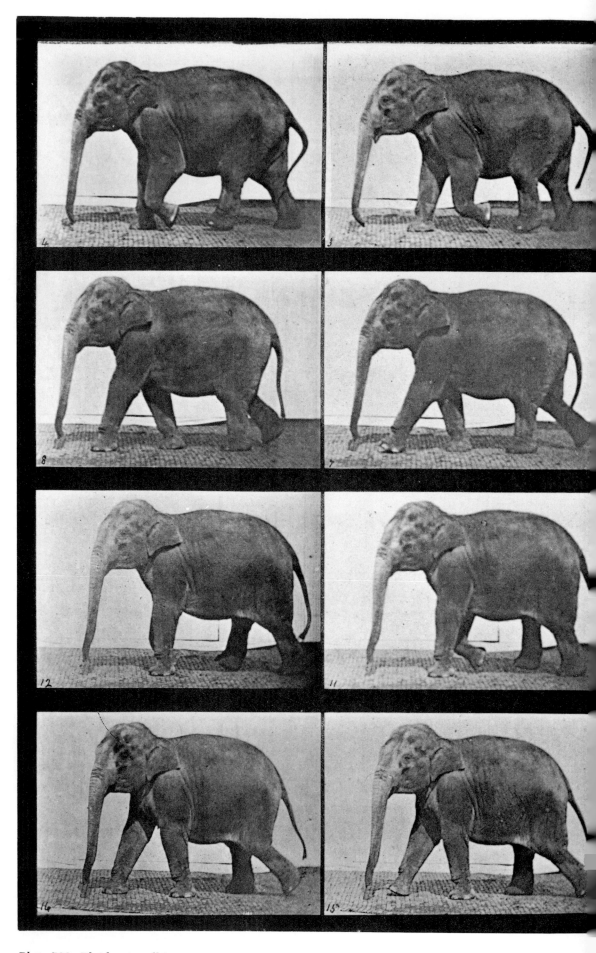

Plate 732. Elephant walking.

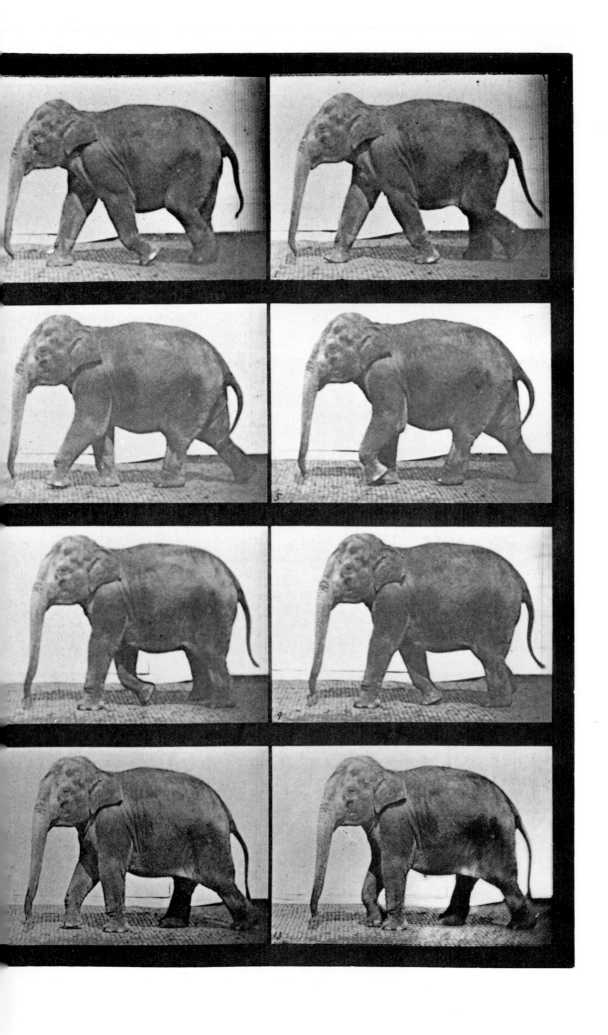

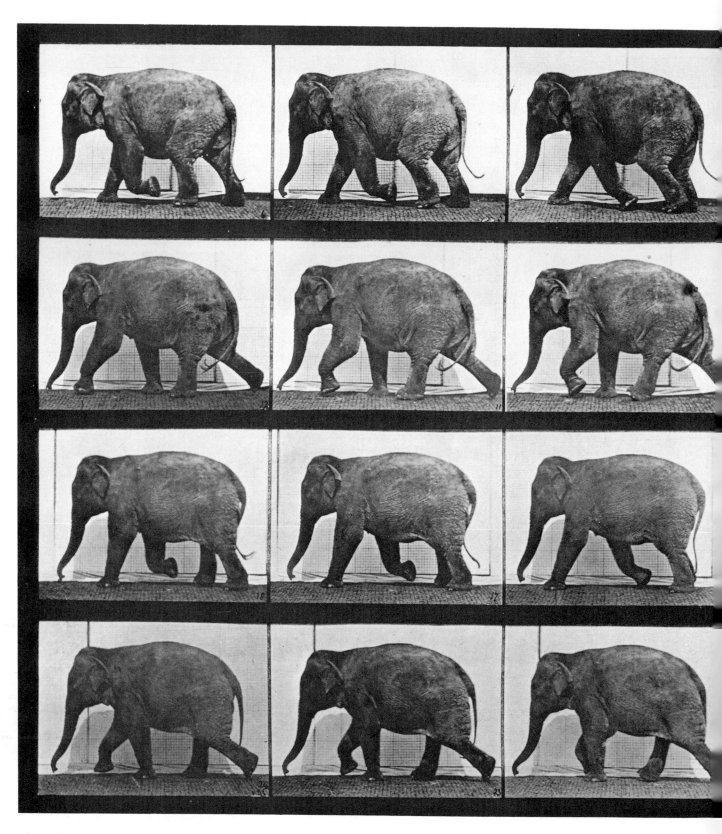

Plate 733. Elephant walking.

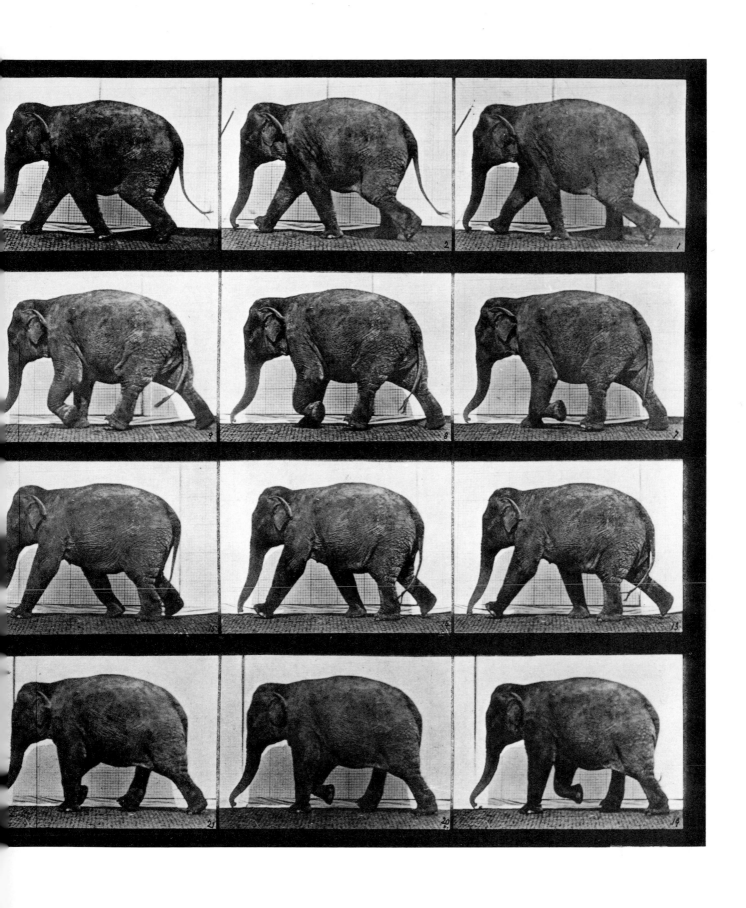

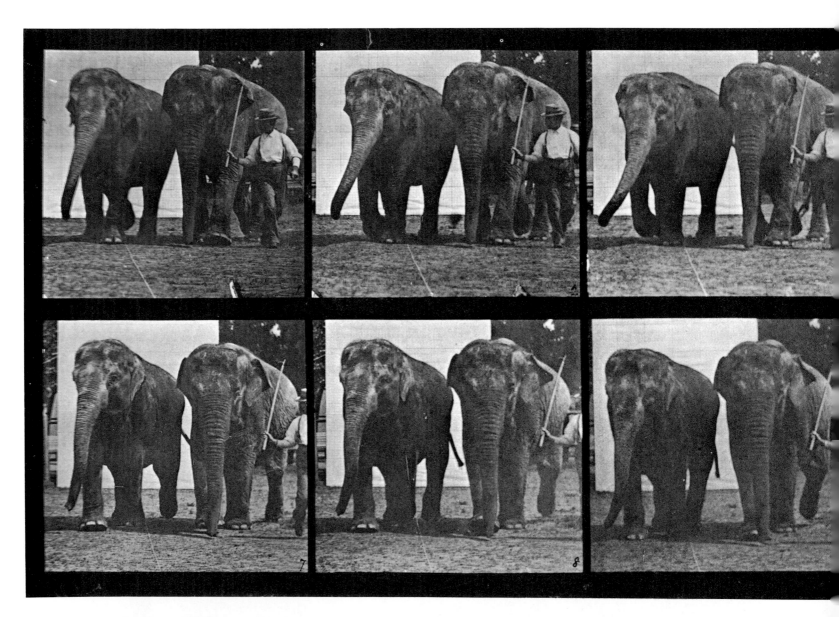

Plate 734. Two elephants walking.

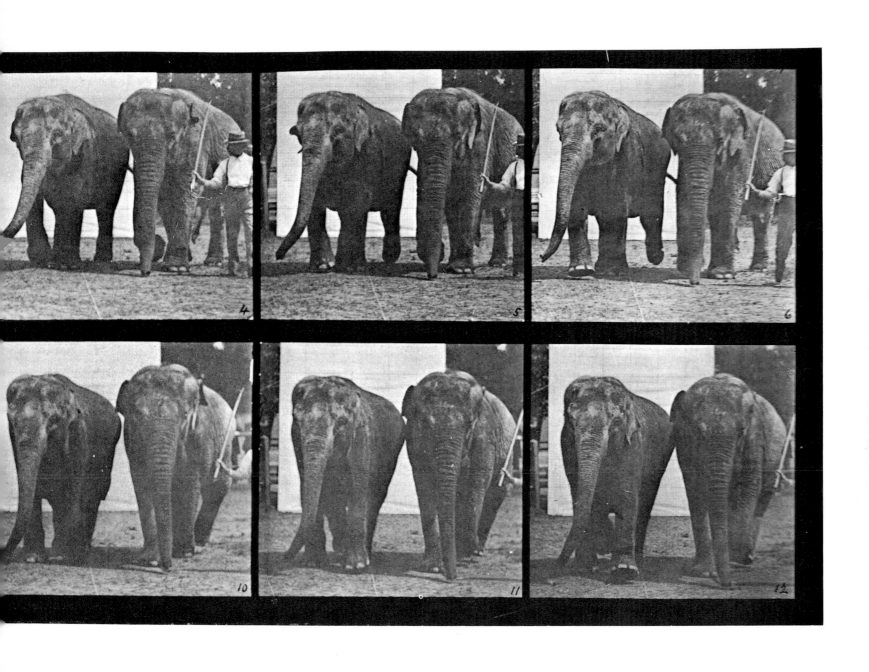

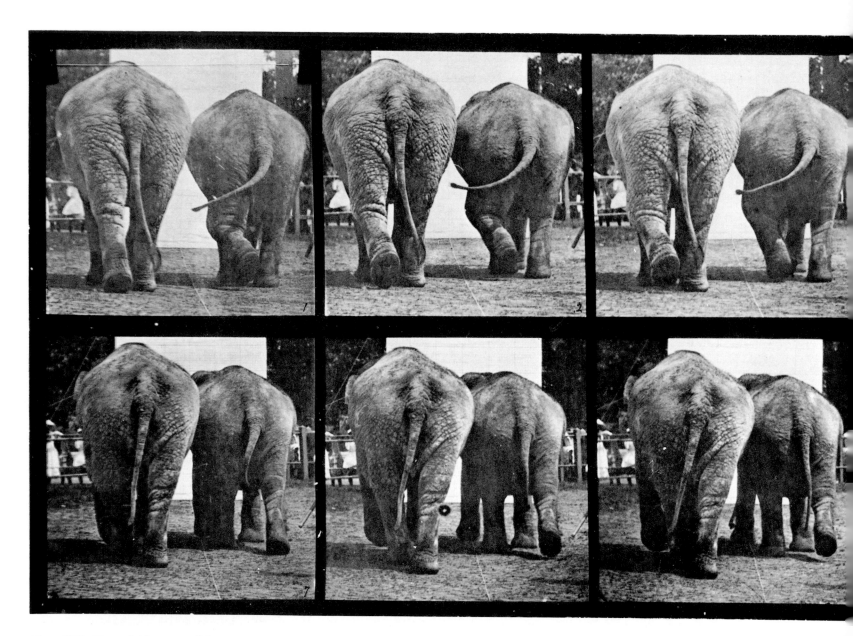

Plate 735. Two elephants walking.

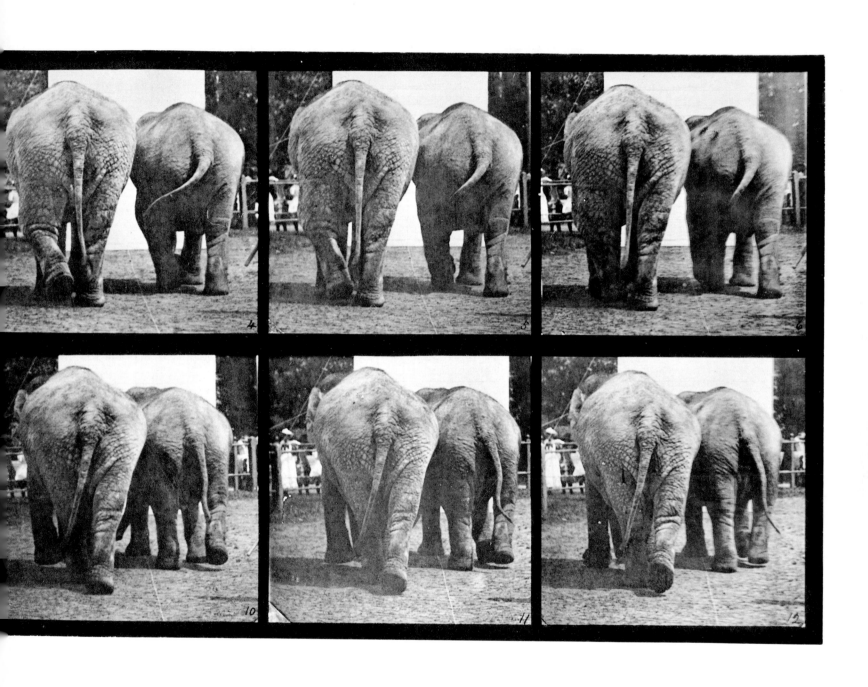

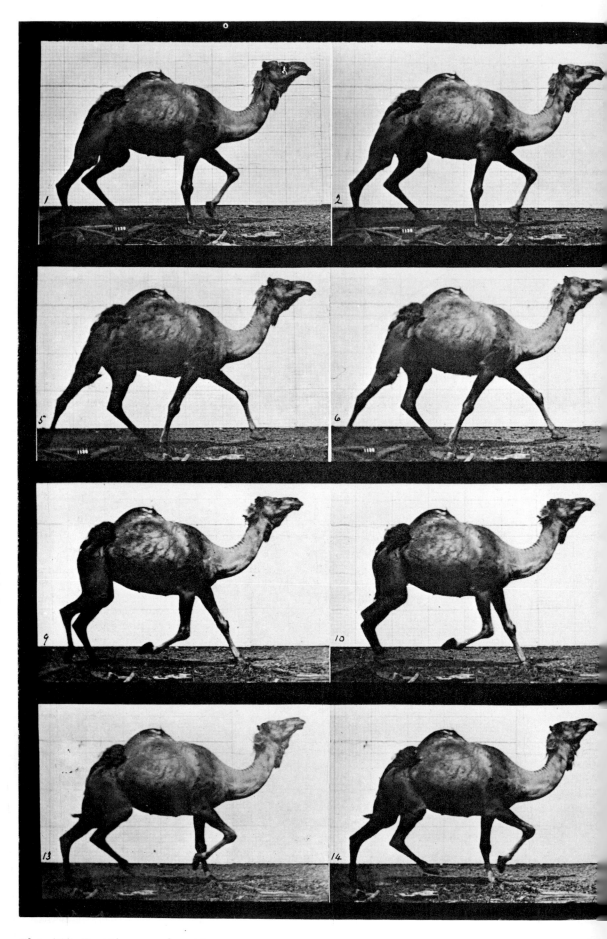

Plate 736. Egyptian camel racking.

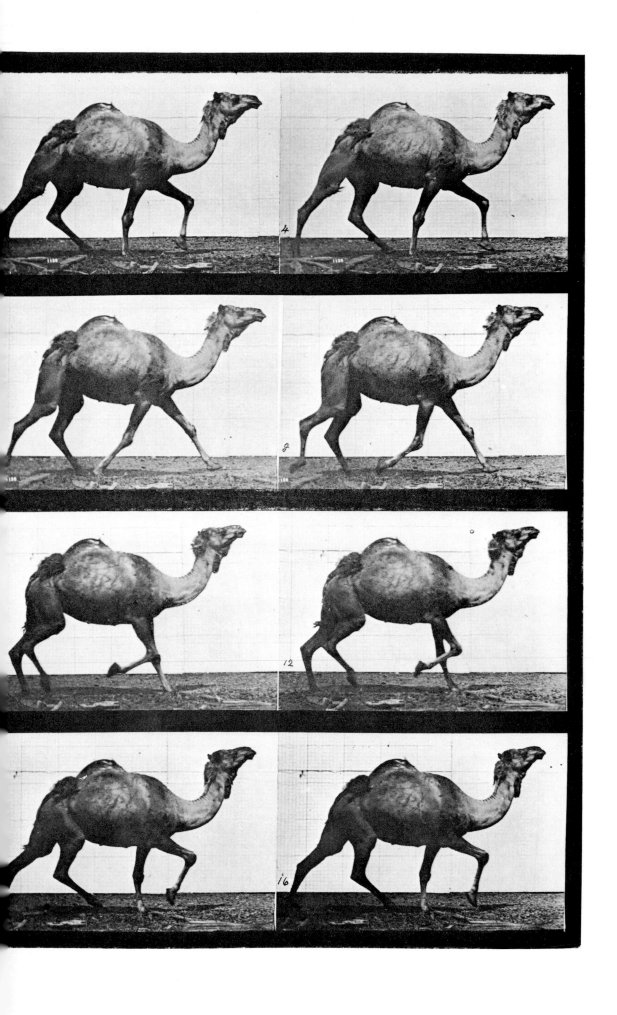

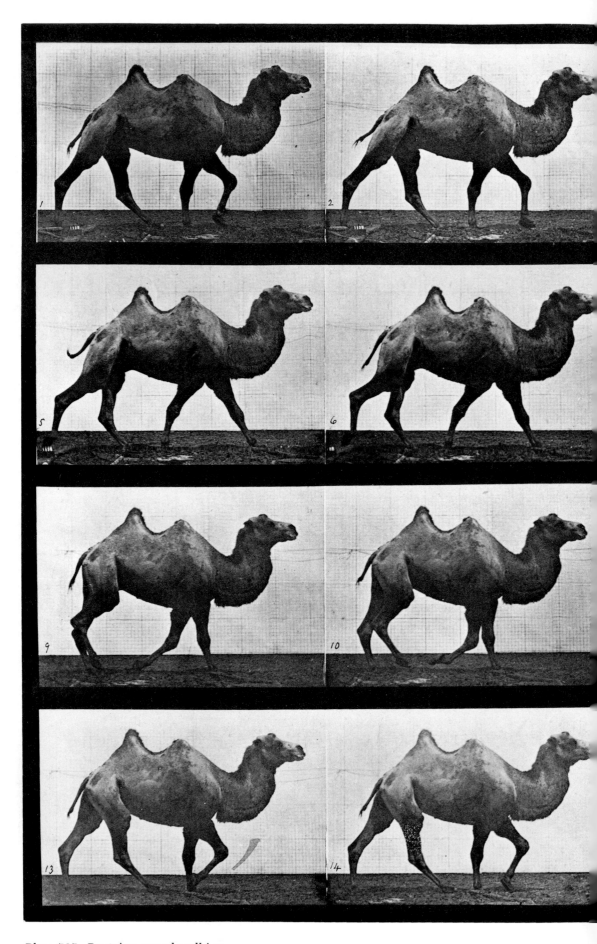

Plate 737. Bactrian camel walking.

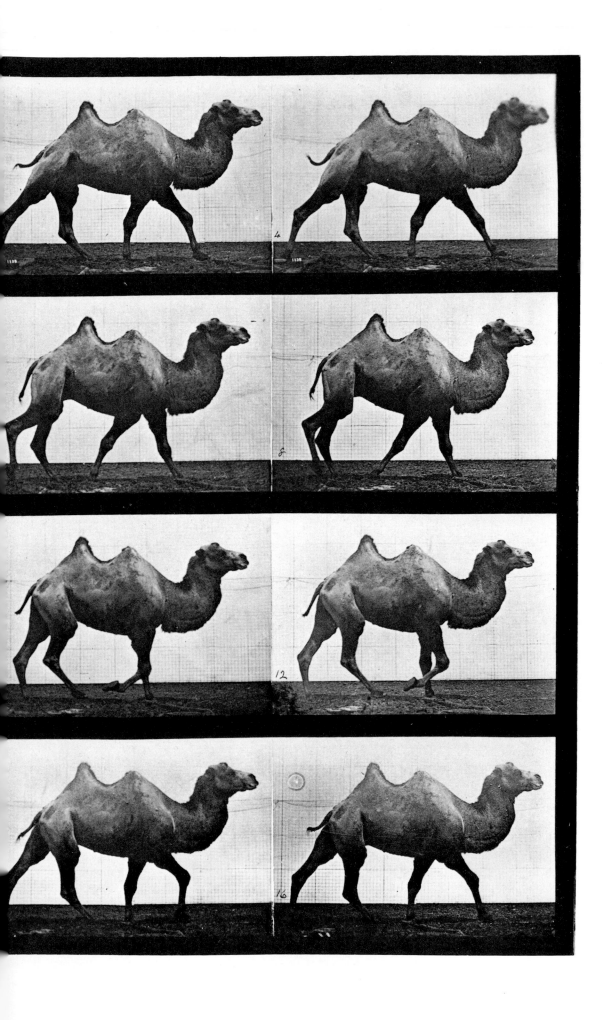

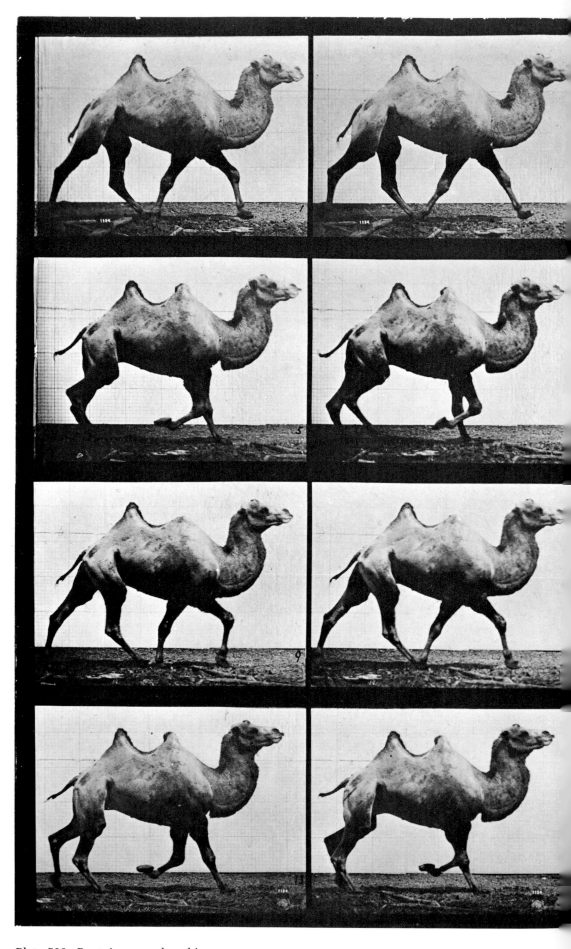

Plate 738. Bactrian camel racking.

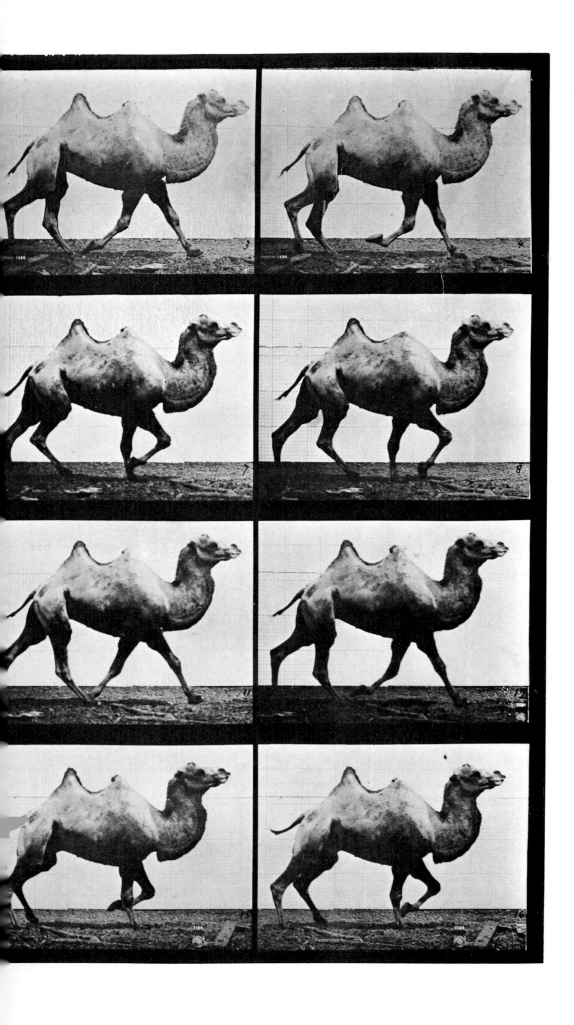

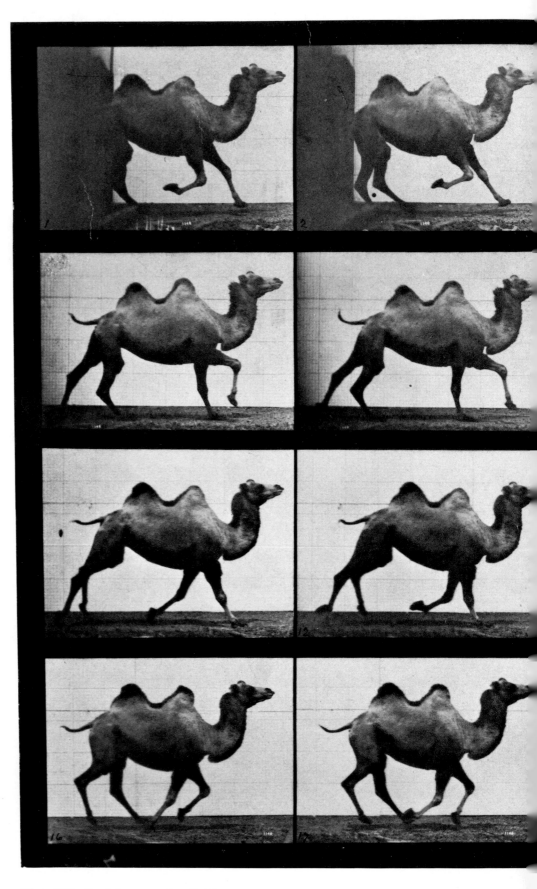

Plate 739. Bactrian camel galloping.

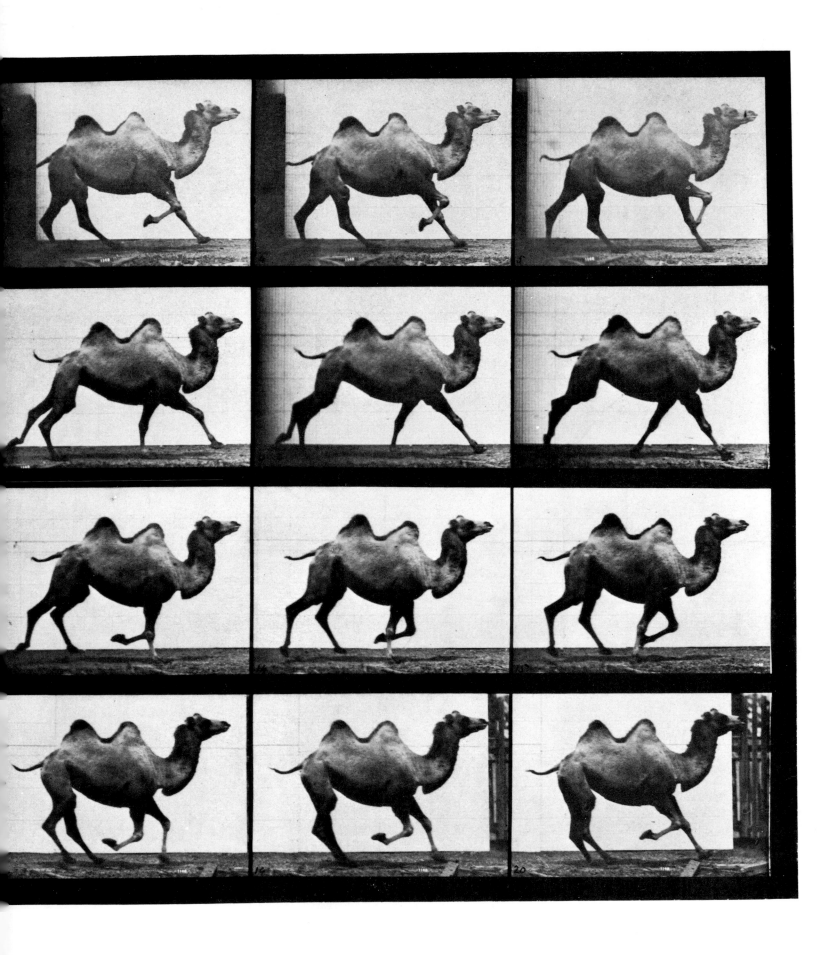

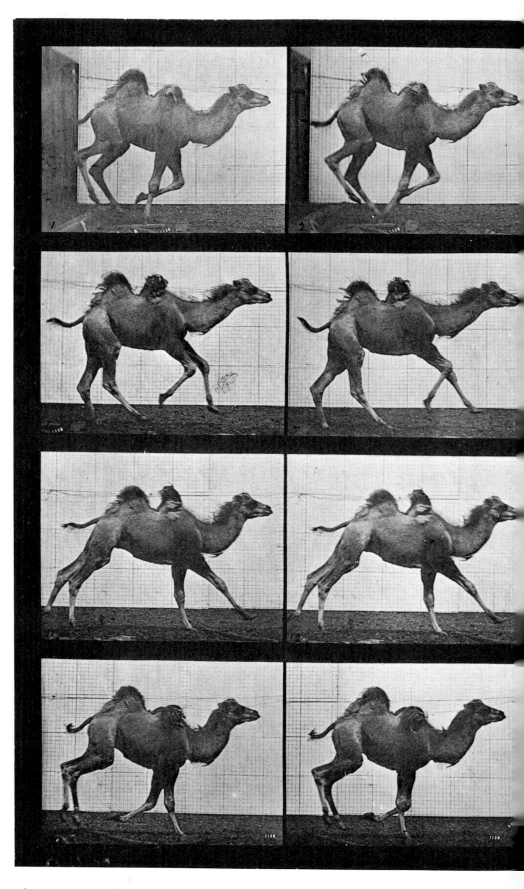

Plate 740. Bactrian camel galloping.

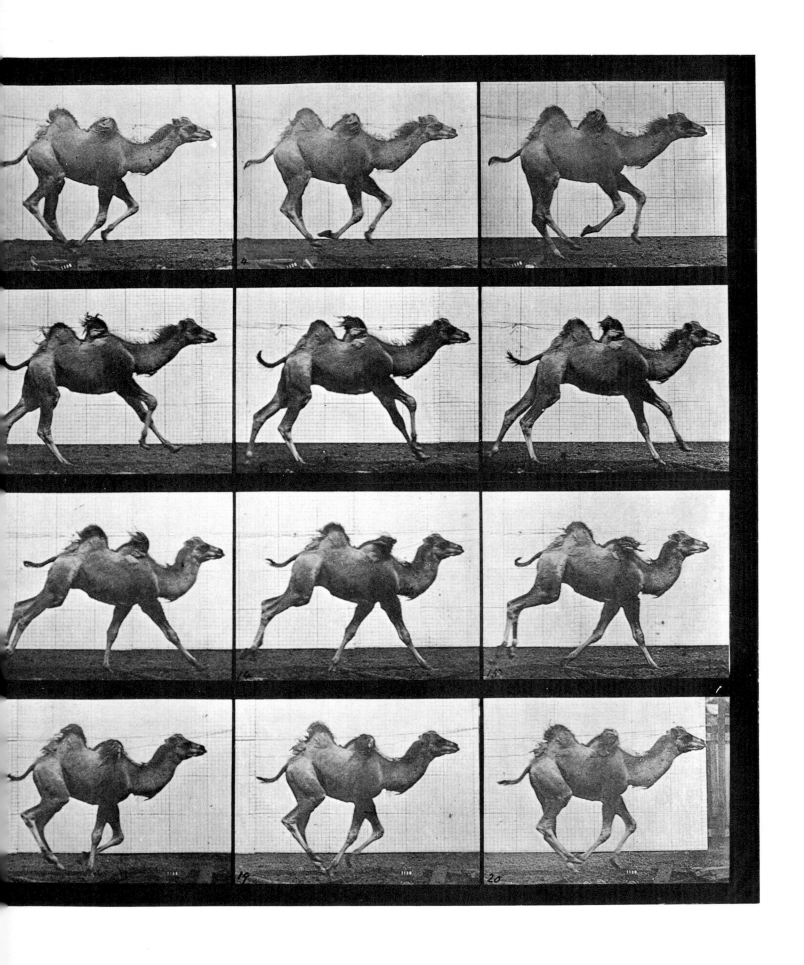

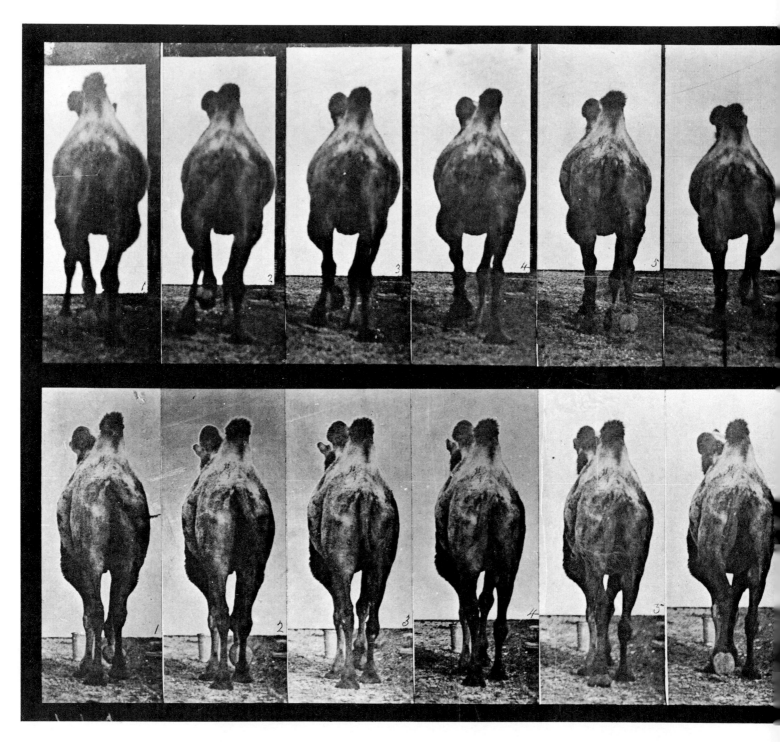

Plate 741. Bactrian camel. A: Walking. B: Racking.

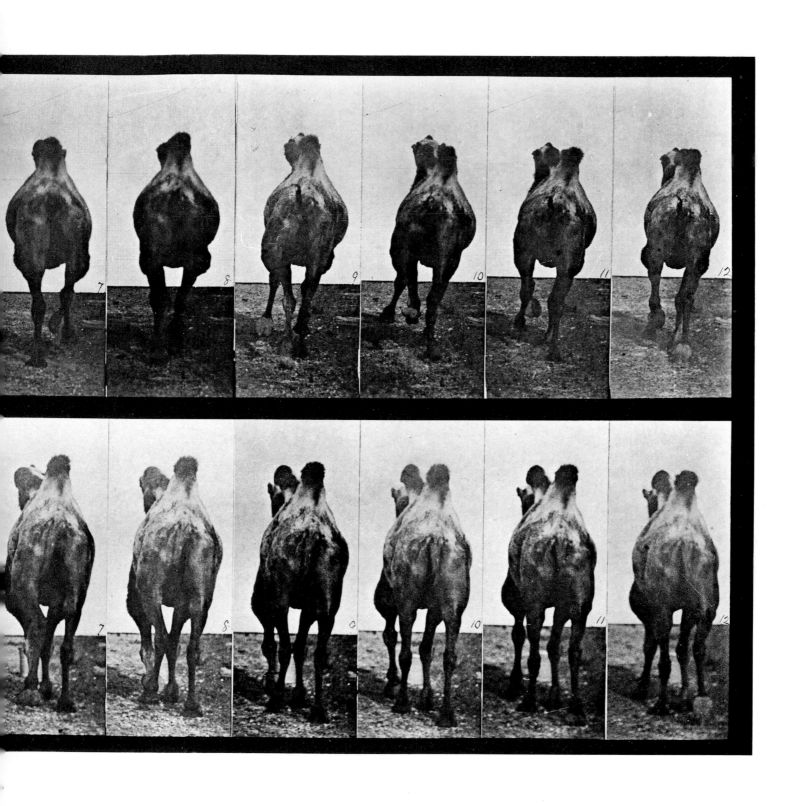

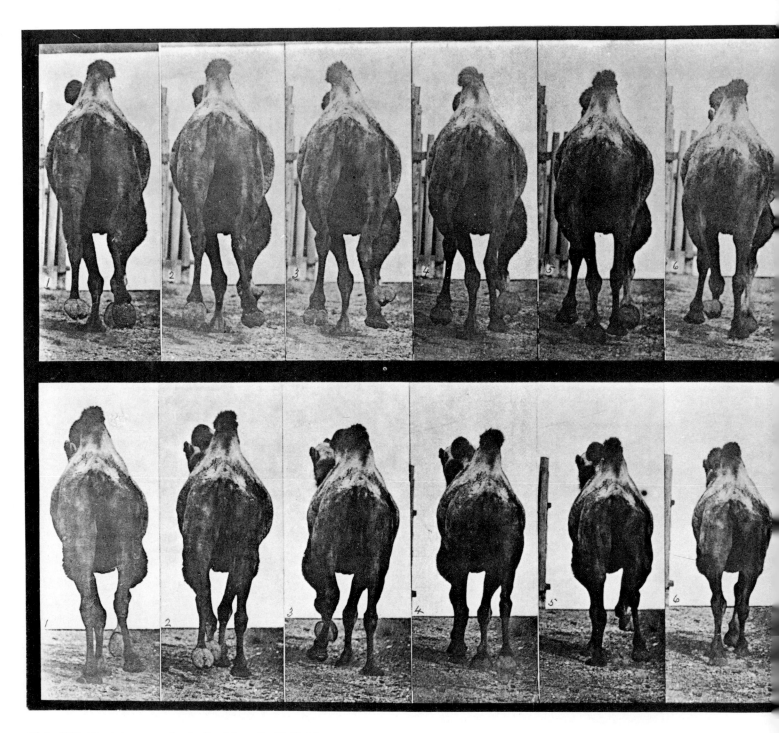

Plate 742. Bactrian camel. A: Racking. B: Galloping.

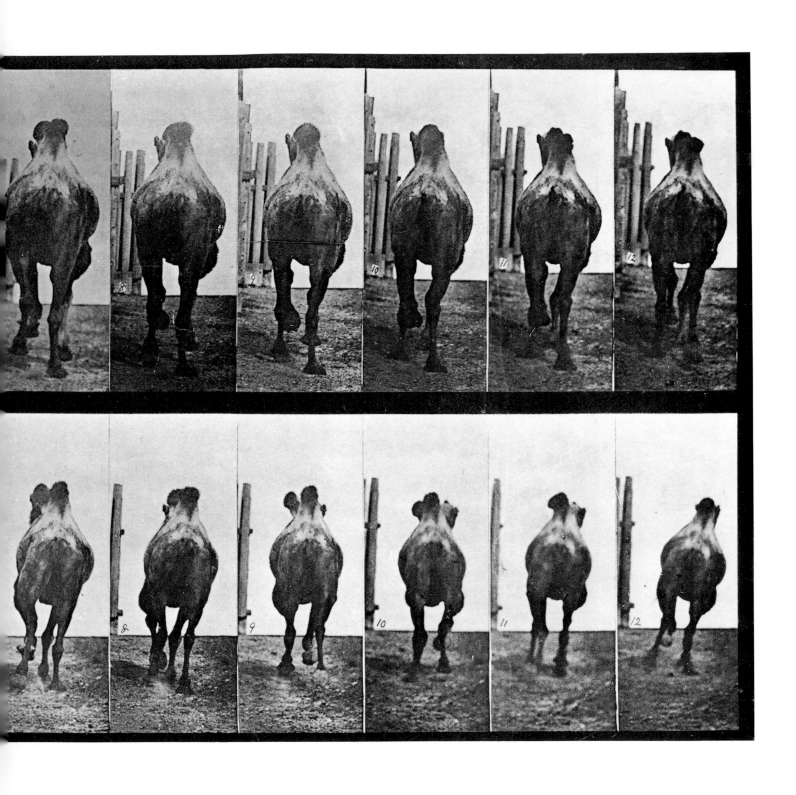

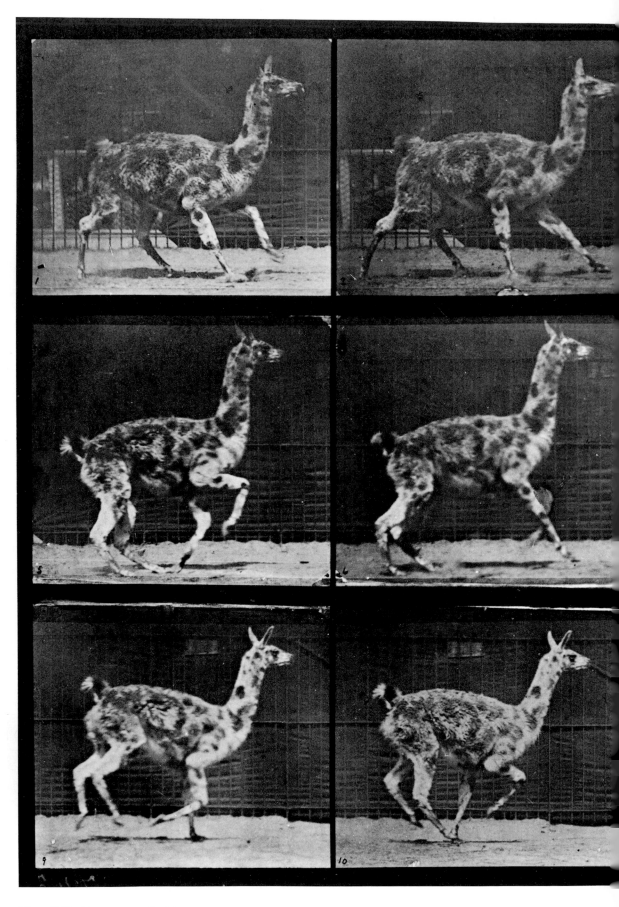

Plate 743. Guanaco galloping.

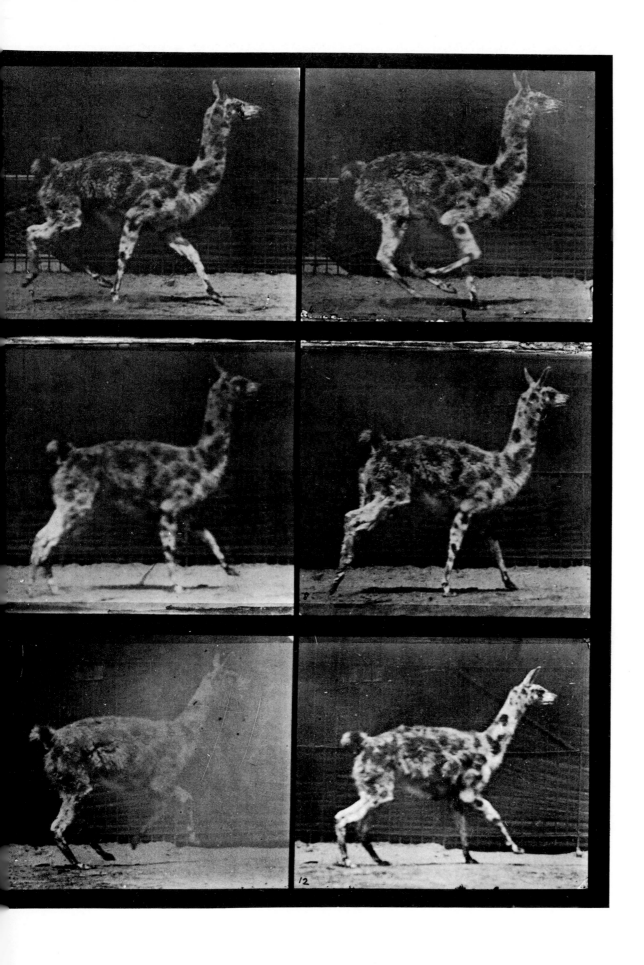

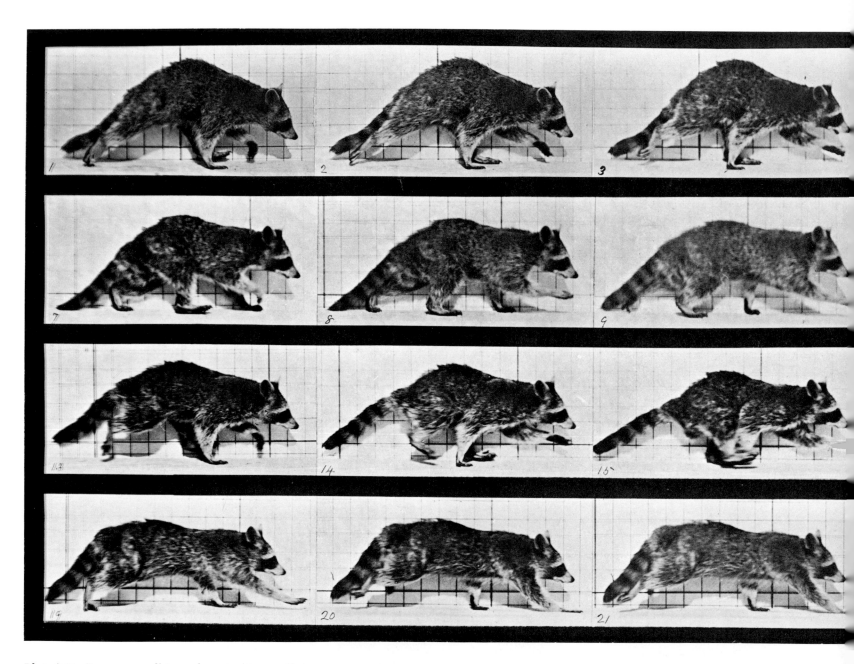

Plate 744. Raccoon walking, changing to a gallop.

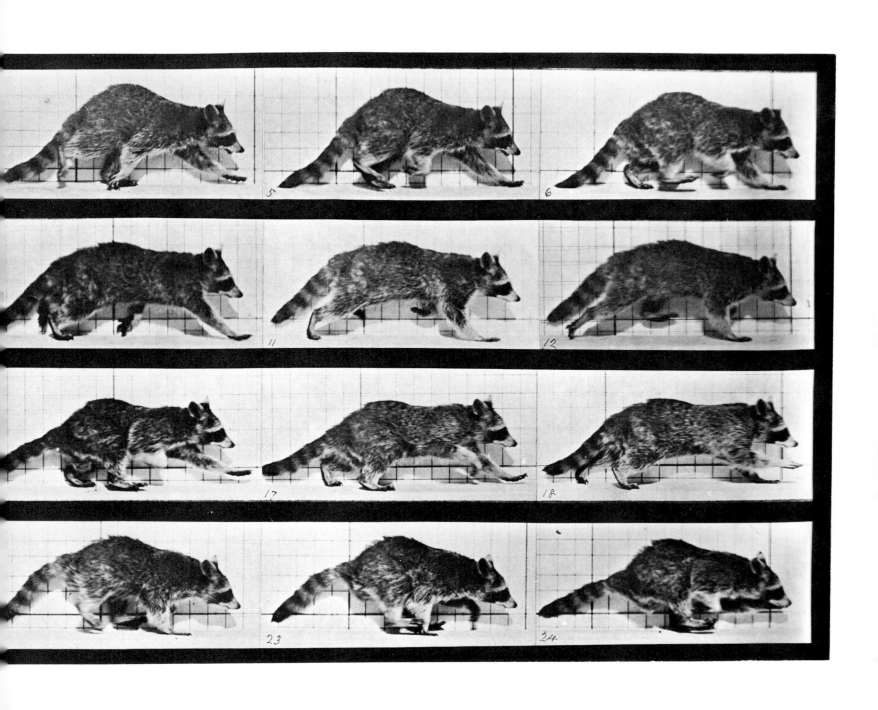

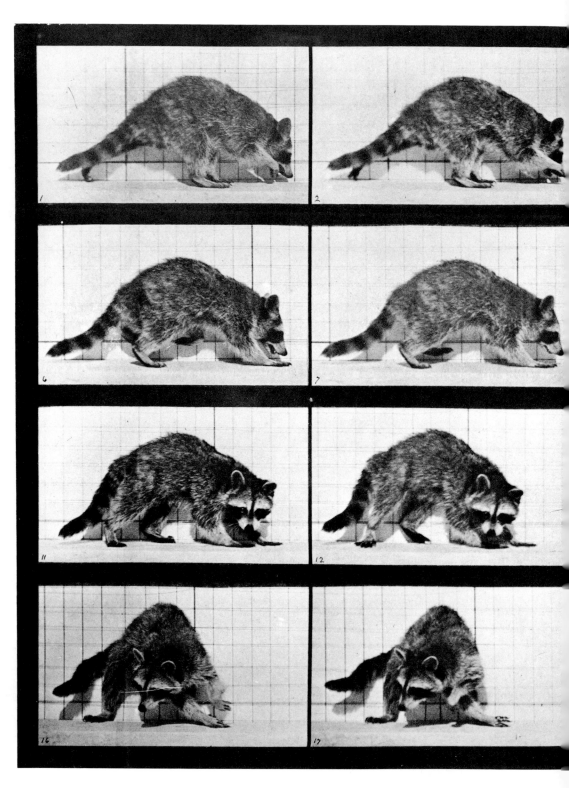

Plate 745. Raccoon walking and turning around.

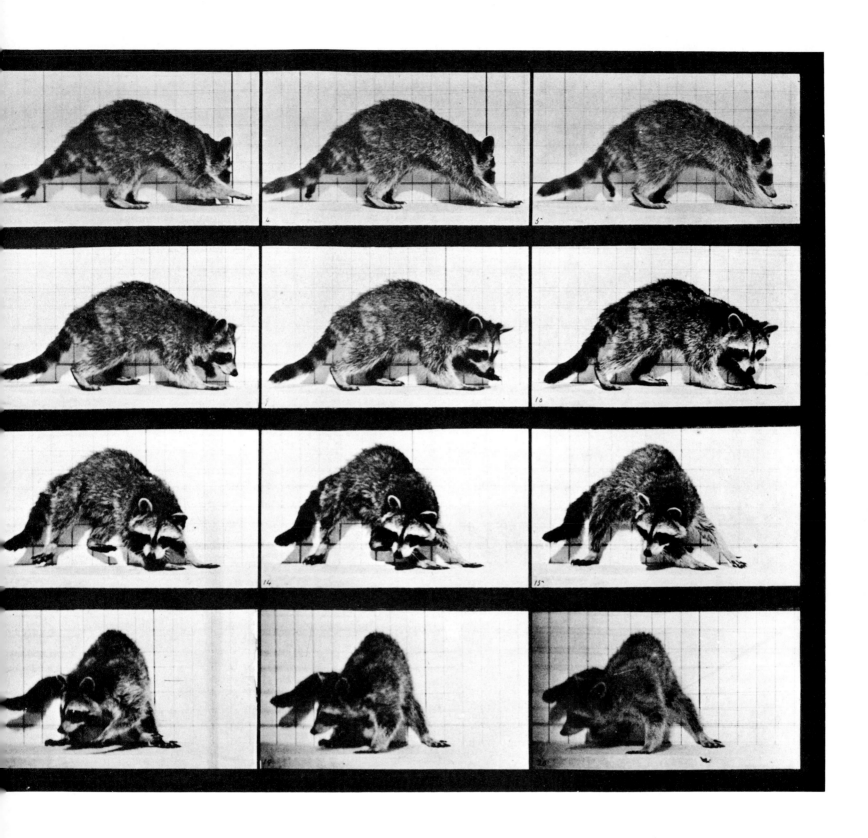

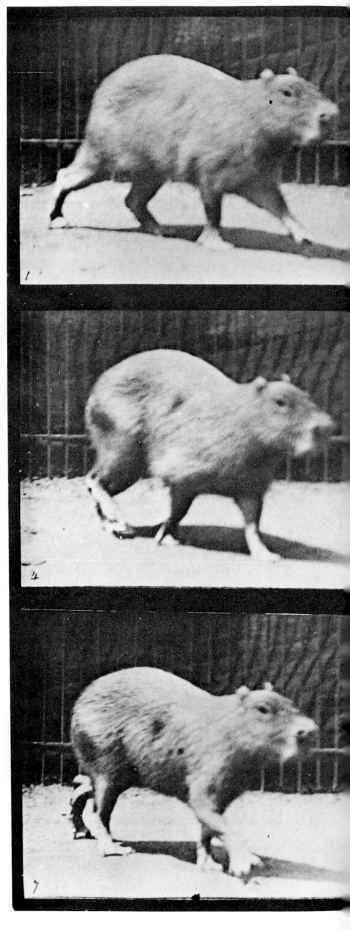

Plate 746. Capybara walking.

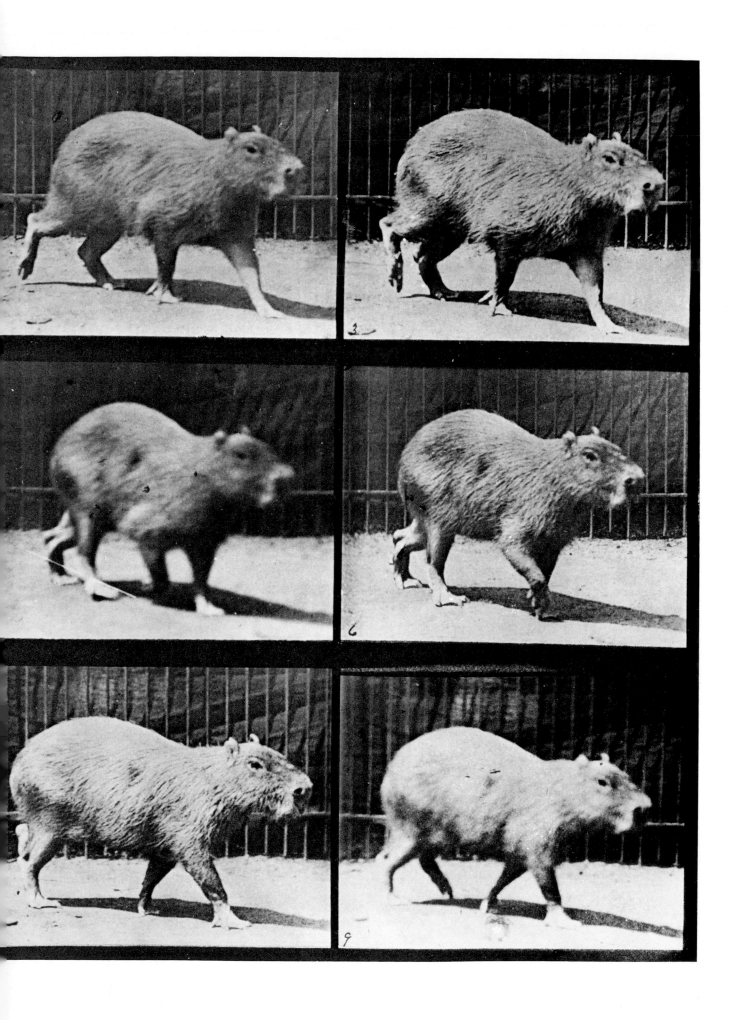

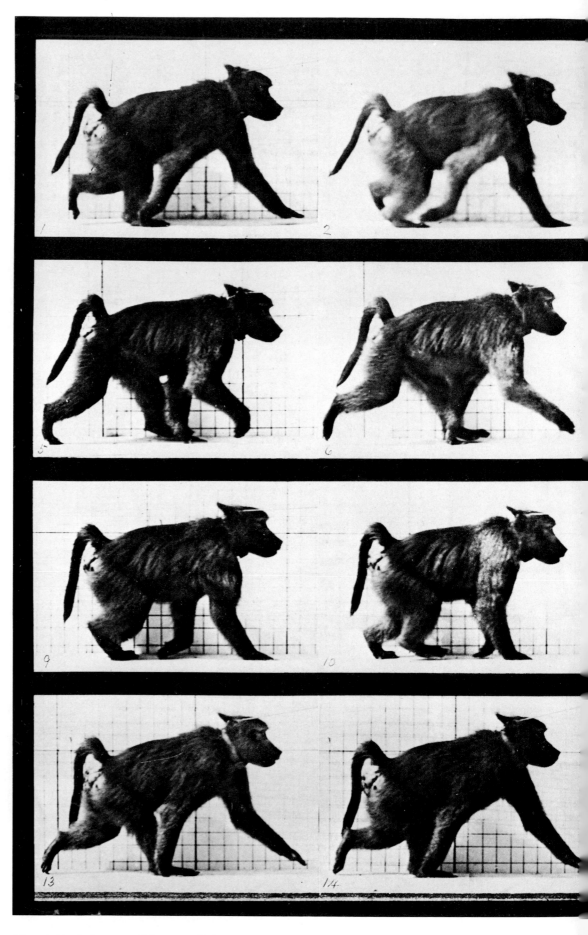

Plate 747. Baboon walking on all fours.

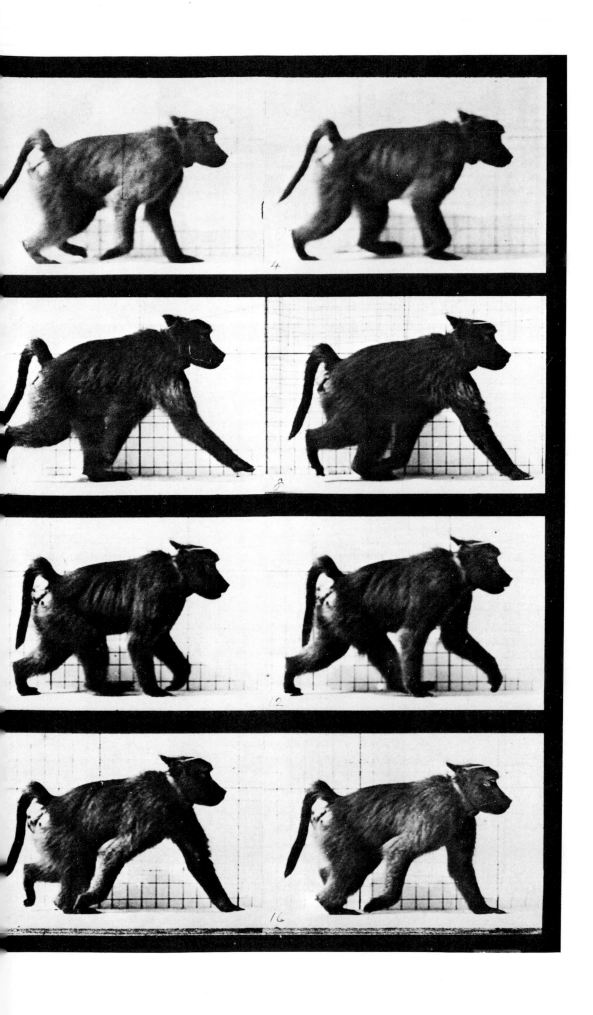

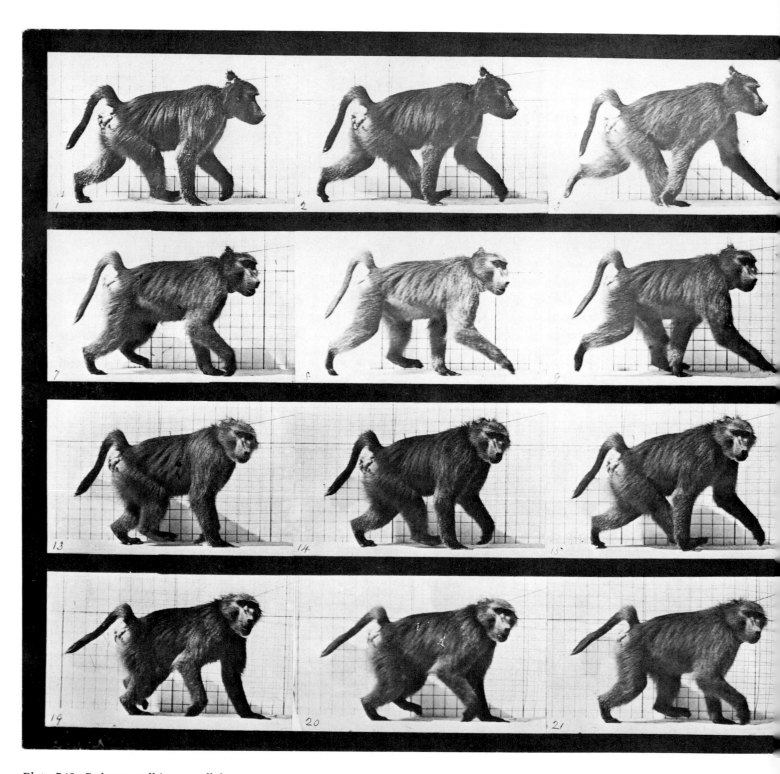

Plate 748. Baboon walking on all fours.

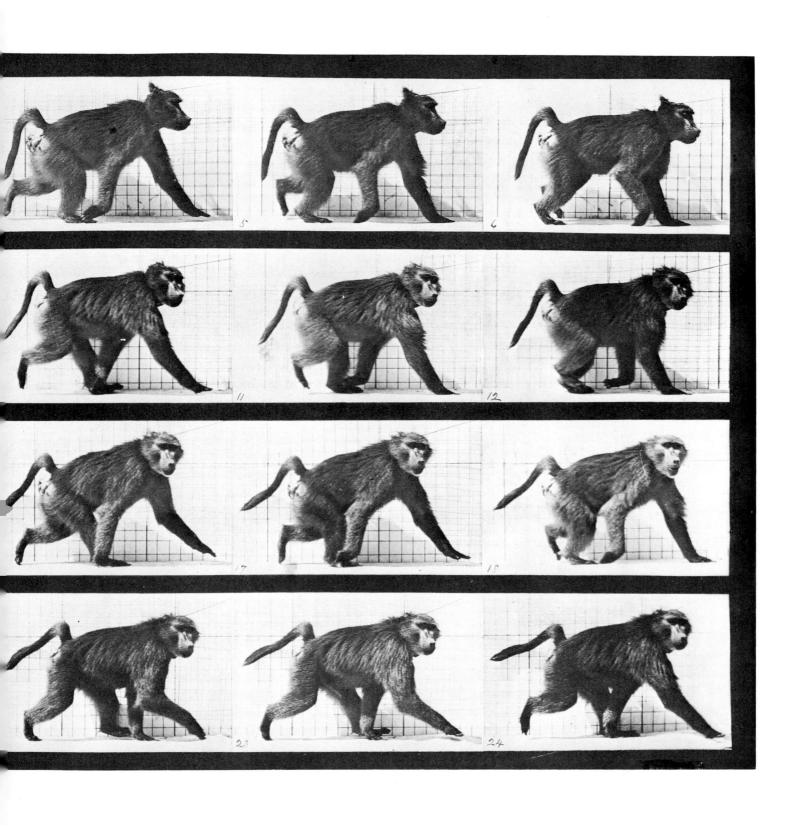

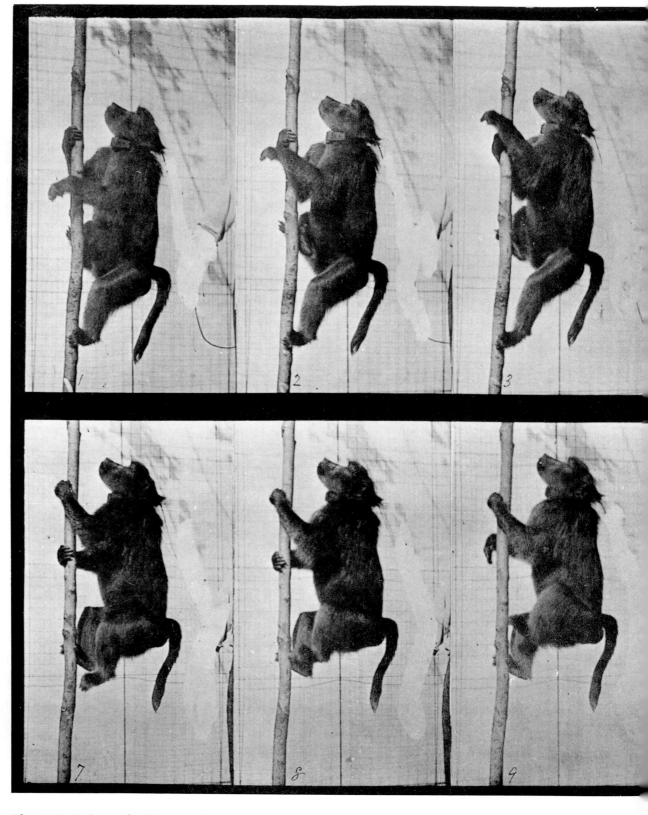

Plate 749. Baboon climbing a pole.

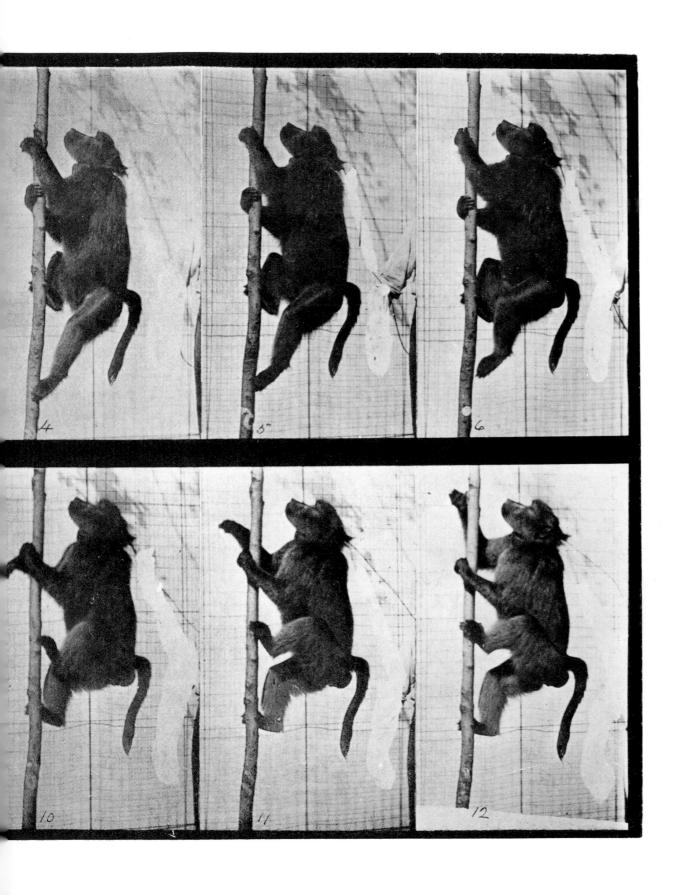

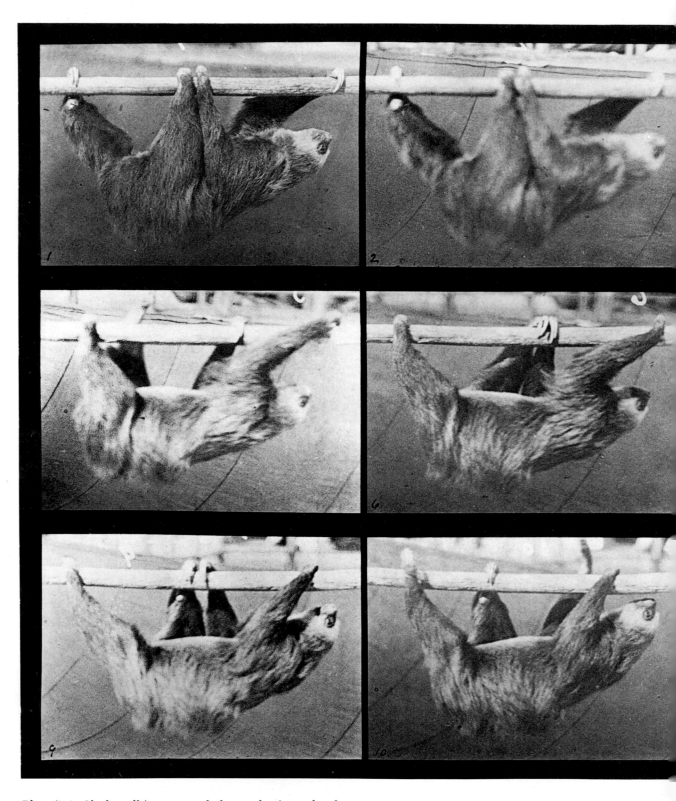

Plate 750. Sloth walking suspended on a horizontal pole.

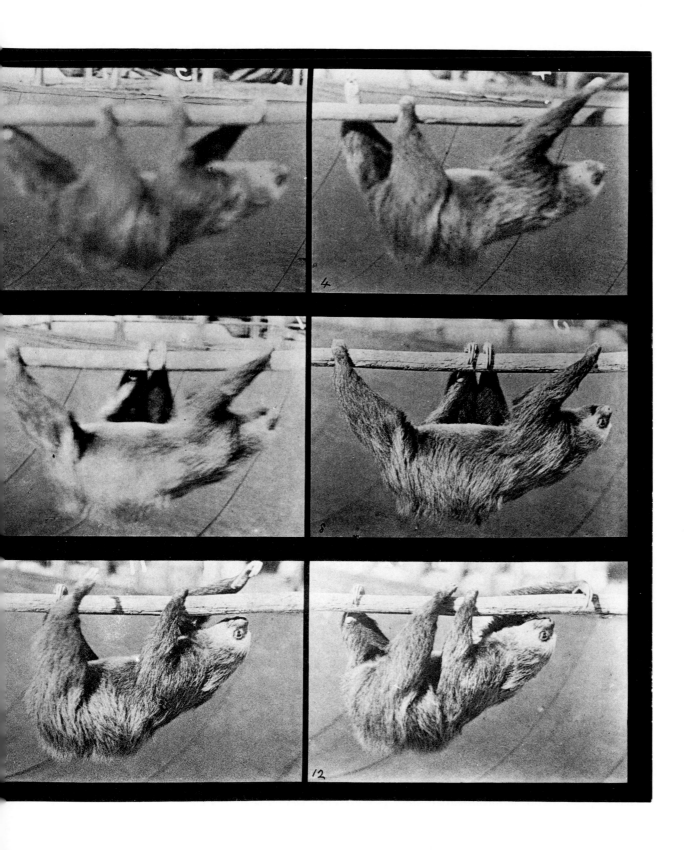

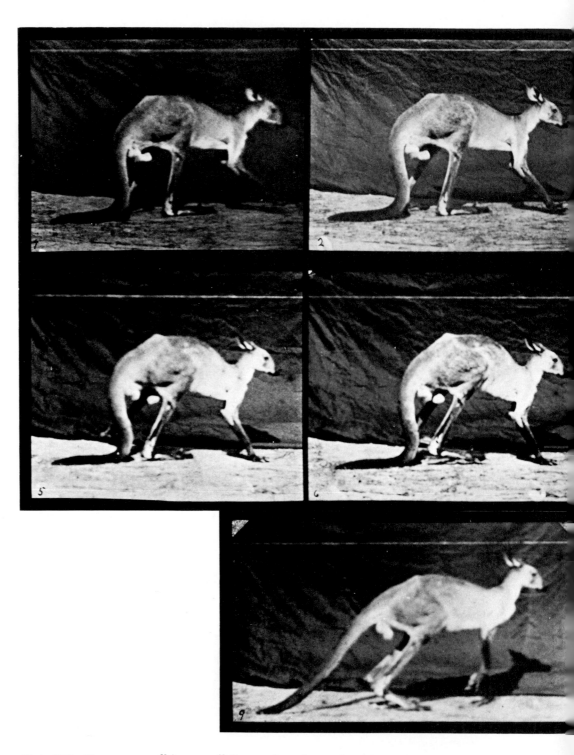

Plate 751. Kangaroo walking on all fours, changing to jumping.

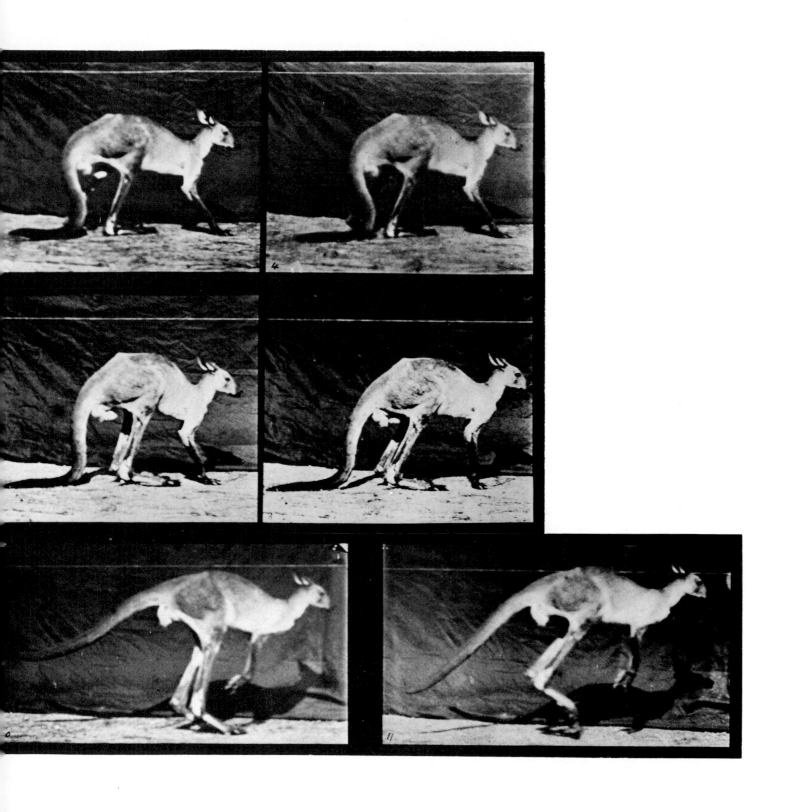

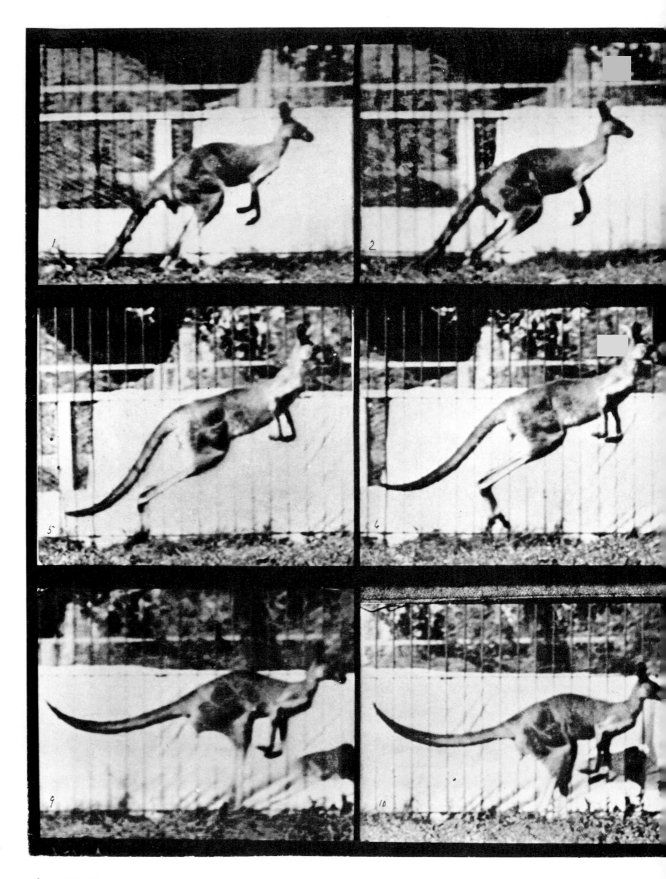

Plate 752. Kangaroo jumping.

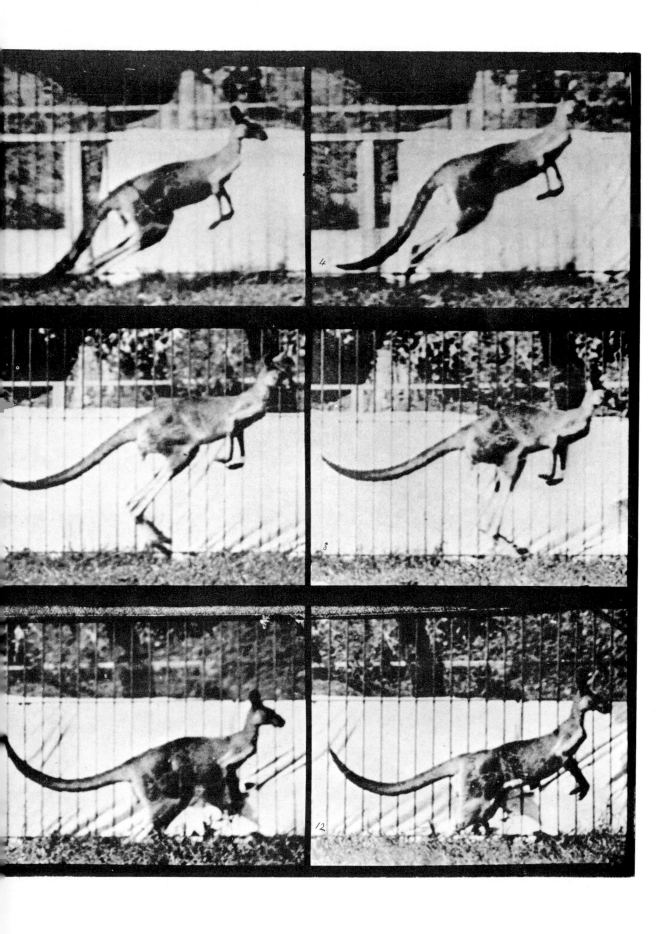

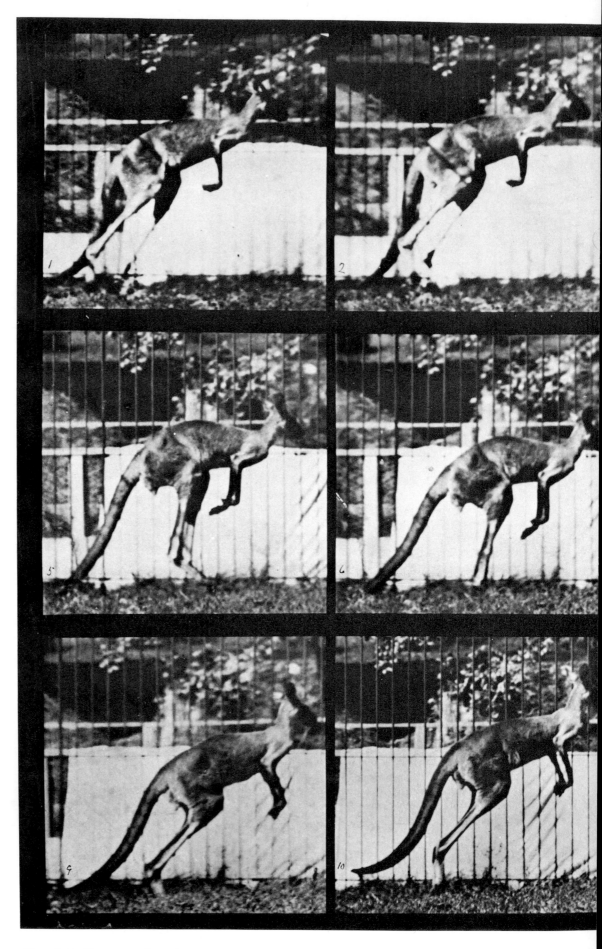

Plate 753. Kangaroo jumping.

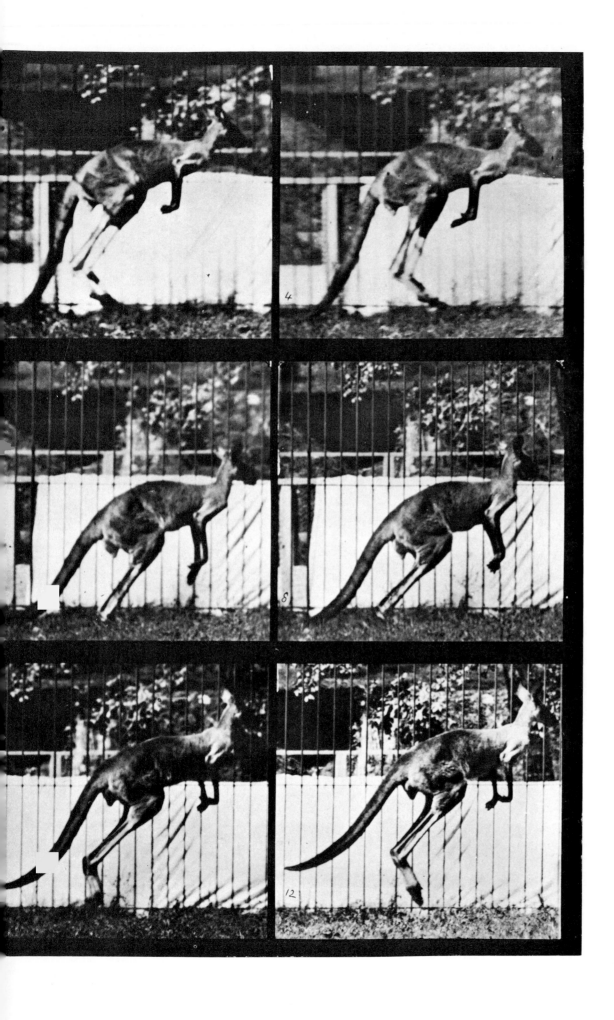

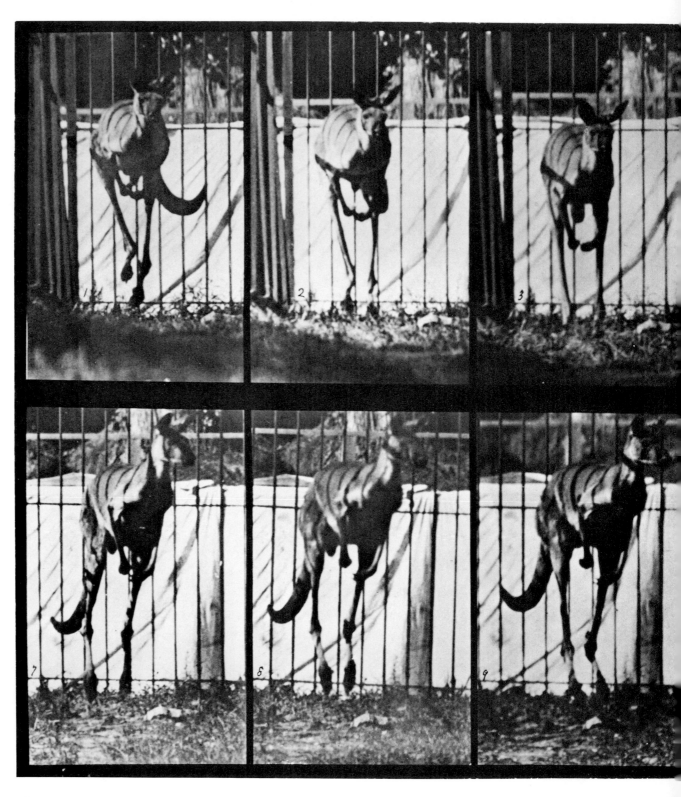

Plate 754. Kangaroo jumping.

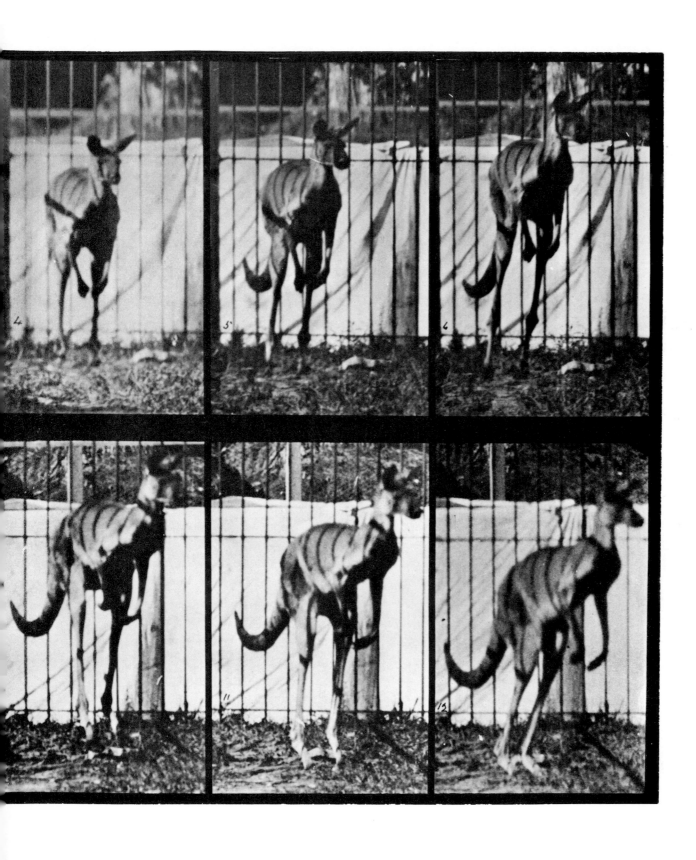

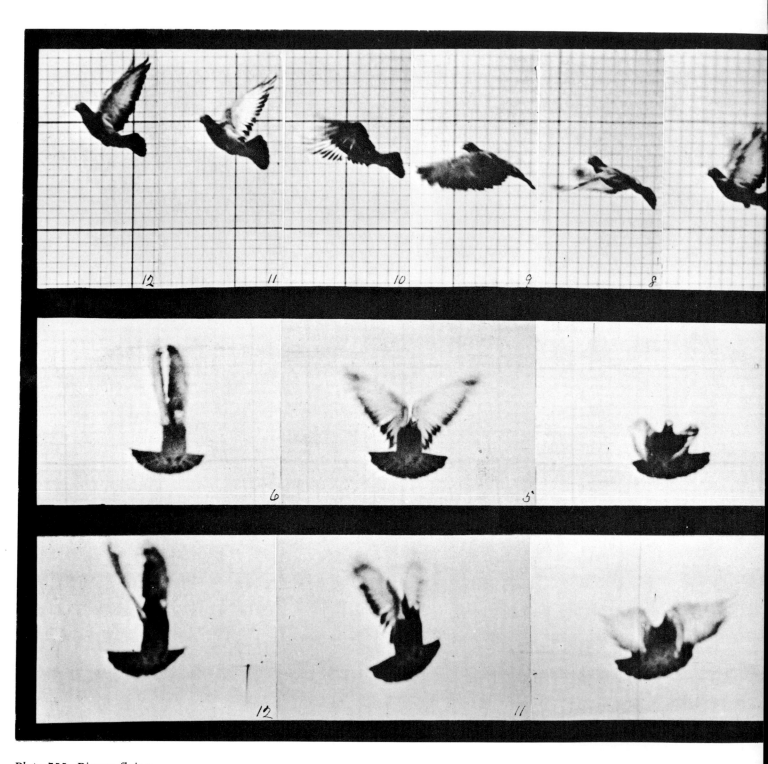

Plate 755. Pigeon flying.

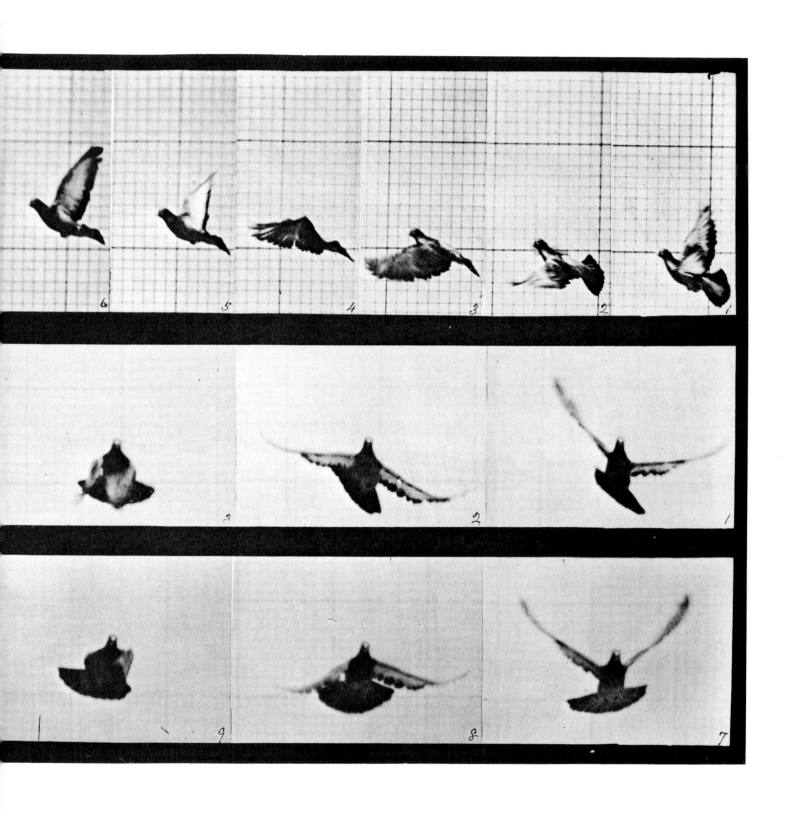

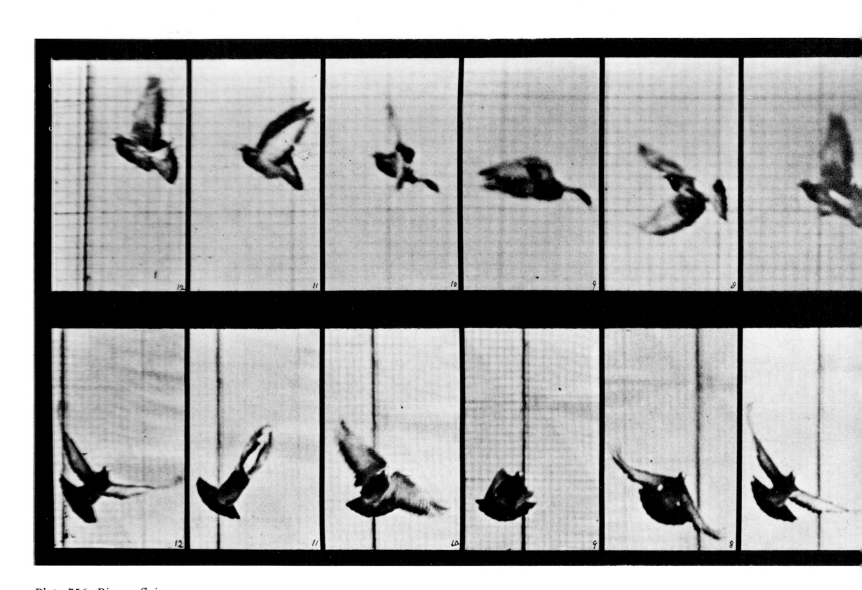

Plate 756. Pigeon flying.

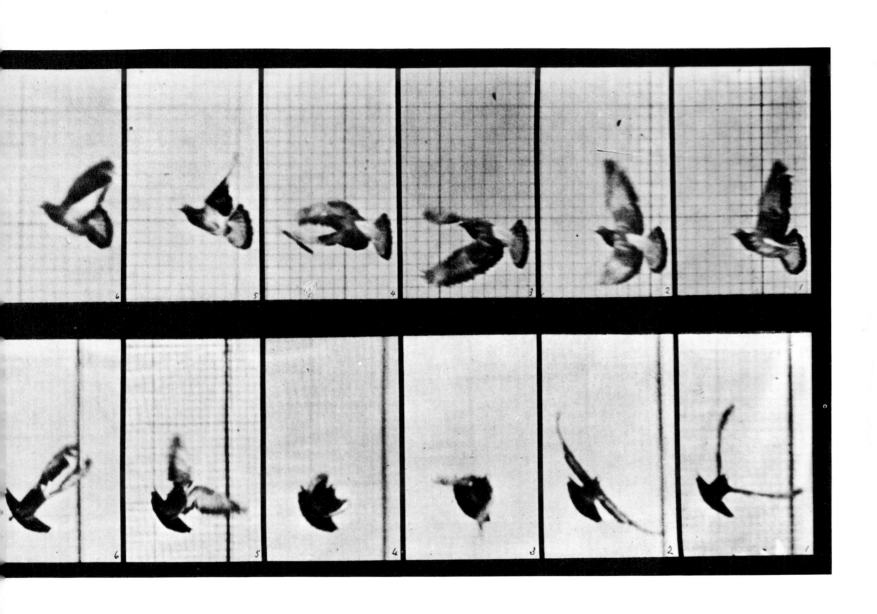

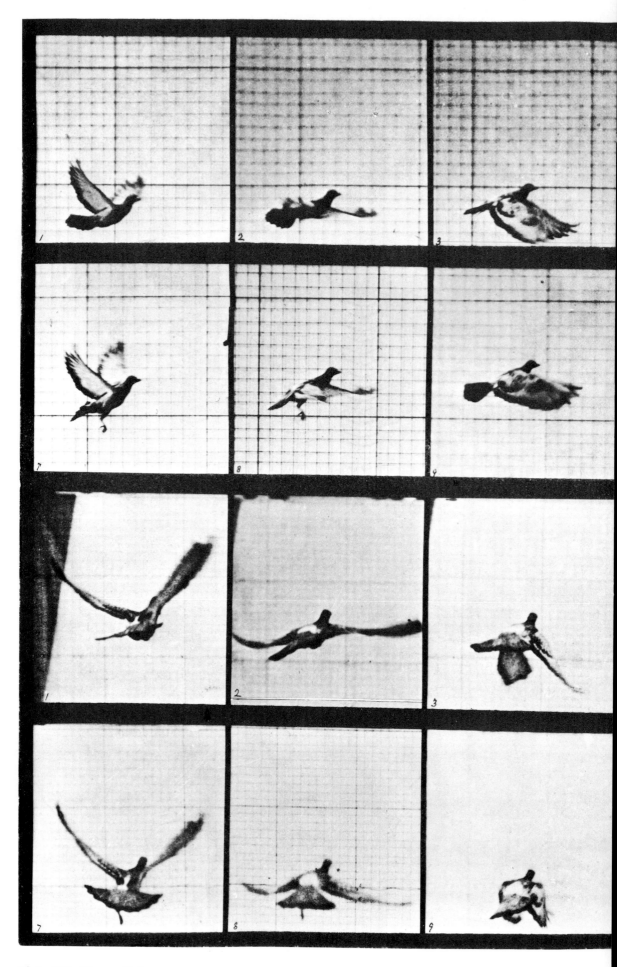

Plate 757. Pigeon flying.

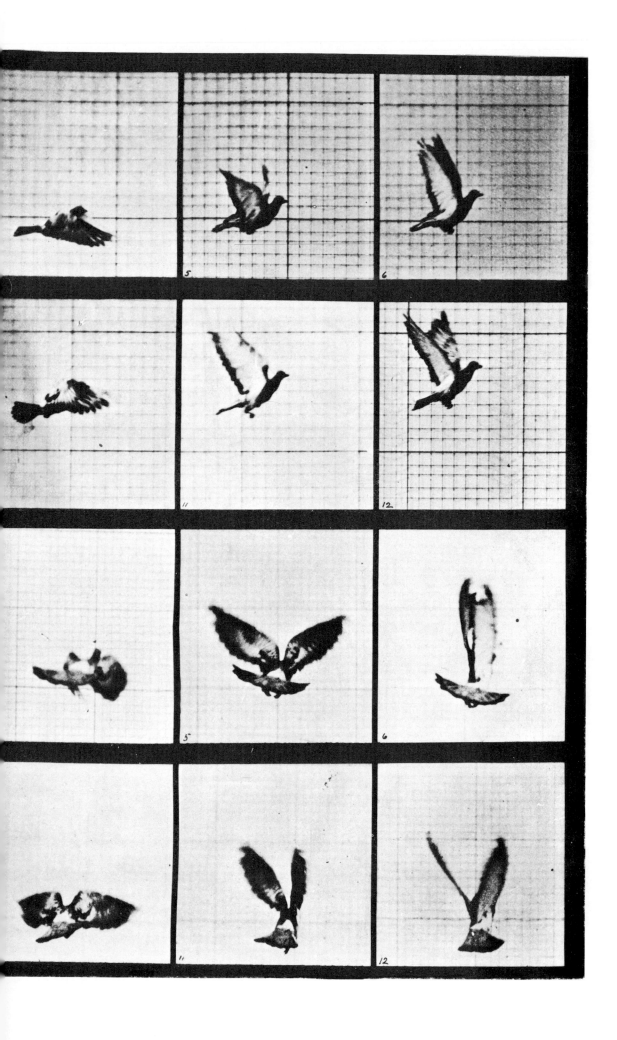

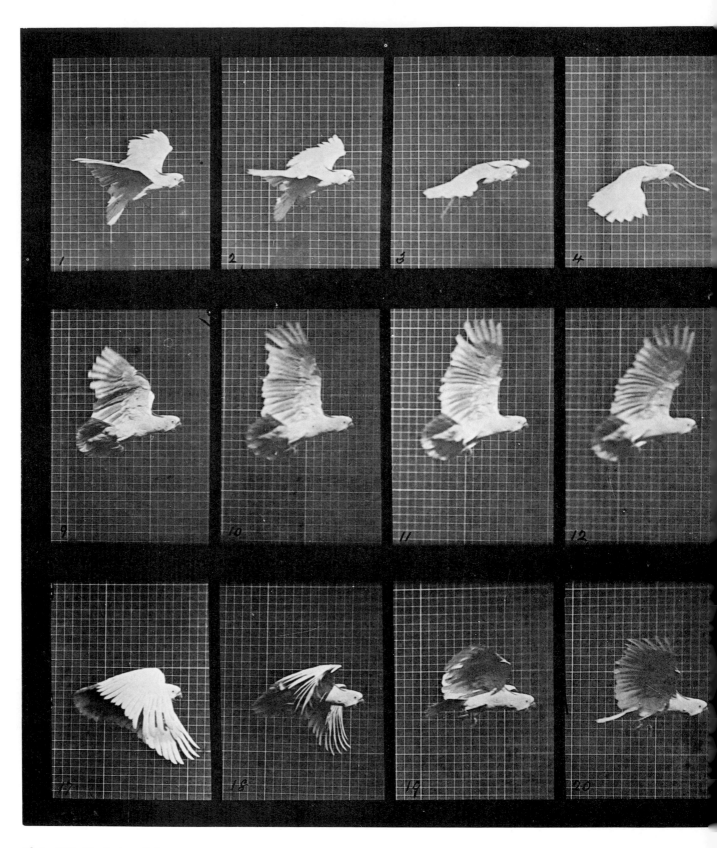

Plate 758. Cockatoo flying.

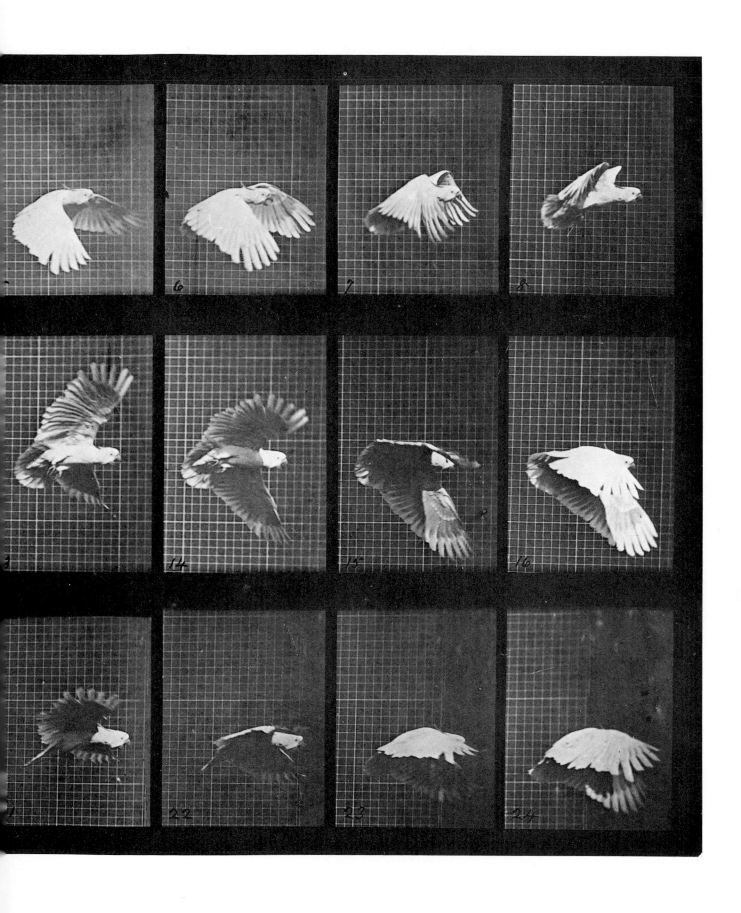

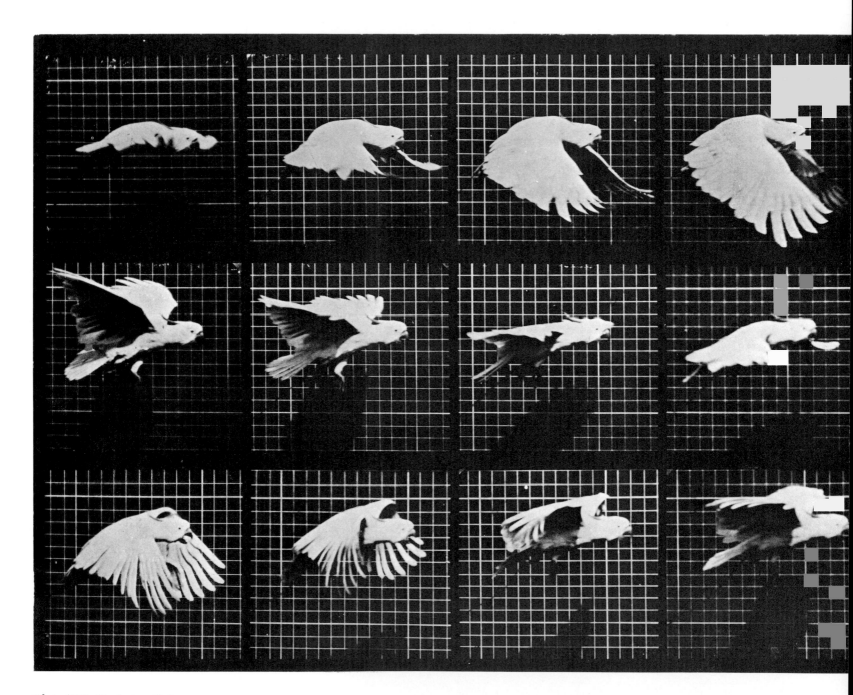

Plate 759. Cockatoo flying.

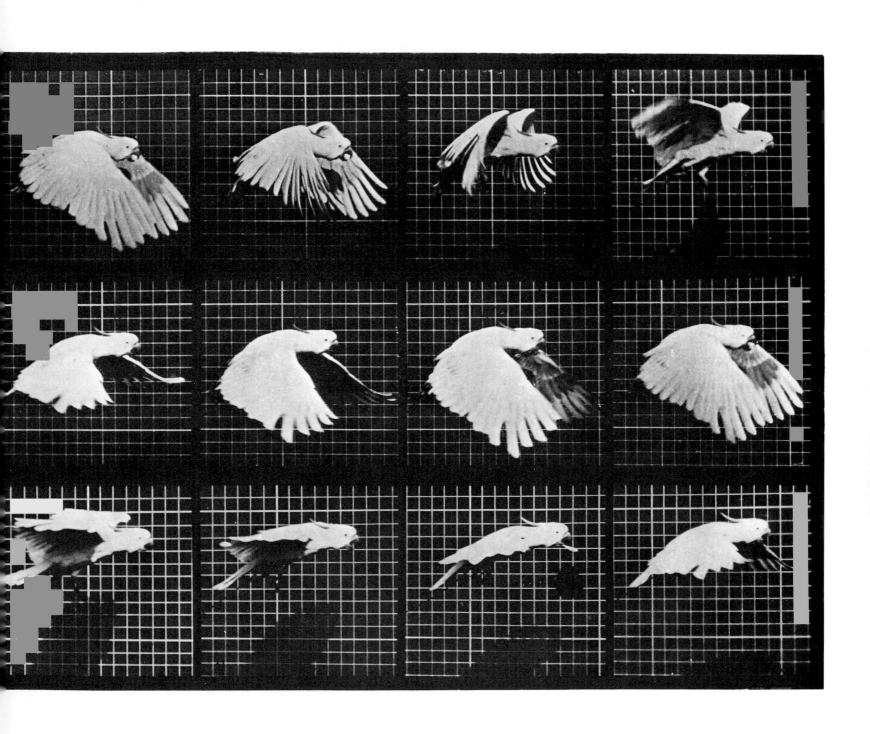

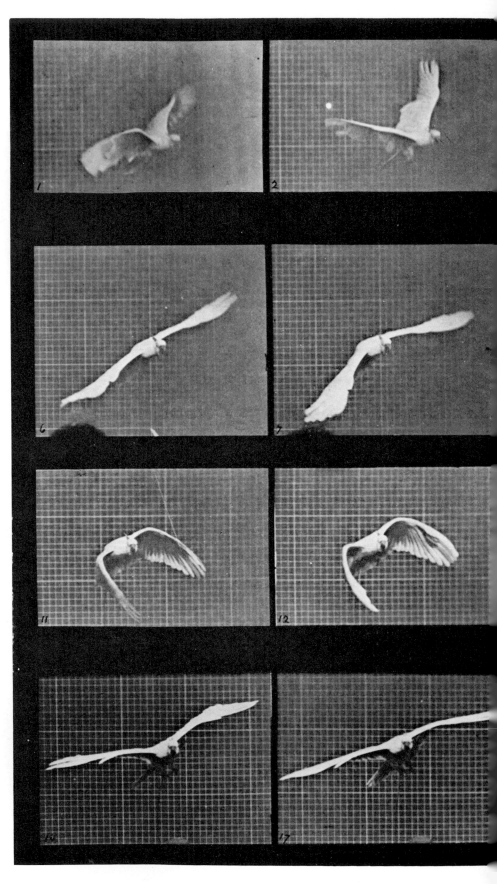

Plate 760. Cockatoo flying.

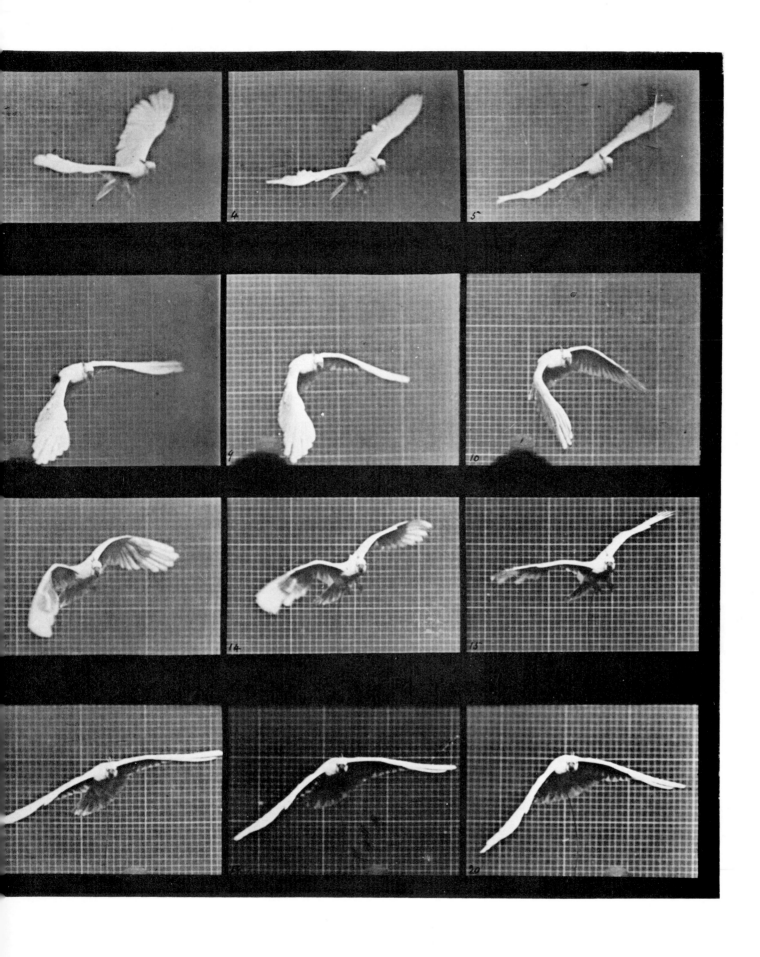

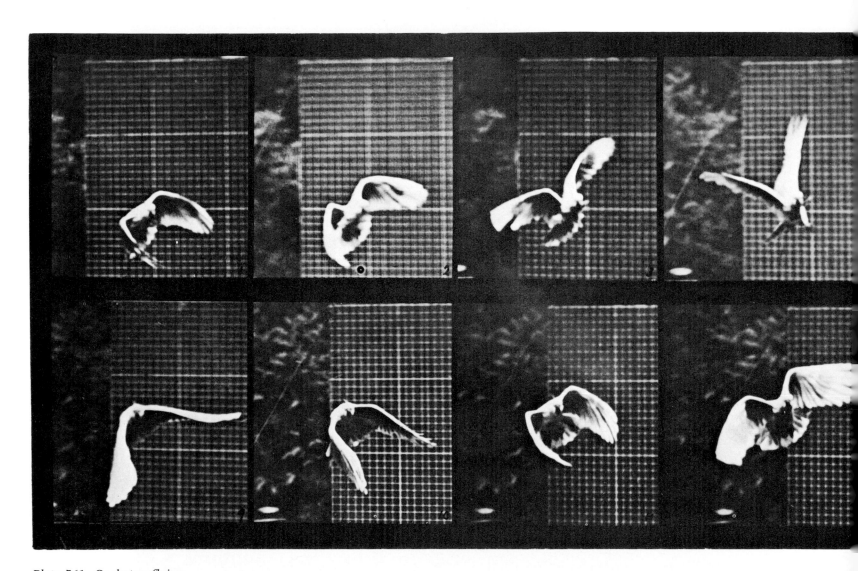

Plate 761. Cockatoo flying.

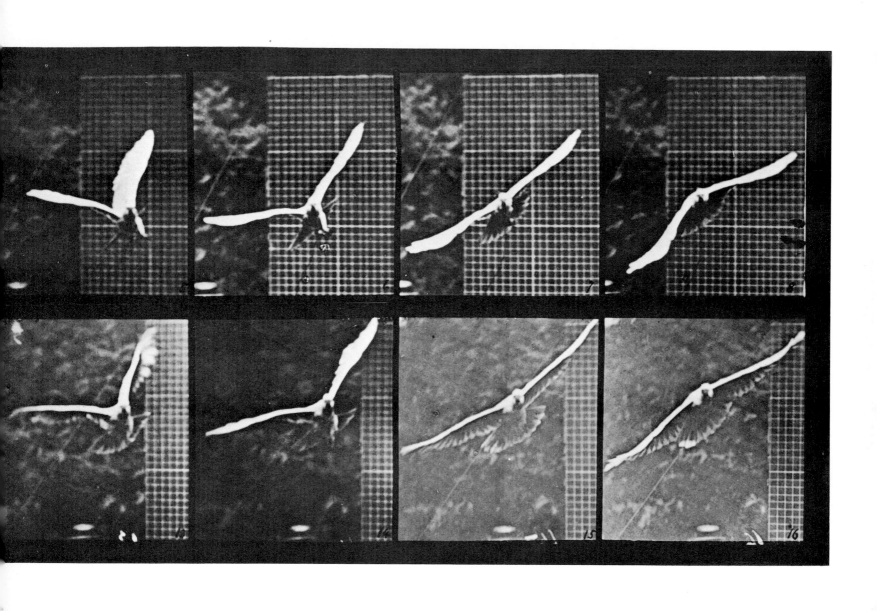

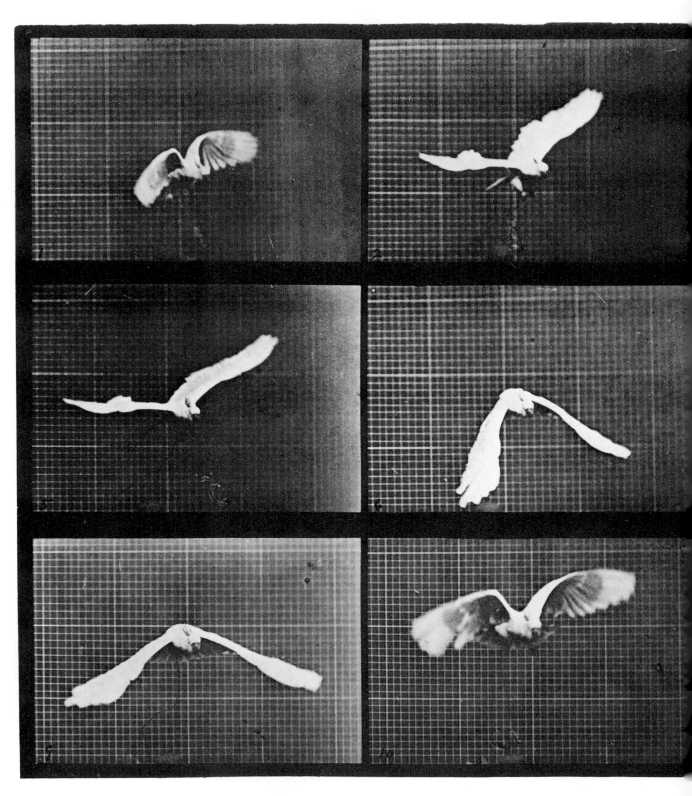

Plate 762. Cockatoo flying.

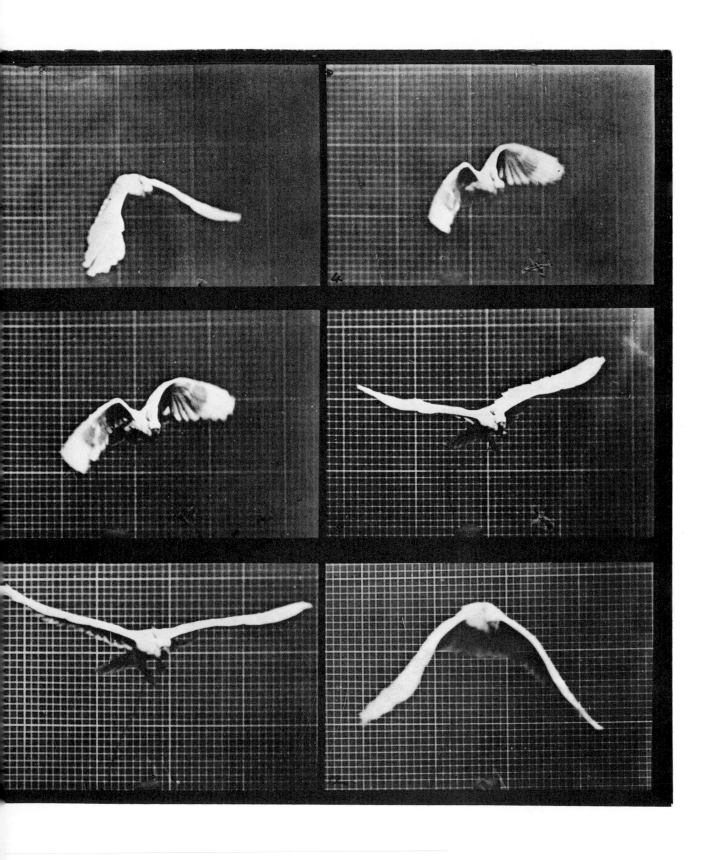

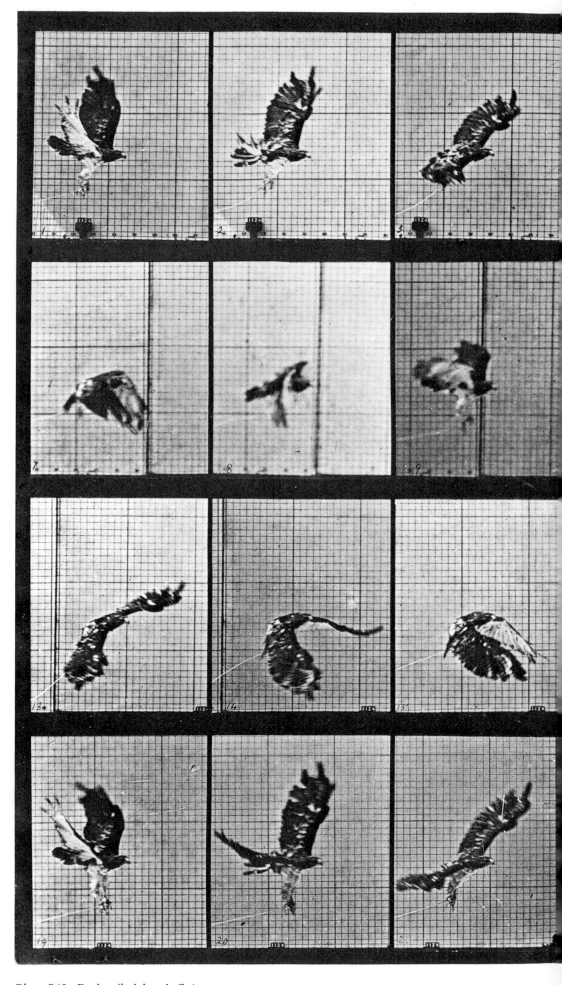

Plate 763. Red-tailed hawk flying.

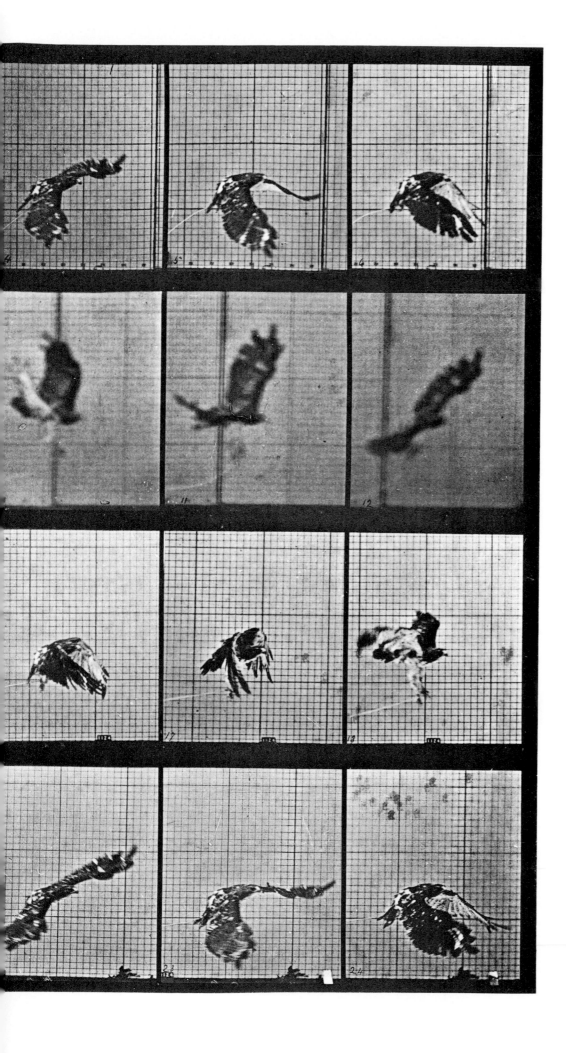

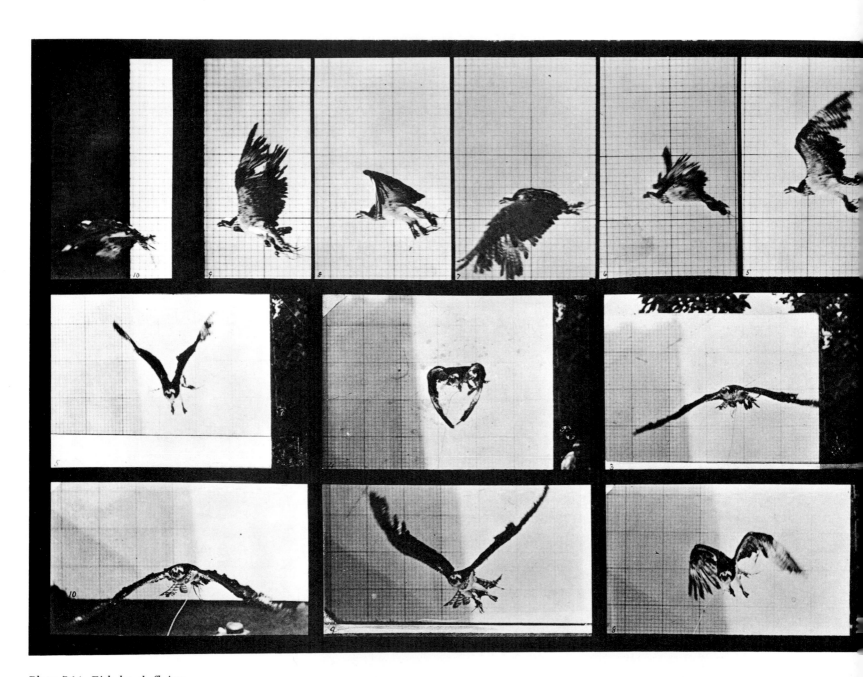

Plate 764. Fish hawk flying.

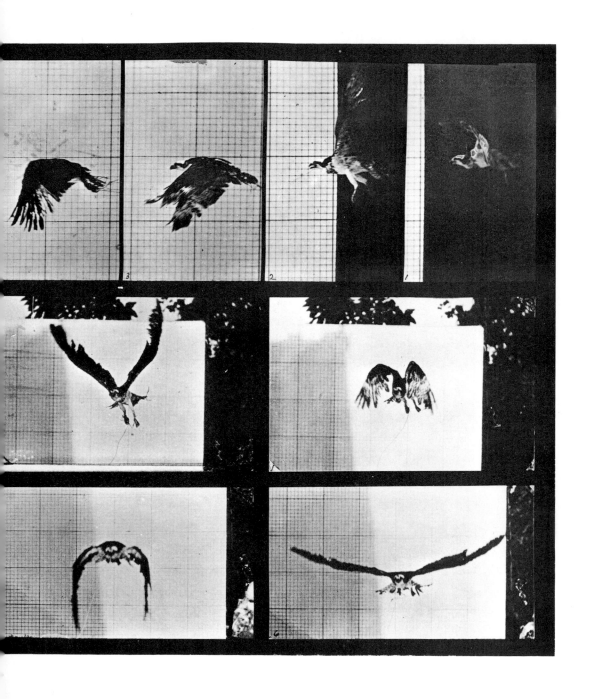

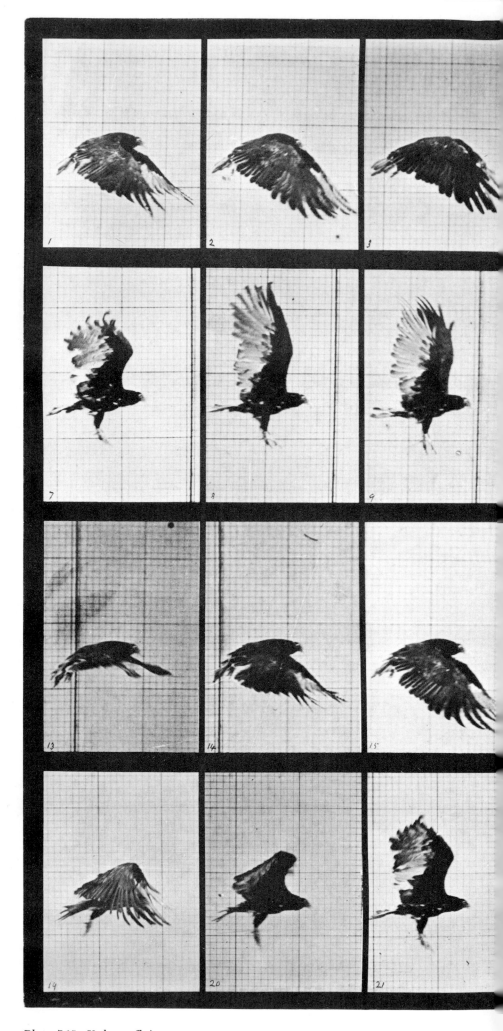

Plate 765. Vulture flying.

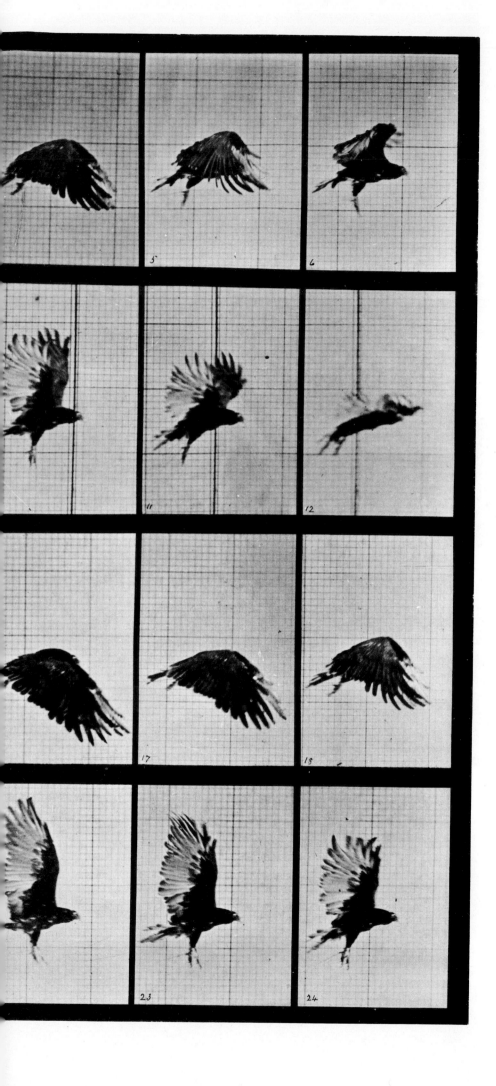

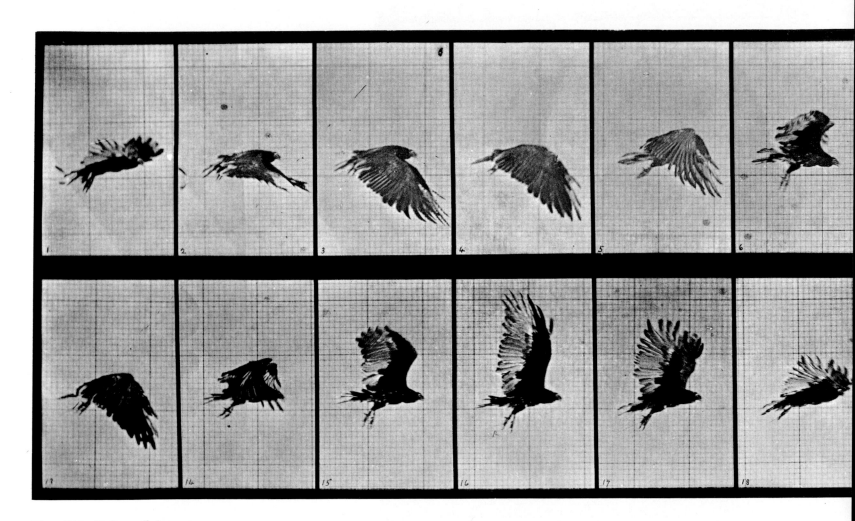

Plate 766. Vulture flying.

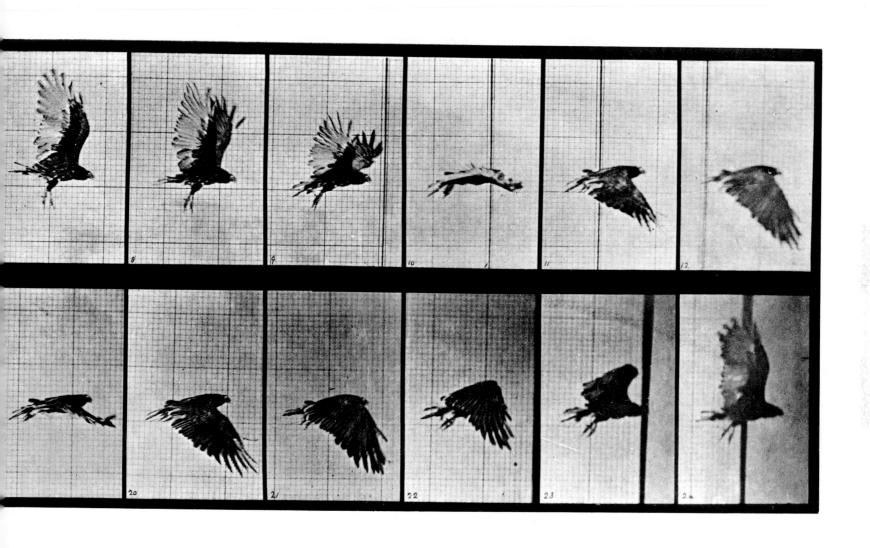

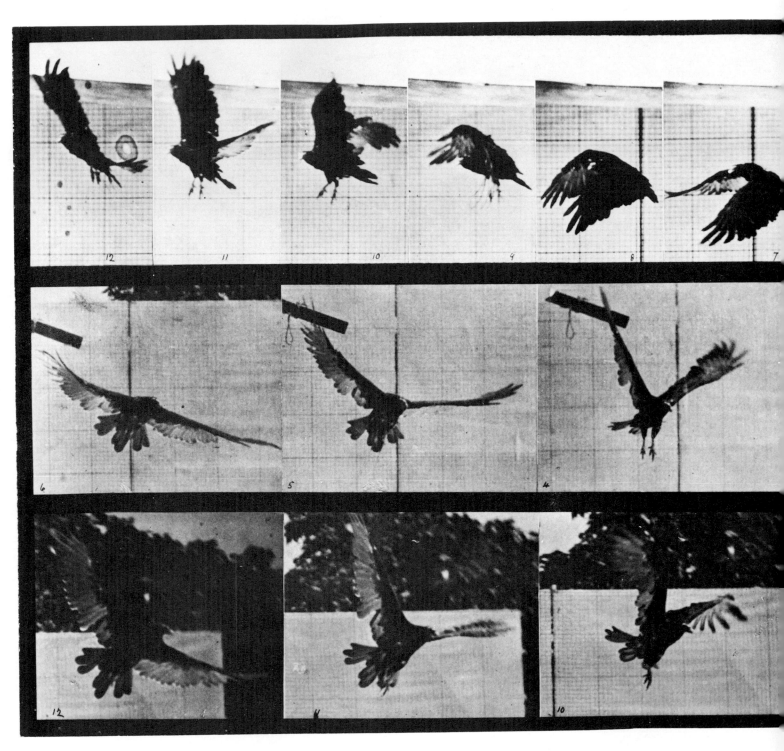

Plate 767. Vulture flying.

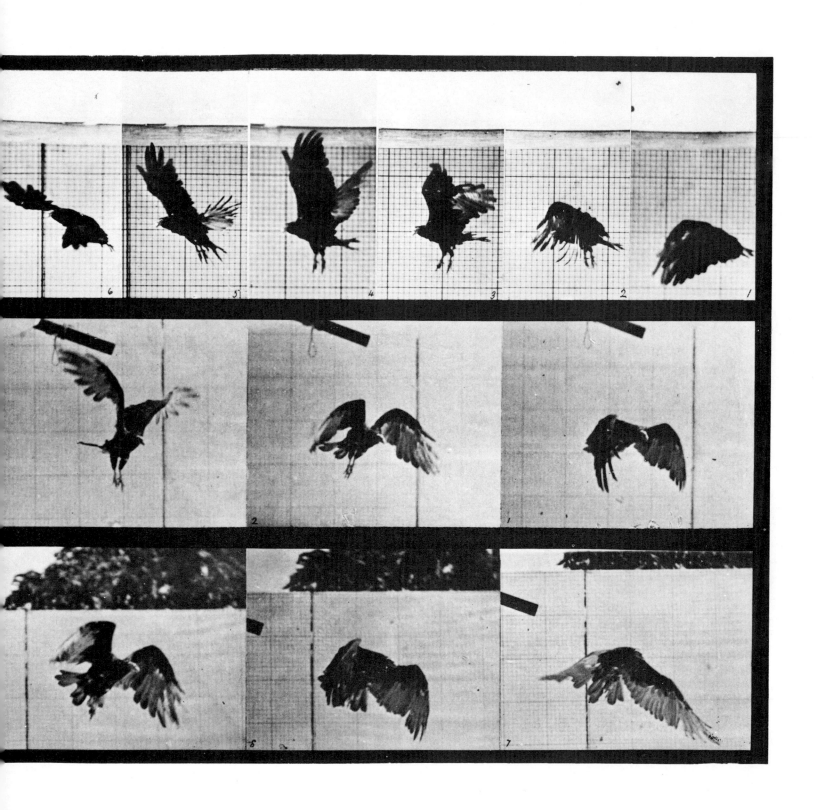

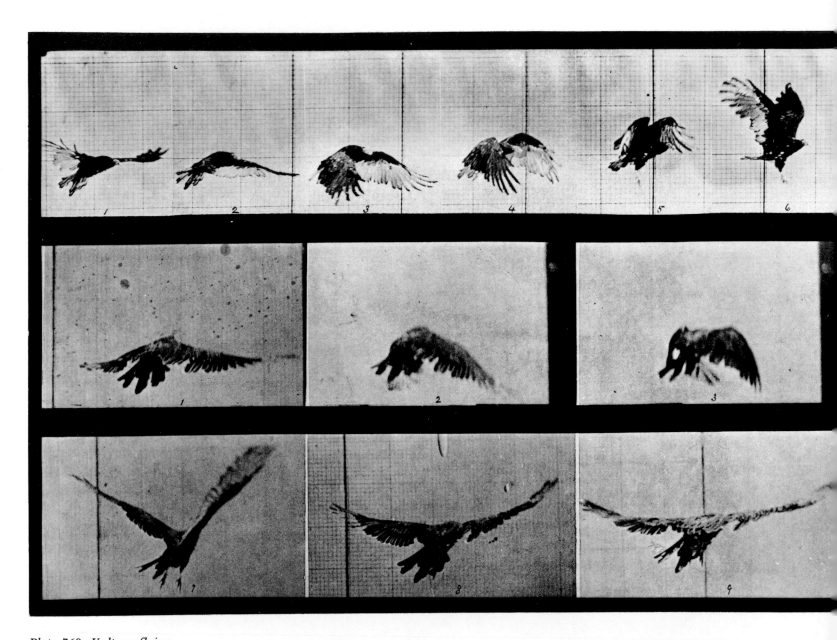

Plate 768. Vulture flying.

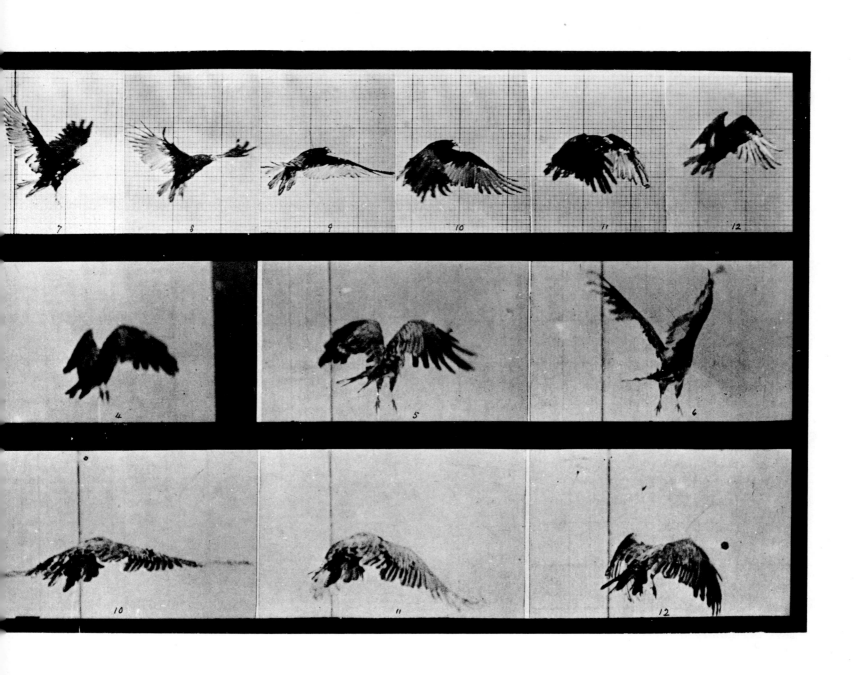

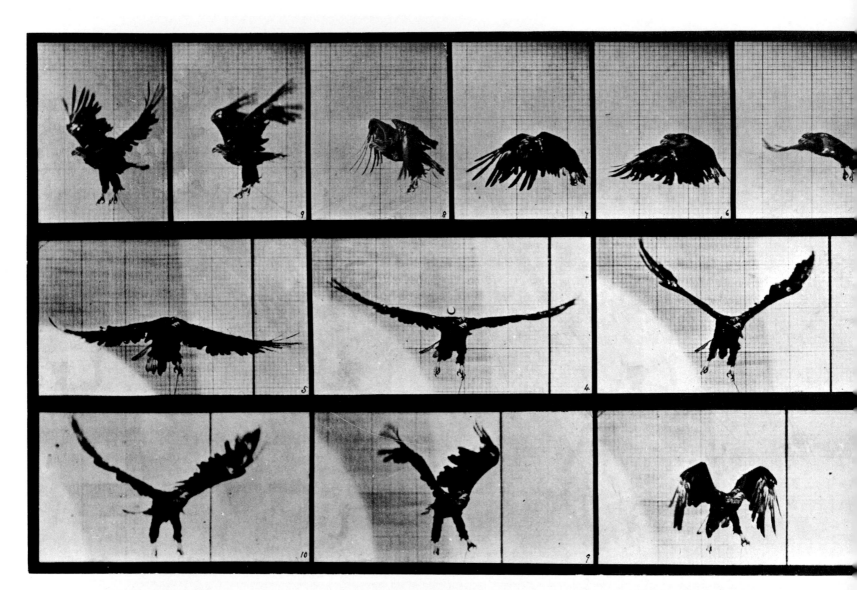

Plate 769. American eagle flying.

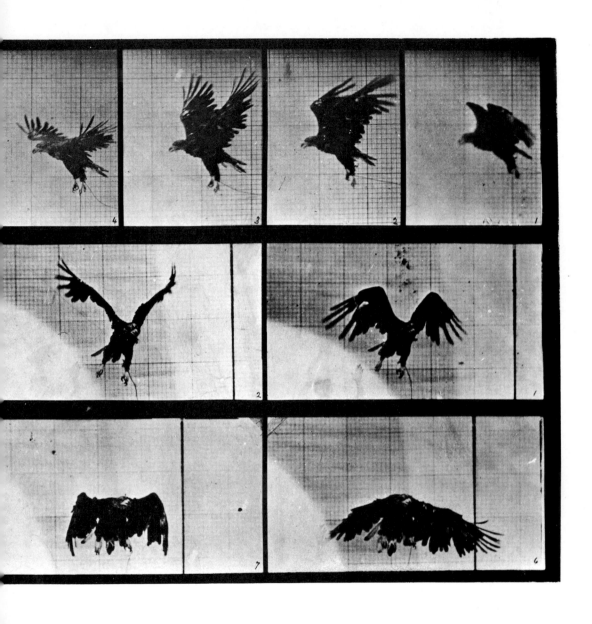

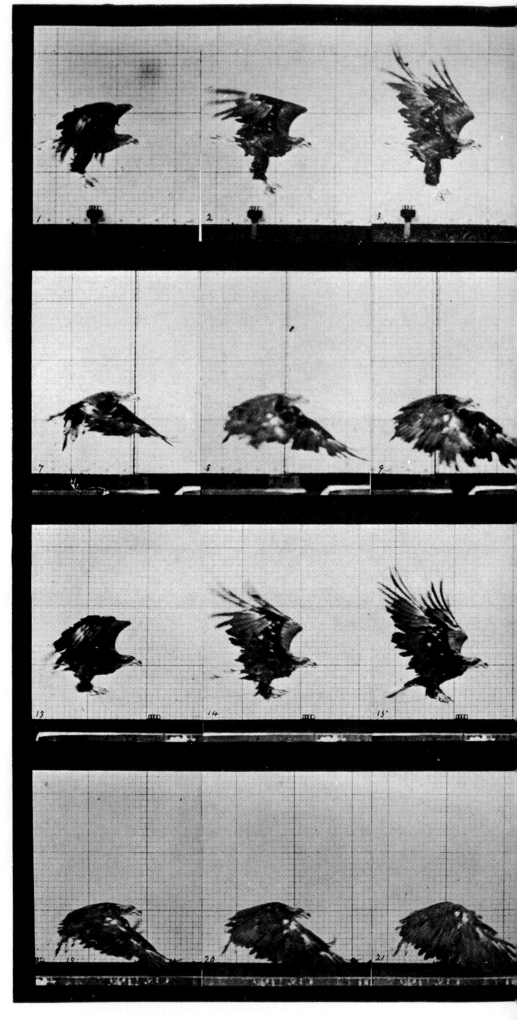

Plate 770. American eagle flying near the ground.

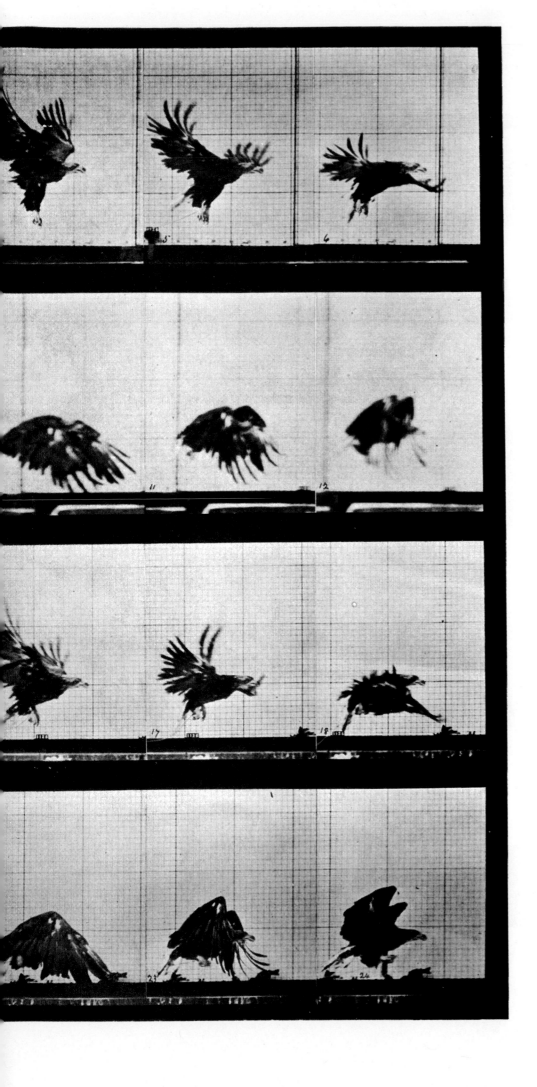

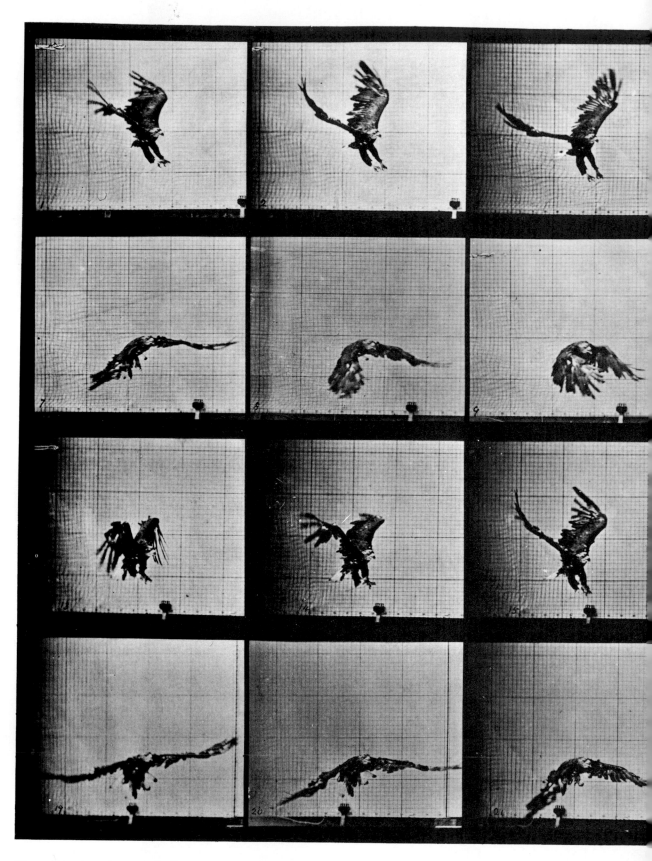

Plate 771. American eagle flying near the ground.

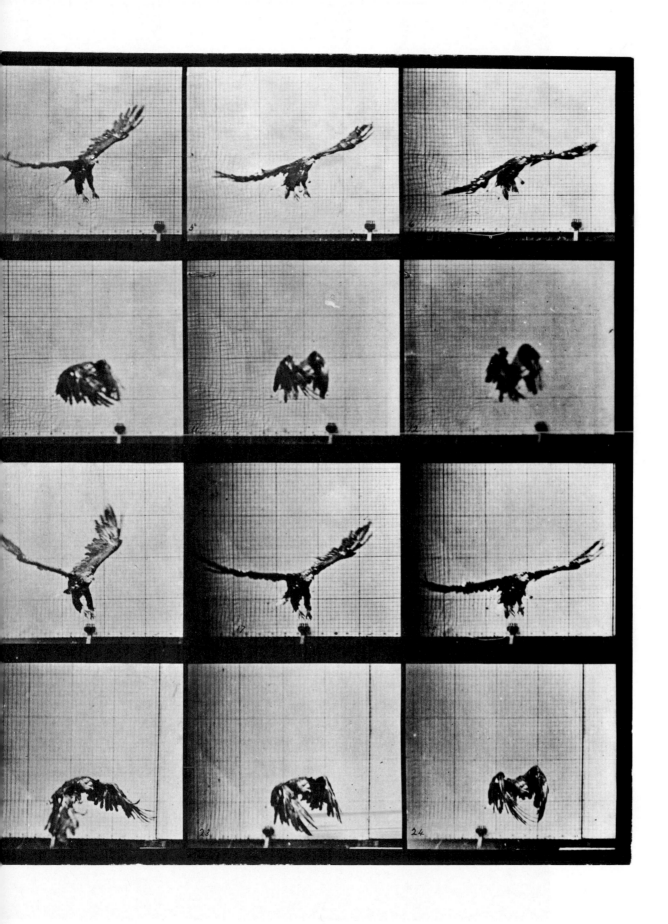

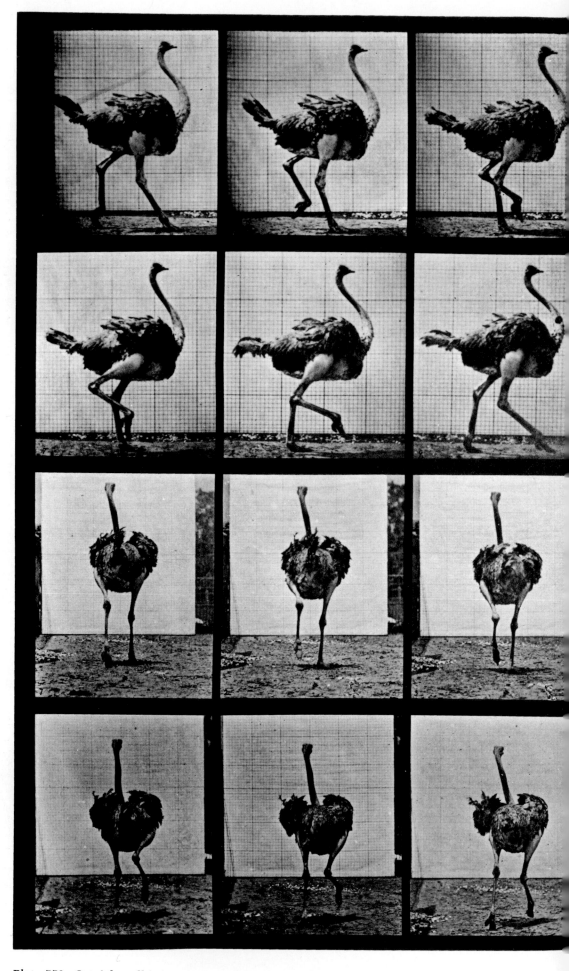

Plate 772. Ostrich walking.

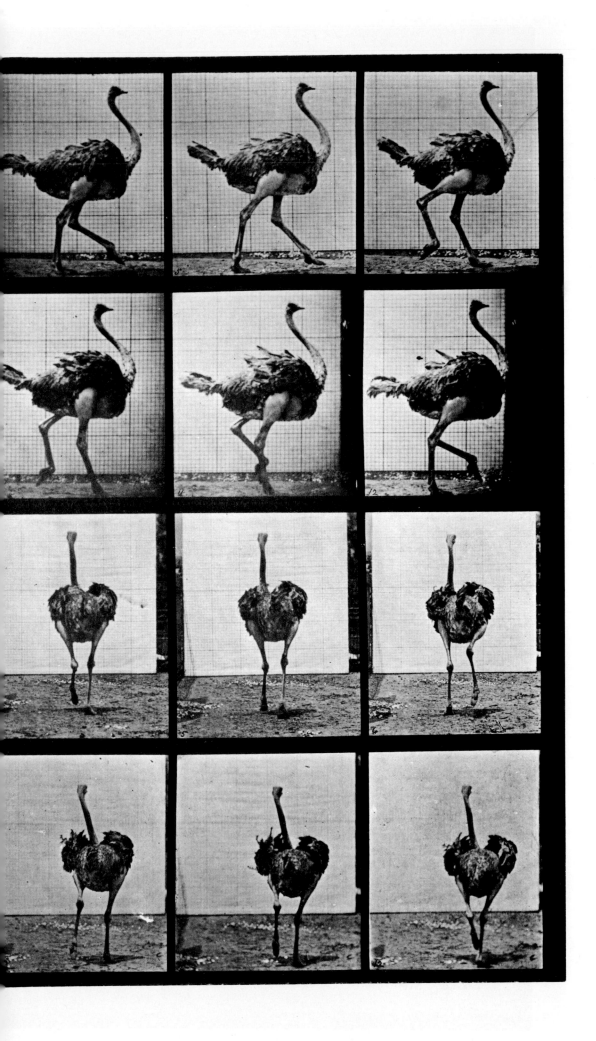

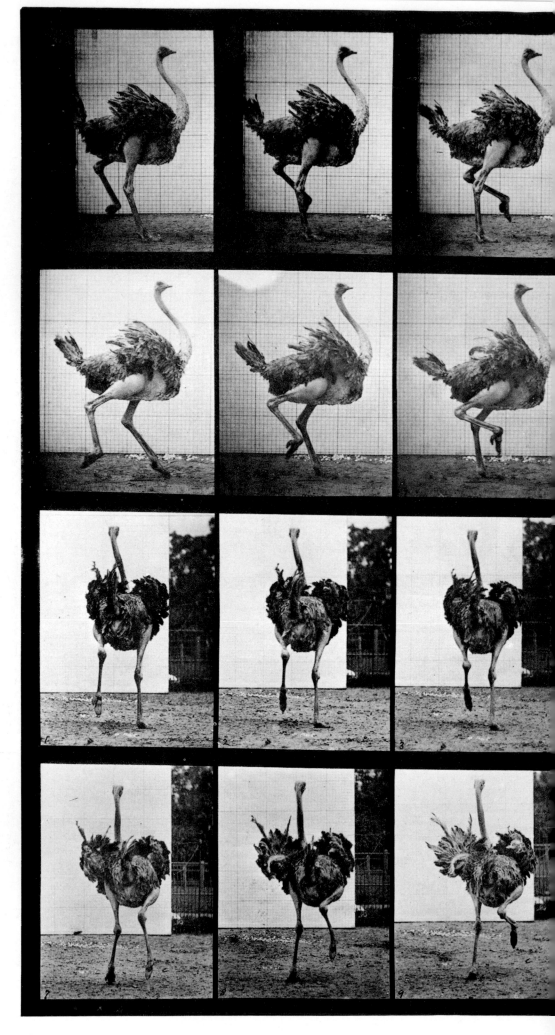

Plate 773. Ostrich running.

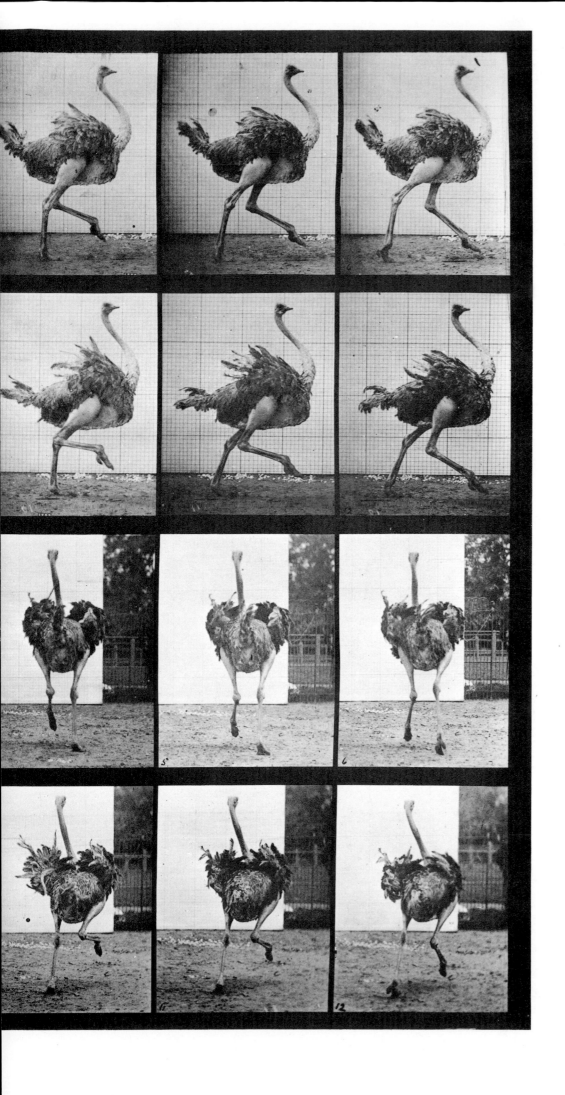

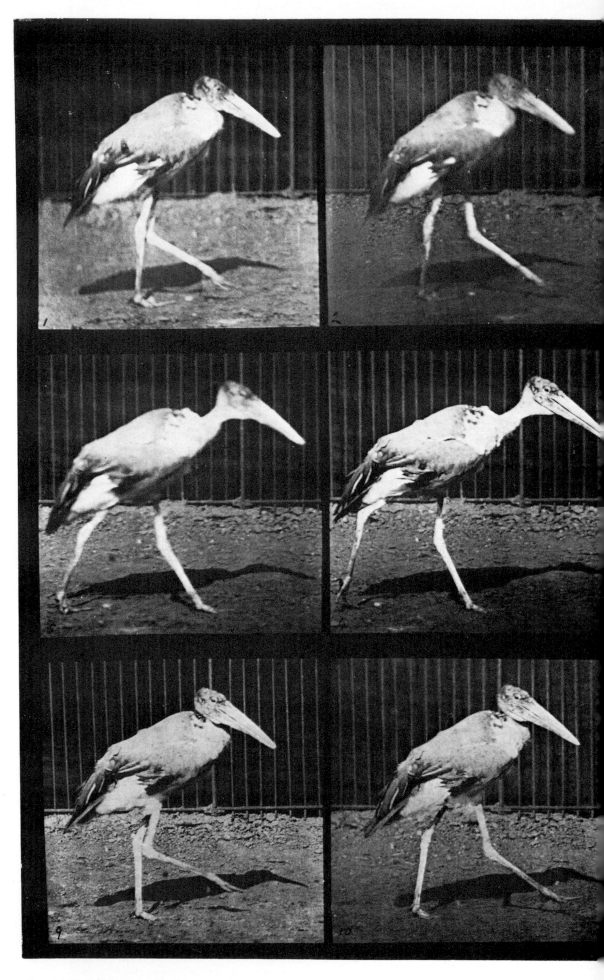

Plate 774. Adjutant walking.

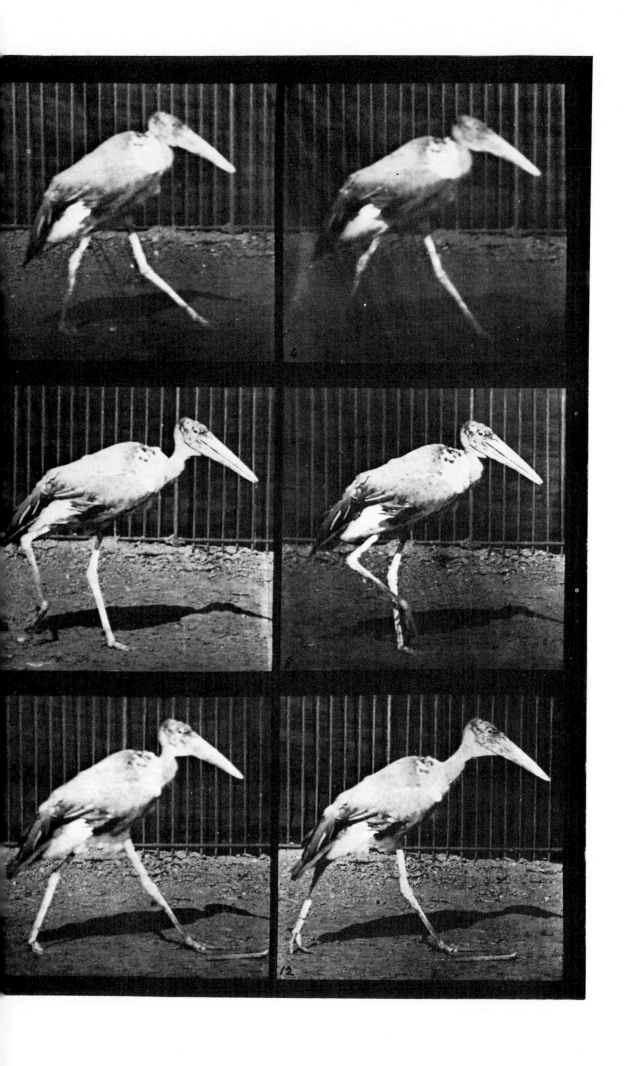

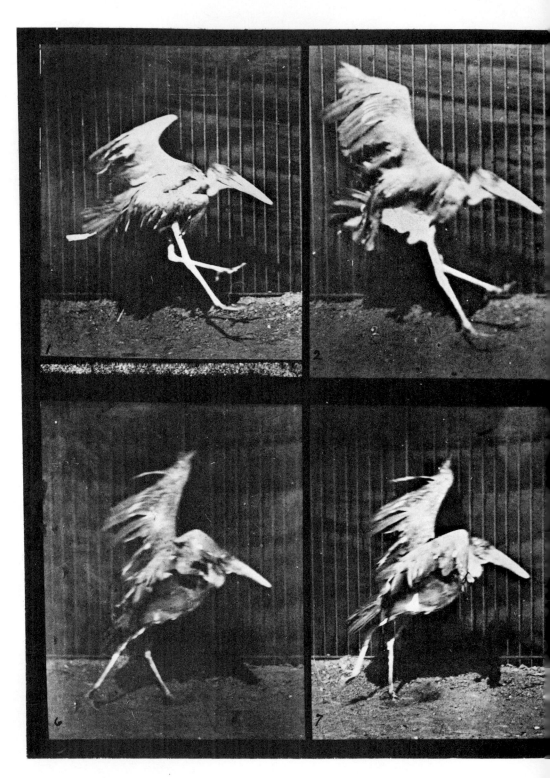

Plate 775. Adjutant, flying run.

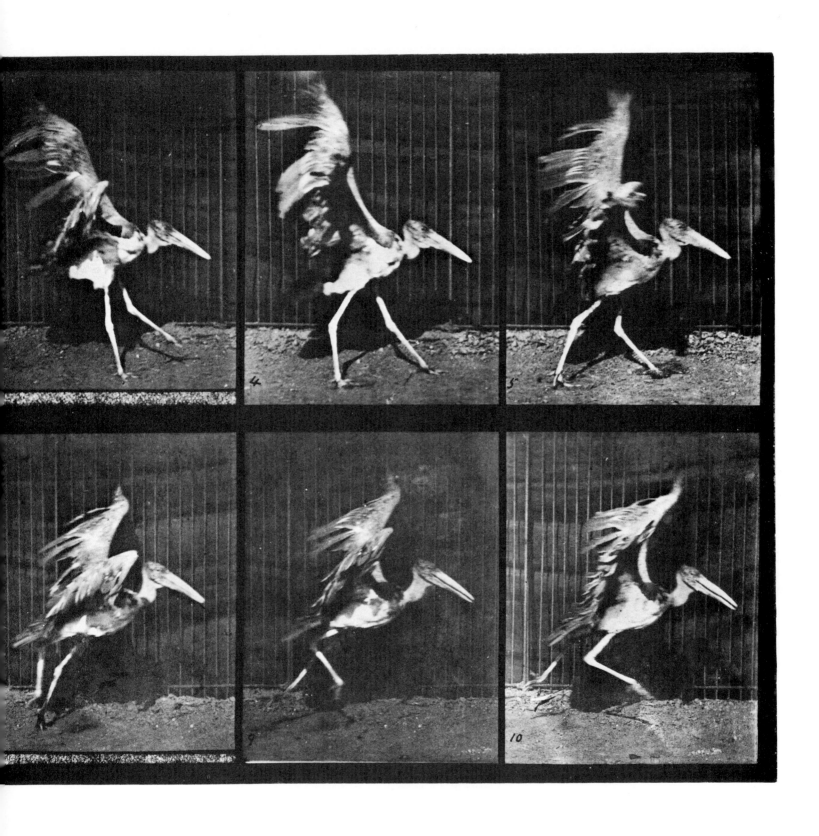

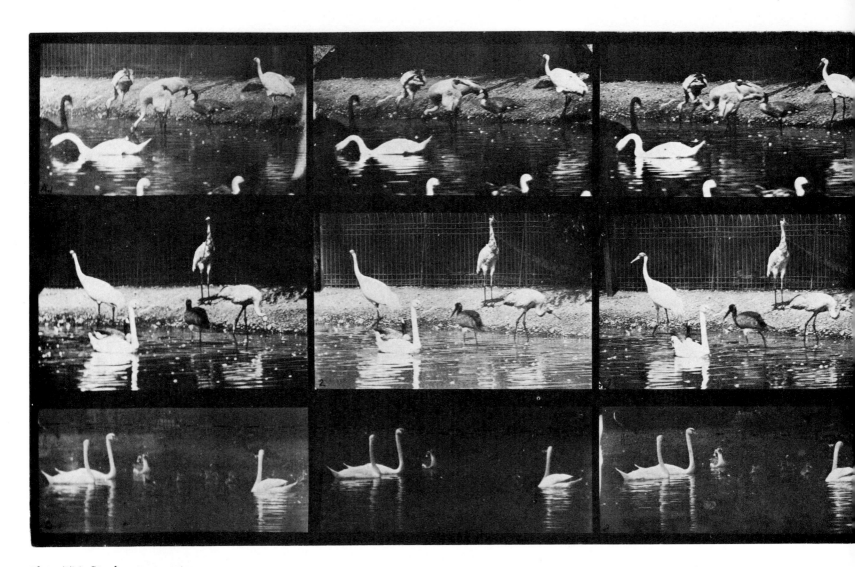

Plate 776. Storks, swans, etc.

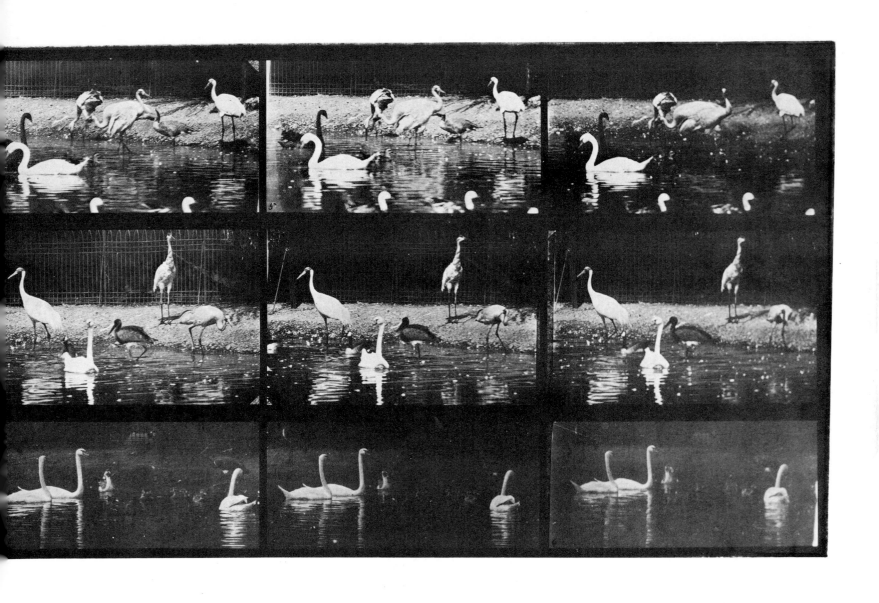

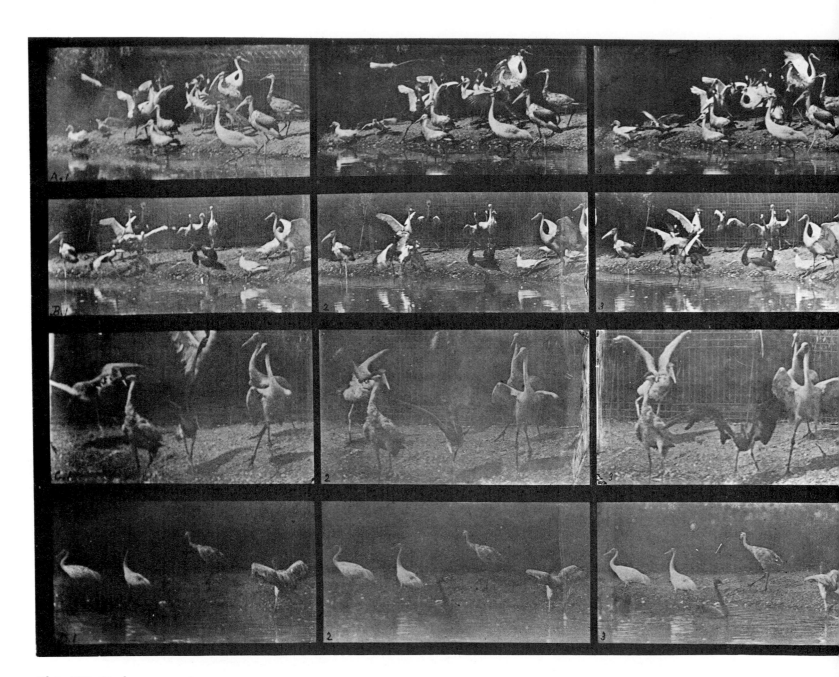

Plate 777. Storks, swans, etc.

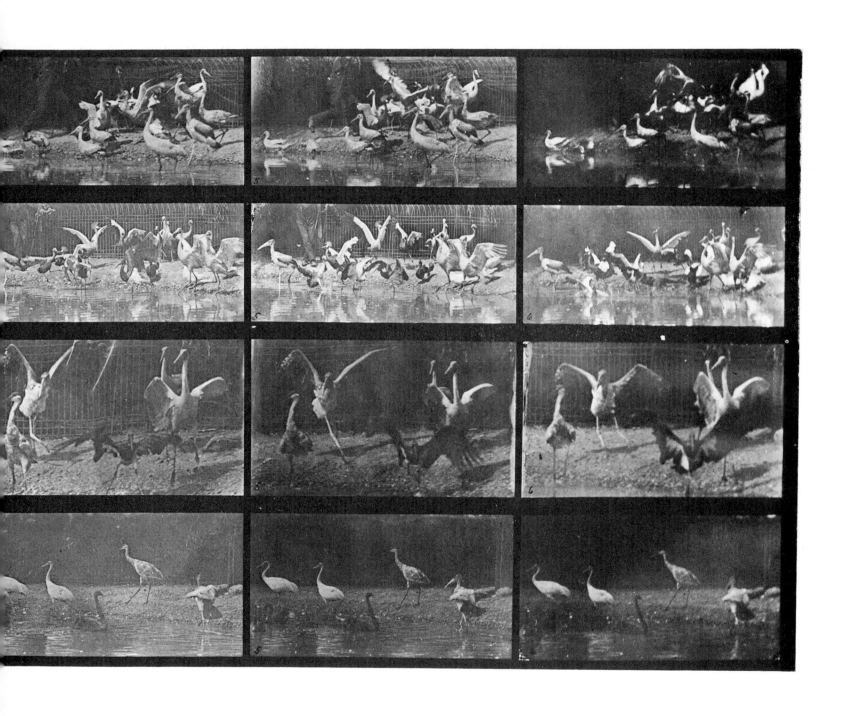

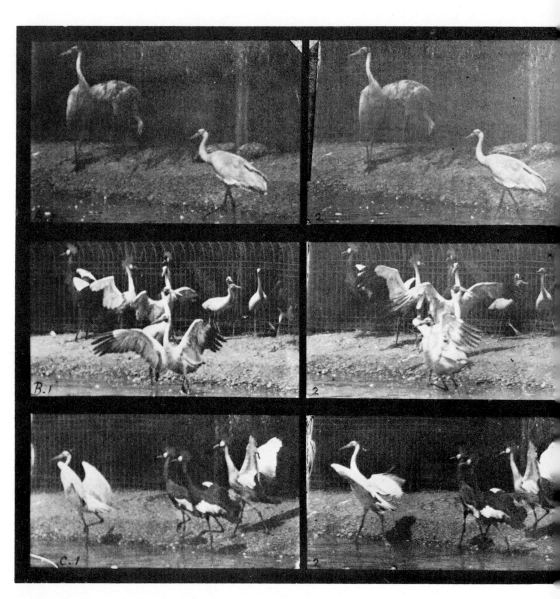

Plate 778. Storks, swans, etc.

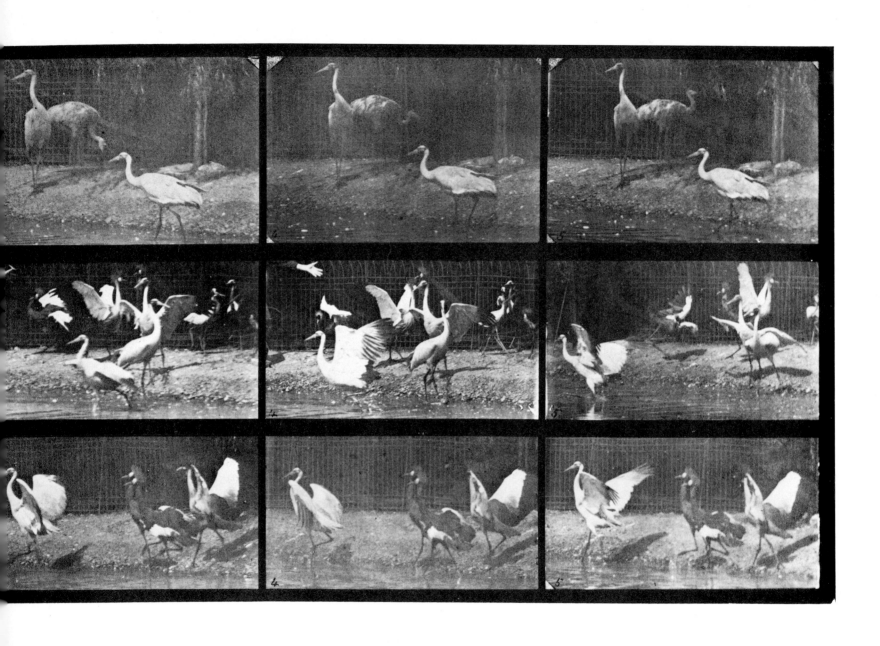

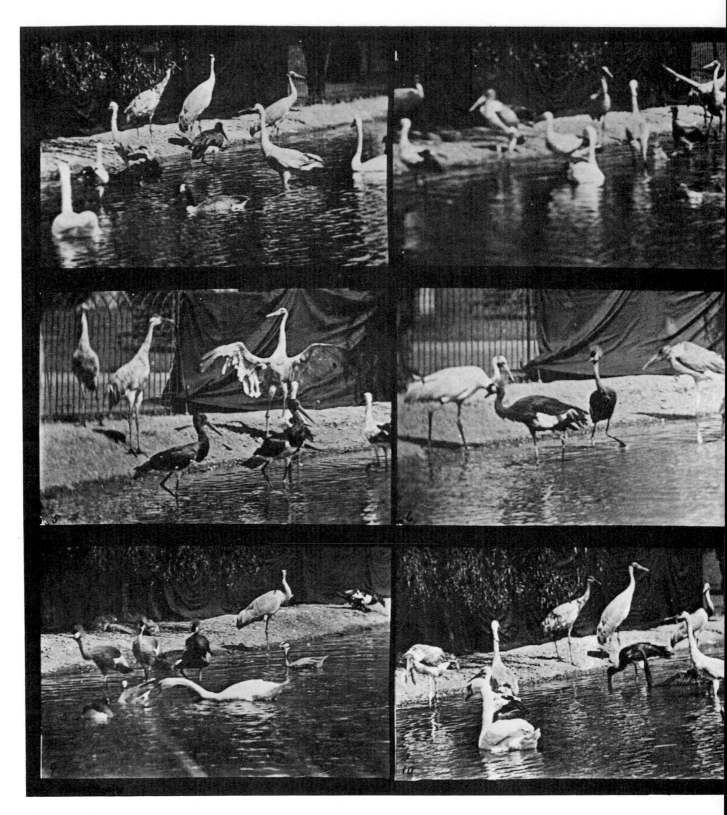

Plate 779. Storks, swans, etc.

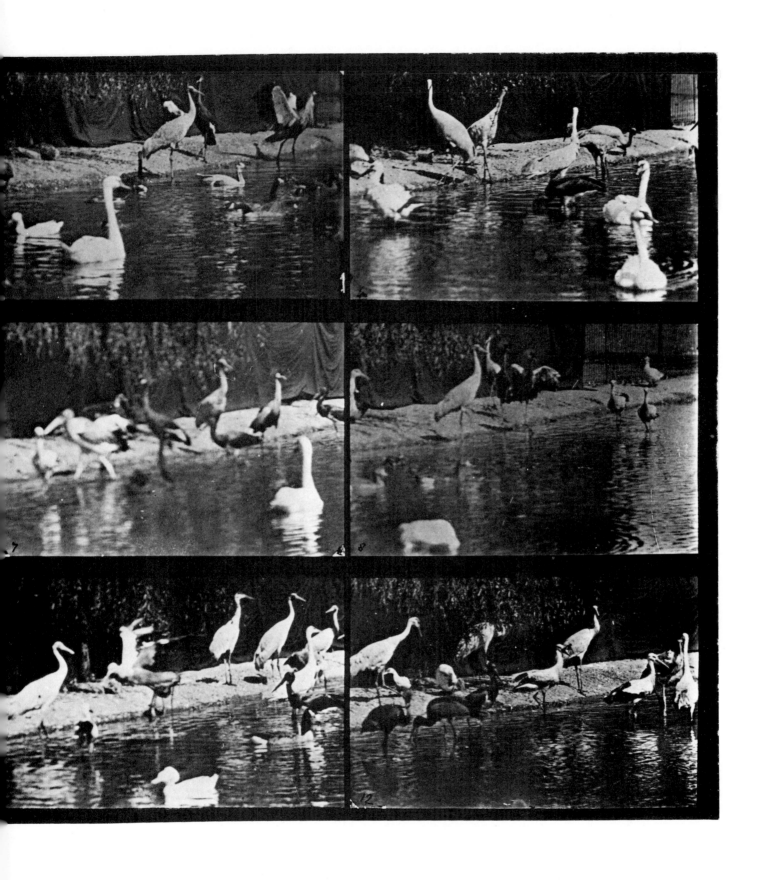

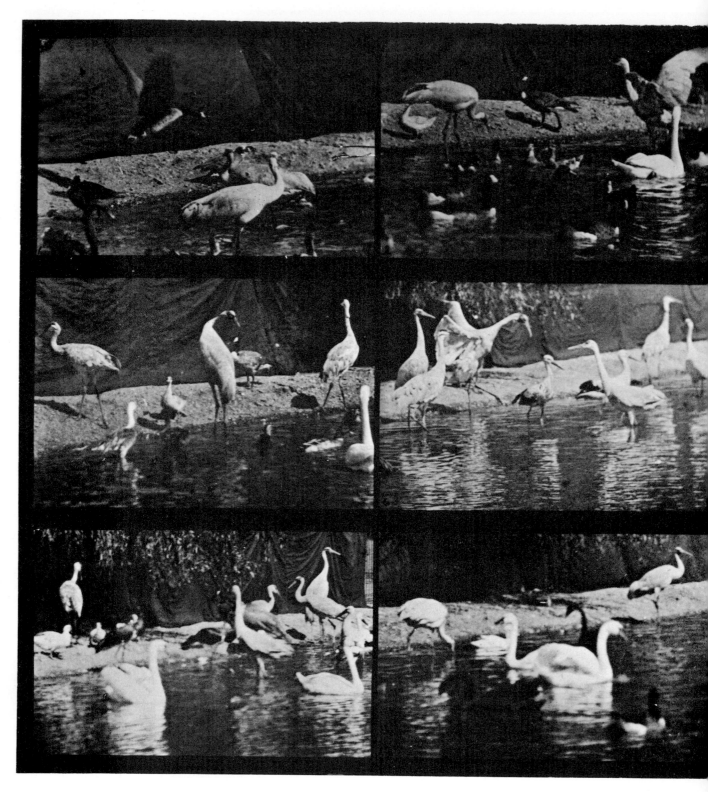

Plate 780. Storks, swans, etc.

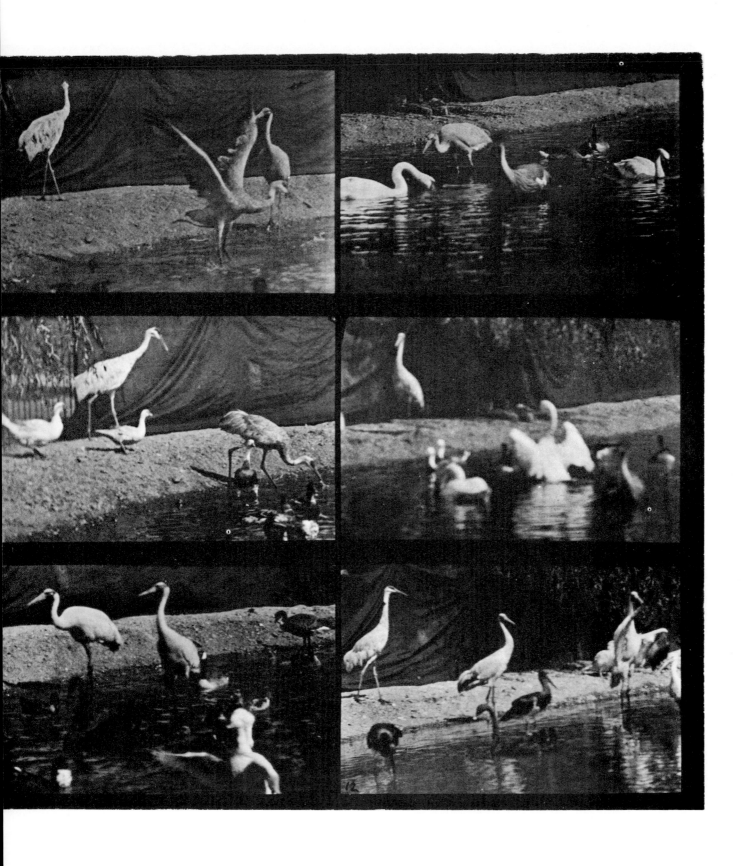

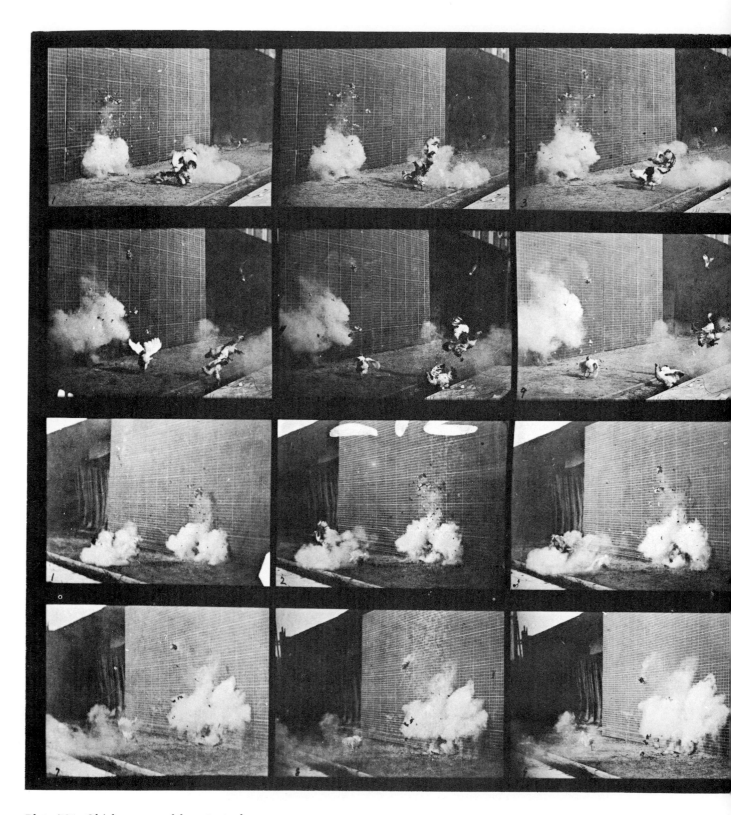

Plate 781. Chickens scared by a torpedo.

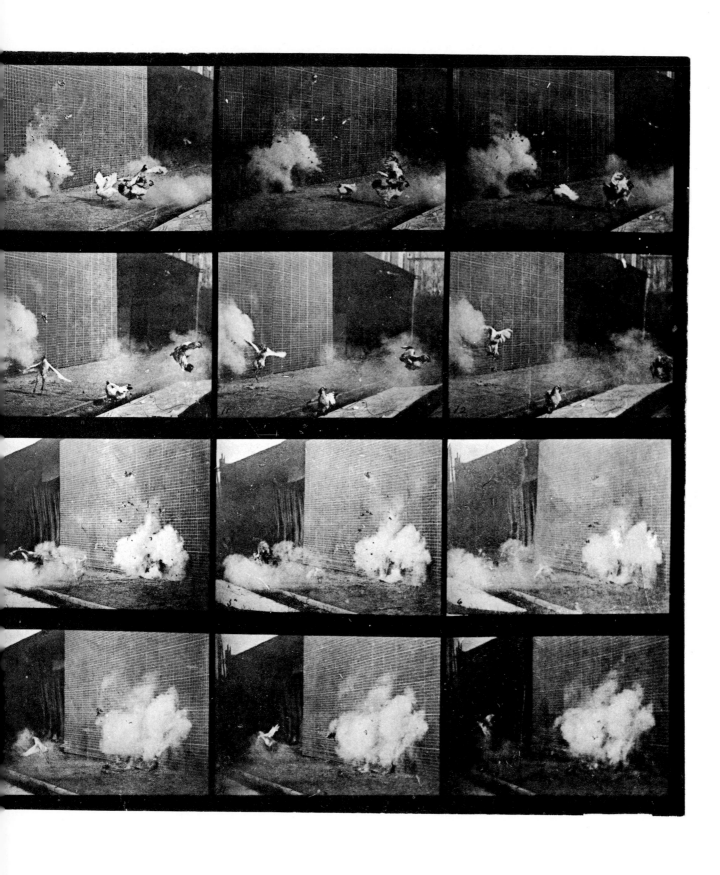

ORIGINAL PROSPECTUS & CATALOGUE OF PLATES

ANIMAL LOCOMOTION

AN ELECTRO-PHOTOGRAPHIC INVESTIGATION OF CONSECUTIVE PHASES OF ANIMAL MOVEMENTS

BY

EADWEARD MUYBRIDGE

PUBLISHED UNDER THE AUSPICES OF THE
UNIVERSITY OF PENNSYLVANIA

PROSPECTUS

AND

CATALOGUE OF PLATES

THE PLATES PRINTED BY THE PHOTO-GRAVURE COMPANY OF NEW YORK

PHILADELPHIA
1887
PRINTED BY J. B. LIPPINCOTT COMPANY

ANIMAL LOCOMOTION.

PROSPECTUS.

IN 1878 the author of the present work published a few Photographs under the title of "The Horse in Motion;" these were the results of some experiments in California with automatic electro-photographic apparatus, devised by him for the purpose of demonstrating the successive phases of Animal Locomotion. This subject had engaged his attention since 1872, when the first lateral photograph of a horse trotting at full speed was made by him.

The experiments were continued in 1879. Upon their termination the author became convinced that a comprehensive and systematic investigation with improved mechanical appliances, and newly-discovered chemical manipulations, would demonstrate many novel facts, not only interesting to the casual observer, but of indisputable value to the artist and to the scientist. This investigation demanded of necessity so large an outlay of money, and the subsequent publication in its present generous form assumed such imposing proportions, that all publishers not unnaturally shrank from entering the unexplored field.

In this emergency The University of Pennsylvania took the prosecution of the investigation under its auspices, and its liberal assistance has enabled the author to complete his work, which he hereby announces as ready for publication.

THE WORK WILL BE PUBLISHED EXCLUSIVELY BY SUBSCRIPTION, AT THE PRICE OF ONE HUNDRED DOLLARS FOR EACH COPY.

1 3

One Hundred Plates of illustrations will consti-
tute a Copy of the work.

These one hundred Plates, the subscriber is entitled to
select from those enumerated in the subjoined Catalogue.
It is believed the description given therein of each move-
ment will be found sufficient to enable this selection to be
made with intelligent discrimination.

The 781 Plates described in the Catalogue comprise more
than 20,000 figures of men, women, and children, animals
and birds, all actively engaged in walking, galloping, flying,
working, playing, fighting, dancing, or other actions inci-
dental to every-day life, which illustrate motion and the
play of muscles.

The figures illustrating the various movements are re-
produced from the original negatives by the photo-gelatine
process of printing, without any attempt having been made
to improve their pictorial effect, either in outline or detail;
or to conceal their imperfections.

In the Title of the work, the term "Locomotion" is
stretched to its broadest capacity.

The Plates, without margin, vary in dimensions from
12 inches high by 9 inches wide, to 6 inches high by 18
inches wide.

The average area of the Plates is 108 square inches, or
about 660 square centimetres; they are printed on linen
steel-plate paper, of size 19 by 24 inches, and weight 100
pounds to the ream.

Subscribers desiring a greater number of Plates than
the one hundred for which they subscribe; will be entitled
to obtain such additions, and at the same proportionate
rate of payment; *provided they make the selection at the same
time that they select the Plates for their Subscription Copy.*

Subscribers for two or more Copies have the right of an
independent selection of Plates for each Copy.

Subscribers for six Copies of the work,—that is, for 600
Plates,—each Plate being of a *different serial number*, will
be entitled to the remaining 181 Plates without additional
payment. They will thus have an impression of each one
of the 781 Plates.

Each Copy of the work will be enclosed in a Portfolio.
The entire collection of 781 Plates will be enclosed in
8 Portfolios.

Upon receipt of the accompanying blank, duly filled
with the necessary instructions, and a remittance of twenty
dollars, on account of each Copy subscribed for, the work
will be forwarded free of express charges to any part of
the United States; the remainder of the subscription to be
paid upon delivery.

Subscribers in foreign countries should, preferably, desig-
nate an agent in the United States to act in their behalf;
or, they will be corresponded with, direct.

All remittances and correspondence to be addressed to

EADWEARD MUYBRIDGE,

University of Pennsylvania,

Philadelphia, U.S.A.

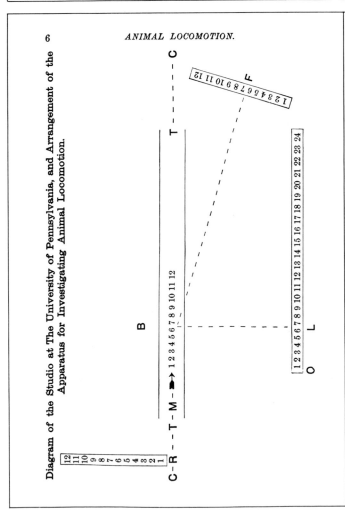

Diagram of the Studio at The University of Pennsylvania, and Arrangement of the Apparatus for Investigating Animal Locomotion.

STUDIO, APPARATUS, AND METHOD OF WORKING.

In the diagram, B is the *Lateral* background; consisting
of a shed 37 metres, or about 120 feet, long, the front of
which is open, and divided by vertical and horizontal
threads into spaces 5 centimetres, or about 2 inches, square,
and by broader threads into larger spaces 50 centimetres,
or about 19¾ inches, square.

At C and C, 37 metres, or about 120 feet, apart are "*fixed*"
backgrounds, with vertical threads 5 centimetres, or about
2 inches, from their centres, with broader threads 30 centi-
metres, or about 12 inches, from their centres.

For some investigations, readily distinguishable in the
plates, "*portable*" backgrounds are used, consisting of frames
3 metres wide by 4 metres high,—about 10 feet by 13
feet 4 inches,—over some of which black cloth and over
others white cloth is stretched, all being divided by vertical
and horizontal lines into square spaces of the same descrip-
tion as those of the lateral background.

These portable backgrounds are used when photograph-
ing birds and horses, and also wild animals when possible
to do so.

L. A lateral battery of 24 automatic electro-photographic
cameras, arranged parallel with the line of progressive
motion, and usually placed therefrom about 15 metres or
49 feet.

Slow movements are usually photographed with lenses
of 3 inches diameter and 15 inches equivalent focus; the
centres of the lenses being 15 centimetres, or about 6 inches,
apart.

Rapid movements are photographed with a *portable*
battery of cameras and smaller lenses.

1*

The centre, between lenses 6 and 7, is opposite the centre of the track T.

For illustrations comprising both "Laterals" and "Fore-shortenings," cameras 1 to 12 only are used.

When "Laterals" alone are required, cameras 13 to 24 are connected with the system and used in their regular sequence.

R. A portable battery of 12 automatic electro-photographic cameras, the lenses of which are 1¼ inches diameter and 5 inches equivalent focus; the lenses are arranged 7½ centimetres, or about 3 inches, from their centres. When the battery is used vertically, lens 6 is usually on the same horizontal plane as the lenses of the lateral battery.

In the diagram this battery is arranged *vertically* for a series of "Rear Foreshortenings"; the points of view being at an angle of 90° from the lateral battery.

F. A battery of 12 automatic electro-photographic cameras, similar to that placed at R, arranged horizontally for a series of "Front Foreshortenings"; the points of view averaging an angle of 60° from the lateral battery.

O. The position of the operator; the electric batteries; the chronograph for recording the intervals of time between each successive exposure; the motor for completing the successive electric circuits, and other apparatus connected with the investigation.

T T. The track parallel with the lateral battery and covered with corrugated rubber flooring.

M. The model, approaching the point number "1" on the track where the series of photographic illustrations will commence.

An estimate having been made of the interval of time which will be required, between each photographic exposure, to illustrate the complete movement, or that portion of the complete movement desired, the apparatus is ad-

justed to complete a succession of electric circuits at each required interval of time, and the motor is set in operation. When the series is to illustrate *progressive* motion; upon the arrival of the model at the point marked "1" on the track, the operator, by pressing a button, completes an electric circuit, which immediately throws into gearing a portion of the apparatus hitherto at rest. By means of suitably-arranged connections, an electric current is transmitted to each of the 3 cameras marked "1" in the various batteries, and an exposure is simultaneously made on each of the photographic plates, respectively, contained therein. At the end of the predetermined interval of time, a similar current is transmitted to each of the cameras marked "2," and another exposure made on each of the 3 next plates, and so forth until each series of exposures in each of the three batteries is completed. Assuming the operator to have exercised good judgment in regulating the speed of the apparatus, and in making the first electric contact at the proper time, and that the figures 1 to 12 represent the distance traversed by the model in executing the movement desired, the first three photographic exposures—that is, one exposure in each battery—will have been synchronously made when the model was passing the position marked "1" on the track T; the second three exposures will have been made when the model was passing the position marked "2," and so on until twelve successive exposures were simultaneously made in each of the three batteries. This perfect uniformity of time, speed, and distance, however, was not always obtained.

ANALYSIS OF THE PLATES.

Of the broader horizontal lines seen in the plates, the second from the ground is (excepting in special instances

easily recognized) on the same horizontal plane as the lenses of the lateral battery of cameras hereafter described.

The numbers on the background of the lateral illustrations are 15 centimetres, or about 6 inches, apart from each of their centres.

The plan adopted to facilitate analysis of the various movements may be exemplified by a reference to plate 14.

The model "8" is walking towards the right, the *quantity* of movement illustrated is two steps, or one stride. Twelve successive phases of that movement were photographed synchronously from each of the three points of view, L, R, and F in the diagram. The interval of time between each of the twelve phases was about one-eighth of a second, or according to the chronograph one hundred and twenty one-thousandth parts of a second (0.120″), the complete movement having been accomplished in about one and a half seconds.

The number of figures on the plate is 36, arranged thus:

1	2	3	4	5	6	7	8	9	10	11	12
1	2	3	4	5	6	7	8	9	10	11	12
1	2	3	4	5	6	7	8	9	10	11	12

Laterals.

Rear Foreshortenings from points of view on the same vertical line, at an angle of 90° from the Laterals.

Front Foreshortenings from points of view on the same horizontal plane, at angles averaging 60° from the Laterals.

A similar method of arrangement prevails in all those plates which illustrate a movement, as seen simultaneously from each of three points of view.

When the illustrations are, respectively, from one or two points of view only, a system of arrangement is adopted

which is considered the most convenient for their especial comparative examination.

The successive phases of movement are usually arranged in the plates to conform with the direction of the first phase illustrated.

If, for example, the motion of the first phase is towards the right, the arrangement of each succeeding phase is thus: ➡ 1 2 3, etc. If, however, the motion of the first phase is towards the left, the arrangement of the successive phases is thus: etc., 3 2 1. ⬅

When two or more distinct series of illustrations are included in one plate, each separate series is distinguished by the letters A, B, C, etc.

Each series, of the plates numbered 520 to 528, inclusive, illustrates a single phase of motion, photographed synchronously from each of six points of view.

In some instances it will be found that the number of phases of motion from each of the respective points of view do not correspond, some being omitted. This arises from the loss of negatives during manipulation. The subject being, perhaps, one of interest or importance, and impossible to duplicate, it has been included in the work notwithstanding the deficiency.

Serial numbers connected with a brace indicate that one and the same series of phases is illustrated in two plates, the laterals being in one plate, and the foreshortenings in another.

Although, as before stated, the broadest interpretation has been given in this investigation to the word Locomotion, it is not assumed that a response to every possible inquiry in this inexhaustible subject will be found in this work.

MODELS.

A few particulars in reference to some of the human models, will assist subscribers in the selection of their plates.

The greater number of those engaged in walking, running, jumping, and other athletic games are students or graduates of The University of Pennsylvania,—young men aged from eighteen to twenty-four,—each one of whom has a well-earned record in the particular feat selected for illustration.

The mechanics are experts in their particular trades, and the laborers are accustomed to the work in which they are represented as being engaged.

Unless otherwise described the arms of the models in the progressive movements are in a position naturally consistent with the movement.

Each model is distinguished by a number, and may be recognized by that number throughout the work. The male models are numbered with bold-faced type, thus: " 45," and the females with light-faced type, thus: " 8."

The models **52, 64, 65,** and **66** are teachers in their respective professions; **60** is a well-drilled member of the State Militia; **51,** a well-known instructor in art; **95,** an ex-athlete, aged about sixty; **22,** a mulatto and professional pugilist; **27, 28,** and **29,** boys aged thirteen to fifteen; **42** and **49,** public acrobats; 17, 19, 21; **74** to **91,** inclusive; 92 and 94 were patients of the University and Philadelphia Hospitals, selected to illustrate abnormal locomotion.

The female models were chosen from all classes of society.

Number 1, is a widow, aged thirty-five, somewhat slender and above the medium height; 3, is married, and heavily built; 4 to 13, inclusive, 15 and 19, are unmarried, of ages varying from seventeen to twenty-four; of these, 11 is

slender; the others of medium height and build; 14, 16, and 93, are married; 20, is unmarried, and weighs three hundred and forty pounds.

The endeavor has been in all instances to select models who fairly illustrate how—in a more or less graceful or perfect manner—the movements appertaining to every-day life are performed.

In the column headed "Costume," the state of the model with regard to apparel is represented by

N. Nude. When any one figure is *nude,* the entire series is so classified.

S. N. Semi-Nude. The model so designated is usually clothed with a light or transparent drapery from the waist to the knees, or to the ground: in some illustrations of the toilet it also includes more or less underclothing.

P. C. Pelvis Cloth. A strip of cloth surrounds the lower part of the abdomen.

T. D. Transparent Drapery. The model is attired in a flowing garment of diaphanous texture, which permits the action of the limbs to be seen, and the conformation of the folds of the drapery thereto.

D. Draped. Fully clothed.

B. F. Bare Feet. The costume of peasant girls with the legs below the knees, and the feet bare.

ANIMALS AND BIRDS.

The wild animals and birds were photographed in the gardens of the Zoölogical Society, of Philadelphia, by the courtesy of its Trustees and Superintendent.

Nearly all the horses and other domesticated animals were photographed at the Gentlemen's Driving Park, and are good representatives of their various classes and movements.

ANGLES OF VIEW.

In the classification of the illustrations into "Laterals" and "Foreshortenings," the term Lateral applies—with a few exceptions—to those figures photographed with the *lateral* battery of cameras, as described in the diagram. And the term "Foreshortenings" is applied to all the figures made from points of view at varying angles from the lateral battery, regardless of the actual position of the model.

The points of view, described as being in their relation to the laterals at the respective angles of 90 and 60 degrees, are strictly speaking not always so, but as close thereto as careful measurement and circumstances permitted. All stated angles of view, as applied to wild animals and birds, are simply approximate.

The terms "Front" or "Rear," as applied to the Foreshortenings, usually refers to the position of the model when the *first* exposure is made in the respective batteries. In the execution of some movements, the model turns completely around before the series of photographs is finished; the latter phases of motion may therefore be included in the column of "Front" views when they are actually "Rear" views. The character of the movement will of itself explain the relative successive positions of the model, and the illustrations afford ample means of determining the angular relationship to all points of view.

MOVEMENTS AND TIME.

In the column devoted to "The *quantity* of movement," a completed action or a round movement is designated by the number " 1." A "round movement" means a movement which, being completed, restores the body and limbs to the approximately relative position they occupied at its

commencement. For a horse trotting, or for a man walking, for example, it means the execution of two steps; for a horse jumping a hurdle, or for a man who, when batting, strikes a base-ball, it means the execution of the main object of the particular investigation.

The word approximate is used, because it rarely happens that the execution of regular movements by the most carefully-trained man or animal restores the body and limbs to precisely the same original relative position. When a movement is susceptible of being divided into two parts, of which the second part, with a change of the limbs, is virtually a repetition of the first part; it is not always considered necessary to include the round movement in the illustrations; but in order that the relationship which each one-half of the movement holds to the other half may be understood, five-eighths or three-fourths (designated in the column 5–8 or 3–4) of a round movement is usually illustrated. The quantity of movement given in the column is frequently only approximate to the *exact* quantity.

In the appropriate column, the interval of time between each successive exposure is stated in one-thousandth parts of a second, as recorded by a chronograph with a tuning-fork making 100 single vibrations in a second.

The duration of each interval of time between each successive exposure has been carefully examined, and when, from any obscurity in the pen-markings, or from other causes, the exact intervals of time could not be positively ascertained, an average interval of time has been computed, and attention called thereto in the column of reference notes.

It may be stated, as a matter of some interest, that from carefully-executed experiments it was proved at the University Studio that the most rapid exposures were made in periods of time varying from the one two-thousandth to the one five-thousandth of a second. With such exposures

2

details of black and of white drapery were obtained. The use, however, of such very brief exposures was deemed inadvisable, and for the illustrations of the movements of large animals was in practice wholly needless.

For photographs of horses at full speed an exposure of the one six-hundredth or of the one eight-hundredth of a second will usually obtain the necessary sharpness of outline and all essential details.

For slow movements an exposure of the one one-hundredth or of the one two-hundredth of a second will give all desirable results.

REFERENCE NOTES.

1. The interval of time between each phase is an *average* of the intervals of time between all the phases, or an approximation thereto.

2. No record of intervals of time between phases.

3. Isolated phases, photographed synchronously from the various points of view.

4. Successive phases, photographed at *irregular* intervals of time synchronously from the various points of view.

5. The model has a rod attached to the hips to aid the measurement of their oscillations.

In all illustrations of this number the lenses of the lateral battery are on the same horizontal plane as the platform on which the model is walking, or, if ascending or descending, about midway between the two planes of height on which the feet are placed. The backgrounds are those described as " Portable."

6. The lenses of the lateral battery are on the same horizontal plane as the platform on which the model is walking. The backgrounds are those described as " Portable."

7. Isolated phases of motion from a single point of view.

8. A combination of 2 serials, with the same average interval of time between each successive phase.

9. One phase of this series is substituted by a corresponding phase from another series.

10. A combination of 2 serials.

11. Foreshortenings incomplete.

12. Foreshortenings irregular.

13. A double interval of time occurs between phases 2 and 3.

14. A double interval of time occurs between phases 3 and 4.

15. A double interval of time between phases 4 and 5.

16. A double interval of time between phases 5 and 6.

17. A double interval of time between phases 7 and 8.

18. A double interval of time between phases 8 and 9.

19. A double interval of time between phases 10 and 11.

20. A double interval of time, respectively, between phases 4 and 5 ; 9 and 10.

21. A double interval of time, respectively, between phases 5 and 6 ; 7 and 8.

22. A double interval of time, respectively, between phases 5 and 6 ; 9 and 10.

23. Five of the regular intervals of time between phases 6 and 7.

24. Five of the regular intervals of time between phases 5 and 6.

RETROSPECTIVE.

In conclusion, it may not be irrelevant for the author to remark that a number of his early experimental photographs of animal movements, and his original Title, " The Horse in Motion," were copied, and published a few years ago, in a book which is referred to in the following para-

graph, reprinted from *Nature* (London), June 29, 1882. After the full Title of the book is quoted, the reviewer says, " The above is the somewhat long title of a large and important work issuing from the well-known Cambridge (U. S.) University Press.

" Long as is the title, the name of the principal contributor to the volume is left unrecorded there ; though, indeed, even a cursory glance over its contents shows how much indebted is the whole question of the mode of motion in the horse to the elaborate series of investigations of Mr. Muybridge."

<div align="right">E. M.</div>

UNIVERSITY OF PENNSYLVANIA,
January, 1887.

ANIMAL LOCOMOTION

CATALOGUE

2*

CATALOGUE OF PLATES.

Serial Number	MOVEMENTS	No. of Model	Costume	Laterals	Front 90°	Front 60°	Rear 90°	Rear 60°	Quantity of Movement	Time Intervals (1/1000 sec.)	Reference Notes
1	Walking	36	N	12	12	.	12	.	6-8	69	.
2	"	46	N	12	12	.	12	.	9-10	90	6
3	"	46	P C	.	.	9	.	9	8-4	69	.
4	"	46	N	8	9	.	12	.	1-2	48	.
5	"	46	N	8	8	.	8	.	5-8	88	6
6	"	22	N	12	8	.	8	.	5-8	75	.
7	"	29	N	12	.	.	12	.	8-4	54	6
8	"	55	P C	6	6	.	8	.	1-2	71	.
9	"	56	P C	6	6	.	6	.	1-2	74	6
10	"	26	N	6	6	.	6	.	1-2	88	6
11	"	24	N	12	12	.	12	.	1	83	.
12	"	27, 28	N	12	12	.	12	.	1-2	48	.
13	" right hand at chin	1	N	12	12	12	12	12	1	95	.
14	"	2	N	10	.	.	10	.	1	120	.
15	"	4	N	12	10	10	.	10	5-8	103	.
16	"	6	N	12	.	.	12	10	5-8	91	.
17	" left hand across abdomen	3	N	12	12	12	12	12	8-4	94	.
18	"	8	N	12	12	.	12	.	8-4	99	.
19	" commencing to turn around	20	N	12	12	12	12	12	1-2	129	12

Serial Number	MOVEMENTS	No. of Model	Costume	Laterals	Front 90°	Front 60°	Rear 90°	Rear 60°	Quantity	Time	Reference Notes
20	Walking, right elbow bent	7	N	12	.	.	12	.	8-4	91	5
21	" both elbows bent	7	N	12	.	.	12	.	1	106	5
22	" with high-heeled boots on	1	N	12	.	.	12	12	1	98	.
23	" right hand at chin, high-heeled shoes on	8	N	12	12	.	12	.	1	121	.
24	" with high-heeled shoes on	8	N	12	.	.	12	.	1	108	6
25	"	7	P C	9	9	.	9	.	1-2	95	.
26	" carrying 75-lb. stone on left shoulder	46	N	12	12	.	12	.	8-4	75	.
27	" " " on head, hands raised	46	N	12	.	.	12	.	8-4	92	.
28	" 50-lb. dumb-bell in right hand	46	N	12	9	.	9	.	8-4	99	.
29	" bucket of water in each hand	46	N	12	9	.	9	.	8-4	90	.
30	" 75-lb. stone on right shoulder	31	N	9	9	.	9	.	8-4	97	.
31	" bucket of water in each hand	46	P C	9	.	.	9	.	5-8	104	.
32	" 14-lb. basket on head, hands raised	1	N	12	12	.	12	.	9-10	93	.
33	" 15-lb. basket on head, hands raised	1	N	12	.	.	12	.	1	92	.
34	"	7	N	12	.	.	12	.	8-4	89	.
35	" child (70) on right arm	12	S N	12	.	.	12	.	1	102	.
36	" child on left arm	93	D	12	12	.	12	.	1	150	.
37	" left hand holding dress, right hand at face	13	D	12	12	.	12	.	8-4	154	.
38	" opening parasol	3	D	12	.	.	12	.	1	178	.
39	" hands engaged in knitting	13	D	12	12	.	12	.	1-1-2	154	.
40	" throwing handkerchief over shoulders	13	N	12	11	11	11	11	8-4	115	.
41	" flirting a fan	8	T D	11	.	.	11	11	9-10	142	.
42	" pouring water from pitcher	7	N	8	8	.	8	8	5-8	191	.
43	" sprink'g water from basin, turn'g around	8	N	12	.	.	12	12	2	87	.
44	" taking off hat	23	D	24	12	78	.
45	" two models meeting, and partly turning	4, 16	D	12	.	.	12	.	1	350	6
46	" flirting a fan, and partly turning	10	N	12	1	165	.
47	" and turning around	7	N	12	.	.	12	.	1	172	.
48	" " " bouquet in both hands	5	D	12	.	.	12	.	1	.	.

Serial No.	MOVEMENTS	Model	Costume	Laterals	Front 90°	Front 60°	Rear 90°	Rear 60°	Quantity	Time	Notes
49	Walking and turning around rapidly, a satchel in one hand, cane in other	43	D	12	12	.	12	.	1	127	.
50	" and turning around, carrying bucket of water in left hand	12, 8	S N	12	12	.	12	12	1	172	15
51	" and turning around, using sprinkling pot.	8	N	11	11	.	11	11	1	211	.
52	" turning around; carrying child, turning around; another child (70) holding on to dress of 93	93	D	12	12	.	12	.	1	182	1
53	" scattering flowers and turning around	12	S N	12	12	.	12	.	1	867	.
54	" two models (one flirting a fan), turning around	1, 8	N	12	12	.	12	12	1	151	.
55	" arm, turning around	12	T D	11	11	.	11	11	1	228	18
56	" turning around, action of aversion	12	T D	12	12	.	12	.	1	162	.
57	" and stooping to lift train	1	B F	12	12	.	12	.	1	219	.
58	" around, 10-lb. basket on head	7	N	12	12	.	12	.	1-2	174	.
59	" sweeping the floor	37	P C	12	12	.	.	.	5-8	98	.
60	Starting for a run (shoes)	37	P C	10	10	.	8	.	1-2	42	.
61	Running at a half-mile gait (shoes)	37	P C	8	.	.	12	12	5-8	36	.
62	" full speed (imperfect action, shoes)	37	N	10	10	.	10	.	5-8	41	39
63	" "	46	N	10	.	.	10	.	1-2	28	.
64	" "	33	N	8	8	.	8	.	1-2	29	1
65	" "	33	N	.	.	7	.	7	1-2	57	.
66	" "	55	N	8	8	.	.	.	1-2	56	.
67	" "	55	N	9	9	.	.	.	1-2	66	58
68	" "	47	N	10	10	.	.	.	1-2	62	38
69	" two models	46	N	10	.	.	.	8	1-2	61	.
70	" "	27, 28 / 8	N	8	.	.	8	8	5-8	.	.

Serial No.	MOVEMENTS	Model	Costume	Laterals	Front 90°	Front 60°	Rear 90°	Rear 60°	Quantity	Time	Notes
71	Running, leading child (70) hand in hand	7	T D	12	12	.	12	12	1	100	.
72	Turning around in surprise and running away	12	T D	12	12	.	.	5	1	98	.
73	Ascending-incline, angle 1 in 4	36	N	5	1-1-2	289	5
74	"	24	N	9	1	168	.
75	"	8	N	12	12	.	12	.	8-4	122	.
76	"	8	N	12	12	.	12	.	1-2	186	.
77	" flirting a fan	1	N	11	11	.	11	.	5-8	112	.
78	"	7	N	12	12	.	12	.	1	98	.
79	" 20-lb. basket on head	7	N	11	11	.	11	.	1-2	110	6
80	" bucket of water in each hand	1	N	12	12	.	11	.	1-2	71	.
81	" right	8	N	12	12	.	12	.	1	127	.
82	"	21	N	12	12	.	12	.	1	153	.
83	" (wearing shoes)	7	N	12	12	.	12	.	5-8	89	6
84	"	8	N	11	11	.	11	.	8-4	187	.
85	"	8	N	10	10	.	12	.	1	103	.
86	" bucket water each hand (shoes)	36	N	12	.	.	12	.	1	128	.
87	" stairs	39	N	12	12	.	12	.	1	128	.
88	"	24	N	11	11	.	10	.	1	84	.
89	"	22	N	10	10	.	12	.	8-4	182	5
90	"	7	N	12	12	.	12	.	1	86	.
91	"	7	N	12	12	.	12	.	8-4	100	.
92	" looking around; basin in hands	2	N	12	12	.	12	.	1	110	.
93	" a basin in hands	8	N	12	12	.	12	.	1	147	.
94	" looking around; basin in hands	7	D	12	12	.	12	.	1	92	.
95	Turning to ascend stairs, with a pitcher and goblet in hands	8	T D	12	12	.	12	.	1	161	.
96	Turning and ascending stairs	7	N	12	1	284	.
97	"	6	N	12	1	175	.
98	"	5	D	12	1	196	.

Serial No.	MOVEMENTS.	Model	Costume	Laterals	Front 90°	Front 60°	Rear 90°	Rear 60°	Quantity	Time	Notes
101	Turning and ascending stairs, waving hand	7	N	11	·	·	·	11	1	303	·
102	Turning, ascending stairs, bucket water in r. hand	7	N	11	·	·	·	11	1	325	·
103	Turning and ascending stairs, pitcher and goblet in hands	4	N	12	·	·	·	12	1	296	·
104	Turning, ascending stairs, bucket water in ea. hand	4	N	12	12	·	·	12	1	266	·
105	" " water jar on left shoulder	12	S N	12	·	·	·	12	1	446	·
106	Turning to ascend " bucket water in ea. hand	8	N	12	12	·	·	12	1	165	·
107	Turning to ascend stairs, bucket of water and broom in hands	4	D	12	·	·	·	12	1	221	·
108	Turning to ascend stairs; stooping, lifting a pitcher	4	N	12	12	·	·	12	1	206	·
109	Ascending step-ladder	26	N	12	·	12	·	12	1	107	18
110	" " two steps at a time	8	N	11	11	11	·	11	1	95	16
111	" ladder	30	N	12	12	12	·	12	1–2	127	·
112	" "	8	N	12	·	·	·	12	1–2	84	·
113	Descending incline, angle 1 in 4	24	N	12	12	·	·	12	1	103	·
114	" "	36	N	12	12	12	·	12	1–2	90	·
115	" " with hands clasped in front	7	N	12	12	·	·	12	1	128	·
116	" " one hand on chin	8	N	12	12	·	·	12	1	91	·
117	" "	7	N	12	12	·	·	12	1	109	·
118	" "	8	N	12	12	·	·	12	1	129	·
119	" " right hand on breast (shoes)	7	N	12	12	·	·	12	1	143	·
120	" " bucket of water in right hand	8	N	12	12	·	·	11	1	105	·
121	" " "	2	N	12	·	12	·	12	1–2	129	5
122	" " 20-lb. basket on head, hands each	8	N	12	12	·	·	12	1–2	129	·
123	" " " raised	1	N	12	12	·	·	12	3–4	91	·

Serial No.	MOVEMENTS.	Model	Costume	Laterals	Front 90°	Front 60°	Rear 90°	Rear 60°	Quantity	Time	Notes
124	Descending incline, 20-lb. basket on head, hands raised	8	N	12	12	·	·	12	11–4	124	·
125	" stairs	36	N	12	12	12	·	·	7–8	92	·
126	" "	22	N	11	·	6	·	·	1	65	19
127	" "	24	N	12	6	12	·	·	5–8	109	·
128	" " hands clasped	2	N	12	12	·	·	·	1	75	1, 6
129	" "	7	N	12	12	·	·	·	3–4	99	·
130	" "	7	N	12	12	·	·	·	1	110	5
131	" "	6	N	12	·	·	·	·	1–2	159	·
132	" "	7	N	12	12	·	·	·	1	234	·
133	" waving hand	7	N	12	·	·	·	·	1	221	·
134	" turning to look around, and waving hand	13	N	11	11	·	·	11	1–2	101	·
135	" throwing handkerchief over shoulders	8	N	12	·	·	·	12	1–2	89	·
136	" with basin in hands	15	D	12	12	·	·	12	1–2	68	·
137	" and turning; lamp in right hand	39	D	12	12	·	·	12	1	174	·
138	" full demijohn on shoulder	2	N	12	12	·	·	·	1	178	·
139	" turning around	7	N	11	11	·	·	12	1	234	·
140	" turning; pitcher in left hand	6	N	12	12	·	·	12	1	161	·
141	" looking around and waving fan	7	N	12	12	·	·	11	1	326	·
142	" turning and flirting fan	5	D	12	12	·	·	12	1–2	181	·
143	" dress caught	4	D	10	10	·	·	12	1	396	·
144	" cup and saucer in r. hand	8	T D	12	12	·	·	12	1	182	·
145	" basin in hands	4	D	12	12	·	·	12	1	121	·
146	" bucket water in r. hand	4	D	12	12	·	·	12	1	151	·
147	" water jar on l. shoulder	12	S N	12	12	·	·	12	1	163	·
148	" carrying bucket of water and broom	4	D	11	11	·	·	11	1	212	16
149	" stooping to lift a pitcher	8	N	12	12	·	·	12	1	189	·
150	" lifting pitcher, turning	8	N	8	8	·	·	8	1	424	·

Serial No.	MOVEMENTS.	Model	Costume	Laterals	Front 90°	Front 60°	Rear 90°	Rear 60°	Quantity	Time	Notes
151	Descend'g step-ladder, turn'g around, rock in hands	26	N	10	·	10	·	·	1	135	·
152	Jumping; running straight high jump (shoes)	37	P C	12	12	·	·	·	1	87	·
153	" "	37	P C	12	·	·	12	·	1	63	·
154	" "	26	N	12	12	·	12	12	1	125	·
155	" "	8	N	20	12	·	12	·	1	103	·
156	" twist (shoes)	4	D	12	12	·	12	·	1	105	·
157	" "	37	P C	12	12	·	12	·	1	152	·
158	" "	37	P C	12	12	·	12	·	1	160	·
159	" broad jump (shoes)	37	P C	12	12	·	8	·	1	95	·
160	" "	37	P C	8	8	·	8	·	1	161	·
161	" standing high	40	P C	12	·	·	12	12	1	139	·
162	" broad	40	P C	12	12	·	12	12	1	156	·
163	" (shoes)	37	P C	11	·	·	·	11	1	156	·
164	" pole vaulting	46	N	12	12	·	12	12	·	·	·
165	" "	46	N	12	12	12	12	12	1	146	·
166	" over man's back (leap-frog)	54	N	10	9	·	9	·	1	109	·
167	" boy's	28	N	12	12	·	8	·	7–8	87	·
168	" "	27	N	12	·	·	7	·	1	107	·
169	" "	29	D	18	12	·	·	·	1	119	·
170	Stepping from stone to stone across a brook	12	S N	12	12	·	12	12	1	289	·
171	Stepping up on a trestle; jumping down, turning	12	S N	12	12	·	12	12	1	290	·
172	Ascending steps and jumping off	8	N	12	·	·	·	·	1	234	·
173	Running and jumping with skipping-rope	4	T D	24	12	·	12	12	1–2	104	·
174	Crossing brook on step-stones with fishing-pole	12	S N	12	12	·	12	12	1–2	152	·
175	" and can	12	S N	12	12	·	·	·	1–2	152	·

Serial No.	MOVEMENTS.	Model	Costume	Laterals	Front 90°	Front 60°	Rear 90°	Rear 60°	Quantity	Time	Notes
176	Crossing brook on step-stones, with fishing-pole and basket	7	N	10	10	·	10	10	1–2	88	·
177	Crossing brook on step-stones, with fishing-pole and basket	7	N	10	10	·	10	10	5–8	118	·
178	Stepping on and over a trestle	7	N	·	·	·	·	·	1	243	6
179	Stepping on and over a rock, a basket on head, right hand raised	12	S N	12	12	·	12	12	1–2	129	·
180	Stepping on and over a chair	7	S N	12	12	·	12	12	1	242	·
181	Stepping on and over a chair	12	S N	12	12	·	12	12	1	169	·
182	Crawling on hands and knees	8	N	8	8	·	8	12	1	88	6
183	Walking on hands and feet	8	N	8	·	·	·	·	2	106	·
184	"	8	S N	·	·	·	·	·	1	106	·
185	Hopping on left foot	82	N	12	·	·	12	·	1	141	·
186	" right foot	12	T D	12	12	·	12	12	1	277	·
187	Dancing (fancy)	12	T D	12	12	·	12	12	1	277	·
188	" (fancy)	12	T D	12	12	·	12	12	1	192	·
189	"	12	S N	12	12	·	12	12	1	244	·
190	Dancing (nautch)	12	T D	12	10	·	12	10	1	211	·
191	" (fancy)	12	T D	12	·	·	·	·	1	200	·
192	"	7	D	12	11	·	·	11	1–2	146	4
193	"	7	D	10	10	·	12	10	1–2	207	·
194	waltz	1, 8	D	24	11	·	·	·	1	81	·
195	waltz two models	58,7	D	12	12	·	12	12	1	246	·
196	"	14	D	12	12	·	·	11	1	211	·
197	"	5	D	10	10	·	·	10	1	220	·
198	Courtesying	7	B F	·	·	·	·	·	1	163	·
199	fan in right hand	1	N	12	12	·	12	12	1	158	·
200	kissing hand and turning around	7	N	11	·	·	·	·	1	223	13
201	Taking 12-lb. basket from head, putting it on the ground	—	—	—	—	—	—	—	—	—	—
202	Dropping and lifting handkerchief	—	—	—	—	—	—	—	—	—	—

Serial No.	Movements	Model	Costume	Laterals	Front 90°	Front 60°	Rear 90°	Rear 60°	Quantity	Time	Notes
521	A, walking; B, ascending step; C, throwing disk; D, using shovel; E, using pick; F, using pick	95	N	12	6	6	6	6			8
522	A **97**, jumping; B **98**, hand-spring; C **98**, somersault; D **99**, somersault; E **99**, spring over man's back	97-8-9	N	10	5	5	5	5			8
523	A, striking a blow; B, throwing disk; C, heaving a 75-lb. stone; D, throwing a ball; E, throwing disk; F, heaving 75-lb. stone	99	P C	12	6	6	6	6			8
524	A, throwing water from bucket; B, descending step; C, ascending step; D, lawn tennis	1	S N	8	4	4	4	4			8
525	A, descending step; B, ascending step; C, descending step; D, ascending step; E, wav'g hand'chief	1	N	10	5	5	5	5			8
526	A, lifting ball; B, emptying bucket of water; C, kicking above her head; D, striking with a stick; E, stumbling; F, lifting 50-lb. dumb-bell	1	N	12	6 8	6 8	6 8	6 8			8 8
527	A, B, C; 1, spanking child 104	1	N	12							8 8
528	A, B, C; 1, carrying child 104; D, walking with child 104, hand in hand; E, running with child 104, hand in hand	1	N	6							8 8
529	Various poses	68	N	5	10	10					8 8
530	" "	46	N	10	10	10					8 8
531	" "	7		11	11	11					8 8
532	Movement of the hand; drawing a circle	51	N	12	12				1	124	
533	" " clasping hands	51	N	12	12				1	131	
534	" " lifting a ball	51	N	12	12				1	175	
535	" " beating time	51	N	12	12				1	168	
536	" " hands changing pencil	51	N	12	12				1	178	

ABNORMAL MOVEMENTS.

Serial No.	Movements	Model	Costume	Laterals	Front 90°	Front 60°	Rear 90°	Rear 60°	Quantity	Time	Notes
537	Single amputation of leg; hopping with crutches	82	N	12	12		12	12	1	121	
538	Double amputation of thighs; boy; A, moving forward; B, getting on chair; C, down from chair										
539	Infantile paralysis; child, walking on hands and feet	94	N	36	12		12		1	222	2
540	A, bow-legs; boy; B, spinal caries; girl, walking	92	N	12	12		12		1	115	2
541	Multiple cerebro-spinal sclerosis (choreic); walking	90, 91	S N	24	11	11	12	12	1	157	18
542	walking	21	S N	11							
543	Spastic gait (hysterical); walking	17	S N	12							
544	Artificially-induced convulsions; A, B, C, while lying	19	S N	12				20	1	150	1
545	Artificially-induced convulsions; A, B, while sitting	1	N	36							
546	Locomotor ataxia; walking	87	N	24	12		12		7-8	180	1
547	Hemiplegia; walking with crutch	81	N	12	12		12		1-2	117	6
548	Lateral sclerosis; A, B, walking	86	N	24	11		11		3-4	227	1, 6
549	Epilepsy; walking	79	N	12	12		12		3-4	90	1
550	Locomotor ataxia; walking; A, arms down; B, arms up		N	20					1	164	1
551	Epilepsy; walking	84	N	12					5-8	214	
552	Hemiplegia; walking with cane	78	N	12	12		12		9-10	128	
553	After traumatism of head; walking	76	N	10	10		10		1	122	
554	Locomotor ataxia; walking	75	N	11	11		11			118	
555	Muscular atrophy of legs; adult; A, B, walking	83	N	24						124	1
556	Local chorea; A, B, while lying	89	N	22					1-2	52	1
557	A, B, C, while standing	74	N	36					7-8	48	
558	Paraplegia; partial; walking	74	N	12	12		12		1-2	87	2
559	Disseminated sclerosis; walking with cane	80	S N	12	12		12			70	6
560	Locomotor ataxia; walking	88	N	12	12		12		1	108	
561	Hydrocephalus; walking	85	N	12	12		12			213	
562	Lateral curvature of spine; walking	77, 89	N	12	12		12		8-4	62	

ANIMALS AND MOVEMENTS.

HORSES.

Serial No.	Animals and Movements	Laterals	Front 90°	Front 60°	Rear 90°	Rear 60°	Quantity	Time	Notes
563	Hauling; broken log chain; dark-gray Bel. horse — Dusel.	12		12		12	1		2
564	" " dark-gray Belgian horse — "	12		12		12	1		2
565	" " " — "	12		12		8	1		2
566	" " " — Billy						1		2
567	" " " — "	12		12		12	1		2
568	" " " — Hansel						1	51	
569	" light-gray mare — "	16		12		12	1-3	111	
570	" light-gray mare; light-gray mare — Johnson	12		12		12	1	95	
571	head being pulled; light-gray mare — "	12		12		12	9-10	75	
572	man pulling at head; light-gray mare — Hansel	12		12		12	3-4	77	
573	Walking; free; dark-gray Belgian mare — Hansel	24		12		12	5-8	42	
574	" light-gray horse — Eagle	12		12		12	1-2	90	
575	saddle; irregular; white horse — Clinton	12	12	12		12	1-2	52	
576	bareback; dark-gray Belgian horse — Dusel.						1	56	
577	saddle; white horse — "	12		12	12	12	1-2	55	
578	" thoroughbred bay mare — Elberon.	12		12	12	12	1	126	
579	bareback; rider, 43, nude; light-gray — Annie G.	12	12				1-2	44	
580	horse — Smith								
581	saddle; rider, 43, nude; light-gray —	12		12	12	12	3-4	68	
582	horse — Smith								
583	saddle; female rider, nude; gray horse — Tom.	12	12		12	12	1	82	
584	irregular; brown mare — Beauty	12		12		12	1-2	102	
585	sulky; light-gray mare — Katydid	12		12	12	12	3-4	62	
586	" " — "	12	12	12	12	12	3-4	70	

Serial No.	Animals and Movements	Laterals	Front 90°	Front 60°	Rear 90°	Rear 60°	Quantity	Time	Notes
587	Walking; sulky; sorrel mare — Nellie Rose	12		12		12	1-2	54	
588	" bay horse — Reuben	12		12	12		5-8	82	
589	Ambling (single foot); bareback; white horse — Clinton						1	82	
590	Ambling (single foot); bareback; rider, 106, nude; white horse								
591	Racking (pacing); saddle; brown horse — Clinton	12		12		12	1	55	
592	" " — Pronto	20					1	26	
593		12		12			1	51	
594	walking	12	12	12			1	59	
595		12		12		12	11-2	74	
596	Trotting; free; light-gray horse — Eagle	12		12		12	11-2	76	
597	saddle; dark-gray Belgian horse — Hansel						3-4	45	
598	saddle; bay horse — Daisy	20					3-4	85	
599	bareback; dark-gray Belgian horse — Dusel.								
600		12		12		12	1-2	56	
601	saddle; brown mare — Beauty	12	12	12	12	12	1-2	52	
602	bareback; rider, 43, nude; light-gray —	12					1	52	
603	horse — Smith	12		12		12	3-4	43	
604	saddle; rider, 43, nude; light-gray horse — Smith	10		10			3-4	45	
605	saddle; white horse — Elberon						1-2	46	
606	sulky; bay horse — Reuben	12	12	12		12	1-2	51	
607	mare — Lizzie M.	12		12			5-4	84	
608	sorrel mare — Flode Holden	24					5-8	17	
609	bay mare — Lizzie M.	24					5-8	23	
610	gray mare — Katydid	24					1	19	
611	" —	12		12			11-4	52	
612	bay horse — Dercum	12	12	12			1-1	70	
613	sorrel mare — Nellie Rose	12		12			7-8	47	
614	breaking to gallop; sorrel mare — Flode Holden	24		12			7-8	47	
								21	

ANIMALS AND MOVEMENTS. — HORSES.

Serial No.	Animals and Movements	Laterals	Front 90°	Front 60°	Rear 90°	Rear 60°	Quantity	Time	Notes
615	Canter; bareback; dark-gray Belgian horse . . . Hansel	20					1	36	
616	" saddle; bay horse . . . Daisy	24					1	56	2
617	" bareback; rider, 106, nude; white horse Clinton	12	12				1-4	67	
618	" saddle; brown horse . . . Middleton	12	12				1-4	74	
619	" " thoroughbred bay horse . .	12					1	49	
620	" " . . . Annie G.	12	12		12		1	56	
621	" rider, 43, nude; gray horse . .	12					1	55	
622	" bareback; rider, 43, nude; gray horse Smith	12					1	51	
623	" saddle; bay horse . . Daisy	12	12		12		11-12		2
624	Gallop; saddle; bay horse . . Daisy	12					1	22	
625	" thoroughbred bay horse Bouquet	22					1	31	
626	" " mare Annie G.	16					1	28	
627	" " . . Daisy	20					1	23	
628	" bay horse . . Daisy	20					8-4	95	2
629	" bareback; Belgian draught horse Hansel	12	12			12	11-4	42	
630	" saddle; gray mare Pandora	12	12			12	7-8	44	
631	" thoroughbred bay horse Bouquet	12	12				3-4	44	
632	" " . .	12					7-8	38	
633	" gray horse . .			8		8		37	
634	" " . . Dan		12		12		8	64	2
635	" mare . Pandora		12		12		1	42	2
636	Jumping a hurdle; saddle; preparing for the leap; bay horse . Daisy	20							2, 15
637	Jumping a hurdle; saddle; clearing, landing and recovering; bay horse . Daisy	20							2
638	Jumping a hurdle; saddle; bay horse . Daisy	20							2

Serial No.	Animals and Movements	Laterals	Front 90°	Front 60°	Rear 90°	Rear 60°	Quantity	Time	Notes
639	Jumping a hurdle; saddle; bay horse . Daisy	20					1		2
640	" " . . . Daisy	20					1		2
641	" saddle; knocking over hurdle and landing; rider 105; gray mare Pandora	12						64	
642	Jumping a hurdle; saddle; rider, 105, nude; gray mare Pandora	20					1	60	
643	Jumping a hurdle; bareback; rider, 105, nude; clearing and landing; gray mare Pandora	12						60	
644	" knocking over hurdle; rider 105; gray mare Pandora				8			149	
645	" saddle; clearing and landing; rider 105; gray mare Pandora				8			155	
646	" saddle; rider, 105, nude; gray mare Pandora		12		12		1	122	
647	Jumping a hurdle; bareback; rider, 105, nude; gray mare Pandora		12		12		1	120	
648	Jumping over three horses; A, B; chestnut horse Hornet	24							
649	Hornet, rocking; B, Eagle, rolling barrel, etc.	18							
650	Walking, with a bucket in mouth; light-gray horse.	12						73	4
651	A, bell ringing; B, teeter board; C, military drill horse.	30							4
652	A, B, C, D, E, horses rearing, etc.	12					1	116	
653	Walking; saddle; lame, right front foot; horse . Buckskin	12	12		12		1	104	
654	Walking; saddle; spavin, right hind leg; horse . Gazelle	12	12		12		1	99	
655	Walking; free; ossification of cartilage, right front foot; horse . Bob	12	12		12		1	101	2
657	Rolling a box; pony . Lotta	12	12				1		

ANIMALS AND MOVEMENTS.

Serial No.	Animals and Movements	Laterals	Front 90°	Front 60°	Rear 90°	Rear 60°	Quantity	Time	Notes
658	Mule; A, kicking; B, kicking . Ruth	16						{ A, 62 B, 65 }	1
659	" A, B, bucking and kicking . Ruth	16						{ A, 91 B, 90 }	1
660	" miscellaneous performances . Denver	26							4
661	" A, B, a refractory animal . Ruth	24							2
662	" A, B, " . Denver	24							2
663	" A, B, " . .	24							2
664	" various performances; at a table, etc. .	30							4
665	Ass; walking; bareback; a boy riding . Jennie	12					1	94	
666	" saddle; a girl riding . Zoo	20					1-2	36	
667	" " a boy " .	12					1	82	
668	" ambling; irregular; saddle; a boy riding .	8					1	87	
669	Ox; walking .	16	12		12		1-2	48	
670	" " .	12				8	8-4	123	
671	" trotting .	12			12		5-8	115	
672	Sow; walking .	16					1	56	
673	" " .	12	12				5-8	77	
674	" trotting .	12			12		1	67	
675	" " .	16					1-2	81	
676	Goat; walking .	16					1	43	
677	" in sulky .	12					8-4	51	
678	" trotting, in sulky .	12	12			12	1	44	
679	" galloping .	24					11-4	29	
680	Orex; galloping .	10					1-2		
681	Virginia deer; (no antlers;) buck; walking, startled to a gallop	12			12		1-2	59	

Serial No.	Animals and Movements	Laterals	Front 90°	Front 60°	Rear 90°	Rear 60°	Quantity	Time	Notes
682	Fallow deer; buck; A, trotting; B, galloping .	16					11-2	83	2
683	Virginia deer; (no antlers;) buck; galloping .	24					1		2
684	Fallow deer; A, buck and doe; B, two does; trotting, galloping .	16							
686	" buck and doe; trotting .				12		1	69	
687	" galloping .						1	52	
688	" group of does; galloping .				12		1	71	
689	" A, B, buck, and group of does; galloping .	16						75	
690	" buck and group of does; various movements .	12						90	2
691	" doe; galloping; and kid; jumping .	12					1		
692	Elk; trotting .	20					3-4	32	
693	" galloping .	20					1	27	
694	" irregular .	8					1-2	59	
695	" .	8					3-4	51	
696	Eland; trotting .	12					3-4		
697	Antelope; trotting .	12	12				1	65	
698	" galloping .	24					1		
699	Buffalo; walking .	16					1-2	29	
700	" galloping .	10							
701	Gnu; walking .	10				8			
702	" bucking and galloping .								2
703	Dog; walking; interrupted; mastiff . Dread	12	12		12		11-2	110	
704	" " mastiff .	8	12		12		11-4	43	
705	" trotting; . Smith	10			12		11-2	41	
706	" " . Dread	10			10		2	49	
707	" galloping; . Ike	12			12				
708	" brown racing hound . Maggie	12	A, 12		B, 12			{ A, 42 B, 37 }	2
711	Dogs; two, racing; A, B; racing hounds . Ike, Maggie								

Serial No.	Animals and Movements.	Laterals	Front 90°	Front 60°	Rear 60°	Rear 90°	Quantity	Time	Notes
712	Dog; jumping hurdle; mastiff . . . Dread						1	174	2
713	" turning around, etc.; setter . . . Kate	12	12			12		95	
714	" aroused by a torpedo; mastiff	12	12			12	1	31	2
715	Dogs; three, tugging at a towel . . . Ike, Maggie, etc.	24						30	
716	Cat; walking; change to galloping	20						35	
717	" trotting;	24						28	
718	"	20						17	
719	" galloping	24					1-2	76	
720	"	24					3-4	75	
721	Lion; walking			9			1-2	114	1
722	" "	12					1-2	119	1
723	" turning around			12			1-2	119	
724	" "	12						114	
725	"	12	12				1-2	125	1
726	" and lioness; walking	12				12	1-2	125	1
727	Lioness; walking; lion; lying down.	12					3-4	114	
728	"	12					1-2	125	
729	Tigress;	12					1-2	75	
730	" turning around			12			1-2	119	
731	Jaguar; A, walking; B, turning around	24					1 / 1	A,144 / B,129	1
732	Elephant; walking	16					11-12	63	
733	" "	24					1-2	36	
734	Elephants; two, walking						1-2	92	
735	"					12	1-2	86	
736	Egyptian camel; racking	16	12				1-2	24	1

Serial No.	Animals and Movements.	Laterals	Front 90°	Front 60°	Rear 60°	Rear 90°	Quantity	Time	Notes
737	Bactrian camel; walking	16					1-2	57	
738	" racking	16					3-4	87	
739	" galloping	20					1	29	
740	" (young); galloping	20					1	32	
741	" A, walking; B, racking				24			A,91 / B,58	2
742	" A, racking; B, galloping				24			A,133 / B,39	
743	Guanaco; galloping	12						82	1
744	Raccoon; walking; change to galloping	24					1	82	
745	" and turning around	20		9			1-2		2
746	Capybara; walking	16					1	45	
747	Baboon; walking on all-fours	24					1-2	42	
748	"	12					3-4	41	2
749	" climbing a pole	11					1	69	
750	Sloth; walking suspended on a horizontal pole	12					1	64	2
751	Kangaroo; walking on all-fours; change to jumping	12					1	66	2
752	" jumping	12							
753	"								
754	"								
	BIRDS AND MOVEMENTS.								
755	Pigeon; flying	12	12	20			1-8-4	19	
756	"	12	12	16			2	21	
757	"	12		12			11-2	20	
758	Cockatoo; flying	24			12		2	28	
759	"	24					2	17	
760	"						1-2	16	
761	"						1-2	24	1
762	"						8	75	
763	Red-tailed hawk; flying	24					2-1-2	19	

Serial No.	Birds and Movements.	Laterals	Front 90°	Front 60°	Rear 60°	Rear 90°	Quantity	Time	Notes
764	Fish hawk; flying	10	10				2	58	
765	Vulture; flying	24					1-1-4	19	
766	"	24		12			2-1-4	34	
767	"	12			12		1-1-4	40	
768	"	12	10				1-1-4	40	
769	American eagle; flying near the ground	12			12			40	
770	"	24	24		12		1-2	21	
771	Ostrich; walking						1	19	
772	" running	12					1-2	91	
773	Adjutant; walking	12					3-4	52	
774	" flying run	10					5-8		2
775	Storks; swans, etc., A, B, C .	18					1-2		2
776	" etc., A, B, C, D .	24		24					2
777	" " A, B, C	15							2
778	" swans, etc.	12							2
779	"	12	12			12			1-7
780	"								7
781	Chickens; scared by torpedo		12	12		12			2